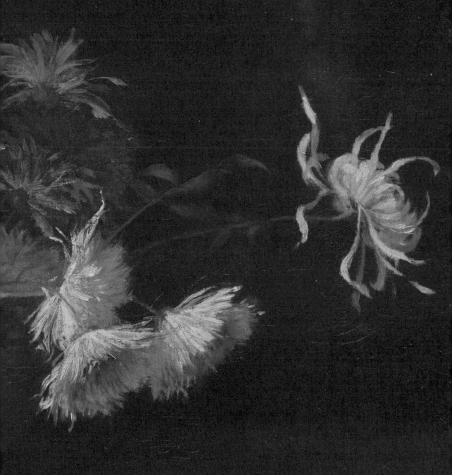

"Peacock does with words what Delany did with scissors and paper, consummately constructing an indelible portrait of a late-blooming artist, an exalted inquiry into creativity, and a resounding celebration of the 'power of amazement.'" —*Booklist*, starred review

"Affecting and engaging, Peacock's own candor combines with Delany's wit and honesty to prove that it is never too late to make a life for oneself and to be sustained by art. VERDICT: This marvelous 'mosaick' makes an indelible impression." —*Library Journal*, starred review

"[*The Paper Garden*] is organized by flower—forget-me-not, thistle, poppy, etc., each a metaphor for a different phase in Delany's life. In this way, the book itself is a complicated, delicate, and beautiful collage." —*Los Angeles Times*

"A winsomely unorthodox ode to Delany that is part biography, part miniature coffee-table book, and part memoir. . . . Peacock skillfully and tangibly evokes Delany's era. . . . The point Peacock makes most convincingly is that Delany's rarefied oeuvre, and her late but metaphorically apt 'blooming,' was the perfect, logical product of the life that preceded it." —*Toronto Star*

Flower Diary

Flower Diary

IN WHICH MARY HIESTER REID
PAINTS, TRAVELS,
MARRIES & OPENS A DOOR

MOLLY
PEACOCK

Published by ECW Press
665 Gerrard Street East
Toronto, Ontario, Canada M4M 1Y2
416-694-3348 / info@ecwpress.com

Editor for the Press: Susan Renouf
Cover design: David A. Gee
Cover image: Mary Hiester Reid, *Chrysanthemums*,
1891, oil on canvas, 52.9 x 76.2 cm, National Gallery
of Canada, Ottawa. Gift of the Royal Canadian
Academy of Arts, 1893. Photo: NGC / Mary
Hiester Reid, *Chrysanthèmes*, 1891, huile sur toile,
52.9 x 76.2 cm, Musée des beaux-arts du Canada,
Ottawa. Don de l'Académie royale des arts du
Canada, 1893. Photo: MBAC. George A. Reid,
Portrait of Mary Hiester Reid, 1885, Oil on canvas,
76.7 x 64.3 cm, National Gallery of Canada, Ottawa
Gift of Mary Wrinch Reid, Toronto, 1965 Photo:
NGC / George A. Reid, *Portrait de Mary Hiester
Reid*, 1885, Huile sur toile, 76.7 x 64.3 cm, Musée
des beaux-arts du Canada, Ottawa Don de Mary
Wrinch Reid, Toronto, 1965 Photo: MBAC.

LIBRARY AND ARCHIVES CANADA CATALOGUING IN
PUBLICATION

Title: Flower diary : in which Mary Hiester Reid
paints, travels, marries & opens a door / Molly
Peacock.

Names: Peacock, Molly, 1947- author.

Identifiers: Canadiana (print) 20210210796 |
Canadiana (ebook) 2021021094X

ISBN 978-1-77041-622-2 (hardcover)
ISBN 978-1-77305-839-9 (ePub)
ISBN 978-1-77305-840-5 (PDF)
ISBN 978-1-77305-841-2 (Kindle)

Subjects: LCSH: Reid, Mary Hiester, 1854-1921. |
LCSH: Painters—Canada—Biography. | LCGFT:
Biographies.

Classification: LCC ND249.R442 P43 2021 |
DDC 759.11—dc23

We acknowledge the support of the Canada Council for the Arts. *Nous remercions le Conseil des arts du
Canada de son soutien.* This book is funded in part by the Government of Canada. *Ce livre est financé
en partie par le gouvernement du Canada.* We acknowledge the support of the Ontario Arts Council
(OAC), an agency of the Government of Ontario, which last year funded 1,965 individual artists and 1,152
organizations in 197 communities across Ontario for a total of $51.9 million. We also acknowledge the
support of the Government of Ontario through the Ontario Book Publishing Tax Credit, and through
Ontario Creates.

PRINTED AND BOUND IN CANADA

PRINTING: FRIESENS 5 4 3 2 1

For my husband, Michael Groden (1947–2021):
In the Attempt Is the Success

TABLE OF CONTENTS

AUTHOR'S NOTE XIII

PROLOGUE: THE OPEN DOOR XVII

PART ONE: THE TRIANGLES

CHAPTER ONE: Painter & Traveler 3

CHAPTER TWO: *A Study in Greys* 15

CHAPTER THREE: An Inglenook, a Studio 27

CHAPTER FOUR: Silhouette 33

CHAPTER FIVE: *Early Spring* 43

PART TWO: A CALLING, A ROMANCE

CHAPTER SIX: *Nightfall* 61

CHAPTER SEVEN: Life Class 77

PART THREE: HONEYMOON

CHAPTER EIGHT: Yellow Gloves 99

CHAPTER NINE: The Sister 109

CHAPTER TEN: *Still Life with Daisies* 117

CHAPTER ELEVEN: *Gossip* 127

PART FOUR: PARIS

CHAPTER TWELVE: City of Flowers — 137

CHAPTER THIRTEEN: *Studio in Paris* — 153

CHAPTER FOURTEEN: Angry Mary — 163

PART FIVE: ONTEORA & ROSES

CHAPTER FIFTEEN: *Roses in a Vase* — 177

CHAPTER SIXTEEN: *Chrysanthemums* — 189

CHAPTER SEVENTEEN: *Three Roses* — 203

PART SIX: TORONTO & AN ARRANGEMENT

CHAPTER EIGHTEEN: Modern Madonna — 219

CHAPTER NINETEEN: Portraits — 223

CHAPTER TWENTY: *The Evening Star* — 231

CHAPTER TWENTY-ONE: *Chrysanthemums:* — 235
　　　　　　　　　　　A Japanese Arrangement

PART SEVEN: SPAIN

CHAPTER TWENTY-TWO: *Castles in Spain* — 241

CHAPTER TWENTY- THREE: Madrid and the Prado — 255

CHAPTER TWENTY-FOUR: A Husband Sketches a Marriage — 269

PART EIGHT: ARTS & CRAFTS

CHAPTER TWENTY-FIVE: *Moonrise* — 277

CHAPTER TWENTY-SIX: Portrait of Mrs. Reid — 287
　　　　　　　　　　　Arranging Roses

CHAPTER TWENTY-SEVEN: Mrs. Reid in a Frock, Outdoors — 293

CHAPTER TWENTY-EIGHT: Lunch, Friendship, 303
and Menopause

CHAPTER TWENTY-NINE: Two Marys, a Miniature 313

CHAPTER THIRTY: *Nasturtiums*, a Restoration 317

PART NINE: WYCHWOOD, PORTRAIT OF THE
ARTIST AS A TREE

CHAPTER THIRTY-ONE: *The Women's Globe* 329

CHAPTER THIRTY-TWO: Art Metropole 341

CHAPTER THIRTY-THREE: Self-Portrait as a Table and Chair 345

CHAPTER THIRTY-FOUR: *The Little Bridge* 353

CHAPTER THIRTY-FIVE: *Past and Present Still Life* 367

CHAPTER THIRTY-SIX: *Elm Tree Shadows* 373

POSTLUDE 383

TIMELINE 390

BRIEF BIBLIOGRAPHY 393

IMAGE AND LITERARY CREDITS 394

NOTES 399

INDEX 426

ACKNOWLEDGMENTS 435

AUTHOR'S NOTE

I.

Flower Diary enters an era of individuals with limited and destructive ideas about gender, race, and colonialism. While exploring the fascinating life that Mary Hiester Reid lived within such limitations, I have tried to keep a contemporary lens while also telescoping deep into the norms of her day. I hope these shifts address some of the stunning cultural complexities that arise when delving into examples of historical lives.

2.

I had been warned not to undertake this project. She left no diaries! The letters are skimpy! Was that admonition meant to steer me to a well-documented public figure? Someone, for instance, like Mary's husband? But how could I heed such a caution when daily I hurried past the place of her first studio in Toronto, and weekly stopped to buy vegetables

at the historic market where she, too, must have shopped? Often, I ambled past the building that supplanted her light-filled second studio. As a matter of course, I strolled past a cathedral she had to have promenaded past, if not attended, and a smaller church nearby where she no doubt had shifted her bustle on a wooden pew. I'd shiver up Jarvis Street to go to Allan Gardens to visit, in deep winter, the glass Palm House that had opened in her day for all of Toronto to marvel at. I lived inside her geography, an American with Canadian roots who married and moved to Canada, as she did. I paced her ground.

from "443"

I tie my Hat—I crease my Shawl—
Life's little duties do—precisely—
As the very least
Were infinite—to me—

I put new Blossoms in the Glass—
And throw the old—away—
I push a petal from my Gown
That anchored there—I weigh
The time 'twill be till six o'clock
I have so much to do—
And yet—Existence—some way back—
Stopped—struck—my ticking—through—
We cannot put Ourself away . . .

—EMILY DICKINSON

from "Poem"

Art "copying from life" and life itself,
life and the memory of it so compressed
they've turned into each other. Which is which?

—ELIZABETH BISHOP

The Open Door

She left a door ajar, slipping through a threshold into the almost impossible-to-balance world of love and art. Over three hundred paintings and a lifelong commitment to a partner: she's one of the artists from the past who made it possible to live and love in the present. Often, we who look for models of creativity learn the names of those who banged down doors and wrecked their own and others' lives. But she, who mined a rich and unconventional interior life while clothed in discreet propriety, turned the handle more quietly. And handle is a word that belongs to this woman who made still lifes like diary pages and landscapes like dream logs. She planned and coped, sized up situations, then seized moments, managing a subtle ménage with her painter husband and their talented student in a stiff society, all the while making five transatlantic journeys and creating some of the most devastatingly expressive works you've likely never seen, signing them Mary Hiester Reid.

The Triangles

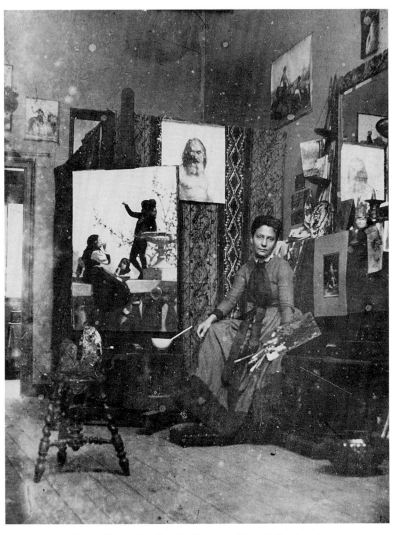

Mary Hiester Reid in her Paris studio at 65 Boulevard
Arago, 1888–1889, photograph by George Agnew Reid,
Art Gallery of Ontario, Toronto.

CHAPTER ONE

Painter & Traveler

I.

Alone in the world. Mother? Dead. Father? Dead. Only sister an ocean away and never coming back. When the first notes of a calling burst inside her in 1883, she made a decision about the course of her life that took her far away from the rooms and norms of the time she lived in.

Mary Augusta Catherine Hiester (April 10, 1854–October 4, 1921) leapt into real painting, not just ladies' watercolors, at twenty-nine, when her dress went nearly from her ears to her ankles and close along her arms to the wrists. The registrar at the Pennsylvania Academy of the Fine Arts wrote her name in a steady, copperplate hand.[1] Then, in the all-female oil painting class, she watched a naked woman climb on a riser and turn her back. Scrunched behind her canvas, Mary crowded for a view among the other young women at this art school led by the genius and so-called libertine Thomas Eakins. Eakins allowed his female students to learn to paint by looking at bodies like their own. Mary saw the lobes of the woman's buttocks, the s-curve of her spine, the tilt of her

shoulders, the angles of shoulder blades moving under her skin as the model positioned her arms. She stared longer and more intently than she'd ever have a chance to in her own bedroom mirror in the household where she lived with her cousins. Breathing in the heavy oil paint and turpentine perfume of the studio, she began to paint flesh like hers.

But later Mary would rarely paint the human figure. Instead she injected that figure into the flesh of flowers, curves of jars, and spines of trees. She painted blowsy, sensuous, billowing roses trapped at the necks in vases as if they were silk-gowned beauties grabbed by their corsets. Pewter jugs as solid as ironclad wills. Evergreens pointed in fierce declarations. Each element fully in possession of its body. And she positioned those bodies in relation to one another, making each rectangle alive with emotion and gesture.

It was a challenge to throw away watercolors and enter the world of oils. Following a course so separate from familiar occupations would make any person feel forlorn. But the lack of immediate family made a radical decision possible for Mary. No father to put his foot down. No mother to disapprove. No sister to be shocked. With the world of expectations that made such a choice revolutionary for a woman of her time and class, it was undeniably lonely.

In another studio, the male students painted. Later in the day, the groups would merge, and she would see him.

2.

She stayed only two years at the school before she embarked on her career. For a painter who focused on still lifes, her life would rarely be still.

Mary piled her trunks with cloaks, muffs, boots, paints, her travel easel, her campstool, lace collars, and ankle-length dresses. Those trunks, enduring five transatlantic crossings, were hoisted onto railway platforms, heaved onto docks, hauled into steamships, strapped onto carriages, carted up stairwells, and settled into strange rooms. There the leather-buckled boxes became like little bedroom dressers, each wooden-slatted steamer trunk a world within the wider world she traveled. Within these sanctuaries, her handkerchiefs, jewelry, menstrual cloths, and money all nestled in their side pockets. When she chanced to look in that mirror, she'd see her brunette hair and licorice eyes.

"A conspicuous traveling dress is in very bad taste, and jewelry or ornaments of any kind are entirely out of place,"[2] Florence Hartley pronounced in *The Ladies' Book of Etiquette, and Manual of Politeness*, and MHR, as she sometimes signed her work, had every reason to agree. She preferred not to be accosted on the street as she sketched.

"I was somewhat jostled as they crowded about me to see what I was doing," she wrote of a gaggle of male students who mobbed her in the university town of Salamanca, Spain. "I fancy that a woman sitting alone on the street . . . was an unaccustomed sight."[3] A figure stood in a nearby doorway. A small man, not too much taller than herself, with a soft beard and an unadorned, direct look in his eyes.

3.

MHR took weeks to sail from North America to Europe where she studied classical painting techniques, absorbed the belle époque art worlds of Paris, London, and Madrid—and sometimes chose the wrong hotel, admitting, "It cannot possibly be any worse."[4]

She enrolled in classes at the Académie Colarossi in Paris and learned the traditional salon underpainting methods, even as she also took in, with those dark, ever-absorbing eyes, the Impressionist vision—but at a time when Paris was post-Impressionist. She fell in love with Whistler's *Arrangement in Grey and Black No. 1* well after he established the Tonalist vision. She built on all she learned from her teacher Eakins and sought out Diego Velázquez's seventeenth-century paintings decades after Eakins recommended them. Because she had to voyage across an ocean to learn, years collapsed and reversed for her education. Ideas of "art for art's sake," the basis of Aestheticism, mixed with ideas of "art for all." But the fact that she was behind in painting modes allowed both the slow and the simultaneous absorption of contradictory styles; she felt her way through all those techniques. Her instincts—as well as what she could sell to her public—carried her.

After she studied and observed in Europe, she stood with her splendid posture and packed again to return—not to Reading, Pennsylvania, where she was born, or to Beloit, Wisconsin, where she grew up, or to the Catskill Mountains in upstate New York where she later maintained a studio, but to the cold inglenooks of her adopted

Canada. Out from the trunks came the sketching crayons, the rolled canvas, and her evening dress. Time to air her travel suit and put it away until the next excursion. For there was always another journey.

"Strong boots and thick gloves are indispensable in traveling," Hartley went on to advise, "and a heavy shawl should be carried, to meet any sudden change in the weather."[5] For seventeen late muddy springs and early summers, she chugged back and forth between Toronto and Onteora, an artists' colony in the Catskills. Onteora was the vision of Candace Wheeler, associate of Louis Comfort Tiffany and mother of North American interior design and its Arts and Crafts movement. Wheeler was also the force behind the Woman's Building at the 1893 World's Columbian Exposition in Chicago, and there Mary's sensuous chrysanthemums would glow on display in the Palace of Fine Arts for over twenty-seven million visitors.[6]

Each trip was an upset. However carefully a person packs, travel puts life in disarray. Constant commotion: what you thought you'd packed, suddenly lost. Constant checking: Tickets? That paintbrush with the thinnest of sable hairs? That best piece of lace for a neckpiece? The proper currency in the purse? Pesos, francs, pounds, dollars? And little enough of those, too, for though she was born an American Brahmin, the great-great-granddaughter of Henry Ernst Muhlenberg, called the "American Linnaeus"[7] and a descendant of George Clymer (a signer of the Declaration of Independence), she sailed on economy steamship lines. Her botanical heritage informed her vision, but she was not a botanical artist. Her flowers inhabit moody, expressive still

lifes accomplished during periods when she was bumped in stations, jolted through miles.

The close-fitting dress with its floor-length ribbon in the photograph of Mary in her Paris studio looks very much underpinned by dark linen, recommended over white petticoats and corsets as a defense against mud[8] flung up by the hooves of coach horses on the Boulevard Arago in the fourteenth arrondissement. Who took that photograph? The man with the clear, direct gaze.

4.

The journeys of her adult life recalled her first train trip at the age of about nine, as she, her mother Caroline Amelia, and older sister Carrie escaped the city of Reading (now an outer Philadelphia commuter community) in the chaos at the end of the Civil War. How thrilling to be about to board with them, the steam of the engine obscuring the signs on the platform as her mother tipped the porter to oversee trunks containing all their earthly possessions. How wrenching to leave the aunts, great-aunts, and cousins; the Muhlenbergs, Mussers, Clymers; her families of prominence. The upset of leave-taking recalls other griefs: her father, John Hiester, a physician and naturalist, died in her infancy. He was a myth to her, alive in her sensitivity to plants. When she was twenty-one, her mother died. Mary boarded another train to a new life, but then her sister took a shockingly unexpected turn: Carrie sailed to Europe,

never to return to North America. The unanticipated followed the unforeseen.

When love came, it was the biggest upset of all: the man who had sauntered from the all-male painting studio at the Pennsylvania Academy of the Fine Arts; the one who emerged from the shadows to rescue her in Salamanca, Spain; the one who stood behind the tripod to take the photo in Paris.

George Agnew Reid (July 25, 1860–August 23, 1947) was bearded, stocky, talented, driven. He barreled through life. Six years younger than Mary, the darling of the Pennsylvania Academy of Fine Arts, an Ontario farm boy with shocking ambition—almost as shocking as her own—George became the husband of the brunette painting student. At the moment when Mary decided to embrace painting as a way of life, she also decided to embrace a marriage—and forge a new kind of partnership. In a world of misogyny as dense and threatening as any fairy-tale forest, they painted together, side by side. And they traveled together, moving through the decades of the 1880s, the fin de siècle, the beginning of a new century to a world war.

"I went cheerfully on with my sketch," she wrote when she described how she tried to wave away those milling "rude"⁹ students in Salamanca, Spain. But when George materialized, the young men scattered. George reordered her universe with that step, as he did many times in their travels and artistic lives together. Akin to Hartley's advice to carry a heavy shawl, she chose him as her protective wrap. How much she would need those outer layers as she paced a

path following the progress of women's suffrage till her last public act: walking down the street to vote.

Travel spurred her independence. The rules of conventional life were not suspended, exactly, but jostled and transformed. Acceptable behavior was unshaped, then reshaped, just as landscape forms and alters from the windows of a train or the ocean bulges and drops from the deck of a steamship. She could make what is called a "companionate marriage";[10] she could also have a voice in paint. Mary Hiester could be Mary Hiester Reid—and never leave that H from her signature.

In an era where Mary Cassatt eschewed marriage and a fully adult life to live with her parents in Paris so that she could produce her work, Mary Hiester bounded into an adulthood of painting with a grown-up's problems of money and sex and logistics. She made a life in Toronto and upstate New York with all the shocks and trade-offs of a compromising, inspiring, sad, and exuberant marriage. Existing with an ambitious man in a socially constricted world for women of which a person today can barely grasp the demeaning dimensions, she lived, by her lights, "cheerfully." She painted around the obstacles of an artist's life by employing a woman's emblem, the rose, and later an emblem of independence, the tree.

5.

Mary made money from her work. She recorded the fee for each painting she sold in her various Toronto studios, as well as the summer studio she maintained in Tannersville, New York. After she represented Canada at the World's Columbian Exposition in Chicago (1893), she won places for her gem-like still lifes at the Pan-American Exposition in Buffalo in 1901, and at the Louisiana Purchase Exposition in St. Louis in 1904.[11] She priced and sold her oils side by side with her husband and with influential Canadian naturalist painter Robert Holmes.[12] She hosted studio sales of her work and sent paintings yearly to the exhibitions of the Ontario Society of Artists and the Royal Canadian Academy of Arts, where she was among the few women members. She joined the Women's Art Association of Canada. She exhibited in the galleries of the Art Metropole in Toronto and at the Royal Ontario Museum.[13] She showed years before the Group of Seven.

6.

Does a journey somehow lead to its seeming opposite, home? MHR lived in the contradiction that one's home studio is where art is made, yet crossing oceans and passing borders to view paintings was necessary inspiration. Art is not made without other art. She did not inhabit an era where an oeuvre could be viewed with a click, or even a place with a capacious library of art books, or a time when

color photo reproduction flourished. She made do with *Art & Architecture* and with viewing the copies of paintings that she and her friends and teachers and colleagues reproduced.

It requires will to sketch when one is in motion. As she coped with train platforms and shipping docks and new languages, then as she built fires in recalcitrant stoves to boil water for the tea for all her husband's friends, living surrounded by men who smelled, as she did, of oils and turpentine, Mary painted her vibrantly emotional, enigmatic still lifes. She would become the first woman to be honored with a solo show at the Art Gallery of Ontario, back then a small brick building on Toronto's Dundas Street West in a gray city tightly tied to the British Empire.

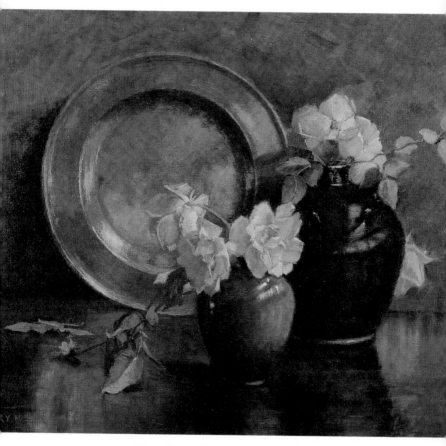

Mary Hiester Reid, *A Study in Greys*, c. 1913,
oil on canvas, 61.0 x 76.2 cm,
Art Gallery of Ontario, Toronto.

A Study in Greys

I.

Georgiana Uhlyarik, the Fredrik S. Eaton curator of Canadian art, seemed to have a ready laugh waiting to peal from her curatorial self-control. I followed her heels as they clicked across the galleries of the Frank Gehry–redesigned Art Gallery of Ontario until she stopped at Mary's *A Study in Greys*. The curator was stylishly and monochromatically dressed—in gray. It was 2012, almost a century after the painting's completion. It hung in a salon-style exhibit of historical Canadian paintings at knee height, so low I doubted many viewers bothered with it. I sank into a deep yoga squat to examine it. I couldn't last, so stood, then bent to look again, my fanny upended in a way that would have appalled the modest Mary in my first meeting with one of her works. Her elegant *Study* is sumptuously contained. Like René Magritte's *The Tomb of the Wrestler*, a quite different, Surrealist painting of a rose in a box painted half a century later, but of which I was suddenly reminded, it is the tale of roses in a frame.

She may have titled it *Greys*, but she packed it with subtle built-up color. Delicate pinks underpin the white roses like lingerie beneath pale gowns. Blues like five o'clock shadows fortify the jars and pewter plate. In the quivering tension of restraint, layer after layer of these understated colors build up to the grays. Mary was gray and about sixty years old when she painted it.

I reacted to *A Study* both as a poet and as a biographer. Three sets of roses. (Two sets practically faint from the ceramic jars, while a third hangs quietly off to the right.) Three objects—two ceramic jars and, behind them, a pewter plate. The horizon line one-third of the way up. "Batter my heart, three-personed God,"[1] John Donne wrote in one of his Holy Sonnets that Mary, a poetry reader and churchgoer, might have understood. She paints a trinity here. Donne's poem reminds every reader that when the spiritual is evoked, the sensual is not far behind.

"Look at all the triangulation in this painting," I exclaimed to Uhlyarik, expert in Canadian painting. I'm not an expert. I am a viewer captured by a painted voice from the past. I was looking at work from a thoroughly mature artist who, I would soon discover, had led a life layered with contradictions and emotions, both inwardly wild and outwardly tempered. "Where did all these threes come from?" I pressed Uhlyarik. That was when the curator let out her peal of laughter. "I'll tell you a story," she said as she was interrupted by an assistant, "later"—and marched out of the room.

2.

For anyone who calls themselves a late starter, or a slow processor, *A Study in Greys* is an argument for your kind of life. Mary took a decades-old Tonalist painting technique and made it her own, with a Realist's touch, deriving her style partly from her much-admired James McNeill Whistler (1834–1903). His 1885 "Ten O'Clock" speech laid the groundwork for Tonalism, an approach that takes its impulses from music, or tones.[2] Tonalists attempt to represent emotions in their paintings through times of day like sunrise, twilight, or sunset, and weather like fog and rain, all the indistinct moments and often gray weather that are called "poetic." Mary was a reader of poetry—Robert Browning, Robert Burns, and William Wordsworth—as well as a poet in paint. (She wrote easily and well, turning a metaphor deftly and making dreamy, detailed descriptions of landscapes in a series of travel articles she composed in 1896 for *Massey's Magazine*.[3]) Even as poetry attempts to take the ineffable and put it into words, so a tonal painting attempts to portray mixed and indistinct yet present, persistent emotions.

A Study in Greys is dated circa 1913—the year of the Armory Show in New York City. Then Marcel Duchamp's Cubist painting *Nude Descending a Staircase, No. 2* set off an earthquake in the art world, and accepted narrative says that modernism was officially born in North America. *Greys* looks nothing like Duchamp's work, for Mary had zero interest in the hard abstraction of modernism. Her interest was in feeling and in time. But that does not mean she was retrograde. She foreshadowed the softened realism

and atmospheric techniques of twentieth-century photographers like Edward Steichen and Alfred Stieglitz. With her smooth-stroked, sublimely crafted paintings suggestive of interior states, described in musical terms like symphony, nocturne, and harmony, Mary was one of a handful of North American women Tonalists, along with painter Mary Rogers Williams (1857–1907)[4] and photographer Gertrude Käsebier (1852–1934). Across the Atlantic, there were British painters Dod Procter (1890–1972) and Gwen John (1876–1939), and farther away, the Australian Clarice Beckett (1887–1935).[5]

Mary espoused a way of painting that was becoming passé before her very eyes, superseded by the march of masculine abstract artists and, in Canada, the all-male Group of Seven.[6] Soon she would be considered one of those lady painters of ho-hum naturalistic style to be passed by. The vibrant reviews of her work in the yearly exhibitions of the Ontario Society of Artists and the Royal Canadian Academy of Arts gave way to progressively fewer, and increasingly condescending, lines, *A Study in Greys* labeled "a well-painted work" at the bottom of the third column of type in a *Montreal Gazette* review.[7] When Georgia O'Keeffe reacted against the proportions of ladies' flower paintings of the past, enlarging petals, stamens, and pistils until viewers had to look them in the face, it was painters like Mary she rebelled against. But if Mary hadn't persevered and left a legacy of works in the National Gallery of Art, the Art Gallery of Ontario, other museums across Canada, as well as the Reading Art Museum, and in distinguished collections like the one owned by the Cooley Gallery in Old

Lyme, Connecticut, then twentieth-century women painters would have had one fewer mother to rebel against.

Even if we don't know the figures of the past, they influence us, nonetheless. Georgia O'Keeffe's tumultuous marriage to Alfred Stieglitz was built partly on a foundation provided by stably married and vigorously producing painters like Mary. To classify an intuitively bold and technically deft artist like Mary Hiester Reid as a poetry-reading lady flower painter in a high collar misses the fact that she slipped that collar at every opportunity, and when she couldn't, wore it with stately dignity.

The year following *A Study in Greys*, the Great War stopped her travels for good. She wouldn't go to Europe; she wouldn't even cross the border to her studio-house in the Catskills again. The war called on Canadians to stay home and to contribute time and money and service, and just after the war, the flu pandemic of 1918 and her own health demanded that she stay home permanently.

Uhlyarik's shoes clicked across the gallery again. She stopped in front of *A Study in Greys*. "About those triangles you noticed," she said, picking up our conversation, "Mary Hiester Reid seems to have willed her husband to a younger painter, Mary Evelyn Wrinch, on her deathbed. And he took her seriously." *Willed* her husband? Gave him, like the chattel women in her generation were supposed to be, to another woman of the next generation? "Let me get this clear . . ." I said to Uhlyarik.

But Tonalism is the opposite of clear.

The words in both English and French for black and white derive from the same Indo-European root, meaning

ash. The midpoint between black and white is what fire leaves: charcoal. *A Study in Greys* records what occurs between the black and white of ordinary perception, and even between the black and white of the standard social mores of its time. Tonalism as an artistic style embraces mystery. A Tonalist approaches the canvas with some of the attitude that the unusual, eccentric, eyebrow-raising personalities of late Victorian Toronto and blue book Onteora did. These artists lived outwardly acceptable existences, within the confines of their rigid, Protestant, church-going, gender-separated, heteronormative, white societies. Tonalism might even be construed as a description of a lifestyle, one that embraced shadowy emotive forces and shaped them without naming them, because they couldn't (yet) be named.

But Mary tweaks her tonal technique with the realism of giving still life objects weight and volume. As we handle and clean objects, dust and place them, things that Mary did with the plate, jug, and jar in this painting all her life, it's easy to feel them come alive, or to see our lives through them. We've only to tap into childhood to find the "transitional object," as British psychologist D.W. Winnicott called it. Our very first adventures into reality are through the objects—a soft toy, a blankie—given to us as infants. Much of our early growing up involves an absorption with them, from toys to soccer balls. A transitional object, Winnicott tells us, "has vitality or reality of its own."[8] Mary was consumed with the things she painted. She portrayed them over and over again, hundreds of times. Rachel Gotlieb, adjunct curator at the Gardiner Museum,

explains that household objects in both the painting and literature of the Victorian and Edwardian eras were commonly identified as male or female, categorized as young or old, and labeled with such qualities as full and robust or empty and stingy.[9] These objects act as individuals in still life compositions.

Because still life flirts with portraiture—and self-portraiture—Mary's work has an allegorical feel. That great sturdy pewter plate, made of metal, like currency, backs both the jug and the vase. The shiny gray jar, with three roses optimistically upright, steps out in front like a youthful offspring. Between what would have been recognized in her day as the masculine plate and the youthful female jar, Mary anchors a matronly midnight-blue jug with its own three roses, two upright in the neck of the opening, one fainting, trailing behind.

George? Mary? Mary Evelyn?

A century later, the plate that completed this threesome now leans against the mantlepiece of her former house, cared for by reverential tenants.

INTERLUDE

My husband and I were married twenty-eight years—
though we'd known each other sixty years, since we were
thirteen. We were boyfriend and girlfriend in high school,
and our romance lasted through our freshman years at uni-
versity. Then we lost touch for two decades. During that
gap, we each married other people the year after graduat-
ing, and exactly six years later, we each divorced. When we
met again as adults—both with the feeling of having come
home at last—we had lived separately on our own a long
time. We were forty-four.

If I am to throw in my lot with this person, I thought
then, my first serious boyfriend, my first lover, my
companion-in-sync, I knew that I couldn't hold back. I'd
have to hurtle over the emotional falls and expect him to
be there, arms open. Had eighteen years of psychother-
apy led to me being able to trust that much? I would be
giving up New York, a place I adored (not entirely, as it
turned out), and an independence I had labored toward. I
would be giving up my identity as an American poet and
assuming some sort of just-over-the-border expat status.
Though I could have immigrated to Canada on my own, it
was so much easier to accomplish that as a wife. "Always

do what's easiest," Samuel Butler is supposed to have said (a quote I've long searched for and never found).

But emotionally it wasn't easiest. It required a huge leap of faith. We did not fashion our wedlock traditionally. For nearly the first decade, we conducted our marriage in two cities in two neighboring countries. Our rule: no more than two weeks apart. Otherwise, the transitions were just too hard. I launched into a freelance life. (A freelance poet? When I told my mother that I'd given up my teaching job, I nearly had to call her an ambulance.) But I had this new union, a safe harbor, an anchor: emotional, sexual, financial. And I was a safe harbor to my husband Mike—emotional, sexual, and financial, too. We commenced constructing something within the larger mold of what our friends, families, jobs, and governments understood as marriage, without slipping into a prefab shell.

Instead, we began a marriage by design. We didn't expect each other to give up our lives. We kept our places (my ample one-bedroom, rent-stabilized apartment in New York; his house in London, Ontario). Mike continued as professor of English at Western University and with his international research as a James Joyce scholar, while I did more readings, workshops, and independent teaching. It felt like building a house on the foundation we had dug as teenagers.

What really let me feel it could work was this: I could sit and write a poem not six feet away from him.

He could be reading the paper while I curled up in my bathrobe and wrote a sonnet, completely and vulnerably closing the covers of consciousness over my head while

making the deep dive through layers and layers down to that place of metaphor where, as if I were at the bottom of a pond, I would be oblivious to the dry, outside world. My husband was but yards away from me. I could trust him not to interrupt. He could trust that I would swim back up to the surface to meet him. And this took place within tacit boundaries we didn't elaborately discuss. Mike was the first person I was involved with as an adult who didn't constantly occupy a huge space in my head. He didn't insist on inserting himself into my consciousness at all. Just the opposite: if I wanted him, I had to go get him. I often felt as if I were an emotional biologist on a field expedition, waiting for a rustle of leaves in the forest camouflage that would let me know he was there.

Perfect.

I had found my ideal mate. Apparently, I'd known this—as had he—since the junior prom. We just hadn't known how to arrange it, create it, make it, manage it, live it until there was a sexual revolution, birth control, second-wave white feminism, and two talented therapists (his and hers). Importantly, we didn't have children—and wouldn't. We had both made that decision independently.

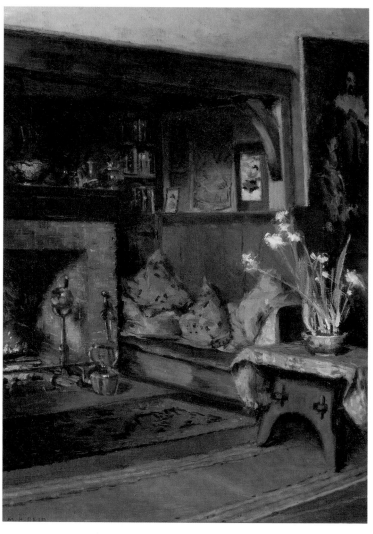

Mary Hiester Reid, *A Fireside*, c. 1912,
oil on canvas, 61.2 x 46 cm,
Art Gallery of Ontario, Toronto.

An Inglenook, a Studio

I.

An autumn chill in 1921. A fireside in Upland Cottage, the Arts and Crafts fantasy of a house designed by George for two working artists, himself and Mary. The couple worked side by side in his and hers studios there at 81 Wychwood Park, a magical artists' community, in what's now the City of Toronto. George's studio was gargantuan, big enough for huge murals. Mary's comfortable studio with its cozy fireplace and inglenook led to the dining room and kitchen. That day, two young painters arrived to visit and to help. One was Marion Long (1882–1970). The other was Mary Evelyn Wrinch (1877–1969), who lived in a studio-house, also designed by George, just beyond the garden behind their house, with its address on a neighboring street, 29 Alcina Avenue.[1] Miss Long and Miss Wrinch were there because Mary was ailing. Angina had plagued her for several years, and now she was dying.

It was to Wrinch, the shadow Mary, twenty-three years younger, that Mary Hiester Reid is said to have whispered

an instruction that would never be entered in a will. The older painter verbally bequeathed her husband to the younger painter. "George will be needing a wife," Marion Long recollected Mary saying nearly two decades later, telling Muriel Miller, the biographer of George Reid: ". . . and I think," she is said to have said to the shadow Mary, who was in her early forties, "it should be you."[2]

The titles of MHR's paintings, incorporating words like Harmony, Study, Roses, and Moonrise, mask the mettle of a woman who, rather than leave the afterlife of her marriage in the hands of fate, attempted to direct it before her death. But Mary Evelyn Wrinch titled her work from that time quite differently. Take *Saw Mills, Muskoka* (1906). It is vigorous, full of personality and dash—an exterior scene of logging not far from the Lake of Bays in Ontario where Wrinch had a cottage—and it was painted with a conception of a new level of abstraction over a decade before the Group of Seven began to exhibit. Her smokestacks are about as far from flowers as you can get.

2.

Simply to have a studio, let alone a fireplace. Simply to claim a space within a house, a marriage. How many of us negotiate and renegotiate much tinier spaces in our lives, bargaining for them financially, emotionally? *A Fireside* is rich, warm, and pillowy. It's full of interest for the beholder's engagement (books, copper tea kettles, a Japanese print brought back

from Paris, George's copy of a huge Velázquez that Mary admired). To the side of the umber beams bloom paperwhite narcissus bulbs in a ceramic bowl. The sparkler flowers hurl out their scent in swift dashes of white that make you know it must be snowing outside. (Canadians plant them to bloom in January or February, life in the dead of winter.) Painted in 1910 when she was fifty-six, it is of a generous room where MHR lit her own art fire, warmed others, and somehow negotiated the complexities of a spiritual, aesthetic, familial, and perhaps sexual, quasi–ménage à trois.

It's the room where she gave away her husband.

When an artist portrays her studio, it is a form of self-portraiture. But Mary isn't painting her workspace. There's no easel here in this vision of an interior about interior life. She's painting her hearth. Or, removing that second h, heart. Mary's mantra, "I went cheerfully on with my sketch," wasn't a superficial one. It was the motto of a person who processed her being by portraying states of mind as they were revealed to her through objects and the natural world. A painter is necessarily also a beholder, and MHR turned a knotty mentor-mentee connection with another talented woman, who also adored her husband, into a relationship where that younger woman eventually became the steward of MHR's life's work.

The three of them are even buried together in Toronto's Mount Pleasant Cemetery, section 18, lot 22.[3] Not side by side, but on top of each other: MHR is the foundational layer. Then George on top of her. Last, Mary Evelyn on top of George.

3.

Were Mary's written diaries destroyed and did each recipient of her letters casually toss all but a crucial few of them? The scholars Janice Anderson and Brian Foss, whose thorough and imaginative work brought Mary Hiester Reid back to light in 2000 with their exhibition and catalog *Quiet Harmony*, thought that individuals with correspondence would step forward after the show they curated at the Art Gallery of Ontario. No one did.[4] Now art historian Andrea Terry and the Art Canada Institute have brought MHR's works and impact comprehensively online.[5] But diaries are not always verbal. One's daily work exudes one's daily emotions, especially if one has command of those emotions at the tip of a brush. We don't always need words to convey the vitality of a life. An image can do the work.

Mary, who was notoriously reticent, serving five times on the executive council of the Ontario Society of Artists but hardly recorded as saying a word,[6] made examples of fraught silence. A person can feel a way into what she has presented: a scene of solitary comfort. But look at the daybed-like bench with its pillows—three of them. Three plumped pillow-bodies flop together, two of a vermillion and green pattern, the third a separate, mellow orange.

"Mrs. Reid was a member of the Toronto Ladies Club, the Women's Canadian Club, and the Social Service Club," C.W. Jefferys wrote in an essay intended for the catalog *Memorial Exhibition of Paintings by Mary Hiester Reid*. "Such were the externals of a life whose current flowed evenly and quietly along simple, wholesome, and beneficent ways."[7]

Beneficent, perhaps. Wholesome? Not sure. Certainly not simple. Before that triple take of two Marys and a George, and before the paintings of three roses, three jars, three trees, three vertical sections, three horizontal sections, and triangulations of other kinds, were the original three: Mary, her older sister Carrie, and her mother Caroline Amelia.

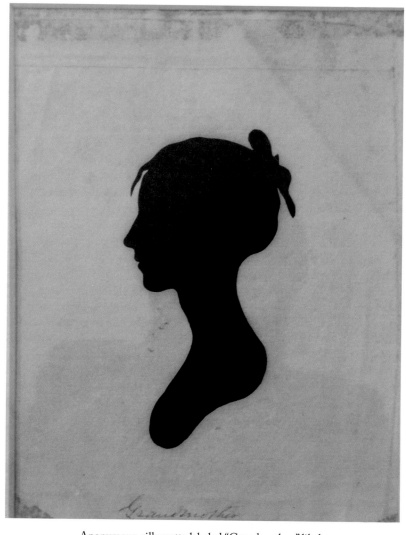

Anonymous, silhouette labeled "Grandmother," likely
Mary Hiester Reid's maternal grandmother,
Mary Catharine Muhlenberg (1776–1843),
undated, paper, 12.5 x 10 cm, private collection, Texas.

CHAPTER FOUR

Silhouette

I.

Mary Hiester Reid's mother, Caroline Amelia Musser (December 28, 1808–November 8, 1875), likely thought she would die a spinster, unlike her twin sister Selina Matilda, who married at eighteen.[1] The twins and their five siblings were descended from Heinrich Melchior Mühlenberg (1711–1787), a Lutheran missionary sent from Germany to Trappe, Pennsylvania, where he founded the Lutheran Church in North America—and also a political, religious, and scientific dynasty.[2] Rarely pacifists, they leaned toward pugilism. Two of Heinrich Mühlenberg's colonist sons fought for the American Revolution and were later elected to the United States Congress. But another of his sons, softer and more inquisitive, Henry Ernst Muhlenberg,[3] eschewed political life to become a pastor and a botanist, and eventually the president of Franklin College. This "American Linnaeus," part of the first generation of settler scientists in North America, wrote *Catalogus Plantarum Americae Septentrionalis* (1813), and from him extends a

botanical thread that entwined his great-granddaughter Caroline Amelia Musser and her future husband and eventually surfaced in the glistening flower paintings by his great-great-granddaughter Mary Hiester.[4]

Though Caroline Amelia's twin sister married at an appropriate time, something happened in Caroline's own life that led her to find her suitors unsuitable, or that led her suitors to find her unsuitable, or that resulted from a death or a broken engagement, and so she lived encased (literally encased: whalebone stays were like wearing a half-dozen underwire bras one over the other) until an almost miraculous midlife awakening.

2.

Someone else within Caroline Amelia Musser's sphere was also waking up: Dr. John Philip Hiester (June 9, 1803–September 15, 1854), a widower whose first two wives died without having children. He came from a line of physicians. (The Hiesters had intermarried with the Mühlenbergs so thoroughly that he, too, was a Mühlenberg descendant.) One of his forebears was George Clymer, a signatory of the Declaration of Independence, a congressman, and the first treasurer of the United States. A devoted naturalist as well as a respected doctor, Hiester was loved and esteemed by his colleagues in the Philadelphia area, a hub for both medicine and horticulture.

He was forty-six when he spied the great-granddaughter of the famous naturalist. Here was a companion who

would fit into his life, not a youngster in a bustle who could give him all the children he ever wanted, thus carrying on the Hiester name, but a spinster pushing forty with deep ties to his interests. (Another of her relations was William Augustus Muhlenberg,[5] an Episcopalian cleric and educator, who had established St. Luke's Hospital in New York City.)

John (or, as his German Lutheran family likely called him, Johannes) convinced Caroline Amelia to marry him on July 5, 1848.[6] He lifted her skirts, and she perhaps unbuttoned his trousers, and they consummated their marriage, a middle-aged woman with a sex life for the first time and a middle-aged physician, affiliated with Jefferson Medical College, who knew very well from his anatomy education exactly the location of a woman's orgasm.

In the year of their honeymoon, Lucretia Mott, Elizabeth Cady Stanton, and a congregation of men and women that included Frederick Douglass, gathered at the Wesleyan Chapel in Seneca Falls to draft the Declaration of Sentiments, modeled on the Declaration of Independence that John Hiester's ancestor had signed. The Sentiments are piercing to read.

When Caroline Amelia Musser said "I do" to John Hiester, she surrendered to "a history of repeated injuries and usurpations on the part of man toward woman, having in direct object the establishment of an absolute tyranny over her." The Sentiments throb on, proving the point with "facts . . . submitted to a candid world."

He has never permitted her to exercise her inalienable right to the elective franchise. He has compelled her to submit to laws, in the formation of which she had no voice . . . He has made her, if married, in the eye of the law, civilly dead.[7]

The new Mrs. Hiester, narry a legal right under the sun, had entered into a partnership that was a legal tyranny. Yet marriage released her from a spinster's obedience to her family and gave her the responsibilities (if not the control) and the pleasures (if not the independence) of adulthood.

3.

Caroline Amelia became almost immediately pregnant with a son, John Louis Hiester, born on September 2, 1849, perhaps delivered by his father's hands and named for him. The year and a half after their little boy's birth may have been the richest of John's and Caroline's lives. She had become a mother and a wife, a part of an established couple—with a respected physician's household and all the servants and social obligations that went with it. Both her family circle and his practice were replete; John may even have been able to leave the laughter of his baby and the ailments of his patients to tramp to the woods to keep up his naturalist's activities, as his wife received her relatives for tea. Within less than a year after her son was born, Caroline Amelia was pregnant again, this time with a little

girl, born on March 29, 1851, whom they would christen Caroline Elizabeth and call Carrie.

But three weeks after Carrie's birth, on April 20, John, their firstborn, died. Whatever ailed the little boy, his physician father could not save him. Carrie's infancy unfolded as her parents mourned their son. She absorbed the grief of the household; she was both a sign of the absence of her brother and, insofar as a girl might be one, a sign of the future.

By the following year, Dr. John Philip Hiester was elected president of the Berks County Agricultural and Horticultural Society, and in October 1852, he oversaw the first county fair,[8] the nineteenth-century equivalent of a shopping mall, a museum, and a product debut in a time when exhibitions (and demonstrations) were essential places for a person to learn about new material things. When daughter Carrie was just three, her father was elected president of the Pennsylvania Medical Society.[9] He was vigorous, intelligent, in charge; in his late forties, he was at the peak of his career as a physician as well as fully engaged in his horticultural interests. Others trusted him, and perhaps more importantly, he sought to be trusted. In the flowering of his energy, he and his wife conceived their last child, Mary.

As the men in the Reading, Pennsylvania, drawing rooms discussed the new book *Walden* by Henry David Thoreau; as the Missouri Compromise was repealed, slave states lining up against free states; and as Commodore Perry steered a bullying United States Navy steamship into Edo Bay, beginning a North American infatuation with all things "delicate" and Japanese, Caroline Amelia, at the age of forty-four, began her third lying-in.

Her husband hardly needed to be reminded of the physical toll a third pregnancy can have on a woman in her fifth decade of life. As John felt his second daughter's growth curled beneath the stretched skin of his wife's belly, he may have been aware that he himself was severely ill. Or perhaps his illness progressed so silently that he had yet to connect its symptoms. Into this emotional dusk just before a spring snowstorm on April 10, 1854,[10] Amelia gave birth to their dark-eyed baby girl, Mary Augusta Catherine, in the fire sign of Aries.

Five months after Mary's birth, her father died.

4.

The baby was a life force, full of an infant's needs that her mother and others in the household must fulfill despite the loss of a fifty-one-year-old beloved man, despite the dyeing of Caroline Amelia's dresses black and the purchasing or borrowing of jet jewelry, despite the dressing of three-year-old Carrie in the mourning flounces of the mid-nineteenth-century girl. Mary's first five months may or may not have been filled with intimations of her father's illness, but it is certain they were filled with her mother's recovery from the birth. It is impossible to ignore a baby's primary needs, but it is also possible to ignore a baby in other ways in a household turned upside down by the death of a healer, the frailty of an older mother, the cries of a sister, the comings and goings of family and

friends and servants. His death occurred before his little daughter acquired language, shaping an infant grief.

5.

John Philip Hiester's shortened life was noted in the *New England Journal of Medicine* in 1854.

> He was not a mere practitioner, but a close student at all times to the progress of science . . . an active and efficient member of the Pennsylvania Medical Society, of which he was recently its President, and probably contributed more to stimulate a spirit of inquiry and philosophical research among its members, than any other individual connected with it.[11]

The sense of his capability, influence, and strength; the variety of his interests and his ability to get things done; as well as his tender interests in plants and things growing, including the tendrils of his own daughters, remained in the air and in his daughter Mary's sense of who he was—and thus who she was herself.

Then Mary began her life as the youngest anchor of a family triangle, the triumvirate of mother and two daughters that would structure her childhood.

INTERLUDE

The Japanese word ukiyo[12] conveys the notion of the fleeting nature of life. And across the globe, a few years after John Hiester died, the great ukiyo-e printmaker Utagawa Hiroshige (1797–1858) passed away. (The long-lived printmaker Katsushika Hokusai [1760–1849] had died a decade before.) In the woodblock prints of Hiroshige, Hokusai, and others, the transitory took on a dreamier, more joyfully romantic quality, and the character for ukiyo-e is often translated into English as "the floating world," one of alluring images of courtesans, kabuki actors, and famous landscape vistas.[13] When Mary was a toddler and the stories of her father's energy and kindness were annealing, as family mythology does, the ukiyo-e period was coming to an end in Japan. The American idea of manifest destiny intruded on Japanese sovereignty, and trade began.

Then, beginning a tangled legacy of appropriation and veneration, the prints began to travel.[14]

They were not packed as precious cargo. They were used as wrapping around the cargo of exported objects. They stowed away on ships along with sawdust, padding, fans, teapots, and kimonos, objects to kindle the imaginations

of the women of the West. The prints were folded, they were crumpled, they were stuffed. The floating world literally floated across the world—and was thrown away.

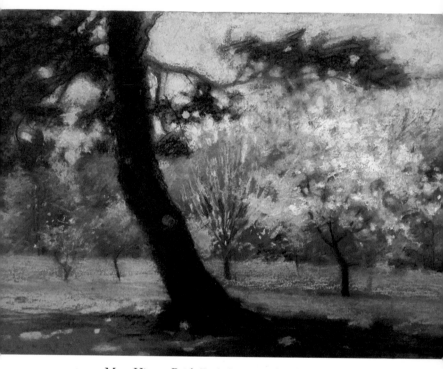

Mary Hiester Reid, *Early Spring*, undated, pastel on card, irregular dimensions, Agnes Etherington Art Centre, Queen's University, Kingston.

CHAPTER FIVE

Early Spring

I.

I seized on *George Reid: A Biography* to find out more about his wife. It was written by Muriel Miller who, if she were dressed as in her photographs, was wearing a short-brimmed fedora-like hat at a jaunty angle when she knocked on the door of 81 Wychwood Park in January 1940. That night, she began the Sisyphean task of interviewing the taciturn widower—who was not that forthcoming despite the fact that he'd asked Miller to write about his life. Miller proceeded to probe and prod George for two years as she wrote and researched (though her book wasn't published until after World War II in 1946, the publisher not having access to sufficient paper).[1] Miller inspired me to flesh out a chronology of Mary's life through what she had chronicled of George's. As I filled in my vague, rather Tonalist list of Mary events, I went to other sources about George as well, coming across art historian Christine Boyanoski's phrase "sympathetic realist."[2]

Sympathy. Of course. I stuck with Mary for eight years, through my husband's terrifying health crises. Year after year, my admiration and respect and sympathy for her grew. Or was it empathy? Digging around to find the sources of those emotional words, then hoping to find out what they had to do with realism, I came upon the Empathists, a loose group of European thinkers—four of them contemporaries of Mary—who were trying to sort out the emotional mechanisms of perception and projection. And they did it by starting with visual art.

Could the psychological process of projection—of taking our inner life and putting it outside ourselves, to examine consciously or to act on unconsciously—be inspired by the perceptual process of viewing paintings? The Empathists thought so. Vienna School aesthetic Alois Riegl (1858–1905) spent the heart of his philosopher's life thinking about what it means to behold—to hold with the eye as well as the mind.

For Riegl, beholding a painting was always made with "psychological connection." "That is," he explained, "attentiveness,"[3] which was "based on sympathy and thus selfless."[4] As a beholder, one abandons self-absorption in the process of directing attention outward.[5] Together a spectator and a painting share a space, thanks to Riegl's psychologically nuanced ideas of the absorption of our "attentiveness." When the fireplace in Mary's painting of her inglenook feels warm to us, and we find ourselves believing in its reality so thoroughly that we form a relationship with it, interacting with it, we have Riegl to thank for defining our perceptual process.

Fellow Viennese Sigmund Freud (1856–1939) carried the idea of beholding away from the world of perceiving art into psychology and medicine, and from viewer to patient. At the same time, German philosopher Theodor Lipps (1851–1914) was also trying to get down his thoughts about perception by using painting: what does it mean to put ourselves in another person's place—or in the place of an object in a frame? There had to be a word for this sense of "feeling" ourselves "into" other people, other things, enlivening them, and making them speak back to us. As Lipps, the revered professor at the Universities of Bonn and Munich[6] admired by Freud, cast about for the language of projection, he came upon the work of the fourth, oldest, and least known member of this quartet, Robert Vischer (1847–1933). Vischer, also obsessed with the process of projection, coined the term Einfühlung ("feeling into") and began elucidating his theories using this expression, which was later employed by Lipps—though not translated into English until the twentieth century. First it was called sympathy, then a new word: empathy.[7]

As I tried to make sense of all this, from the tones of feeling that make music in painting, to the philosophies of perception that derived from looking at paintings, the ideas that floated up and materialized like wafting, transparent fabric forced me back to solid ground—history, her continuing family history.

2.

Two days after her seventh birthday, the American Civil War began[8] and Mary and her mother and sister entered an atmosphere of uncertainty and fear. The women of Reading mobilized to sew uniforms for Union soldiers. For the next two years, her mother Caroline Amelia would hear news of the battles as the Confederates moved north. Mary's cousin, Union Army Major William Muhlenberg Hiester, raised eight thousand troops[9] for Pennsylvania's defense. Another relation, Rosa Catherine Muhlenberg Nicolls, founded the first Ladies' Aid Society (later the Reading Ladies Volunteer Association) for the support of Union soldiers on April 16, 1861.[10] Women collected food, bedding, medicines, and bandages for the Berks County boys who fought in the war.

In September 1862, General Lee crossed the Potomac into Maryland. In 1863, his forces reached Pennsylvania. Philadelphia was seized by rumors of war reaching the city.[11] From July 1 to 3, the Battle of Gettysburg, the biggest battle ever fought on American soil, occurred ninety-eight miles from Reading.

Widowed Caroline Amelia decided to pack up her daughters and leave the state. Her destination was her nephew Henry McLenegan's farmhouse[12] at the edge of the twenty-year-old town of Beloit, Wisconsin. Her aim was to take refuge with him, the son of her much older sister, Henrietta Augusta Muhlenberg, who had married Zephaniah McLenegan.[13] Caroline Amelia ushered her daughters, Mary (then nine or ten years old) and Carrie

(then ten or eleven), along with their possessions onto a train powered by a steam engine that huffed from Reading to Chicago,[14] and then from Chicago to Beloit.

The little family boarded with boxes and valises, with Caroline Amelia's dresses and the frocks of the girls. Before their trip, a household upside down: corsets, capes, nightgowns, hairbrushes, and combs flew into trunks and cases. It was a permanent move for Caroline Amelia; she would never live out east again. She packed a miniature portrait of her husband[15]—or perhaps she carried it with her, for dear objects seem to disappear as they are stowed. To ride on a steam engine in 1863 meant to go at a speed of fifteen to twenty miles per hour and to stop at town after town. The little group journeyed in what we today, accustomed to highways and airports, might experience as slow motion.[16]

Across 860 miles, and through many days, the rolling of the train took over. As Mary watched the hills hurry on, materializing and dematerializing, visual details appeared and vanished. Her father was gone. Her mother was soldiering on. Her older sister had the gravity of one who comes along to occupy the position belonging to a lost firstborn child. By day, they sat on the wooden bench seats; by evening, the seats folded flat so the three could huddle and doze through the night.

At last, the McLenegan relatives—Henry and his wife Sarah, and their three sons, Charles, Samuel, and Archibald[17]—opened their doors to Caroline Amelia Hiester, a weary woman in a traveling dress and hat with, one hopes, sturdy boots and gloves, accompanied by two exhausted, excited, wary, observant girls. She'd had the command of her own

household and, for a few years, the sensuous life of marriage. But now she was back living at the polite accommodation of family, there both to help and to provide her nephew's wife company. The girls, though young, would also supply helping hands. Observing their mother's behavior would teach them how to make compromises, so that all might live in peace in a tall, rectangular, Italianate house with a low-sloping roof on an unpaved road.

Caroline Amelia followed her cousin Henry McLenegan, who had been in the hardware business in Reading,[18] away from war and toward new money—and freedom from old family attachments. There, in the dense forests of southern Wisconsin, on the lands of the Ho-Chunk, Potawatomi, and Sac and Fox Peoples,[19] a Yale graduate had started Beloit College. His fellow New Englanders traveled up from Chicago to fell hundreds of old-growth trees. Then they laid out streets and commenced their lives as strict abolitionists and hearty Episcopalians and Methodists.

In time, Caroline Amelia purchased lots seven and eight as well as part of lot six in Beloit and moved herself and her daughters out of Henry's home into their own two-story house with outbuildings.[20] Here her younger daughter absorbed her mother's tactics of independent living. Caroline Amelia never remarried, and she acquired forty acres of land and comfortable furnishings for her house: tables, silverware, china. Her finances were secure enough that she was also able to extend loans to others.[21] The "That's final!" baritone opinion of a Victorian father figure never rang in this house capably run by a member of "the fair sex."

3.

In a blithe moment just before another war—World War I—Mary drew a buoyant chalk study on a card, scrawling on the back a single word, Spring,[22] and seems to have transformed it into a painting she called *Early Spring* in 1914. *Spring* has the celebratory feel of an April birthday. The study hints at her working process: it's remarkably complete, a full artwork in itself. The Degas-like ballerina quality of the two flowering trees bring with them her Parisian idylls, a romance with Impressionism. Every element in the pastel is in the painting, down to the knobs of the burls and the dents in the trunk of the jack pine tree, though in the painting she vivifies the colors. (Those burls and dents become a Fauve-like red, the middle tree orange and chartreuse, the sky a royal blue.) Made of the driest chalk, the pastel still manages to conjure up the damp odor of apple or pear petals. The pine throws a parental arm across the top of the two flowering trees, so much smaller that they could be two dancing girls.

The girlish fruit trees gambol and twirl. Though chalk can be so easily blended, Mary forgoes the Tonalist blending technique she employs at other times, and the flowers on her trees burst in quick strokes, almost using the Impressionist painting technique of obvious brushstrokes, color laid next to color left for the eye to fuse them. As I think of her childhood, the strength of the jack pine with its curving trunk gives off a maternal feel, a hint of the efficacy and vigor of a single mom like Caroline Amelia, and below, her burgeoning daughters.

The tall figure of her Pinus banksiana presages Tom Thomson's iconic painting *The Jack Pine*, finished near the end of the war in 1917. Thomson and the Group of Seven, those rugged fishing and hunting young male artists, had caught up to Mary in the eyes of reviewers. In the notices of exhibitions around 1914, the long paragraphs of attention were given to the likes of Group of Seven painter Lawren Harris.[23] Though the positive reviews of her work never dropped, they trailed in as afterthoughts at the end of the pieces as she was slowly frozen out of the art scene.

<div align="center">

4.

</div>

Mary had to get used to being cold in Beloit before any kind of spring burgeoning. The January temperatures went below zero degrees Fahrenheit (and the heating of the house was by fireplace or cast iron woodstove).[24] About the time of year that *Spring* conveys, she saw the horses start to shed their winter fur and smelled the hot manure as it hit the last remnants of snow. She breathed in the sawdust from the lumberyards, processing the multitudes of trees felled from clearing the land taken from the stewardship of the local Indigenous Peoples. It was a frugal, fruitful life for a settler girl who was, perhaps even unknown to herself, developing an ambition within the intense pioneer ethos of making things and making success on land they simply assumed was theirs for the taking. When the weather brightened, she climbed into the family carriage for "drives in the country."[25] Beloit, Mary

said when she was interviewed by Marjory MacMurchy in 1910, just a few years before she painted *Early Spring*, was a place "favorable to the growth of spirit which was to care for beauty."[26]

A decade of Mary's growing up rolled by: crops were cultivated and harvests stored. Her hands lifted quills to dip in iron gall ink. She grasped brushes between her index and middle finger and thumb, drawing and painting what she observed for, as MacMurchy said, "she always expected to paint." Growing up among people who "read much and talked of books" but who also, as Mary remembered, "lived simply,[27] it was a life an urbanite today can barely conjure. She rose to birdsong, the lowing of a cow. She fell asleep to the snap of fire crackling, woke in the night (if she woke) to the glow of embers. She sniffed rosemary and lavender as the herbs dried. She pooped in a chamber pot. A sensuous awareness came on as puberty approached—her sister had probably already crossed that line.

5.

Across two states and two Great Lakes, in farm country over five hundred miles from Beloit, on the lands of the Aamjiwnaang territory (of the Anishinaabe, Haudenosaunee, and Cree),[28] young George Agnew Reid drew on the chalkboards of the log schoolhouse in East Wawanosh, Ontario, and snuck off to devour the *Arabian Nights* in the hayloft.[29] A traveling bookseller noticed the

young boy's visual hunger and brought him art books on his spring visits.[30]

By the age of ten, when Mary was sixteen years old in Beloit, George Reid's ambition to become a painter had already materialized. In 1871, in a strictly gendered agricultural world, he astonished his homesteading family, announcing that he was going to be "a painter of pictures." His father Adam is said to have responded that making pictures "is a girl's work."[31] Still, the artistic—and musical—boy was learning to sing and to grasp transpositions of keys. After he'd been sent to live with his maternal grandfather, Thomas Agnew, to help on his farm, he learned the rudiments of five instruments: the flute, the guitar, the concertina, the piano, and even the organ—in a mere year.[32]

When he returned home (which was now in Wingham, Ontario) as a twelve-year-old, he set up a studio in his attic bedroom. The gifted boy copied pictures from books early in the mornings before he hummed through his farm chores, then labored at drawing animals after school and after the evening meal. He had no path to follow to become an artist—only books brought by that enthusiastic itinerant bookseller. But his schoolteachers and a joyful connection with both his grandfathers gave him the idea that he could assert his gifts—though those gifts were so prodigious they may simply have asserted themselves. His talent frightened his father who, after his grandfathers passed away, tried to extort a promise from his son to stop painting.

George did not promise. Instead, he fell silent, resolving

not to speak about painting—and determining to leave home. His biographer claims that George's distinctive unwillingness to speak, his habit of quiet, dates from this resolve: "He became a doer not a sayer, a dreamer and a worker, not a talker."[33]

By 1875, fifteen-year-old George had acquired some watercolors to aid his nearly adult drawing skills. He had not left home. One of his older brothers now worked on a neighboring farm for wages, the result of the financial hard times that caused their father almost to lose the family acreage altogether. Another brother's hand was crushed by a straw cutter. His father injured his back. The only son left, George took over the grueling, morning-to-night work of the farm.

6.

Carrie and Mary, on the cusp of becoming brunette beauties, lived within a farm community's expectations of marriage. But the Panic of 1873 rocked the economy. Money was scarce; resources unpredictable. Suitors may have gathered, but something in their natures or circumstances allowed the two, so lovely, so marriageable, to hesitate at becoming Midwestern matrons. Their mother's example did not rush them into wedlock. Carrie appeared to have a thoughtful, independent spirituality, and she began a different kind of romance—a girl's attraction to religion. The household's makeup supported both her inclination and Mary's pull toward art.

7.

In the waning light of November 1875, Caroline Amelia died.

Curiously, she hadn't left a will, and her fresh-skinned, fine-lipped daughters, the twenty-one-year-old Mary and twenty-three-year-old Carrie, were suddenly on their own. Her girls had matured among the simple washstands, pianos, and horsehair sofas of the Midwest, but they were also the inheritors of the intellectual thought and lore of their sophisticated family and its generations of wealth in Reading and Philadelphia. Nothing could hold them to that little lumber town.

So began a long probate in the local court. By December 11, 1875, the two sisters had signed an agreement that their mother's estate be administered by their cousin Henry McLenegan. All of Caroline Amelia's goods—every tablespoon—as well as her real estate and interest earned from loans were catalogued. The list goes from room to room: Parlor, Library, Kitchen, Hall, Bedchamber, Spare Bedchamber. Pictures and clock. Books. Rocking chair. Caned chair. Small tables. Stove pipe. Two dozen plated forks. One silver pitcher. Two and a half dozen silver tablespoons; one and a half dozen silver teaspoons. Five lamps. Beds, bedding. Set of mahogany furniture. Carpets. China. Crockery. All the objects Mary and Carrie and Caroline sat on, slept on, said kind or sharp words over. By January 24, 1876, the catalog was complete.[34]

8.

In that same year, George's mother, Eliza Agnew Reid (1837–1877), was ill. His father decided to build a dream-house for his wife: a new abode for an ailing woman. He enlisted George to draw up the plans. George applied his spatial skills to something very practical, and this pleased his father. The boy added gables, and the house on paper took shape. As his mother's illness worsened, his father began to think he might apprentice George to an architect. The Homestead, as they named the house, was finished the following year—just as his mother passed away.[35]

9.

In Beloit, on March 14, 1876, in the midst of the probate of her mother's will, Carrie signed a power of attorney to her younger sister.

It seems Carrie was leaving town.

All alone Mary faced the real estate sale. Then the auction. Every item assigned its price. Each lamp, $1; the mahogany furniture set, $16; one of the beds and bedding, $8; the silver teaspoons, $16; books and bookcase, $50; the two and a half lots with two-story house and outbuildings, $2,000; forty acres, $400; interest on notes of lending, just over $300. The complete estate totaled $6,993.97, or about $170,000 U.S. today.[36]

The house was sold and its contents dispersed—except for Mary's heirlooms: pieces of silver belonging to the

Hiester family, among them a Sheffield plate teapot and sugar bowl, and the miniature of her father painted on ivory. The auctioneer was paid his fee of $6.

Mary's twenty-second birthday came and went.

On June 11, 1876, the judge settled the probate.[37] When Mary signed for her sister, she did not sign her sister's formal "Caroline." Instead she signed "Carrie."[38]

Then, in orphanhood's sad liberty, Mary got on the railroad car that would take her east. Five hundred miles away, her future husband was picking up the hammer to drive nails into lumber for his mortally ill mother. As the train lapped the miles, in Emily Dickinson's phrase, Mary came closer to a destination of a decision. Decisions seem to have geographies. Answering a calling occurs in a place. Or perhaps it is simply a place that comes to be associated with a major decision. For Mary, Philadelphia was associated with art. She was going toward it, the location where she might become herself.

INTERLUDE

The ukiyo-e prints, tucked around teacups in cases that had tossed on ocean journeys, eventually arrived in England— as the American painter James McNeill Whistler did, making his way from Paris to London. In 1863, Whistler is said to have stopped in a tearoom near London Bridge, his eyes taking in the objects from all over what he would have called the Orient. Scanning the tins of tea and the curious cups without handles, Whistler noticed their wrapping papers: Japanese prints of faces, kimonos, cats, turtles, and waves.[39]

A Calling, a Romance

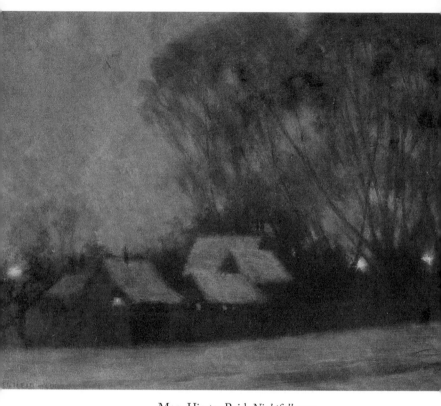

Mary Hiester Reid, *Nightfall*, 1910,
oil on canvas, 76.5 x 102.0 cm,
The Robert McLaughlin Gallery, Oshawa.

Nightfall

I.

Hurrying home from a walk begun in daylight, only to find the light has faded faster than you expected—that's what Mary evokes in *Nightfall*. Dim kerosene lights or gaslights glow from the small group of buildings. Three orbs glimmer from the copse of trees at the right, and one from the trees at the left. The field in the foreground is almost moonlit; the afterglow of sunset vaguely infuses the sky. Heavens, it's really late. The world is going in without us—and without the painter who stayed outside to paint this scene.

When Tonalists introduced low-light times of day into their paintings, they connected light both to emotions— and to the sounds of emotions. Using musical vocabulary, like nocturne or symphony, they suggested that emotions could be *heard* through paint—magnetic for a woman who, since her first baby cries, would have been urged to be quiet. "A work of art does not appeal to the intellect," Tonalist George Inness avowed. "Its aim is not to instruct, not to edify, but to awaken an emotion."[1] The sensation

experienced in mourning of everyone else going on about the business of ordinary life while you, in a state of loss, vibrate quietly outside it all—that's *Nightfall*. If there is a single word one associates with Tonalism, art historian Wanda Corn mused, "it is loss."[2] In *Nightfall*, the sun, the primary source of light, has vanished. In the afterglow, Mary implies the warmth of a house. But we can't go in. She insists that we stay outside in the gloaming.

Mary inhabited the land of mourning. In 1876, in Reading, Pennsylvania, she moved her clothes, mementoes, and the silhouette of her grandmother into the home of her cousin John McLenegan.[3] The fact that she lived with a cousin, not aunts or uncles, allowed inches of the social reins to loosen for her. The small city of Reading was increasing in prosperity (Philadelphia was quadrupling in size), and laws were passed that fined homeowners if they did not leave a lamp lit by their doorway after dark.[4] At night, without candles and without all the ambient sources of light an urban dweller now experiences, Mary's bedroom was as dark as the broad, furred back of an animal. Those still awake heard the night watchman pass.

At some time around Mary's move, her sister Carrie walked up a gangway, stepped onto a steamship to Europe, waved goodbye, and later lay down in her ship's berth, never to return to North America. Once she reached the warmth of Spain, Carrie declared her marriage to Christ. Vaulting back from their family Lutheranism[5] to the hierarchical, gilded emblems of the Catholic Church, she became a nun.

Had she taken Mary into her confidence? Was it a split-second decision to run from her escorts (it's highly

unlikely that she was alone) into that Spanish convent and seek asylum? What spiritual crisis had she reached? For all the strictures the church insisted on, it also offered the promise of a life of the mind, of mental and spiritual discipline. The resolute rejection of sex released a nun from the control of a man and the terrors of childbirth. The Carmelite sisters she turned to offered a world of women—a more crowded, more ritualized world than the all-female house Carrie had grown up in, but familiar nonetheless. Caroline Amelia, the metaphorical mother superior, had passed away, and her eldest daughter, cast adrift, had settled on the shores of female spirituality and literal mothers superior, of the Roman Catholic nunnery.

How people make life-altering decisions remains an intimate mystery, as anyone who attempts to sort out how they came to a calling comprehends. Both sisters were responding to inner urges—to a gift for prayer, for art. They both understood that they were drawn to destinies that were unusual, unpredictable, and required stepping off the path to which young women of their age and stature and beauty were destined: conventional married domesticity. Without parents, they shaped their futures. Each sister resisted being swept along in a tide of cultural expectations and events. Each expressed a choice and each entered a defined community, though the cloistered community of the nun had far more strictures than the group of artists in the Arts and Crafts movement Mary would eventually join.

2.

The doors and windows of the houses of Reading opened to catch the early breezes of the day, before the sweat could begin to gather on her forehead and upper lip in the notorious heat wave that swept Philadelphia in 1876. Despite it, the United States Centennial, an exhibition of the future intended to heal the great wound of the Civil War, and officially named the International Exhibition of Arts, Manufactures, and Products of the Soil and Mine, opened in Fairmont Park. Though the rising temperatures kept the crowds smaller than expected for the summer, women still planned their outfits for centennial viewing—even those wearing mourning clothes.

In the slanted light of shutters and shades drawn against the sun and humidity, Mary stepped into her dark-dyed cotton or linen drawers. Then she donned her cotton or linen chemise. After her chemise, she wriggled into her corset. When her corset was in place (easier if she had someone help her, but possible to accomplish alone), she squirmed into her petticoat. Over the petticoats, she fixed her corset cover. Then Mary tied her bustle, a wire extension for the derriere, around her waist. She adjusted her underskirt over her bustle. At last she inched into her skirt itself. As she struggled in the fierce heat of the summer of 1876, she finally writhed on her bodice (blouse), over the chemise and corset.[6]

Some women sensibly waited to attend the exhibition until the fall when the weather cooled. But in the excitement of that summer, could Mary have been sensible?

Carrie, perhaps to some, had chosen the least sensible alternative of her life. In some ways, the spiritual choice and the urge to make art are opposed, but in other ways, those of declared commitment, intensity of attachment, conviction in the face of so-called normal life, and sacrifice of everyday expectations, they are similar. Both require serious ambitions and fortitude. Carrie had to eschew the Protestantism of her family for Rome. Mary was about to discard the comfort of a social life within the ample structure of an old family for art.

For a young woman seeking edification and training—and soon to become a voracious tourist—is it too much to assume that Mary paid her admission to the exhibition grounds? I don't have hard evidence from this scantily documented five years in her life, but knowing her intrepidity, the way she devoured any visual opportunity, and the fact that the exhibition was practically in her backyard, I lay my bet that she paid her fifty cents—and probably more than once. She could have seen a typographic machine displayed and perhaps had a swig of Hires Root Beer. Or paid ten more cents and sat down to eat a yellow novelty, the banana, with a knife and a fork.

3.

Mary painted *Nightfall*'s melancholy in 1910, the year she made her last trip to Europe, her traveling life ending with the death of King Edward VII and the close of the Edwardian age. *Nightfall*'s duns and purples are the colors

of mourning clothes. When Mary wore her sorrow over the passing of her mother in 1876, the process of women's grieving was expressed with gradual change of clothing color. After many months, the coal-black worn in immediate grief eased to brown and umber. As the harshness of loss further diminished, and a kind of emotional convalescence began, the colors slipped to purple. Finally ladies' mourning clothing used dyes of gray, silver, and pewter.[7] The colors fanned out sumptuous and expressive varieties of grief long before twentieth-century psychologists defined mourning by stages.

In a parallel to the shifting shades of bereavement were the progressing hues of Tonalism. As "soft painters" sought a visual language for emotion, they employed the technique of blending. The idea was to create a surface that seemed as if no hand had held the brush at all. Such a painting appeared as a vision directly out of the artist's interior. "Paint should not be applied thick," cautioned Whistler. "It should be like breath on the surface of a pane of glass."[8] Enthusiastic New York art critic Clara Ruge, writing in 1906 for the *International Studio*, declared the Tonalist school "destined to leave a mark on the history of art."[9] But it turns out that their mark would be as ephemeral as nailing down a feeling.

Feelings and senses are method in MHR's *Nightfall*; George Inness was convinced that emotional release powered greatness in art. It's daring to attempt to describe constellations of reactions, to keep the creative work focused internally without trying to please an audience, all the while knowing the audience is there. It was something that, a

century later, artists still have to teach themselves. How do creators make an art of feeling, yet anchor it with form? How does a person stay inside, where art is created, yet venture outside the self for perspective, outside where an audience is? I've had a lifelong grapple with those questions. However, in 1876, the Women's Pavilion offered clues.

4.

North American women were becoming a consumer audience, and beyond the main exhibits in Fairmont Park appeared the Women's Pavilion "of many angles and squares and flags . . . snapping with vigor."[10] A verse from Proverbs 31 graced the doorway: "Let her works praise her in the gates."[11] Wood-carving, furniture-making, pot-throwing, weaving were all activities women could accomplish with their imaginations and their hands. The displays showcased the new craft ideology—and it was a revelation to spectators. Emma Allison of Grimsby, Ontario, demonstrated her "small six horse-power engine" that "generated enough energy to run a printing press, spinning frames, and power looms."[12] Tending it, the inventor declared, required "far less attention" than minding a small child or taking charge of an ordinary stove.[13]

The $31,160 (or $757,850 U.S. today) to fund the pavilion had been raised exclusively by women in a mere four months. The whole enterprise of building and funding it helped fuel a nascent notion of equal pay for equal work. "The wife who cooks, mends, makes clothing, washes, irons,

and does an untold amount of labor that would cost every year hundreds of dollars if paid for by the husband," promoters argued, "should receive a better and nobler reward than being told she is extravagant."[14]

<p style="text-align:center">5.</p>

Even now to examine one's own needs and values can be thought extravagant. So can a quest for an education—but it was a profoundly sober mission for a young woman in 1876 to take herself seriously. Quaker Elizabeth Croasdale, the principal of the Philadelphia School of Design for Women (now the Moore College of Art and Design), gathered a harvest of her students' meticulous and subtle work to flaunt at the exhibition. She fanned out the results of her lady students learning perspective, contrast, and proportion. The work by the apprentice artists displayed deft line shading and polished watercolors.[15] "The practice of the Arts of Design is one peculiarly adapted to the female mind and hand," declared the *Prospectus of the Philadelphia School of Design for Women, 1875.*[16] Croasdale had put on a show, and prospective students noticed.

It would take several years for Mary to transform from a girl with arty inclinations to a young woman determined to get herself a full art tutelage. This time in the cocoon of cousins that allowed her to emerge can seem like a Tonalist fog. But infiltrating that fog was a new insistence to give women commercial art skills: Mary Heister settled on applying to the Philadelphia School of Design

for Women. During these years, she may have become a teacher in her own right,[17] instructing young ladies in drawing and watercolor. To set up assignments, she'd have had to learn how to break things down into their parts. She'd have figured out ways to position still life, to train the girls' young, darting gazes to focus on the rounding of a stoneware vase or a leaf's shadow. A few of her students might have shared her interest, and they might have absorbed the intensity of her looking dance, the seeing through shadows, the watching of layers of inner life build through the contours of the subject.

Learning design techniques "provided a form of life insurance"[18] for a woman on her own, and when Mary enrolled at last at the age of twenty-seven in 1881, she began to practice their hierarchy. These skills were geared to china painting and pattern design. In Stage 1, students completed "a. Drawing in outline, and shading . . . b. Pencil drawing from flat examples. c. Practice in handling of instruments. d. Ornamental geometry. e. Primary perspective." In Stage 2 came "Coloring of diagrams." Students finished their assignments step by step, according to the rules: "All these works must be executed with an intelligent clearness and precision."[19]

6.

But before this hierarchy of skills to be acquired, when Mary had yet to emerge from being a mourning daughter to a young woman with mounting proficiencies, another

mourner strolled across the exhibition. Long-nosed, full-cheeked Candace Wheeler (1827–1923) was a design entrepreneur with a husband, children, and a career in New York City. She had impressively established herself as an associate of Louis Comfort Tiffany, though for purposes of this visit, she was simply an overwhelmed mother whose oldest adult daughter had just died after years of health struggles. "It is all over in life with my darling baby," Wheeler wrote to her sister-in-law, "& she was glad to go."[20]

As Wheeler distracted herself by inspecting handiwork, she was struck by a tiny English booth. In the vast structure of the main hall stood this diminutive, luxurious tent, fifteen by twelve feet, designed by Walter Crane. It was created from needlework hangings in floral motifs worked by the women in Great Britain's Royal School of Needlework. Two panels, each containing a female figure, represented doors. Overhead, appliquéd panels showed three fates of ancient Greek mythology stitching. Clotho, the spinner, Lachesis, the allotter, and Atropos, the unturnable, spun the mother threads of destiny.[21]

In that lavish little shelter, Wheeler was struck with the idea of providing North American craftswomen with money. If she could engineer it, women themselves could design useful, simple domestic materials—for other women. The floral motifs of textiles and wallpaper would interlock into patterns to decorate other women's homes.

7.

Home was exactly what Mary did not have then. She was like a hermit crab, darting from abandoned shell (Beloit) to borrowed shell (Reading). But as Wheeler, who would eventually influence Mary's life, wandered through the fairgrounds, there's a chance that the nascent painter also strolled—the older and the younger woman each absorbing, in very different ways, the impulses and visions of craftswomen.

The three fates were operating. Life was portioned out as long skirts swished from booth to booth, passing only seven comfort stations among the two hundred buildings. Perhaps Wheeler lived in hope not to have to use the public privies, two of which, in brick and wood, still survive in Fairmont Park today.[22] Then again, she may have passed Mary in the long line for the ladies' room.

In her dotage, Candace Wheeler wrote that the loss of her daughter "changed my whole attitude toward life and taught me its duties, not only to those I loved, but to all who needed help and comfort."[23] If Wheeler could somehow employ those women who needed help, finding a way for them to use their needlework skills, then she could lead them out of poverty, or dependency, and into independent lives—and make money, too, both for herself and for them as the implementers of her designs.

Soon she was training and employing embroiderers and textile-designers-to-be at Louis C. Tiffany and Company's subsidiary Associated Artists, where she urged the women to use a needle as if it were a brush, to be "bold strong

designers" and "to treat textiles with a feeling belonging to pictures."[24] The magnificent embroidered panels she was responsible for went on to decorate the homes of celebrities, including her friend Mark Twain. When the partners at the Tiffany company went off in separate directions, Wheeler retained the title Associated Artists.[25] Her firm now consisted of a woman employing women, refining domestic skills—and for bankable cash. Soon, this tough businesswoman would embark on wallpaper, too, retaining the services of between forty and fifty women at an average salary of $15 per week.[26]

8.

By 1882, Mary was laboring through the requirements of the Philadelphia School of Design for Women. In the Advanced Stages, she absorbed "a. Drawing and shading from casts of single leaves" and "details of architectural ornament, consisting of a leaf molding." It was only "every Monday" that the young artists "engaged in drawing and painting in water-colors, plant forms, mostly from nature."[27] On those cherished Mondays, Mary began to develop the leaf and petal shapes her work would depend on for the rest of her life. Though the school's no-nonsense courses cut women a path toward commercial art and the foundations Mary received were precise and practical, depicting emotion was not part of the curriculum. To make commercial art, she had to hold imagination captive.

After her second year of cramping her fingers in step-by-step techniques, Mary fled the school. She was going beyond Wheeler's imprimatur to fabricate "with a feeling belonging to pictures"—she would feel her way into those pictures themselves. By leaving the design classes, Mary escaped the "craft" label, the homebody and amateur label. Yet Wheeler's notion of the help and comfort of the home would always circulate around her. Home things both beautiful and useful threaded into Mary's own intentions, for later she priced her own paintings to hang affordably on the walls of those very houses that were providing new environments for North Americans. Her dreamy, psychological flowers would pour from jars in the sublime ambiguity of being both contained and free. She'd had a bit of the education she sought, but it wasn't the real thing of painting in oils. At last, she took off to study art as men did.

INTERLUDE

Mary had no one pushing her to become an artist. She was on no one else's timetable. Nor was I, as I gradually decided to call myself a poet. Now I am so grateful I could emerge on my own. I did have a mother to guide me, but she had no idea of how to help other than to hope I would attend a university, as she was unable to do—a farm girl with neither expectations nor money. I was left at sea after I graduated from a public university, in a brief, tender young marriage people would call a starter marriage now. But I see it as our cocoon. In the closed life of graduate school—my first husband, Jeremy Benton (1946–2007), was then a philosophy student—we went to campus parties, and at one of them I met a young man who declared on introduction that he was a poet. Really?! It would take me a decade to introduce myself as that. How did one know that one was a poet? (I guess young men in fringed buckskin jackets hanging around at 1970s parties knew.)

Though I was writing and publishing my poems, I wasn't sure I'd heard my calling for real. To myself, in a striped blouse and jeans, I was just trying things out, composing my first serious poems and working my day job writing commercials for a local television station. Timing a

sentence to pack product into thirty seconds seemed to me the opposite of poetry, even though some poems can fly by in thirty seconds. Writing commercials, I found, pays the bills but can trap and kill the firefly of the poem in an airtight jar. A poem was emotion lighting up. Even its structured language, it was dawning on me then, needed a jar with the lid off—air.

It was hard both to look inward to make poems and look outward to see them and myself in the world. How glad I am that no one pushed me. I could wait to feel the push from inside. Bolstered by my feminist consciousness-raising group, my newly acquired therapist, an acceptance to the MacDowell Colony, as well as by my soon-to-be-former husband and my old professors, I applied and won a Danforth fellowship for women. In the summer of 1976, I took myself off, newly divorced, not yet thirty, with my gray IBM Selectric in the trunk of my green sedan, to the Johns Hopkins University Writing Seminars. I was awash in insecurity, but I knew one thing: I needed an education.

George Agnew Reid, *Study of a Woman with Arms on Head*,
done at Academy of Fine Arts, 1884,
oil on paper, 18.6 x 9.5 cm,
Art Gallery of Ontario, Toronto.

Life Class

I.

The female model stepping onto the riser in the all-male studio class at the Pennsylvania Academy of the Fine Arts in 1883 was not absolutely naked. Above her bare feet, calves, thighs, patch of pubic hair, roll of belly, fall of breasts, collarbone, and neck, hung a rectangular veil of black cloth. As George Agnew Reid painted the masked woman, a mother by the looks of her torso, he depicted the cloth pinned to her hair and draped over her face almost to her chin, covering her eyes.[1] He was twenty-three.

When Mary saw a female model in the women's life class she had entered, there was no mask of modesty. The all-female class painted the model from behind[2] in the studio still in use today.[3] That year she had upped her game to real oils. She was twenty-nine.[4]

2.

Thomas Eakins had only recently been appointed director at the Pennsylvania Academy of the Arts.[5] Three years later, he would be dismissed.[6] But Mary had the fortune to study at the height of Eakins's tenure. His edict that all his students should paint flesh directly from life affected every move of every brush of every arty young woman who had convinced her parents to pay the minimal tuition. (The fees at the academy were about $10 per term,[7] the literal equivalent of about $243 now, though perhaps the economic equivalent of several thousand dollars.[8]) In Eakins's classroom where the fine dust of the plaster casts drifted in motes from high ceilings, Mary sat in a haphazard circle with the other female students around the nude model. Then she began to turn the darkness behind the torso of the woman into positive space. In this act of connecting to the fleshly existence of another body like her own, an aperture opened for her art—like the lens in Eakins's friend Eadweard Muybridge's camera.

Eakins, a vigorous American realist, was bursting with his power as director to urge his instructors to teach as he thought art should be taught: painting directly, without drawing first. At last the lithe, talented Mary Hiester had found an education that featured both technique and passion. Eakins's instructions let her brush touch a canvas as intimately as a finger might trace the flesh of an inner elbow or the hollow of a neck.

When the model stepped off her platform and collected the salary she received for an act outside polite society

(construed by some as near prostitution),[9] then returned home, it was likely to be a place smaller and darker than the chandeliered stairwells of the students' houses. The feet of the heavy wooden easels scraped across the floor as they were repositioned; brushes were briefly left to soak in spirits, then cleaned with rags.

On other days in the life-painting studios, a man naked but for a loincloth would mount a platform to model for the young women. He would pose simply, perhaps with his arms clasped behind his back, at least as Eadweard Muybridge's and Thomas Eakins's nude photographic studies tell us.[10] Mary's task was to trace the cheekbones, the chin, the Adam's apple with her brush. She would paint the cavity of the man's chest, outlining his navel. She would glide her brush over the loincloth emerging on the canvas. She would quicken to paint the veins in his forearms, then summon up the energy to focus on the individual hairs on his thighs, then his calves, then back to the flesh of the ankles and the difficulty of getting those feet.

On certain days after the morning painting classes, the art students would convene in the coeducational afternoon costume classes and field tours.[11] On these occasions, they visited the Jefferson Medical College where they heard lectures on anatomy and witnessed dissections. The body under the knife and the body under the brush mixed again and again, not only in Philadelphia life and in Eakins's life, but in Mary's DNA. Jefferson Medical College was a connection to her father, now dead for nearly three decades. Her distinguished ancestor, Congressman George Clymer, had been the first president of the school she was now attending.[12]

On the days that the Jefferson Medical College physicians set up to lecture on anatomy, preparing charts to outline veins, sinews, muscles, and bones,[13] the male art students filled the seats of the lecture hall as Mary and other young women filed in. Inevitably the cotton of their skirts and the wool of their shawls brushed against the young men's wool jackets and trousers as they chose their places. Once settled, Mary removed her tight kidskin gloves and lifted the graphite to note and sketch during the lecture, as her classmates did.

All of Eakins's students attended those anatomy classes, even the Canadian George Reid, whose talent was so impressive that he'd been released from introductory classes after Eakins noticed his figure painting proficiency. The portraits George had composed to earn the money to travel to this school had rewarded his efforts. He studied everyone he looked at, figure obsessed. He picked up the lines of necks, limbs, feet, and hands. Quick-eyed, vigorous, and ebullient, he began to make the other men his friends as their freshman year unfolded.

George observed the gloved, then ungloved, hands of Mary Hiester.

Medicine and art were inextricably mixed in Philadelphia. Doctors collected paintings; painters provided medical illustrations. Eakins believed in studying anatomy directly: "To study anatomy out of a book is like learning to paint out of a book. It is a waste of time."[14] Close friendships formed, like that of Thomas Eakins and his friends Dr. Gross and Dr. Agnew, whom he depicted in their surgeries. Mary may have been aware that Nurse Clymer, portrayed in Eakins's

monumental painting *The Agnew Clinic* (1889),[15] shared one of her ancestral family names.[16] The huge work (7'0" x 9'10") focuses on the coldly terrifying removal of a breast. As the male students lean energetically over the surgery theater, their dark clothes and dark hair form a great shadow encircling the limelight of the central oval, the creamy breast with its salmon-pink areola (the color that Mary would adopt for her roses) as their focus. Nurse Clymer, in black and white, looks stoically on.

Mary heard the slice of the scalpel into the soft flesh of the cadavers. After a surgeon made his dissecting cut, she might notice where he wiped the blade, perhaps casually against the heel of his well-made boot.[17] The amphitheater stank of blood and decay. Though the nude female models in the male painting classes were masked, the surgical mask had yet to be adopted.

3.

As ill-considered an exhibitionist as Eakins eventually proved to be (stripping off his own clothes for his female students to better demonstrate points of male anatomy, and, as a last straw, flipping up the loincloth on a male model so that his female students—many of whom were supposed by their families not to learn the facts of life until their wedding nights—could note the proper shading of the testicles), he sanctioned life beneath the corset. As he insisted that what required a loincloth had a full, rich claim as the subject of art, he also emphasized attention to technique.[18]

Mary's foundation in traditional perspective and watercolor gave her solid ground, but to work in oils, not on paper with watercolors, was still a breathtaking step forward.

Eakins was only ten years older than Mary, and his colleague Thomas Pollock Anshutz (1851–1912) only three years older. We'll never know what these teachers said to her, but it did not seem to be discouraging, for she kept on, taking in their lessons as she came into her talents and sexuality. Importantly, even as Eakins gave her permission to explore the figure, he seems to have left her alone to her own development, often the best thing a teacher can do for a student. Another student, Susan Macdowell (with whom Mary must have been acquainted, since they overlapped as classmates), had caught Eakins's attention. She had been his student for six years, married him in 1884, and more or less stopped painting once she was his wife. (However, she did insert a portrait of Eakins into the gallery background at the right edge of *The Gross Clinic*.[19]) Though ideas of propriety were Eakins's scourge, and though he was marrying his student Susan out from before her easel, the educational energy he radiated also made it possible for her classmate Mary to create. He gave her the tools and perhaps even the confidence that complemented her own painterly authority. She had the assurance of birth, the medical school in her blood, and the city in her backbone, the independent air of a woman on her own—as much as an unmarried woman, sans parents and sister, could.

4.

It had taken George years to make it finally to Philadelphia. When he was sixteen, after his mother died, his father's sophisticated younger sister, Aunt Maggie, arrived to help the bereaved family. Her talented nephew suddenly had a new ally. Convinced of his gift, she laid plans for him to study art immediately. But they were foiled by Adam Reid who had, behind his son's back, apprenticed the shocked and angry teenager to a local architect. It would be for three whole years, according to a legal document that his father produced. His aunt helpless, his father determined, George signed on for the apprenticeship. At least it wasn't farming.

He chafed at the tight collar of his new training, but he was engaged despite himself. He learned drafting. He worked on perspective—until his employer's business failed. In the spring of 1878 he was released from that paper his father had signed. Immediately he packed for art school—but just as quickly his father kept him with another suggestion: that he study bookkeeping.

While George squashed his imagination in order to learn bookkeeping as his father wished, his maternal uncle became his champion. Thomas Agnew offered him a job designing the circular exhibition building for the local agricultural fair. The farm boy then became a nascent agricultural architectural designer. In the fall of 1878, Adam Reid at last capitulated to both his sister's and his brother-in-law's opinions of his son's talent. He sold a load of wheat and gave George the money to leave the farm at last for Toronto. There George boarded with his cousins, labored

a ten-hour day in a machine shop putting the threads in nuts, and studied drawing at night. In the galleries of the Ontario Society of Artists at 14 King Street West, he saw oil paintings for the second time in his life.[20]

He carved his own left-handed palette, instantly excelled at oils, and was awarded scholarships. But it was still expensive to pay for both instruction and supplies, so during the following summers in Wingham he began selling his conté sketch portraits to local farmers. Then he brassily opened a summer portrait studio, demonstrating his gift to potential customers with a displayed portrait of his father, who had by then remarried, and another oil portrait, in memoriam, of his mother.

By 1881, he'd finished fifty commissioned portraits—with the growing bank account to show it. The following year, with four hundred dollars in cash, he started again at what was called the Toronto School of Art.[21] When at last he arrived in Philadelphia in 1883, with five hundred greenbacks in his pocket and an art-besotted rube's ambition, he was able to take his place among the American gentlemen student-painters in more tailored coats and paint that masked nude model.

5.

After George's first year at the Pennsylvania Academy of the Fine Arts, he returned to Toronto to convince two of his friends from the Ontario School of Art, W.E. Atkinson and Donald McNab, to come to Philadelphia and share a studio

with him on Market Street.[22] Eakins appointed him to be part of the select group of male students who assisted in the lectures, the demonstrators who brought the dead mammals into the dissection rooms, preparing them for Eakins's lectures on mammalogy.[23] The Canadian farm boy peeled back the skins to reveal the guts of the raccoons, the dogs, the pig, whatever the school could come by, whatever the farm boy could splay for Eakins to identify and teach from. When it could be had, the school brought the students the carcass of a horse.

Stocky, silent, he stood at the front of the room with the carcass specimen. From her seat, Mary could notice the deftness of fingers. The beard he had grown.

6.

The city of Philadelphia ended more abruptly then, without acres of suburbs. Fields ran down to the banks of the Schuylkill River, and on fall afternoons the academy students went on sketching trips. (Plein air painting for students was another of Eakins's innovations.[24]) As the young painters approached their destination, they scattered to choose their positions, seeking both a view and the level ground to set up a camp chair and laptop easel. Did Mary position herself alone? In the midst, or at the edge, of a gaggle of friends? In Canada, George had simply painted figures in interiors. Now the outside light captivated him.

As she rolled up her sleeves to reveal the tawny skin of her arms, as she sketched the gnarled tree trunks and grasses

with her determined strokes, the tendrils of her hair undoing in the moisture, he noticed her.

On these plein air trips, Mary was aware of George. Though she had to concentrate on the view before her, she also absorbed the sound of his arm as it rushed across his sketchbook or canvas, knowing that he saw what she saw. Though not precisely: they each viewed nature in a different frame, with a separate vigor as they sat and looked in parallel motion, bare armed, tandem.

Later he asked her to come sketch outdoors with him alone.[25]

Delicious combination of discomfort and freedom: the bugs, the slant of the sun, the sweat pooling in the hollows of necks, then below the shirt or blouse. If, beneath the long skirt, she subtly kicked off her shoes, no one would see. Then she might run her stocking feet through the grass and feel a coolness.

Would George have tossed his jacket on the grass? Quick reek of sweat from his neckerchief and his tobacco. Her sweat? Women protected their dresses with a puff of baking soda. The young couple smelled leaves, mud, the mushroomy forest floor. They heard the breeze come up, with its bit of leafy music. Rustle of her dress. Shifting of their camp stools. They got hungry, of course. Did she offer him part of her lunch—a hunk of cheddar? Sourdough bread? Early apples, a few walnuts?

Love is a medium, like air (like paint itself), a full, caring environment for body and for spirit. Inside that medium, one can metamorphose into the being one wants or hopes to be (or even what you feel you really are). Aspirations

become realized in the uncanny connection with another. A hopeful student can become a painter. Or two can become painters together. Love, weird and mysterious, drops the lovers into a complete environment of connection.

7.

Probably Mary took the train home from the academy to Reading. No doubt she had duties in the McLenegan household. As the season progressed, cold walks past the Schuylkill. Colder every day. Mornings: the splashing of water from the big urn on the washstand into the wide ceramic bowl. Soap? Or not. Washing the body sometimes was just the rubbing action of water and a cloth on the torso and limbs, especially as the temperatures dropped. Soon the long wool coat and the woolen gloves. Boots with their eyelet hooks. Out came the fur muff from the mothballs, aired in anticipation.

What appeal did Mary, six years older, hold for George Agnew Reid, whose mother had died when he was a teenager and whose father scorned the very thing that made him who he was? Simply by painting, she affirmed what he knew was his essential self. There are many ways of falling in love, but for a woman who painted objects and emotions, the discovery of a love object with a mutual gift created a space where she, too, could transform—into an artist for real, into a true self, into a fully sexual woman. The attraction is palpable; it feels inevitable: a love that is also a way of loving.

During the winter of 1884,[26] Mary invited George to Reading to sketch the Schuylkill River.[27] Of course he accepted. They must have sketched outside until their hands turned blue. They drew. Drew closer.

They sketched from a common viewpoint, but separately. A grid of accommodation was being laid down between them. The subtle shifts of competition and support teeter-tottered, seeking a balance.

Anatomy lessons.

Concerts. George loved singing.

Jokes. Mary had an enticing laugh.

In the prosperity of Reading in 1884,[28] the row houses leaned into one another like refined old friends. At dinner with the McLenegan family: proper embroidered table linen and silver. Beyond the snap of logs on the fireplace grate, what sounds? Titters of the little cousins? The clearing of John McLenegan's throat? Her hand lifting the teapot. The rough-bearded Canadian she's brought home balancing his cup.

8.

By the spring of 1884, George had grown anxious to make his next step. At the end of the school year, he would complete his course of study. But what did a full-fledged artist actually do? As he considered his life, he thought about how his teacher lived. Eakins had studied in Paris with the influential teacher Jean-Léon Gérôme (1824–1904). Paris was where the Canadian artist Paul Peel (1860–1892) had

studied, too. Peel, who had married in Paris, was already showing his works there. George, a planner both in life and on paper, aimed to take the next step: live and paint abroad, visit Paris and London and Rome to see the paintings he had only seen in reproductions. He hadn't very much money. If he wanted to get to Europe, what was the cheapest way to go? The Inman Line ran budget to mid-price ships to Europe. He discovered that the SS *City of Chicago*,[29] a steamship rigged for sail, would leave New York harbor for Liverpool that spring. He could be on that ship to England, and he could take the train to Dover, then sail to Calais.

But he did not want to go alone.

A negotiation began: George Reid was a paradoxical combination of gruff and gregarious, Mary Hiester a combination of somber and amused. Inside their incongruities was a shared core of ambition and artistry. In the buildup of anxiety at completing his requirements to finish school and leap into the world, in the deadline of a steamship's schedule, in his own artist's schedule for himself—where was Eakins when he was his age?—George planned. The more anxious he became, the more urgently he put his calculations to Mary, she of the dark looks of a Velázquez painting. Velázquez was to be found in the Prado, and after they were established in France, they could certainly go on to visit Madrid. Didn't she have a sister in Spain?

He was so eager to achieve his goal that he neglected the veneer of sophistication he had shellacked himself with. He didn't prepare her, smooth her way, or lead her. He didn't flirt; he didn't tease her. He met her straight on with his idea.

She heard in his voice the flatness of an Ontario farmer's son who had thought it all through. She had heard those direct farm voices in her childhood in Beloit. It was the country talk of her young cousins. "His proposal," Muriel Miller writes in *George Reid: A Biography*, "was a matter-of-fact proposition, the urgency of which had to do with overseas bookings, not emotions."[30] Or was he afraid of rejection? Mary may have balked at his practical proposal of marriage. How would he have the means to do it? Or did he expect that she was the vehicle to his dream? She had some personal money from her inheritance.

Running around Europe seemed to preclude a sensible union. In a traditional marriage, George could forbid Mary to paint altogether. Yet their tandem viewing and sketching had derived from the energy of two independent spirits. She had made her claim as an artist. He had pursued her because of this. He did not aim to take it away. And she, as conventionally clothed and mannered as she may have appeared, did not mean to give it away. Years of carefully kept records of painting sales testify to that.

9.

Theirs would never be a legally equal partnership. She would take his name, becoming Mrs. G.A. Reid. She would set his table. And she would have to bear his children, too, if any came—though none did. Could the contradiction of an equal partnership in art and the societal niceties of legal conventions resolve?

Both their identities were at stake in a union. He wanted a wife—not on freely realized egalitarian terms, but still on new terms for the times. Mary, who had insisted on being trained to paint as men were, was training her gaze at *him*. In one of her portraits of George, she paints him in profile, headed somewhere, thick-bearded, earnest, softly handsome, with the reddish glow of physical warmth. If he looked half like this, *was* half like this, he was irresistible.

He suggested that they marry and take an extended honeymoon, stretch their money so they could slip into little hotels and soak up paintings at every museum in England and France and Italy and Spain. See her sister. And return to North America, not to Reading or Philadelphia or New York, but Toronto, where he saw another opportunity. There they could take a studio and paint and teach from it, just the way Monsieurs Colarossi and Julian did in Paris. They could sell their paintings. And make money. Save and go back to Paris and study, together.

Not if I get pregnant, did she think? Quite likely she knew that withdrawal was not a reliable family control method. She may have known about pessaries, primitive nineteenth-century diaphragms,[31] and may have read the love manuals passed among women, perhaps especially those freer spirits at the Pennsylvania Academy of the Fine Arts, the booklets with instructions for douching and withdrawal. If she became pregnant, their plan would wither. But who dwells on that when such an attractive alternative to spending your life as a spinster upstairs in your cousin's house in Reading, Pennsylvania, appears, however much you like to sketch trees along the Schuylkill River?

The Reverend William P. Orrick, rector of Christ Cathedral in Reading, journeyed from the homeplace of the McLenegans, the Hiesters, the Mussers, the Muhlenbergs, to Philadelphia to perform their marriage service at St. Luke's Church on Wednesday, May 13, 1885.[32] His words marked that fresh hour in mid-May when Mary and George's partnership began. Their new-fashioned commitment swelled with possibility, like buds on the trees on Spruce Street.

As M.H. attached that fresh initial R. to her name, sketching aboard the SS *City of Chicago* with her new husband by her side, a little girl was detaching from her once-stable life at Birch Hall, Kirby-le-Soken, Essex, England. Sandy-haired Mary Evelyn Wrinch, born on May 12, 1877,[33] had celebrated her eighth birthday the day before Mary and George were married.

Since she'd been tiny, she'd heard the lowing of cows and the clip clop of the Birch Hall hairy-ankled plow horses. She heard their family servant Jenny Manning's broom as it swept the fireplaces and the swift movements as she straightened beds for a family of nine in a substantial house. Her older siblings clattered down the stairs to the dinner that their cook dished up from Birch Hall eggs, Birch Hall vegetables, and Birch Hall pork. Her mother, Elizabeth Cooper Wrinch (1839–1897),[34] busied herself supervising their domestic life, while her father, Leonard Wrinch (1825–1882),[35] presided over his six hundred acres of leased lands with tidal creeks and rich wetland soil.

Birch Hall was an iconic example of the phrase "safe as houses," but the British economy was weakening. That year, poor weather spoiled the harvest. Though the Wrinch

farm was solid, its lands sizable, what would become the lasting depression of English agriculture had already set in. Season after season, the family gathered in the dining room saying grace, even as farm produce prices were collapsing.[36] Yet Mary Evelyn's parents had brought Miss Clarissa Golding as governess to their farm where fifteen hands worked. Mary Evelyn, a child in a great agricultural Victorian enterprise, learned her alphabet and numbers, and learned to draw. She was a wonder at drawing, and her mother understood what a talented girl she had.

As the Wrinch clan grew up, Miss Golding was replaced with a tutor. But when Mary Evelyn's brothers planned their futures, their ears pricked to opportunities in Canada. Their mother's sister, Aunt Emily, had already immigrated to Montreal, where she lived with her husband, Thomas Cole of the Young Men's Christian Association.[37] Then Leonard and Elizabeth sent one of Mary's brothers, fourteen-year-old Horace, off to Liverpool, then to sail in steerage for Canada, where Aunt Emily and Uncle Thomas took him in.

Like a sand painting, Birch Hall's seemingly stable Victorian design was blowing away. In 1882, Leonard Wrinch died, leaving a small estate of £2,317.[38] Mary Evelyn was five.

With a sense of carrying on that seems similar to Caroline Amelia Hiester after the death of her husband, the soft-browed, long-faced, tiny-eared Elizabeth Wrinch, then forty-three, wearing her hair in a center part to be easily tucked into a hat,[39] decided to give up the farm and insure her children's futures. At first, she could not leave her surviving aged father or mother-in-law. But soon her

father died, leaving a substantial estate of £24,000, some of which must have come to her, for her eldest, Leonard, was able to sail to Canada on the passenger list as a "gentleman," not in steerage like his little brother who had sailed before him. Their aunt and uncle's household in Montreal, including the two brothers, decamped for Toronto when their uncle Thomas Cole began a new position with the YMCA. There, Leonard scouted for rich, marshy lowland soil, the kind he had known on the shores of the North Sea. He found it in the lands of the Mississaugas of the New Credit, on the shore of a freshwater sea with a Haudenosaunee name, Lake Ontario (sparkling water). His generous uncle staked him a loan to buy the once–First Nations land in Bronte Harbor.[40]

The younger children, including Mary Evelyn, the one with the fine motor skills who held her graphite with pleasure, were staying in Essex with their mother. Elizabeth was saying a long goodbye to her existence as the mistress of a sizeable farm and to all her husband had built, before she and her children would disperse from a disappearing way of life.

Honeymoon

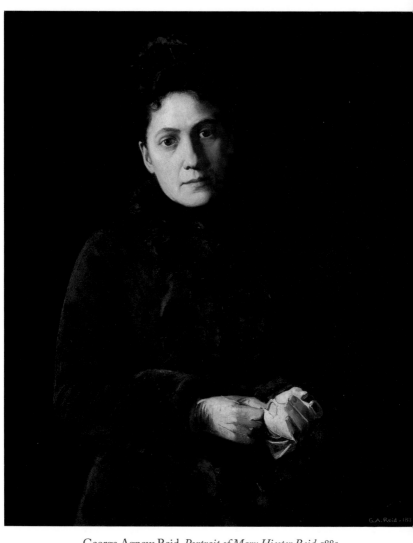

George Agnew Reid, *Portrait of Mary Hiester Reid*, 1885,
oil on canvas, 76.7 x 64.3 cm,
National Gallery of Canada, Ottawa.

Yellow Gloves

I.

The first-class customers luxuriated above Mary and George's second- or third-class stateroom on the Inman Line's SS *City of Chicago*. Below them rode the steerage passengers. In the hold of this Royal Mail steamship, two years old and built with both steam stacks and sails, slumped bags of letters from the United States. Just over a week[1] it took the newlyweds to cross from New York to Liverpool—a perfect interlude for a honeymoon. With nothing to do but engineer lovemaking in the narrow bunk and feel the roll of the waves, then get up and make their minimal ablutions (a pitcher of water), they navigated the stairs to eat their meals in the salon, then gathered their sketchbooks and sat, when the weather permitted, on deck. Even in fine weather, though (and George, decades later, recalled that it was fine[2]), the ship rolled and the deck chairs with it.

Weeks earlier questions of what to pack and how: neither of them had ever traveled in this way, with two sets of

artist's gear and their clothes, constricted by weight and the amount of travel they planned. One thing Mary didn't have to pack was a passport. American citizens traveled freely to Europe in the nineteenth century.[3] As a Canadian, George did not have to have a passport, either; sometimes the new government issued travel letters, sometimes not.[4]

Mary was learning George's habits: recognizing his cough, his morning breath, his farts, his insistences and enthusiasms. Simply sleeping with another body was new for both of them. Puking into buckets on rough seas? Certainly new. Chamber pot in the corner. Washing semen off private parts—new.

> It will be quite a shock to feminine modesty when she, a pure-minded maiden, shall be called upon to lie down in the same bed with a man. It will seem repulsive at first, because she will feel that lying down robs her of her feminine prerogative, and puts her person in the power of another. To some women the shock is painful; it matters not that those with whom they are to lie down, are their own lovers with whom they have passed so many pleasant hours; everything is new, and it takes them some time to fall in with the new order of things.[5]

In 1883, George W. Hudson published *The Marriage Guide for Young Men*, assuming that young women before marriage did not have an inkling of the sensuous life but also in sympathy with the loss of power for women in the

marriage bed. However Mary and George reacted to each other sexually, the sensuous feel of their portraits of one another gives off a kinesthetic sense of each other's bodies. Looking was what got them together and would hold them for the coming decades. They probably looked at every inch of one another before they docked at Liverpool. No jet lag—at sea the time had slowly changed an hour a day— though the port that morning in late May[6] bustled in contrast to the quiet of the week's crossing.

Porters scurried and George had to manage hailing and tipping the person who hauled the steamer trunk and handbags to the coach that would take them to the Lime Street Railway Station and the huge North Western Hotel[7] that fronted the station. There they installed themselves for a night. Now would come the travelers' regrets of packing too much and leaving some little thing so necessary, and now so unavailable, behind.

Mary could not with propriety be unaccompanied; the couple could not divide their public tasks between them. She had to wait for George to hail the porter and to fumble with the foreign currency. She had to wait for George to register them at the hotel. They struck out together from their room to the Walker Art Gallery, where MHR discovered *Dante's Dream at the Time of the Death of Beatrice* by Dante Gabriel Rossetti, a large work featuring four red-headed figures and the poet Dante. Rossetti had sold the painting directly to the gallery in 1881 for the inspiring sum of £1,575.[8] Four years later, Mary would paint her own red-head—a portrait of a nineteenth-century woman in the enforced activity of waiting.

So begins a process of slow thinking, of mulling, of an image lodging within and lying dormant, sometimes for years, sometimes for whole decades before she uses it.

2.

Often, we think of the artistic process as a flash of inspiration, an idea suddenly born. However, what bursts in a flash sometimes has silently grown for years before it seems to explode. Think of biennials taking two whole seasons to bloom. Or an elephant's gestation. A memory from childhood can dawdle for years before something provokes its appearance—whereupon an artwork is made in response.

Mental dawdling is fostered by waiting. Enforced stillness leads a person to attend more closely to the senses: sniffing the mineral smell of petrichor before the rain, then hearing the ping of raindrops on a windowsill. Close attention, being present in the present, paradoxically allows the past to bubble up. This freedom of association lays a groundwork for creating something new. In Mary's work, the provocation of an image sometimes quickens four, fourteen, or twenty years after that image was first encountered.

The poet Phillis Levin has often in our conversations described the delayed time—sometimes decades—that it takes for an image to surface in her imagination as she writes. This works in reverse, too. Poets can experience their own poems as prescient. When my first husband and I finally broke up our marriage, each of us emerging from

our cocoon to go off to separate cities, it was time to pack up my poems. In re-reading them, I discovered that I'd been writing about things breaking and shattering and also inventing imagery of growth and surprise, beginning with poems composed three whole years before I consciously understood it was time for us to go our own ways. My imagination was, in psychological terms, working through the emotions of that divorce before I was awake to wanting it. I am not talking about poetry as therapy, but about art that reflects a psychological process. And the suspended state of waiting, of being prepared to do, to go, to speak, but not yet, gives a creative person a blank page, an empty canvas. So, there is Mary, waiting for her husband at many, many intervals.

3.

Yet through George's eyes, in his first portrait of her, she's not waiting at all. She is venturing. And her hands in sexy yellow gloves gesture suggestively. Far below the grave expression that makes Mary appear older than her thirty-one years, those gloves blossom. In the enticing language and etiquette of gloves in the Victorian era, the slowly undraped hand has just a hint of the striptease. Two fingers of Mary's right hand are bare, and the folds of the gloves hang down, making a complicated construction. Social manners codified "Glove Flirtations." According to *The Mystery of Love, Courtship, and Marriage Explained*, "Right hand with the naked thumb exposed" signified

"kiss me," and dropping a glove meant, "Yes."[9] Whether the gloves are coming off or going on is ambiguous, and it's not her thumb but two middle fingers exposed as she slides a glove against her skin, but a sensuous drama unfolds. George's hands poured energy into his new wife's purposeful, golden fingers. Those digits were the makers of her paintings, and when bare, they caressed his face and his limbs.

The umber darkness he paints resembles the palette of Diego Rodríguez de Silva y Velázquez (1599–1660), the emotive and psychologically acute Spanish court portraitist George revered and who was deeply admired by his teacher Eakins, as well by Eakins's mentor at the École des Beaux-Arts in Paris, Jean-Léon Gérôme.

George would paint or draw Mary's portrait many more times, at crucial moments during the thirty-six years of their marriage, and he would photograph her (once in Paris, more times in Toronto) at the bookends of her painting career. He would also style his wife as a model. Through four decades, she never ceases to draw his eye; he never stops wanting to look at her. Intervals go by when they are, perhaps literally, out of touch, but he paints her young and middle-aged, photographs her young and old. Her visual presence anchors the arc of his work for the span of their marriage.

And with his first portrait, he presents Mary the traveler. She doesn't look capable of cracking a smile as she goes out into the world in her coat with fur trim. At the precipice of her next life, having professed her calling, she is serious all the way.

4.

The next day, they were on another platform with another set of porters, piling their possessions onto a train for London, where at Charing Cross Station a porter offloaded the luggage to a cart and steered it to Craven Street, where they found a small hotel on the street where Benjamin Franklin had lived and where Herman Melville later stayed. Mary and George had fallen into a story, into a city they had read about and heard about since their childhoods.[10] They spent hours in the British Museum with its low steps, the clack of their leather boots on the marble floors. It would take another hundred years for viewers to see the friezes from the Parthenon as controversial; for Mary and George, they were emblems of the museum's prestige that far outdid the Philadelphia Museum of Art.

Daily struggle with newness. Finding affordable food. Learning the streets. On they went to the Royal Academy and the National Gallery, where paintings they had only seen in newsprint or engraved in magazines were suddenly enlivened in all their original colors. They who had spent years drawing naked bodies now drew each other out in a foreign bed. The inevitable disappointments. The sudden pleasurable surprises. The interruption of a chambermaid's knock.

Within days, they prepared themselves to board another train: the paying of the hotel account and the reloading of the trunk on a cart, the buying of a basket of victuals and the train ride to Brighton, the reloading of luggage and the supplementing of that food basket for the hours across the

English Channel to Dieppe. Their energy was high and they detoured to Rouen to see the cathedral before trekking to Paris and to the 1885 Salon where, beyond the work by Jean-Joseph Benjamin-Constant, a premiere salon painter, MHR would find two paintings by two ambitious women.[11]

Marie Petiet (1854–1893), a married working artist who would die young,[12] showed *Plumeuses d'oie* (four young women pluck goose feathers, supervised by a tired-looking older taskmistress). The longer-lived Jeanne Rongier (1852–1929) contributed *Une séance de portrait sous le Directoire* (an artist's studio with a young woman posing in an empire dress for her male portrait painter who is hard at work as a group of gossipers look on). Here were works by women, both around her own age—and both of whom would show their work beside hers a few years later at the 1893 Chicago exposition.[13] The excitement of a Parisian influence was beginning for Mary. There was an intense painting world to join, one where a woman might choose both conjugal love and art.

They hurried to the Luxembourg galleries. They spent hours at the Louvre. As they glided toward the *Venus de Milo* and the *Mona Lisa*, gawking at Titian and Ingres, Delacroix and Watteau, they passed painters who had set up easels to learn by apprentice copying. From French academic painting to Impressionism, the two inhaled, ingested, imbibed the angles, colors, and gestures of French contemporary artists: Gérôme, Cabanel, Robert-Flury, Bastien-Lepage, Lefebvre, Courbet, Renoir, and Merson.[14]

But how expensive it all was!

INTERLUDE

When we tucked ourselves in for Hanukkah and Christmas in 1991 at my future husband Professor Michael Groden's house in London, Ontario, we had been reunited for just about six months. Until 1985, we hadn't seen or heard from one another since our breakup in 1966. It was at first a grown-up friendship—no romance! Just occasional long, long phone calls for about six years. Then he sent me an invitation I couldn't resist.

As the snow piled up on the porch of Mike's house, we sat in our bathrobes exchanging presents. I opened a large rectangular package. It was a traveling art kit, full of supplies for the nascent drawer-painter on the go. I hadn't drawn or painted for decades—transmuting my visual impulse to imagery in poems. "Why did you give me this?" I asked him quietly. "I'm delighted, but,"—what did that "but" mean? (But I don't have time? But I don't do this anymore?) "A poet is a failed painter," the saying goes.

"Well," he said, looking at me with his brown-flecked green eyes, "you used to paint in high school, so I thought you might like it." I loved it. Because he was seeing me twice, once at seventeen, then at forty-four, I felt he'd observed some layer in me I'd ignored.

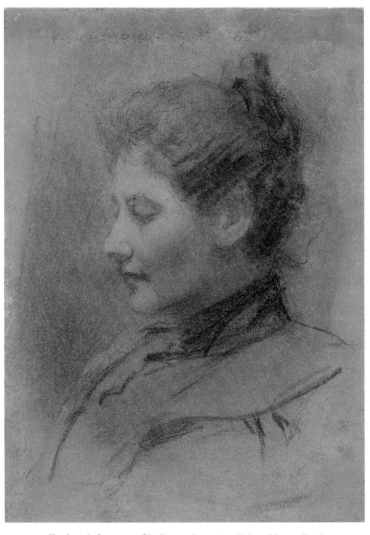

Frederick Sproston Challener, *Portrait of Mary Hiester Reid*,
unknown. Charcoal on paper, overall (paper): 17.5 x 12.7 cm,
Art Gallery of Ontario, Toronto.

CHAPTER NINE

The Sister

I.

In their small hotel room, Mary and George counted their money. There was enough for a third-class railroad ticket to Madrid—and they had been advised by more seasoned travelers to travel to Spain only on a first- or second-class carriage.

They bought the third-class tickets anyway.

They spoke no Spanish. They bumped along with families and chickens, without privacy or sleeping accommodations, shifting against one another, dozing, eating bits of the food they had packed, and squatting over a hole in the car to urinate. (Underneath Mary's dress, her bloomers were split with a convenient opening. Women's underwear in the 1880s did not close the crotch.[1]) In the waning light one evening, they reached the town of Irun on the Atlantic, at the far western border of France and Spain. There officials issued bewildering warnings they couldn't understand, though they heard the word "Madrid." Was it only that no

trains were running to Madrid? Exhausted, disoriented, they found a room at another small hotel.

It was nineteenth-century Europe's fifth cholera pandemic they were being warned against. A Spanish guest at the hotel spoke English and advised them to avoid Madrid. That meant giving up seeing the Velázquez paintings. Mary could abandon the seventeenth-century painter but not Carrie. Her sister was by then living in a cloister in Malaga. The English-speaking traveler suggested that they follow his route directly to Cadiz (also in Andalusia, in the southernmost part of Spain), skipping Madrid, stopping only to change trains.

And so they did, veering off to a small hotel on the harbor of Malaga, escaping the pandemic.[2] The early July heat and the soft blanching light that glances off the Mediterranean were new to Mary and George. The warm water, the lapping of the waves so unlike the northern lakes of Canada or the Atlantic Ocean, drew them to breathe in a fresh way. When the wind off northern Africa blew in the afternoon, they lay after the Spanish midday meal in the darkness of their shuttered room.

2.

Mary proceeded up the hill toward the Carmelite convent.[3] The two sisters had not seen each other in nearly a decade. They were more mature now, each on a separate vector of life: Mary, full bodied, sketchbook in hand, and

husband in tow. Carrie, severe, thin, in her hooded black-and-white habit.[4]

As a follower of St. Teresa of Ávila, Carrie was living just as the saint described in *The Interior Castle*. The idea of a home—of a mansion—is central to the interior castle, where seven courts lead to the spiritual home of God.[5] At this moment Mary was without a home. The sister in the traveling dress communed with the sister in the nun's habit, someone who in every exterior way had made the opposite choices to her own. Ambiguity had to be embraced in this July heat where Mary could swoon from everything foreign, even her sister, who had gone from a novice to a full-fledged nun, and now was swathed in a religion their Lutheran ancestors had fled.

One solution to being overwhelmed is to get practical. Mary signed up for Spanish lessons. Then got out a sketchbook.

She and George strolled the beaches, sketching the fishermen's clothes, the pewter-colored catch of fish in the nets, the dusty ochre of the walls—all strange, compelling, thrilling, and disorienting. At mid-July came the festivities for the Virgen de Carmen,[6] patron saint of fishermen, her statue carried in procession throughout the streets. By this time Mary had also brought George to the convent, where Carrie welcomed him and the Carmelite sisters allowed him to sketch her in a compelling three-quarter portrait. At age thirty-four, Carrie peeks out in calm profile from the dark folds of the habit, with smooth, enviably arched brows, dark lashes, and dark eyes both serene and intense. She does not

smile, but her lips are relaxed, patient, intent. The attitude is inwardly focused. A face from the interior castle.

<div align="center">3.</div>

In contrast: the bullring.

The whole town was attending. Carrie and the sisters convinced them to go. George recalled to his biographer that both he and Mary were captivated by the red jackets of the picadors and the glitter of the torero's traje de luces, suit of lights. But after the teased bull had gored one or two of the horses, throwing the picadors to the dust only to be saved when the torero distracted the bull, bloody from the lances, Mary couldn't stand it anymore and wanted to leave. George protested.

So they stayed.

After the first deranged, exhausted bull was teased and killed, they both rose to their feet and edged out of the crowd, escaping the arena.

Muriel Miller describes this event in such detail, even adding dialogue, in *George Reid: A Biography* that it leads me to suspect that George had explained this particular event to her with a storyteller's gusto. The recollection reveals a pattern of negotiations that would prevail in their marriage: She initiates. He responds negatively. She adjusts. He changes. Then they agree.

Escaping the blood sport, they left Carrie and ventured to Italy, spending the month of August watching Vesuvius, visiting Pompeii, finally settling in Venice in summer heat

that they may by then have gotten used to. They sketched palaces and gondoliers, until the days multiplied, and the dream state of painting in the hot weather with the stench of the canals and the luminosity of the water lulled them into the end-of-summer realization that they had nearly run out of money and had to get home.[7]

Train to Milan, trains to Calais, boat to Dover, train to London, train to Liverpool, and finally the Inman Line back to New York. Now they were used to each other, coordinated, navigating, her breasts more familiar to him, his penis more familiar to her. Their opinions would not surprise one another so thoroughly, but still they would surprise, for the two were full, growing, adult beings. All the organic bonds of love, anger, disappointment, haste, and appetite were there— as well as the ultimate bond of eye-hand coordination that guided what they saw: the instinct that flowed down their arms and onto the canvas. Their trunks, heavier now with completed sketchbooks and souvenirs, were banged into a taxi carriage at the port of New York as they were taken to Pennsylvania Station, at last to entrain toward Reading.

There they landed on the McLenegans full of stories of Carrie and all their adventures in Europe, and announced that they would not be making Philadelphia their home but taking the train north, to Toronto, a place as far in color and temperature from Malaga as a person might find.

INTERLUDE

As the newlyweds prepared for their move to Canada, Elizabeth Cooper Wrinch, bonnet firmly beneath her chin,[8] scooped up her eight-year-old daughter Mary Evelyn, her older girl Agnes, and two younger boys, Frank and Albert, then shepherded them all aboard a ship from England to Canada. She was following her sons Leonard, Horace, and Warwick[9] to the Loyalist stronghold of Bronte, Ontario, built where Twelve Mile Creek empties into Lake Ontario on lands stewarded by the Mississaugas of the Credit First Nation. The harbor of the muddy fishing village, named for Lord Nelson, Duke of Bronte (now part of the wider Oakville-Toronto area) was hospitable to the transport of agricultural goods to ports along the Great Lakes—and the scions of the Wrinch family planned to produce them.

It could not have been an easy transition for Elizabeth, used to being the matriarch in a substantial manor house, now finding herself at the age of forty-six in this outpost, on farms barely established with wooden houses, and a rhythm of strenuously hard work in a short Ontario summer, followed by a long, snow-dense winter. The previous spring, she'd had to witness a household auction of the Wrinch family's earthly goods. From a Brussels carpet

to a mahogany telescope, from featherbeds to a Copeland green-and-white dinner service, she saw their possessions vanish into the hands of others on April 30, 1885.[10] Now she was without friends, and also without the class structure that had scaffolded her life. As a widow in a new landscape, she was freer to figure out what to do with her last, talented child, Mary Evelyn.

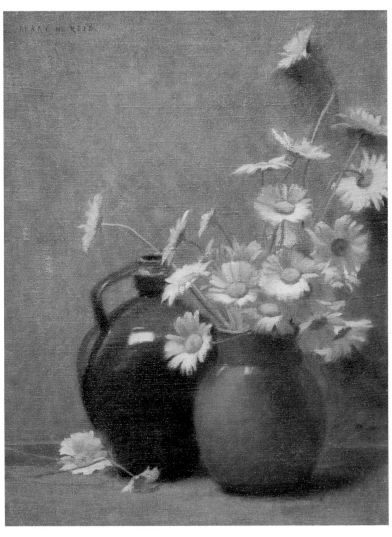

Mary Hiester Reid, *Still Life with Daisies*, undated,
oil on canvas, 50.8 x 41.9 cm, University of Lethbridge
Art Collection, Alberta.

Still Life with Daisies

I.

The new Mrs. G.A. Reid arrived in Toronto, about thirty miles from the Wrinch farm in Bronte harbor, in the fall of 1885, just as the last daisies struggled in the gardens. She had not had to apply to be a landed immigrant, to provide a passport, or a list of accompanying goods.[1] Now, as horses' hooves slid over wet leaves on the cobblestones of September, she and George began a search for space. They found two rooms—one to use as a studio, the other to use as living quarters—on Adelaide Street East near the corner of Toronto Street,[2] and they set up their lives, aiming to paint side by side and make money. Small floral still life paintings might sell, and after they shopped for furniture, Mary began work.[3] But even in 1885, when paintings routinely hung on the drawing room walls of staid Torontonians and no one bought reproductions, it proved nearly impossible to earn a living from labor at an easel.

And it was lonely. Women rarely went out unaccompanied, and no one would have thought to invite a lady to

the group George was about to join. He had reached out to friends from his student days at the Ontario School of Art. They got together several evenings a week for life-painting, pooling resources to hire a model. Gregariously, George offered their studio as a meeting place, and in the winter of 1886, Mary of the slender waist and coffee-bean eyes began her role as entertainer-host-painter. George had brought the Toronto art world—all male—to her. When the men trouped into the studio room, past the kitchen, bed, and table of the living quarters, they saw her easel, her palette, and the Venice and Rome paintings she needed to finish.

By Valentine's Day, 1886,[4] she had finished six paintings and two sketches, priced them, and showed some at the Ontario Society of Artists (OSA): *Church of Sta. Maria della Salute, Venice* at $20, *Tempus Fugit* and one simply called *Venice* for $25 each, plus two pen and ink sketches, "Venice from the Lido" and "Desdemona's House" ($5 each). Then the Royal Canadian Academy exhibit in Ottawa accepted three others: *Church of the Salute, Venice* ($15); *The Grand Canal, Venice* ($25); and *A Study* ($15). Her prices would range from about $150 to $700 today[5]—obviously the impetus for George to start taking portrait commissions in addition to trying to sell his landscapes and figure studies.[6]

Younger artists began to hear of George's painting group, and inexperienced Frederick Challener (1869–1959) inquired if he might join.[7] After they turned him down, Challener asked to study with George, who took the penniless Challener on for free. When he clambered into the Reids' studio for his lessons, the couple realized that there was a hunger for what they had learned from Eakins and

had viewed in Europe. The idea for a small painting school materialized: they would run it from their studio. Now George let it be known to his friends that he would be taking students privately[8] with Mary as hostess, amanuensis, and maybe school secretary.

2.

MHR's *Still Life with Daisies* sports two pieces of sturdy stoneware: a whiskey jug and a milk jug. Any of her contemporaries could have identified them instantly. The larger, heavy one-armed whiskey jug, its handle like an elbow akimbo, was a standard taproom item. (Though women were hardly forbidden in taverns, it was the men who flocked to pubs to drink the liquor that was brewed just blocks away from the Reids' studio.[9]) In front of the green whiskey jug, Mary paints a tan milk jug frilled with oxeye daisies. Witty, blonde ceramics expert Rachel Gotlieb, curator at the Gardiner Museum, identifies the full-bellied milk jug with flowers popping from its mouth as the whiskey jug's obvious partner, a fertile wife. In nineteenth-century novels and paintings, depictions of crockery were loaded not only with drink and food, but with cultural weight. "Specific objects, especially jugs, were coded by color, size, form, and location to demarcate gender and virtue," Gotlieb explains, while those "filled with food, drink, and flowers signified happiness and domesticity."[10] The buoyant daisies spring straight up on their stems.

That winter, the horses snorted as they swished the sleigh runners of the streetcars through the frozen streets. Cattle

lowed from the stockyard across from the St. Lawrence Market a few blocks away. The iced-in docks of the Esplanade ran along Lake Ontario, its color a steely green under the gray sky. Mary was learning what it meant in Canada to have a painting of a bloom on a wall in a house where windows gave onto earth, dead and dry-cold, scarred where the snow blew, gray where the snow crusted with smoke from the chimneys. A flower on a wall meant a promise in a season when all promises felt broken. Unless she planned all her work in the summertime when flowers were available, she'd have to buy them from the greenhouse and shop of S. Tidy and Sons a few blocks away on King Street West.[11] The following year, she'd offer *Pansies* and *Lilacs* at $25 each and *Yellow Roses* for $30 (the equivalent of about $700 today)[12] at the 1887 Ontario Society of Artists exhibition.[13]

Eventually a pinkness came into the bare branches in the park and cathedral a few blocks east, and with the valiance of anything being born, leaves struggled to unfurl on the maples in the spring mud. Now George was teaching fourteen students and planning an outdoor class. They were living their lives as artists, in a community, making a financially viable married life. They were in the vanguard of a new way to live, a very modern partnership, a team of two talents and two wills.

3.

By the following year, the private classes had grown so large that Mary and George had to look for new quarters, and they found them at 31 King Street East across from a jail.[14] The two painters become a magnet in this new locale (which is now near a subway stop in the heart of Toronto's business district), giving classes both during the daytime and the evening, hosting young artists as well as the serious, professional painters of the Royal Canadian Academy (RCA). Mary was organizing a great many people coming and going from her flat and also managing to get some painting done. (But from a letter she wrote some years after this time,[15] about her inability to combine housework and painting, we know she was not always successful.) In the never-ending struggle for balance in the freelance life, the scale was tipping toward earning a living. But there she was, working on *Snowballs* ($15), *A Hundred Years Ago* ($25), *Studio Interior* ($20), and *The Colosseum, Rome* ($25) (between $400 and $700 U.S. today)[16] to exhibit at the society. In the cold snow-into-mud season of April, letting the muck dry on her boots and on her skirt hems, then flaking it off, greeting and encouraging their students, came her birthday. She was thirty-two, a working artist, showing with men—but at women's prices. And why, like her wifely milk jug, wasn't she pregnant by now?

"The effectual Prevention of Conception is a subject in which everybody is interested," Dr. James Ashton writes in *The Book of Nature: Containing Information for Young People Who Think of Getting Married, on the Philosophy of Procreation*

and Sexual Intercourse; Showing How to Prevent Conception and to Avoid Child-Bearing. Also, Rules for Management During Labor and Child-Birth, his lucid, informative mid-nineteenth-century handbook. "No class of mankind in civilized life desires an unlimited number of offspring; yet Nature has made prevention a somewhat difficult task."

Dr. Ashton endorses withdrawal before ejaculation, and he assures men that they will get used to it, finding it pleasurable: "Persons of energy and resolution can, however, fully accomplish their object in this respect if they will but discard the notion that the delights of sexual intercourse are marred by the withdrawal of the male organ just before the discharge of Semen takes place."[17] He also espouses the cleanliness of this act, detailing exactly how it is to be accomplished, accoutered by a cotton or a linen table napkin.

> I would then suggest to married people the following rule: Always carry to bed a clean napkin, which is to be kept in the hand of the male during the nuptial act. It will then be a very easy matter to place this napkin in a proper position to receive the Semen on withdrawal, at the instant it would otherwise be injected into the body of the female. If you do it at the proper moment, no pleasure is lost to either party; and habit will soon make you expert in this respect.[18]

He reinforces its hygiene, "a great desideratum, as females of any degree of refinement can understand," and assures

readers that "this is the most certain mode of preventing conception that can be adopted."[19]

The pull-out method is still considered 96 percent effective, though it is rarely done completely accurately, so the experience of this rate is much lower.[20] Could Mary always trust George to withdraw on time? "Other plans are sometimes necessary to give the wife confidence, and make her feel sure of success," Dr. Ashton writes, then keeps his promise "to explain as minutely as possible," recommending a large India rubber syringe filled with cold water "or a weak solution of white vitriol or other stringent in cold water, immediately after coition." The syringe, which could be "purchased at almost any respectable drug-store," must be inserted "quite as far up into her person as is necessary."

Ashton details the various spermicidal concoctions that a woman might try: "Solutions of Alum, Sulphate of Zinc, Chloride of Zinc, Sulphate of Iron, &c, will kill the . . . Semen, if injected with sufficient force and profuseness."[21]

Mary would have had to be her own compound pharmacist.

Ashton carefully admonishes that these vaginal cocktails "should be prepared beforehand, and, with the syringe, kept by her bed-side, as success often depends upon promptness in using it. . . . If the woman rises *instantly* and performs the duty, she will probably be successful."[22]

George must be ready with his napkin. And just when she was ready to glide into postcoital oblivion, Mary must be quick to get up.

INTERLUDE

In Bronte, eleven-year-old Mary Evelyn had settled into the rhythm of the farm in summer and school in winter, and the seventh day's hush of activity and family dinner after the long, full service at the Anglican church. The youngest in the household of five brothers and two sisters, prepubescent Mary Evelyn could watch the faces and prayer gestures of her elders as they displayed their beliefs. This was the year that her intrepid brother Horace, who later became a gifted and energetic physician, converted to Methodism.

Within three years, the Wrinch family would divide between Anglican and Methodist beliefs (Leonard and Frank also became Methodists) yet remain together as a family. In the hard-drinking Canadian culture (with its bars, brawling, wife and child abuse), issues of temperance, women's suffrage, health, and religion were merging together. About the time brother Horace was deciding to become a medical missionary, fifteen-year-old Mary Evelyn helped organize a Sons of Temperance concert.[23] But his littlest sister could draw, and making art became a stronger religion.

George Agnew Reid, *Gossip*, 1888,
oil on canvas, 152.4 x 101.6 cm,
Art Gallery of Ontario, Toronto.

Gossip

I.

Mary the registrar. Mary the welcomer. Mary the possible painting instructor. By the spring of 1887, the Reids had a distinguished list of young followers, including C.W. Jefferys and F.S. Challener. They were making a go of the school, allowing George to paint works to exhibit at the Royal Canadian Academy of Art and even at the Walker Art Gallery in Liverpool, England.

Mary the daughter-in-law. Mary the sister-in-law. Mary the Reid family guest. When she and George closed their school for the summer, they repaired to Wingham, Ontario, and the farm of George's crusty father and his sisters Susan and Leticia. Mary merged into the farm-woman summer pattern of doing all the work to be done in the kitchen before the heat of the day: peeling masses of cucumbers for pickling, shelling heaps of peas for canning, stirring pounds of sugar into fruit and bringing it to a frothy rolling boil for jam—sweat running down armpits.

George rediscovered his mother's spinning wheel, and by the end of the summer the spinning wheel bumped along on a horse-drawn wagon to the town of Goderich, then on the train back to Toronto along with George and Mary's clothing and painting supplies, the artist couple themselves—and George's sisters Susan and Leticia as well.[1] George had plans for them that fall. He would ask Susan to model for him, and he would also enlist his wife.

Mary entertaining her sisters-in-law. Mary sorting apples. Mary plucking a chicken bought at St. Lawrence Market. George set up the studio room as a farmhouse, with a wooden bowl and a candlestick on the mantel, and a grandfather clock with a small painting in the background. In the foreground, he positioned a graceful, earnest Susan carding wool, her face turned toward the central figure in the middle of the painting: Mary.

MHR is that lively, dimpled brunette with an intent look on her flushed face, one arm akimbo on her hip, in George Agnew Reid's painting *Gossip*. Capable-looking, unapologetically stopping her spinning for the exchange of a story, the animation of avid interest on her face, she wears a dun-colored farm-woman's housedress with a long white apron as she leans upon the spinning wheel of the mother-in-law she never met. The work portrays women in delicious talk-exchange, and Mary is vivid as the figure of the tattler. Her figure is solid—on her way toward matronly, though that isn't the case in a photograph taken just after this time. It looks like lean Mary took on the role of model-mother-muse—while George, authoritative brother to his

sisters, is the artist-director of the scene, painting her as fecund as a milk jug.

Mary the household manager. Mary the pourer of tea. Mary the shopper, thumbing through the Simpson's Department Store catalog.[2] At the drugstore, women quietly purchased natural dried sponges, heeding yet another birth control suggestion from *The Book of Nature*.

> Procure a fine sponge at a drug-store, and cut off a piece of it about the size of a walnut; then make a fine silk string by twisting together some threads of sewing silk; tie one end of the string to the piece of sponge; wet the sponge in a weak solution of sulphate of iron, or of any of the solutions before mentioned as fatal to the animalculae of the Semen. Before connection, insert the piece of sponge far up into your person.

To accomplish this, Dr. Ashton recommends a "smooth stick of the proper size and shape."[3] Then a woman can let the string hang down so that she can pull it out later, after intercourse. For women able to obtain an American Sears, Roebuck & Co. catalog, they might order a "Ladies Silk Sponge" with a "netting cover" for between 20 and 50 cents, depending on size, and receive this item by mail.[4] Was Mary doing some or none of that, hoping to be a mother herself?

As the cold weather came on, the sisters-in-law returned home.

2.

Mary the welcomer of evening students. Mary waking to the animal shrieks at the St. Lawrence abattoir. Mary at the fishmongers on Lake Ontario, the scales of the small perch glinting. Mary with her leather boots thoroughly soaked from slush and freezing through the long Anglican Sunday service at George's side.[5]

Mary the painter? Absolutely. Somewhere among the school tasks, the domestic tasks, and the wifely support, her small rectangular still life paintings were accumulating. And just like many young women deciding how to sign their names in the twenty-first century, she could not quite figure out her signature. Of the ten works she exhibited in the Toronto RCA/OSA exhibit of 1888, one, *Study of Peacock Feathers*, was signed "M.A. Reid"—Mary Augusta, the two names of her childhood. Another, *Daisies*, she signed "Mary H. Reid," sneaking in the initial of her maiden name. Then for the eight other paintings, she used "M.H. Reid."

Mary priced her fruit and floral works to sell: three different paintings titled Roses were listed for $15, $30, and $45. When she sent *The Guitar Painter* to be shown in Montreal, she upped the price $5, sending it along with the $15 *Roses*. Her domestic tasks wove into the paintings. In spring, she looked for daffodils—perhaps even swiping some from the St. James Cathedral grounds nearby—and priced her painting *Daffodils* at $25. In May and June, there were roses to be cadged perhaps from the gardens of friends.

But she had exhausted this backwater. Even George,

who felt Toronto was home, knew that he had to break out of the provincial ways of seeing. They had promised themselves to study in Paris. At the age of thirty-four, Mary was ready to make another move.

After almost three years of engagement with their students and a thriving private school, they dismantled all those relationships, ready to give up their studio, suspend their friendships, take a sabbatical leave. Down the street, at 57 King Street East, were the showrooms of an art dealer, Oliver, Coate and Company.[6] They approached Coate for a joint exhibition in which they hoped to sell nearly every painting they had. If they made enough, they could get back to Paris, perhaps for an entire year, to study, to paint, not to have to divert energies to their bright amateurs, but to absorb new lessons for themselves. In a move something like a Kickstarter campaign, Mary lowered her prices and sold off her floral studies for prices as low as $1.50; the highest price was $16. She contributed $107.75 to the $1,900 they accumulated to finance their year—a mere 5 percent of their budget.[7] That was, in social terms, about the percentage of political and economic rights that she had. Nevertheless, the industry with which she worked and the intensity she brought to the palette drove her to bring in her part. Both she and George kept careful track of their sales, jotting down in pencil the price after each work sold.[8] With anticipation, they transferred their students to the recently formed Toronto Art School,[9] then packed their trunks and saw them loaded on the train to New York where the steamship would be waiting.

She was in motion again.

INTERLUDE

Because we had to tell each other the stories of our lives
when we met again, and because we were each in psycho-
therapy, Mike and I began to joke that we'd been examin-
ing our lives for a combined third existence. We pored over
each other's motives, choices, and mistakes, fascinated by
how our lives had unfolded over the two decades when we
knew nothing about each other. It turned out that we mar-
ried for the first time in the same year, then both divorced
exactly six years later. We could see lines extending from
our adolescence through cities and landscapes to Mike's
house in Ontario and my apartment in New York. My
mother, then my sister both became ill and died in these
first years of our marriage, compelling me to ponder the
shapes of loved ones' lives as well. My mother's death felt
as if the pencil that began to draw the contour of her life at
birth had suddenly lifted from the page. Her time on earth
had been delineating a shape. At death, her time's contour
was completed, becoming space. The line for my sister's life,
cut short from throat cancer, felt somehow as if it drew an
incomplete silhouette. I wrote a memoir, tracing the shape
of a woman's life in time as she ponders, again and again,
whether to have children. I say "a woman" when the subject

is me, of course, but a memoir reveals you as a separate figure of yourself. I began to show drafts to Mike. And he began swapping them for his articles-in-progress. Soon we were both reading one another's work and responding to it.

"But exactly when did such and such happen, before, after what year?" he would say. His questions began to pin my thinking down. I'd been used to considering life in terms of instances and imagery (the stuff of poems). To fasten it down to actual dates put existence in the context of history. Time and place whittle character as well as perceptions. He would come in drenched with sweat from training for a marathon, while I was writing and making breakfast in my bathrobe, to ask his gentle, curious questions—ones I'd never have asked myself. Earlier in my life, I'm sure I would have felt his who-what-when-where-why queries threatened or jailed my vision. But I'd had decades to develop my powers of invention and be rewarded for that, too. My trust in my imagination was as rooted as an oak. My husband's curiosity put the oak in an ecosystem.

We were over forty-five, with full careers in separate countries. How were we going to juggle it all? I had to get practical about earning money. I had hardly any financial inheritance from my mom, but I did have a legacy of both my mother and grandfather as small (very small!) and extremely independent-minded business owners. What if I set up a kind of poetry studio? I began teaching poetry techniques one on one—mostly on the phone. I loved it and was lucky to be well-known enough that poets in America and Canada reached out to me to learn fascinating, arcane, prosodic techniques. I lived in a wilderness of

sonnet structures, triolets, line breaks, and rhymes. I was not a famous poet, simply a known poet, and at my best a poet's poet. When I discovered that the Reids did private teaching, I recognized something about the rewards—and the setup. The gathering of students, being a one-woman administrator, finance director, human resource coordinator in the tiny, intensely satisfying world of imagery and verbal leaps. Independent teaching let me design my life around my art and my marriage. I worked, wrote, cooked, gardened, exercised, socialized all at home, two homes, a rent-stabilized apartment in New York and a house in Canada. Work and domesticity were inextricable, and so was travel. I traveled continually, giving readings across the continent—and all this under the transparent silk umbrella of our marriage.

PART FOUR

Paris

Eugène Grasset, "Juin," from Calendrier
La Belle Jardinière, 1896, Paris.

CHAPTER TWELVE

City of Flowers

I.

Paris. Late June, 1888. 65 Boulevard Arago, Cité fleurie. A tiny artists' enclave in the fourteenth arrondissement: creamy stucco buildings with an echo of Tudor-style architecture, only about a decade old, constructed around a central garden, covered in greenery—a little city of flowers. Their lucky place, later home to Gauguin and Modigliani,[1] still stands near the Latin Quarter, still home to visual artists, still leafy, and still several blocks away from a scene of its opposite: the thick brick walls of the infamous La Santé Prison. There, the incarcerated poet Guillaume Apollinaire (1880–1918) would write his poem "Á la Santé." The second section begins "Non je ne me sens plus là / Moi-même": "No, in here I no longer feel / myself."[2] But in the Cité fleurie, MHR became more herself, an independent artist in the company of other artists, with her first taste of the affirmation that an art colony can provide.

Her atelier was positioned off the inner courtyard, the kitchen, and studio/living quarters on the main floor. On a

second level, over the kitchen, was the bedroom where she woke to the sound of splashing water from the courtyard fountain. Below it, in the studio dining area, stood a massive fireplace with thick, heavy andirons and a copper brazier. Occupying one whole wall, the fireplace was George's inspiration and Mary's problem. George set up to paint it as a symbol of creative energy—with Mary as model-muse. However, his model-muse was still figuring out how to cook in that giant thing.

He angled her as his subject, seating her before a fire that burns just outside of the right-hand border of the canvas. Mary is settled on a stool, wearing a long white apron, as if she had taken a break from housework—or painting. She slants engagingly toward the fireplace, as if she is speaking to the fire. Relaxed but intensely focused, there is about her figure the sense of a quiet, long-burning flame—not mercurial but steady, as her personality seemed to be. She both leans dreamily, inclining toward the heat (and the danger) of a future, and rests inside the state of reverie that is so conducive to the making of art.

In the painting, Mary becomes a woman with a dream, worked in oils by a man with a dream, who titled the work *Dreaming*.[3] In the complex interaction of Mary both as subject and wife, George acknowledges her longings even as she channels his own. He designed the composition; she, as the model, determined how her muscles and spine would maintain the pose—even as her stomach gurgled.

In practical terms, Mary learned about the French coke stove. Porous, gray coke, from coal fired in ovens (like charcoal briquettes), was used for fuel in small domestic stoves

because it was relatively smokeless.[4] If only she had a coke stove she could turn to for the practicalities of cuisine, she could let that enormous fireplace be a pure symbol.

2.

Students from North America venturing to Paris for limited periods of time, not intending to take rigorous entrance exams for the École des Beaux-Arts, gravitated to two alternative art schools, the Académie Julian and the Académie Colarossi. When Italian sculptor Filippo Colarossi launched his school at 10 rue de la Grande-Chaumière in the sixth arrondissement, he allowed his female students to draw and paint male nudes.[5] While George enrolled at the more established Julian, quite a trek from their studio, Mary chose to take her classes separately and conveniently nearer at the Colarossi. She took the path of Camille Claudel (1864–1943), Rodin's student, assistant, and beleaguered mistress, who attended the Colarossi from 1881 to 1883;[6] later, the tragically short-lived Jeanne Hébuterne (1898–1920), Modigliani's muse, and iconic Canadian painter Emily Carr (1871–1945) would study with Colarossi.[7]

Like the Eakins years at the Pennsylvania Academy of Fine Arts, the Colarossi was fraught with sex and, much later, a destructive act of vengeance. Looking for scraps of information on the school, I went with my husband to the Paris apartment of American scholar Gabriel Weisberg[8] and his wife Simone, a Parisian. The gracious and affable Weisberg led me to a brief correspondence with a

descendant of Colarossi, Christophe-Emmanuel Del Debbio. Both men affirmed Filippo Colarossi as a notorious philanderer (giving the progressive idea of admitting women and allowing them to sculpt and paint male nudes a salacious edge). His school lasted until the 1930s, with Paula Modersohn-Becker, Dod Procter, Paul Gauguin, George Grosz, Amedeo Modigliani, Charles Demuth, and Lyonel Feininger among its students.

Then, in an act of matrimonial retribution, Madame Colarossi burned all the paper records of the school, and up in smoke went any documentation of painters like Mary Hiester Reid.[9]

Burning records. Burning ambition. Burning food. It would be a lot easier for Mary to finish her art education and really start on her life's work if at last she found something to cook on, or something she could ask a servant to cope with, rather than reenact the fireplace scorching from her grandmother's day.

3.

In the Cité fleurie, a quiet figure with a pince-nez who went back and forth beneath the leafy vines to his nearby atelier had a coke stove for sale. This man with the mustache and bushy eyebrows was Eugène Grasset (1845–1917), the father of Art Nouveau. As a young man in Switzerland, he became the companion of a French sculptor whom he had followed to Egypt. There Grasset obtained work as a wallpaper designer. When he later moved to Paris, the designer applied

his patterning skills to another paper art: posters.[10] All things made from les papiers (so fragile, so burnable as the Colarossi alumni discovered after Madame Colarossi torched the files) lured him, including the ukiyo-e prints that also entranced Mary. "These are the friends of my solitude and my work," Grasset said to Arsène Alexandre on the art critic's visit to the small room off the designer's studio in the Cité fleurie. The room was "a place of delicious severity"[11] where a collection of his favorite poetry books and albums of Japanese prints, especially by Hokusai, were impeccably arranged on a shelf Grasset had made especially for them.

Mary's studio was makeshift and rather messy, with copies of unframed artworks slapped on the walls. And she still needed to cook, at least sometimes. That crisp-crusted French bread she had never before tasted in her life she could always buy, and they could always grab meals at those new-style brasseries, but how about a simple stew to come home to?

Learning from his ukiyo-e prints, in an era where French fascination with Japanese culture led to a new word, japonisme, and "a dense brew of appropriation, commerce and respect,"[12] Grasset had inaugurated his new poster approach. He used flattened areas of color as well as curvilinear, organic lines in his advertisements, and then in the magazine covers he designed. This novel style became known as New Art (Art Nouveau), with modest Grasset as its unlikely patriarch, generating the iconic decorative, commercial emblems of the belle époque.

In the photograph of her cluttered studio in the first chapter of this book, where Mary holds not one but five

brushes with her palette, in an actual working environment that was also a home, her ambition is to paint works to be shown in galleries. Her goal is to submit to juries, to be accepted into exhibitions. That she mustered the self-esteem to do it, or that her talent simply was so forceful in itself that she had to do it, is at once obvious from her output—yet also a mystery. But the place of her art remains consistent: her studio was always at home, and her painting always mixed with domesticity.

Blurring the distinction between high art and the decorative art of the home, Grasset not only dedicated himself to décor but did it for commercial gain—as any-one who, even today, has ever bought a calendar or a birthday card or an apron with his images of the months knows.[13] Grasset's illustrations for *Les Mois* advertised one of the first shops in Paris featuring ready-to-wear women's apparel, La Belle Jardiniere on the Île de la Cité. Each month's panel features a fashionably dressed sylph attempting a garden task among seasonal blooms.[14] "Juin" contains a basket of the iconic roses his neighbor Mary would later paint again and again.

The stems and leaves that Mary painted with such per-sonal feeling were what her neighbor Grasset stylized. Their interests crossed in a lattice of common engage-ment, as ornament and art mixed—from ukiyo-e prints to stoves, from vines to flowers growing in their Cité fleurie courtyard. Captivated by the shapes of tendrils and blooms, Grasset would go on to write *La Plante et ses applications ornementales* (*Plants and Their Application to Ornament*). For him, nature became appealing when it suggested patterns

that could be employed in creating human environments: fabric, wallpaper, the decorative arts. "In reality," he said, "what interest is there in slavishly copying nature? The artist's efforts are in vain if he spends a great deal of time representing an object as it is. It is pointless."[15] Mary, who was lovingly reproducing the subjects of her still life painting, might not have agreed on that point, but she shared with him the romance of the Japanese lines, and a neighborly give and take. The stylized tea roses in the basket of the young lady in Grasset's illustration "Juin" show how all but the isolated image drops out of the viewer's sight. When MHR went back to painting roses, she, too, would drop unnecessary naturalistic detail to allow a focus on the flower as a personality, the flower-women she created.

In that photograph, Mary wears a dress with lace cuffs and hem that match the collar, a bow flowing down the whole front of the outfit. Nothing to say for absolute certain that the dress was bought as French ready-to-wear, but the woman with the long nose and mild eyes wears it trim and well. What is her relaxed mouth contemplating? Perhaps it was simply what's for dinner. For, as neighbors do, Mary had discovered that she and Eugène had practical matters in common. When she learned he had a coke stove for sale, she snapped it up.[16]

<p style="text-align:center">4.</p>

In the fresh mornings, she skimmed into the Colarossi studio for the costume and life classes, contending again

with the figure, and concentrating on the textures of fabrics and clothes. For Mary, the Colarossi was like graduate school, and the city of Paris a different kind of tutelage: restaurants, hotels, sumptuous department stores to which one could take a fiacre, a horse-drawn two-seater carriage, precursor to the taxi. Concerts, ballets, wines, pastries, the neighborhood brasserie where even a couple of North Americans on a budget could eat crisp frites at any time of day. Paris teemed with people from all over Europe, and she could almost pick up instruction on how to live from the air.

In the afternoon, George left the Julian, walking the twelve or so blocks from 31 rue du Drago[17] to join his wife in the life classes at the Colarossi. By now the couple had a routine, and maybe some light domestic help to sweep, clean, carry water, lay the fire in their studio. Separate schools allowed them to go their own ways for part of the day. Their daily divergence reinforced a special combination of adventure and security, a parallel order. When George joined Mary at the Colarossi, she had his company and his enthusiasms, his competition and his collegiality. A small man, he occupied a big space.

She must have given up hours to sit for George's painting *Dreaming*. He submitted it to the 1889 Salon as *Revant*, and the salon accepted it. Then, after its debut, the couple shipped the work across the Atlantic where it was bought by the Royal Canadian Academy.[18] Not an image *by* Mary, but instead an image *of* her would hang on the walls of the National Gallery of Canada, a woman

bent away from the viewer toward the fire, a figure leaning toward the flame of her husband's imagination.

<p style="text-align:center">5.</p>

By Christmas 1888 the tour Eiffel had risen far beyond the second floor, and by March of 1889, when it was completed, a lightness and sureness of technique had begun to enter Mary's hand. That year she produced her own fireplace painting, not calling it *Dreaming* but, in counterpoint to her husband, *Waiting by the Fireplace*, a painting now in private hands. In this early work the thirty-five-year-old MHR plunks the hearth smack in the center of the canvas, next to an empty leather-backed chair. A woman in turquoise satin faces both the masculine chair and the fire. Through a curtained threshold, mirroring the arc of the top of the carved fireplace, lies a deeper, shadowed room. The composition is staged and painted stiffly. But in the folds of the dress and in the swag of the curtain, you can see what MHR was learning in the costume classes at the Académie Colarossi—even in a reproduction. The formally dressed woman, hair piled up in the kind of arrangement that requires a personal maid, waits until someone or something arrives to animate her existence. For whom does she wait? A lover, a husband, a child, a friend, a servant, the dead? It's not a mistake to assume that Mary spent a great percentage of her time waiting for George and even waiting for her bread to rise.

But killing time is not only a state to chafe against. Waiting mixes boredom with anticipation. Hanging around gives a person solo fantasy time; its meditative space clears the mind for inspiration. Lingering can allow an opportunity to center; or it can be as heavy as the coke stove that Grasset sold her. Like that stove, waiting has a fire inside it, and with this early painting we have from MHR's hand,[19] she begins her emotional record-keeping. In portraying the very state of being unproductive, Mary breaks out, going forward into a terrific productivity.

On May 6 the Exposition Universelle of 1889 opened, one of the only world's fairs to make a profit, due to the success of the tour Eiffel.[20] "All the cutting force of the wind passes into the interior of the leading-edge uprights. Lines drawn tangential to each upright with the point of each tangent at the same height, will always intersect at a second point," Gustave Eiffel explained of his construction. Tracking the education of an artist has about it an element of architectural construction. "Before coming together at the high pinnacle," Eiffel said of his work, "the uprights appear to burst out of the ground, and in a way to be shaped by the action of the wind."

As I have watched Mary's life being built, or perhaps watched her as the unconscious architect of her life through her paintings, I realize I've been following the thrust of her innate gifts, both with and against her times. Suddenly, Eiffel's description of his tower applies to an ambitious individual learning her craft. The "cutting force" of her experiences "passes into the interior." "Lines drawn tangential . . . will always intersect at a second point." The lines that were

drawn in Paris will come to intersect at a second point, and at points thereafter as MHR's still life paintings thrive. Belle époque Paris was her education before her "high pinnacle," before she transmuted that waiting figure by the fire into the living flames of roses and chrysanthemums that appeared to "burst out of the ground" of her painting—just as her life continued, in Eiffel's words, "in a way to be shaped by the action of the wind."[21]

INTERLUDE

The MacDowell Colony was the brainchild of Mary's contemporary Marian MacDowell (1857–1956), wife of the composer Edward MacDowell (1860–1908). She bought Hillcrest Farm in Peterborough, New Hampshire, and built her weary and subsequently ill husband a cabin in the woods in which to compose, most famously the song "To a Wild Rose." As Edward's illness progressed, Marian fundraised for more studios to make a legacy for artists—the seeds of the venerable art colony institution MacDowell is today.[22] I was twenty-six when I arrived in 1975 to try to finish my first book of poems. I did not realize that this ample woodland acreage dotted with studios for writers, composers, and visual artists was the brainchild of a nineteenth and early twentieth century contemporary of Candace Wheeler. Because of the zeitgeist that allowed these women (and another, Katrina Trask, who founded Yaddo) to create such environments, working-class girls from public universities like me were able to declare that yes, I belonged in such a place because we'd been judged worthy. There I met extraordinary poets of my own generation who were publishing and winning prizes. I didn't even have a book yet.

The sheer validation of carving my name on a wooden plaque in Edwin Arlington Robinson's studio, of hearing the thunk of a lunch basket delivered to my Dutch door, the top open to a view of Mount Monadnock, the piney smell of the kindling next to the fireplace, the braided rug, the piano. What Marian MacDowell understood was that a baby poet like me required space. I was given a whole month in a studio about the size of the entire little house I grew up in, the one where my alcoholic father, a World War II veteran who returned with PTSD, continually threatened my mother with physical and verbal abuse. It was also the box-like suburban house from which my beautiful little sister, who later became a heroin addict, got deeper into trouble while I was absorbing the inspiration of poems by Bashō, Buson, Issa, and Shiki. They were the Japanese haiku poets I loved instantly when I met them at age twelve, thanks to Mrs. Baeumler, the teacher who took me aside. The haiku poets were my version of Mary's japonisme. Those poets found beauty in the tiny. Their unattributed translations now raise issues of cultural appropriation, but those anonymous translators gave me the gift of their tradition. Their three-line verses introduced me to a stillness I could then find in the midst of a father crying and screaming, a sister cutting school, a mother's eyes shutting down like blinds turned to deflect a harsh sun. Asian word-makers from previous centuries embraced individual moments of noticing, even noticing a spider—or, in my case, a chameleon I won at the county fair, sunning its green self on the windowsill as my family collapsed.

There was tremendous pressure at the art colony to produce—wrong. That was my internal pressure. The colony never required me to report. At the dinner table, the then elderly composer Louise Talma told a story about a girl who had come up to the colony from New York City frazzled, exhausted, and blocked. Talma said that Marian MacDowell took the girl aside and explained that if all she did in thirty days was examine a single leaf, she would have done her work—and spent her time richly.

Mary Hiester Reid, *Studio in Paris*, 1896,
oil on canvas, 25.6 x 35.9 cm,
Art Gallery of Hamilton.

Studio in Paris

I.

After paper images of kimonos and umbrellas, curvilinear rooftops and kites, cherry blossoms and snow endured their transit, they found their way into the gloved hands of collectors who slipped them beneath mats and inside frames. Once so rare, the ukiyo-e prints that entranced not only Grasset but Whistler, Degas, Van Gogh, and Toulouse-Lautrec now piled up in the shops that sold engravings on the rue de Seine.[1] In xenophobic admiration, Parisian collectors deemed them folk art: feats by so-called unschooled savants named Hiroshige and Hokusai. Despite the observers' bias, the ukiyo-e works conjured up what all fresh visions do: worlds that did not exist before they were imagined. Playfully the Japanese geniuses suggested volume by color and implied contour simply by angling lines to reveal surprising viewpoints. The prints dear to Mary and Grasset had become so influential that the Académie Julian was preparing to mount a show of japonaiserie.[2]

A group of young painters at the Julian, among them Pierre Bonnard (1867–1947), were coalescing around a new idea of painting that combined japonaiserie with Gauguin's influences (who studied, as MHR did, at the Colarossi). They called themselves Nabis (from the Hebrew nahbi, meaning prophet), and they included Édouard Vuillard (1868–1940) and Maurice Denis (1870–1943). Les Nabis were embracing the idea that color alone could create shape and volume—intensely patterned color. "Before a painting is turned into a battle horse, a naked woman, or becomes any sort of trivial detail," Denis maintained, "it is essentially just a flat surface covered with colors that are assembled in a certain order."[3]

These radical ideas, precursors to twentieth-century abstraction, swirled around George, yet somehow, at a twelve-block distance, it was Mary who seems to have absorbed some of the Nabis's embrace of interior rooms and women at work. Her husband, painting directly from the figure, maintained his unshakeable commitment to narrative and storytelling, and he refused to engage with the Nabi ideas.

Like many creative people, perhaps especially those with fragmented lives full of demands, Mary operated in imaginative slow time. The images she saw in Paris stayed with her for the next seven years. Nabi works, perhaps like Édouard Vuillard's of his mother and sister, with their multiple textiles, or like Pierre Bonnard's sunlit rooms, seemed to lodge in her, only to surface the next time she returned to Paris in 1896 (not to mention years later when she began painting interiors of her own Wychwood Park studio and dining room in Toronto).

Studio in Paris is one of Mary's lusciously small interiors. Scholar Janice Anderson, whose dryly witty feminist observations have introduced so many to the variety in MHR's work, observed that *Studio in Paris* is one room into which the viewer is *not* invited.[4] The bed, the chest, the chair, the pile of books are entirely personal. That chair is like the seat of the imagination, upholstered in green and red. If you sat in it, all you'd have to do is reach around for a book, your cup within grabbing distance. The daybed with its pillows and tapestry cover lies a couple of feet away. It's your nook, your corner. And a corner is a "chamber of being," as French philosopher Gaston Bachelard writes.[5] (I can't imagine that Matisse ever saw Mary's work, but they share the use of scarlet to portray the studio; there's a bit of her red in his 1911 *Red Studio*.[6]) What is safer than the crook of a spot from which one can regard the world? This corner is like a nest in a junction of two walls. In a small painting like this, Mary's angled chair creates a corner within a corner, safety within shelter, imagination tucked inside ruddy well-being.

Bachelard blurs high art and design as he veers his thoughts from household objects to poetry. In fact, he unites poets and phenomenologists in his psychological observations of the correspondences between humans, architecture, and visual objects. (For Bachelard, a basement is not merely the foundation of a house but the unconscious.) Home design brought new vectors of energy to the likes of the Nabis and Eugène Grasset. Bonnard declared, "I myself shared the opinion that artists should produce works which the general public could afford and which would be of use

in everyday life: prints, furniture, fans, screens, and so on."[7] Back in North America, Mary would flirt with decorative art, painting a mirror frame with peacock feathers cleverly reflecting the images of those who preened before it. (The mirror is still in the foyer of the house George built for them in Wychwood Park, and as a woman named Peacock, of course I looked in it.) Paris life in Cité fleurie seemed to allow Mary, as if in a fairy-tale, to pass through a mirror into her own ambitions.

2.

By the time of the Exposition Universelle, the "floating world" prints had become so affordable[8] that Mary could buy one. From images of courtesans in silk kimonos and rice-paper-screened rooms, she selected a gray-kimonoed seated male kabuki figure, probably by one of the artists signing as Utagawa Kunisada (1786–1864).[9] Unlike the woman in *Waiting by the Fireplace*, whom she faced away from us, the kimonoed man sits head-on. She copied him into at least two of her works, a man in silks with the distant energy of a gray rose. Her print had traveled far to get to her, and she had steamed across an ocean to discover him. When it was time to leave Paris, she would bring him back home with her to return in her still life and interiors as well as in a later photograph. The Kunisada gray man, like a long-time lover, occupied a permanent place on her mantelpiece.

We sense a life in objects as they inhabit time—or as time inhabits them. Domestic objects and art objects

peering from our walls seem to have "seen" things, or at least absorbed hours, events, and the personalities of people simply from having been in their presence, sitting ignored and dusty or dusted and touched on shelves or mantles. Especially if one has not owned an object from its creation, one can feel that the object has had experiences that we have not and never will have. It mutely brings a world we can never know to us.

INTERLUDE

Though today we think of empathy as a particularly human emotion, the nineteenth-century Empathists easily extended the notion of feeling to objects. For thinkers such as Theodor Lipps, projection was a union with the essence of another, even the essence of an object. If we connected with "an architectural column," we would feel its "dynamic properties."[10] Aesthetically, empathy allows our emotions to go outside us, and also to let the world into us. This back-and-forth experience of "an objectified self" allows a complex perception of the greater environment. The German Romantic poet Novalis, who felt that when we mix with nature we recognize "the nature of all things," was deeply familiar to the thinkers of this golden age of art history, and certainly to Robert Vischer, who coined Einfühlung. Robert Vischer's father, the novelist, playwright, poet, and philosopher of art Friedrich Theodor Vischer, wrote a novel called *Auch Einer* in which objects have lives of their own, refusing to function just when needed. That novel is the source of the expression Die Tücke des Objekts (the malice of objects). The Vischers' ideas about objects passed on to Theodor Lipps, to Alois Riegl, to Sigmund Freud, on down to phenomenologist Gaston Bachelard, whose classic *The*

Poetics of Space investigates both architectural spaces, such as attics and basements, as well as objects of interior design, such as those furnishings Mary would be drawn to—drawers, chests, and wardrobes. For someone who, as a woman, was objectified in general, and who played roles (a farmwife gossiping, or a woman dreaming) that made her an object in her husband's paintings, Mary took a deep, reverse pleasure in items of décor.

Designer Candace Wheeler was a queen of domestic objects from pillows to drapes to lamps. By the time Mary was living in Paris, Candace had raised and settled her children (and buried one); she'd made a solid marriage with her husband Tom, and she'd created a design enterprise of lasting influence. But something was missing from the socializing and deals and deadlines that is the work of the interior decorator. Seeking an escape, she turned to the landscape of her childhood on a farm just outside Delhi, New York, in the foothills of the Catskill Mountains.

She and her brother Frank Thurber began excursions to the Catskills, hunting for "a height from which there was a great outlook, yet with a close and rugged surrounding of trees and rocks, where we could build a camp or cabin and live a wild life for a few summer weeks."[11] Eventually, they found a farm in Tannersville, New York, that her brother bought the day they saw it. There they built their rustic cottage dream houses, Pennyroyal for Candace and Lotusland for Frank, on land where the Munsee-Delaware, Kanien'kehá:ka (Mohawk), Mohican, and Haudenosaunee (Iroquois) Peoples[12] once hunted game. Pennyroyal, which still stands (Lotusland was destroyed by fire), was furnished

"with twig furniture made by local carpenters."[13] Candace's daughter Dora painted portraits of family and friends directly on the walls, including a portrait of their frequent visitor Mark Twain.[14] For the next three years, they camped in their summer paradise, bringing up water by oxcart and storing food away from foraging black bears.

Then the solitude of just a sister and her brother plus their families summering in the Catskills paled—what about a group in such seclusion? By the summer of 1887, Candace Wheeler hatched an idea with her brilliant sister-in-law Jeannette Thurber, the founder of the first music conservatory in New York City.[15] "It entered into our minds," Wheeler wrote, "to buy the mountain, and the farm sloping eastward to which it belonged, and bring some of our friends to build homes and share permanently with us the joys of solitude."[16] They decided to found a summer artists' colony on this land where they and others could, according to the simplest principles of design, without formality and social stricture, live their wild life. The members on the mountaintop would live without even digging wells, but instead bring up river and lake water for cooking and bathing. They called their colony Onteora (Hills of the Sky), in an appropriation of a Lenape name from the Delaware People.

In January 1888, Candace's brother Frank bought a 458-acre farm, formed a development group with his childhood friend Sam Coykendall (who had become president of the Ulster and Delaware Railroad that had a line to Tannersville, New York), Coykendall's son-in-law, and Candace's husband Tom. They called it the Catskill Mountain Camp and Cottage Company and began laying out building lots,

planning roads, and designating trails. Candace Wheeler's son Dunham designed the first three cottages and an inn that the group called the Bear and Fox.[17] Because of the capitalists financing Onteora, accommodations between the artistic nature of the colony and business interests created anomalies from the beginning. Frank Thurber hired a French chef at the Bear and Fox (the cottages on the colony campus had no kitchens),[18] and his sister Candace was involved in all the design details, including the rustic denim tablecloths and the blue denim uniforms on the waitresses.

George Agnew Reid, *Mortgaging the Homestead*, 1890,
oil on canvas, 130.1 x 213.3 cm,
National Gallery of Canada, Ottawa.
Royal Canadian Academy of Arts diploma work,
deposited by the artist, Toronto, 1890.

CHAPTER FOURTEEN

Angry Mary

I.

November 1889. No omelet or foie gras or baguettes—
Mary had returned to the fried eggs, bacon, and oatmeal
of Toronto. She'd stopped that October in London to visit
the galleries and pack into her memory all the images that
she could contain for later—but now she looked for new
studio space on streets where the ice was already freezing
in the wheel ruts. Just beyond the new department stores
of Eaton's, Simpson's, and the Golden Lion, a bit of a lift:
a smidgen of Europe on Yonge Street near Temperance
Street, a glass-roofed, cast-iron galleria called the Arcade.
The Arcade was a little like a greenhouse, capturing the
sunlight that a cloudy-gray city hungers for. With a cen-
tral arch and an interior balcony, its main tower flanked by
two smaller towers, the building bubbled with commerce
and art. Visitors and tenants basked in the three stories of
sunlight cascading down the 120-foot gallery.[1] Above the
boutiques on the first and second floors were a number of

third-floor artists' studios, placed to take advantage of that light. Mary and George rented two large rooms.

2.

> Likewise, ye husbands, dwell with them according
> to knowledge, giving honor unto the wife, as unto
> the weaker vessel, and as being heirs together of
> the grace of life; that your prayers be not hindered.
> (1 Peter 3:7)

Through the rustle of the women's dresses and the slap of men's leather boots on the cast iron floors came the rattle and ping of Mary's "copper and brass pots, vases and trays"[2] lugged up to the top floor of the Arcade building along with her Florentine mirror and marriage cassone. These vessels had sailed with her, and now she would paint them as emblems of the weaker vessels that Christian churchgoing wives were well known to be. She was back in tightly scripted, Sunday-service Toronto, and she had work to do: another studio-cum-household space had to be set up.

And upset.

On the top floor of the Arcade building, George Reid was deciding that their two-room studio couldn't possibly provide enough space for two painters and two bodies of work. He stalked off to convince the trust company that owned the Arcade to rent him the inaccessible main tower for $5 per month, heated, *if* he could build a staircase to it. He found a ready-made staircase for sale, hired carpenters

to help him install it, hung doors, and prepared a huge studio that could be used for his autobiographical and narrative paintings.

<div align="center">

3.

</div>

With resolve, a person can institute new habits after travel dislodges the old ones. But Mary's lessons from Paris threatened to evaporate in the wind of everyday interruptions: her husband's renovation of the tower studio and his gigantic new painting, *The Story*. She hastily wrote out the invitations to make a party for this painting, featuring four smaller boys raptly listening to an older boy in a hayloft, just before they packed and shipped it to the Paris Salon.[3] They had to celebrate—George had just sold *The Story* to Sir Edmund Osler for the then fabulous price of $1,000 (about $30,000 today).[4] After it returned from the Salon, it would hang in Osler's collection. Though Mary hoisted up her hostess role again, somehow she got her own work done—with a comic view of her obligations. No picture shows her laughing, but this woman was capable not only of entertaining but being entertained. Her laughter is mentioned again and again by Muriel Miller as she probed both George Reid and Mary Evelyn Wrinch for scenes from their past. Both of them, in the 1930s, must have described the throaty chuckle that somehow signaled a refusal to take the social detritus of everyday life too seriously.

Mary held to her Paris lessons—with a newly acquired Gallic shrug?—as, after she hosted *The Story*'s big farewell,

she entered her own painting, *From My Window, Paris,* for the sixtieth annual exhibition of the Pennsylvania Academy of the Fine Arts. Then she finished eight works that she would exhibit the following year, not only at the RCA and the OSA but also at the new Toronto Industrial Exhibition. She upped her prices with a mercantile flourish: *Before Communion* and *Panel of Roses,* priced at a tenth of George's astronomical sale.[5]

4.

Just as he had done in their King Street studio, George built a replica of his setting in the tower of the Arcade as a backdrop for his painting. He was going to resuscitate another scene from childhood. Earlier, he had erected a scaffold across the front window of the studio, improvising a loft where he pitched hay, actually staging a barn for *The Story.* Now in part of the space below the ersatz hayloft, he replicated the front parlor of a farmhouse (the "best room" where guests were entertained). His setup for *Mortgaging the Homestead* (depicting what would become an iconic Canadian scene where a father is forced to mortgage a family farm) needed seven models. The figures in the painting play off those in George's family. At the table, a father signs papers in the presence of an intruding banker while his son, head in hands, looks on; bewildered and anxious grandparents cower at the edge of the canvas; a little sister plays on the floor looking up

at the serious adult scene; a mother, a dour farm woman, holds a baby, front and center.

"Oh, that's Mary,"[6] art historian Brian Foss said to me over lunch in Ottawa as we dove into a baked Alaska. Bearded Charles Hill, former curator at the National Gallery, earrings twinkling, agreed. Together these two individuals share a deep commitment to the history of art produced above the 90th parallel in Mary's time. The farm woman in a rose blouse who stares out directly at the viewer from the same table where the banker prepares his papers has MHR's hairstyle, face, and figure.

There she was modeling again, but for a more painful role. Now George, with an energetic and expert realist's technique, has cast his childless wife as model for a mother, reenacting psychological layers of family drama in a powerfully imagined scene. The son, with his head in his hands, looks on at the table adjacent to his mother, watching his father sign the banker's document, their lives about to change. The disgruntled mother and wife of the signer, modeled by Mary, holds her child in exhaustion. Mary's acting skills (combined with George's casting and direction) are shockingly impressive. Once she beamed and bubbled in his domestic comedy *Gossip*, then leaned in a reverie in his romance *Dreaming*. Now, she presses her lips in set-jawed shame, sharing her disappointment in her family having come to signing away their property. She is the only character to look out at us, her audience, turned away from the anxiety of the elderly couple at stage right, the security of their old age vanishing.

Mortgaging the Homestead is a painted story of a real-life shame that was averted for the Reids. The actual homestead, though it came to be endangered with George's father's financial difficulties, was never mortgaged. It was salvaged by George's brother John, who went to work on a neighboring farm for necessary income. (And while John rescued his father, George abandoned him for art.) The work illustrates a fear, not an autobiographical event. "My intention was to represent possible events in life as realistically as I was able," he wrote in an essay describing his painting process, "The Evolution of Two of My Pictures." "It was my wish to direct attention to mortgages, . . . immediately after the heartrending stories of the sufferings of the Dakota farmers." After describing the adult sympathy behind the painting, he went beyond his social and political concerns, into his childhood shame.

> But it may be necessary that my earliest acquaintance with mortgages was in my youth, when the burden of one limited my life. When I learned of its existence, some cherished hopes seemed to have gone forever, and the homestead changed its character. At that time, in my mind, shame as well as misfortune was connected with mortgages, but when I became better acquainted with conditions, I saw that the worthy as well as the shiftless and profligate were being swept into the vortex of debt.[7]

George depicts something that came close but did not actually happen, though the feeling of shame for his father's difficulties, and the judgment of the family as "shiftless and profligate" stung decades later. He worked the painting beneath a scrim of guilt, as if it were an imagined consequence of his decision to leave the farm to become an artist. Artists, like debtors, are branded shiftless and profligate. Yet George was brave enough to commit his emotions to paper, to publish them for all to read, and to explore the reasons why his fame as an artist came from depicting the very life he left.

Then *Mortgaging the Homestead* vaulted from George's personal experience to a national one. It was taken up as an emblem of the Canadian economy during the 1891 federal election, printed on a political poster, an icon for the Liberals who were campaigning against tariffs and John A. Macdonald's Conservatives. When the *Saint John Progress* and the *Montreal Gazette* ran reproductions of it, Mary's face went the nineteenth-century equivalent of viral.[8] The poster caption, "The Effect of the National Policy (A Picture from Real Life)," spun off her furious look, elaborating the farmwife's "fierce anger at the sad ending of her husband's labors. Farmers and Farmers' Wives, Look at this Picture! Men, Vote for your own welfare—Reform, Unrestricted Reciprocity and Farmers Rights."[9] Mary's farmwife carries the fright of a nation of women, her own expression—desperate, alone, responsible, but without control—embodying their predicaments.

Now eros drained into dread and ire. Mary must have kept that pose, holding a bundle for a child she did not have, maintaining her disgusted posture for hours. George let it fuel the painting, along with his own complex combination of guilt and despair.

Chocolate-haired Mary, who had finished eight paintings of her own that year, found herself two days after her thirty-sixth birthday, on April 12, 1890, giving another reception for George: he had been elected to full status in the Royal Canadian Academy of Arts, while she herself would never be allowed to do so, always having to keep an extra A for "Associate" when she signed her credentials.[10] The painting her husband chose to donate to the collection of the RCA was the very one that preserves her resentful face, *Mortgaging the Homestead*.

I think of Mary's acting skills and George's interpretation of them. How much did she tax herself, managing a seething face yet carrying on with the works that she, too, showed and sold? I don't know where the assurance and conviction required for Mary's sort of persistence comes from precisely, but daily circumstances—the vector of a husband's energy, an active social life, the maintaining of meals, clothes, sleep, friendships, sex, when no one expects you, a weaker vessel, to do what you do—require an internal stamina that must connect to a conviction that something inside will perish if you don't protect your gift. I marvel at the ability to access emotions so thoroughly and to organize an art life, to display rage and to turn toward a

canvas with plans. It is consummately adult to hold at once these contradictory responses and urges. "Going cheerfully on with the task" was her method. Eight paintings equaled health, equaled survival, equaled a truly textured life that could have disintegrated if the rage and disappointment she modeled had been enacted.

But she would not pose for one of his full-scale oil paintings again until 1898—another nine years. She would let him sketch her, and then paint her portrait, but never again would she play a character for him.

INTERLUDE

As Elizabeth Cooper Wrinch recognized Mary Evelyn's gift and reckoned with her own age and circumstances, she came at last to a decision—and an adjustment. She would simply have to call the muddy "New World" home, and if home it was, a muddy farm it would *not* be. In 1889, she and most of her children moved to 619 Church Street in Toronto, leaving Leonard to run the farm in Bronte.[11] In Toronto she could consider the schooling of her clever last child. She enrolled Mary Evelyn at an Anglican school for girls about eight blocks away from Mary's studio in the Arcade, and a fifteen-minute walk from their home at Church and Charles Street East.[12]

When Mary Evelyn Wrinch approached the Bishop Strachan School for the first time, it was located in Wykeham Hall, a three-winged former manor house with a rolling lawn on a little lane called College Avenue at the corner of Yonge Street. At the western end of the lane lay the gates to the University of Toronto, which had just begun admitting women, and the school that Mary Evelyn attended aimed to prepare young ladies at a reasonable cost for university entrance and "for the serious duties of life, as members or heads of families."[13] It was an Anglican Church

school instituted to parallel the Catholic schools. Fees were an affordable $18 per term.

Mary Evelyn Wrinch slipped into the school as into an envelope of comfort and stability, run by its excellent fund-raiser, Miss Rose Grier, principal. Mary Evelyn memorized her lessons, and she learned to play lawn tennis. Then she found herself skipping academic classes to run to "a china painting class," the very thing that MHR did everything to avoid. It was the beginning of the young woman's intense attention to detail. Here she could use her eye like a microscope. "Like Renoir," the art critic Joan Murray wrote of Mary Evelyn after an interview with her in the 1960s, "she entered the field of painting through an approach that demanded great patience, and some attention to the nature of transparent, carefully applied colours."[14] Such patience takes time—and steadiness.

In the summers, she could visit Bronte, with horses and chickens and pigs, with berries and apples and pears, and, importantly, on those breezy days in a landscape that never knew the helicopter spraying of insecticides, a multitude of bees and pollinators, and the freedom to sketch and paint and never have to open a heavy, much-thumbed-for-memorization leather-bound textbook.

Onteora
&
Roses

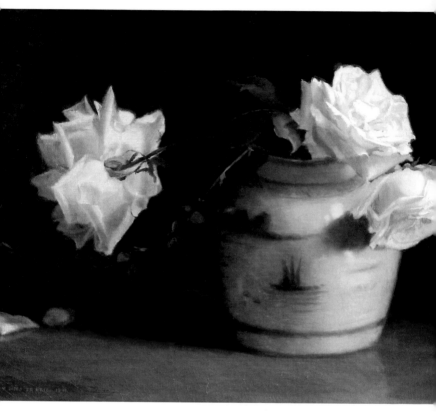

Mary Hiester Reid, *Roses in a Vase*, 1891,
oil on canvas, 35.6 x 45.7 cm,
Cooley Gallery, Old Lyme, Connecticut.

Roses in a Vase

I.

Three roses loll from a ginger jar as if they are stretching from the rumpled sheets of a bed. Each peachy head, negligee-soft, turns from the other, one as far away as its long stem will take it, one centered, as if it were growing out of the pot, and one hanging off, a heavy bloom on a fragile neck, to the side of the blue-painted watery ceramic landscape below. On the jar, a three-masted Chinese junk sails by a tree-lined shore. An unseen window lights the right side of the jar, and the color reflects in the polish of a wooden table on which it sits in MHR's 1891 *Roses in a Vase*.

If this painting were a poem, it would be an aubade, the verse form in which, having stayed up half the night, the figures greet the morning. The black background is dense, still thick-curtained for sleep. It appears to go far into the unconscious land of dreams from which the roses seem to have come. Positioning them theatrically creates— or reveals—a drama: one rose wrenches away from the

others, another hangs its head, the third leans at an angle of concern toward the littlest one at the side. Below, the ship and the two sets of trees compose a triangle that almost reflects the roses in the little ocean of the jar. MHR began to paint her masterpiece in 1890, the year after she threw that party for her husband, and *Roses in a Vase* is nothing like *Mortgaging the Homestead*.

The brushstrokes of *Roses in a Vase* are smooth to the point of disappearing, a Barbizon school technique that MHR learned in Paris, and the colors are lusciously accurate. We owe its current existence and restoration to Jeff Cooley of Cooley Gallery in Old Lyme, Connecticut. The energetic, sociable New Englander almost sold the painting, but felt it was in such poor condition he had to have it restored. Once it was returned from the restoration process, Cooley couldn't part with it.[1] He patiently waited while I stared at the work, one of MHR's most captivating still lifes, gawking at what might be Mermet roses,[2] though rose-lover Nicole Juday Rhoads at the Pennsylvania Horticultural Society could not identify them with certainty because Mary, heeding the edict of Grasset, elided the outlines of the leaves.

The third rose in *Roses in a Vase* turns away, occupying separate space from the other two. It emphatically turns its back. By 1891, the year MHR finished this painting, triads were already firmly in place in her work, something profound, internal, and deeply a part of her. She worked with all kinds of threes. The three of spirituality. The triad of her mother and sister and herself. A mother, a father, a child— though in the case of the Reids, a mother, a father, and no

child, or perhaps a wished-for child. And, of course, the rule of thirds in painting, which is not a rule at all but more of an artist's guideline that maps a rectangle into nine portions, divides it into threes vertically and horizontally.

2.

A pattern from an earlier time of her life had returned: as the air became thick with George's preoccupations and the concerns of society, one way not to be suffocated was to *move*. In the July after the RCA party, Mary and George decamped to Lambton Mills for the summer. They shut the door on their Arcade studio and rented an old mill in what is now west Toronto as a workspace, where Mary continued her oeuvre inside her marriage in another way. Lambton Mills dissolved her role as a model, and Mary the painter emerged, as she rambled through the fields with a sketchbook in hand, collecting wildflowers to paint à la Agnes Fitzgibbon. (Fitzgibbon, daughter of Susanna Moodie, sketched some of the wildflowers for her illustrations of the iconic 1868 book *Canadian Wildflowers* at Lambton Mills.) Here, Mary painted *Playmates* (1890), wherein two children, a boy and a girl, sit in a meadow, trees in the background. The small work is sunlit, Impressionistic, inspired by the portraits she had seen in Paris and the techniques she learned there. The girl stares out while the boy turns into himself, away from the spectator, intent on something—an insect? The work is almost a reverse-time portrait of a man and a woman in parallel

play: the deep engagement of two solitudes that continually repaired their marriage.

In the fall, the repair went deeper.

The Ontario School of Art had new galleries at 165 King Street West, over the Princess Theatre; a new name, the Central Ontario School of Art and Industrial Design; and a new curriculum for art teachers as well as painters, sculptors, and architects. The school employed a new instructor, too: George Agnew Reid, who was hired to lecture on perspective, composition, the history of art, and advanced life painting. On Tuesday, Thursday, and Saturday mornings, he went forth to teach.[3] These three gorgeous mornings were Mary's to use as she pleased. She settled into her work as into a pond.

Mortgaging the Homestead had closed a door for her; George's new job had freed her to open another. By the next year, she entered work in eight exhibitions in Philadelphia, Montreal, Toronto, and Ottawa, including a painting called *Autumn in the Catskills*.[4] The summer after Lambton Mills, she traveled south.

3.

The Catskill Mountains, ancestral homelands of the Haudenosaunee, Mohicans, Wabanakis, and Hurons,[5] offer a kind of shadowed darkness that feels like the background of *Roses in a Vase*. The mountains exude a powerful sense of shadow—they are like human shapes reclining, giant bodies covered by evergreen and hardwood forest. The Catskills

shield the lakes that, by the summer of 1891, were already established as reservoirs for New York City's delicious water. The high landscape lured New Yorkers—a cool respite for women in clavicle-to-ankle clothing and men in shirts with thick jackets.

Mary was drawn there—away from the Ontario countryside near Lake Huron where George grew up and they had painted summers before—by curiosity, ambition, and the solution of being in motion. Paris had enlarged her scope, and railroad travel had become easy. She would have the chance to repossess herself from the year's obligations as they chugged over the Niagara escarpment and gorge, then along the Erie Canal. The tracks took them east, then south down the Hudson River valley, home to the painters of a previous generation. Though the careers of Frederic Church (1826–1900) and his companions had peaked (and the places he painted were now corrupted by those very railroad tracks), the romance of the Hudson River School still lured painters like Mary and George to the valley.

The couple disembarked at Tannersville, where they booked in at a carpenter's house that took summer guests. The place was but a mile down the road from Candace Wheeler's artists' colony, Onteora. Biographer Muriel Miller describes this as happenstance, but the trip took too much planning to be so haphazard. Mary may have known about Onteora through her networks of women artists—though George recalled that the carpenter, Thomas Dunbar, told them about the colony.[6] On George and Mary's second day sketching en plein air, they ran into Onteora artists.

The sketchers invited Mary and George to Onteora's Fox and Bull for dinner—a meal prepared by that French chef. It was like Paris in the woods.

That summer night, in a plain room smelling of the wood it was built from, Mary would at last meet the force of feminist nature, Candace Wheeler. In sixty-four-year-old Wheeler's company, Mary could quietly flip a social calling card that would give her credibility: she was a Muhlenberg, a Clymer, a Hiester from Philadelphia; she had studied with Eakins, had lived and painted abroad. Her atelier had been near to Eugène Grasset, who was about to design the cover of the 1892 Paris exposition catalog, *Des arts de la femme*, featuring a woman industriously employed at her needlework pattern,[7] even as Wheeler was designing the interior of the Woman's Building to display such crafts at the Chicago exposition of 1893. When Mary slipped into her seat at the wooden table made by local carpenters and leaned her forearms on that denim tablecloth, she fit into the thousand-piece puzzle of art and women and late nineteenth-century design.

It was the first of many repasts at Onteora, meals that Mary did not have to plan, presided over by the enthusiastic Wheeler, who welcomed the younger artists into her realm. A generation apart, they would not become bosom friends, but Mary was within the constellation created by Wheeler. With the ease of Mary's social connections and George's gruff gregariousness, the couple fit neatly into place. Her husband could talk carpentry and cottage architecture while Mary could chat about Art Nouveau. Swept up and in, she could live as a painter here, devoting herself

more to her work and less to her wifely duties. That summer they were asked to join the colony—and did.

Women flourished at Onteora, especially those Candace Wheeler had met in the New York publishing world: Mariana Griswold Van Rensselaer, an art critic; editor Jeannette Leonard Gilder; and author Mary Mapes Dodge. Sarah Chauncey Woolsey (1835–1905), author of the iconic *What Katy Did* (1872), was in residence. Chauncey Woolsey had also published an American edition of the letters of the extraordinary eighteenth-century British woman who invented botanical collage, *The Autobiography and Correspondence of Mrs. Delany* (1879), as well as *The Diary and Letters of Frances Burney* (1880). Everywhere around Mary were the inspirations of women artists and writers working—many of them single heads of households.[8] Example after example of individuals steering their own careers were before her as she designed her own paintings and her own style of living.[9] Mary hiked for hours, sketching and roaming, passing other Onteorans on their way to fish the streams or ride horseback. "It is a community that works, reads, paints, writes, and studies very earnestly, and does not look upon the summer as a season of complete idleness," Candace Wheeler wrote in her diary.[10]

Onteora, as she conceived it, fit with George's liberal notions. Yet he had already begun to negotiate the difficult meeting grounds between the artist's life and the necessity for money that led to uneasy friendships with the rich, those collectors, bankers, and businessmen capable of buying substantial paintings. Wheeler herself lived in that special purgatory: on one side, the loose hominess of the farm-like colony so near rural Delhi, New York, where she

grew up; on the other, the strictures of high-society bar-
gaining that were part of her business in the city.

At those summer dinner tables, Mary and George took
a turn away from Canadian politics and economics toward
Arts and Crafts ideas, translating a Canadian liberalism
into egalitarian concepts of art for everyone.[11] Candace
Wheeler's vision of beauty in useful home products, both
coincident with and inspired by William Morris (1834–
1896), the British socialist textile designer, fit with George
Reid's urge "to relieve the inequalities which our civiliza-
tion is slow to throw off."[12] Just before this trip, George gave
a talk at the Toronto Architectural Sketch Club, and what
he said reflected the influences of William Morris's ideas
of handcrafting as a way to stem a tide of greedy industrial
manufacturing, as well as John Ruskin's nascent environ-
mentalism. George's reverence for land use planted seeds
of environmentalism wherever he built. Land, in his view,
should be "absolutely the possession of all who live on it."[13]
(He did not consider in that "all" the Indigenous inhabi-
tants of a territory.) The idea of a person's home, so crucial
to the boy who had almost lost his own, burned bright at
Onteora where socialist Arts and Crafts ideas found their
place—art for all, but in the midst of industrialists' money.

4.

Mary painted *Still Life with Roses* in that luminous sum-
mer. A woman in a corset, she evenly handled her brushes
to depict three peach roses corseted by the unglazed lip of

the ginger jar. In *Still Life with Roses*, the flowers are not planted. They are *cut*. Severed from their roots, they can be transported, as MHR transported herself and us, the viewers, into a world of thingy beauty—that ginger jar with its ocean scene.

Although MHR traveled widely for a woman of her day, she never went to Asia. China and Japan were simply too far away and too expensive to get to. But she felt the continent's artistic influence, for she painted this squat cobalt-blue-and-white Qing dynasty ginger jar more than once. MHR's ginger jar had been made for export, the color of its glaze tells us, sometime from the late eighteenth century to about 1840. Owning one signaled both wealth and the exotic for the people who bought Mary's oil paintings, though she probably did not pay a great deal for it. So many of them were exported (often in ships like the three-masted junk painted on its belly) that you can still buy one at auction today for under $200.[14]

By the end of the summer, Mary began to think of a summer home. With her own money, and in her own name, she bought a lot contiguous with the colony, but not on the same side of the road.[15]

INTERLUDE

During the winter of 1892, fifteen-year-old Mary Evelyn Wrinch, her wispy hair escaping from its pins, had been learning English language, Canadian history, and mathematics at the Bishop Strachan School. She'd had riding lessons and played croquet. Drawing and elocution were optional. Years later, after the school moved to new quarters, she spent decades of her life in the sky-lit art studio teaching generations of girls.[16] But that year, when school was over, she could visit the farm in Bronte and take up the Wrinch family's routine. There she could sketch and paint in the golden light of a rural Ontario summer. The family cats had summer litters in the hayloft. The dogs barked at the hint of a sound of a wagon down the road. Fires were lit under the tubs for the summer washing of the sheets and linens. On Sundays, the Wrinch clan trouped to the table for the roast, however hot outside it was. At sunset, the rays slanted across the silver-green (almost mint-colored) waves of oats as the umber russet apples that Jo savored in *Little Women* ripened on the trees.

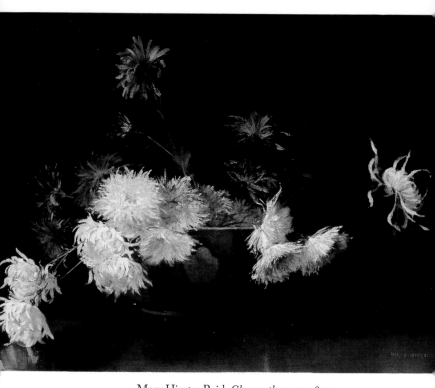

Mary Hiester Reid, *Chrysanthemums*, 1891,
oil on canvas, 52.9 x 76.2 cm,
National Gallery of Canada, Ottawa.
Gift of the Royal Canadian Academy of Arts, 1893.

Chrysanthemums

I.

The Imari ware bowl in MHR's *Chrysanthemums* sails like a vessel on the sea of the wooden table below. A bowl is a vessel, of course, and it holds the tossing flowers. The fourteen yellow mums flop electrically about, yellow as Mary's gloves in George's honeymoon portrait of her, popping against the dark background along with six vermilion flower heads. The flowers seem to crackle as if their energy snapped from logs in a fireplace. *Chrysanthemums* has the feel of a *bodegon*, a Spanish still life painting that usually portrays table objects and food. But Mary substituted flowers for food, conjuring up the deep, dark backgrounds of a Spanish interior with bright lemony flower heads. They jump out the way the citrus fruit in Luis Egidio Meléndez's eighteenth-century *bodegon* paintings do.[1] A Spanish still life superimposed on Asian ware? An east-west combination that is uniquely hers, combining her passions for the seventeenth-century Spanish court

painter Diego Velázquez and her romance with japonisme. That bowl traveled far to come into her hands.

Imari is the English term for the blue underglazed ceramics made in the eighteenth century in the Japanese town of Arita for export, traded by the Dutch East India Company to hungry European clients. The bowls have an overglaze of red, gold, and black, and their designs tend toward the complexity of Western patterns.[2] The Imari bowl in MHR's *Chrysanthemums* was exported from Japan as the Western infatuation with all things Asian increased after the 1876 centennial exhibition.[3]

The chrysanthemums rush out of the bowl. How she managed to anchor them there, I can't quite figure out, since the stems would certainly not have stayed put in such a large opening—except that there were myriad glass anchors for flowers in nineteenth-century arrangements, and MHR must have had her share of them. The flowers are detailed enough to have been directly in front of her as she painted but may not have survived for the whole of the painting. Chrysanthemums are an emblem for a long marriage, though to an Asian literary sensibility they indicate autumn and age and experience—even silence. "No one spoke," the haiku master Oshima Ryota wrote, "The host, the guest / The white chrysanthemums."[4]

2.

"We are all idealists when it comes to building our homes, and, whatever state of development we may be in, we seek

to beautify them even if they are barely habitable," George claimed.⁵ To be married to a person who will actually build your fantasy home with the muscles of his back and legs, with the sinews of his hands, is extravagantly sexy. After she bought the land at Onteora, George planned the shelter. They spent the winter envisioning a storybook studio, an Arts and Crafts vision of what a woodland artist's cottage should be. They dreamt in stone and lumber realizing the first house of their adult lives—and making it in the image of their marriage, not a place for a growing family but a space for two to paint. What was more, it materialized in sketches and drafts on blue architect's paper. Before their studio came from her husband's hands at work with a lathe, it came from the hands that drew—and touched her.

Closing the Arcade studio the following summer, Mary made the second of a quarter-century's worth of trips to Tannersville, with its new train station. George brought with them his student Owen Staples. The three stayed temporarily with the family of the carpenter they had met the summer before, and he helped George and Staples lay the stone foundation. Its centerpiece would be a massive fireplace—like the fireplace in their Paris studio, heart inside hearth, partnership in stone.

In six weeks enough of it was completed for Mary to move into the raw space while the men finished it. She was able to paint outdoors in good weather and to scour the countryside for furnishings for her home that would be lived in just four months a year.⁶ She gleaned what she could from nearby towns and villages, wandering and buying, echoing her habits in Paris. By autumn, the rustic

interior—part fairy-tale cabin, part artist's delight—materialized. George gave it the Scottish name for pleasant hill, Bonnie Brae.

In the long shadows of the pines across the cleared square of earth their cottage occupied, Mary generated painting after painting while the bills for the construction piled up. Bonnie Brae was built with a kitchen, a live-in maid's room, two verandas, a dining room, plus a huge two-storied studio with a balcony that doubled as a living room and a bedroom. Mary and George planned extensive landscaping with lilacs and a kitchen garden. But the whole project exacerbated George's financial anxiety, echoing his father's money worries.

Back in Toronto that fall, the two put up all their paintings for sale, again at Oliver, Coate and Company gallery, and by December 1892, had "sold practically every painting they possessed."[7] Nevertheless, the land and house remained in Mary's name,[8] and she did not sell the painting called *Chrysanthemums*. That one she planned to show at the spectacular World's Columbian Exhibition in Chicago. She was aiming high, and what she planned to send to the exhibition, where Candace Wheeler was designing the interior of the Woman's Building, was her smoky, luminous still life—the very opposite of the kind of large-scale mural that Mary Cassatt (1844–1926) was planning.

3.

"I am going to do a decoration for the Chicago Exhibition," Cassatt wrote to collector Bertha Palmer. "When the Committee offered it to me to do, at first I was horrified." But when her mentor Edgar Degas objected, she changed her notoriously recalcitrant mind.

> But gradually I began to think it would be great fun to do something I had never done before as the bare idea of such a thing put Degas in a rage and he did not spare every criticism he could think of, I got my spirit up and said I would not give up the idea for anything.[9]

While refusing a poor contract and forcing a more favorable agreement (after threatening to resign), she conceived a three-part mural for the Woman's Building.

In a complementary act, Candace Wheeler also accepted the assignment to be the "Color Director" for the entire Woman's Building, a job fraught with difficulties and for which she was paid late and not enough. She decorated the central Hall of Honor "in shades of ivory and gold."[10] Unlike Cassatt, who stayed in Paris, Wheeler was on the spot, supervising, maneuvering, overseeing installations. Because of the global nature of the exhibition, her reputation catapulted outside of her immediate New York City circles, going national—and international. Her point of view, that a women's pavilion should exalt women's craft and art, excited

Cassatt, who made a complete commitment to the Woman's Building, to the point of exhibiting her own paintings there as opposed to in the Palace of Fine Arts where men were showing their work.

The Chicago or World's Columbian Exposition (marking the anniversary of Christopher Columbus's arrival in North America) had from its inception a "Board of Lady Managers"[11] who assured that the proposals for the building design would be made exclusively by female architects—fourteen in all, and all under the age of twenty-five. The commission chose the very young, inexperienced, and hauntingly melancholy dark-haired Sophia Hayden, a recent graduate of the Massachusetts Institute of Technology, for her design of an Italian Renaissance–style edifice with festive balconies and loggias.[12]

By contrast, Candace Wheeler, with strong connections to the chair of the Board of Lady Managers, was shrewd, practiced, and sublimely competent. The construction of Sophia Hayden's white pavilion was fraught with last-minute requests and problems, but Wheeler was able to bring her savoir faire to the entire interior below the ceiling area,[13] where that mural painted by Mary Cassatt was mounted. It was destroyed when the Woman's Building was demolished, preserved only in photographs.[14]

The central section of Cassatt's mural, *Young Women Plucking the Fruits of Knowledge or Science*, presents a witty and captivating image of nine young women. They are not idling but *working* in the Garden of Eden, picking apples of knowledge not as a temptation, but as a necessity to live. Ambition was the theme. To the right was a panel called

Art, Music, Dancing, and to the left was one called *Young Girls Pursuing Fame.*[15]

From the beginning, many women objected to the condescending phrase "Lady Managers," which tainted the project of the Woman's Building. Others did not feel a segregated women's building would help the cause of "the Modern Woman." Sara Tyson Hallowell, who presided over the selection of paintings for the exhibition, strongly argued for the integration of paintings by women into the Palace of Fine Arts. But Wheeler, like Cassatt, felt the need for a female-focused place:

> You know I have always felt that one great purpose of my work was to prove to women their ability to make conditions & results which were entirely favorable & I should like to emphasize the fact of its accomplishment in the Womans [sic] Building.[16]

Female artists were torn about having their work displayed in the segregated pavilion. Many wanted to exhibit in the Palace of Fine Arts, alongside men, in the midst of international art contributed by other countries, uneasy with the fact that the Woman's Building was also a place for craft.

If Mary took the side of Candace Wheeler, she would preserve her relationship with the influential designer and her status at Onteora. But when she chose instead the Palace of Fine Arts, she aligned herself both with her husband and her new country, but sadly against Candace Wheeler. Mary

continued to stay at Onteora, fully participating in its buoy-
ant atmosphere, for decades, but she would tread a tenuous,
foggy line in terms of her relationship with Wheeler.

In the catalog of Canadian paintings sent to the World's
Columbian Exposition, George and Mary are listed in the
table of contents alphabetically.[17] Women's paintings were
hung side by side with those by men in the Palace of Fine
Arts, and MHR represented Canada with three other
women, including Laura Muntz, Mary Evelyn Wrinch's
future teacher. But *Chrysanthemums* was of such circum-
scribed scale and subject matter that it was as visually seg-
regated from the parade of huge narrative works as if her
intimate manifesto for a floral female subject had been
hung in a separate structure.

4.

But *Chrysanthemums* is so worth feasting on. The rim of
the Imari bowl circles the flowers. If we say that it is like a
casual arm around a waist, the simile's mental leap ascribes
a human gesture to an inanimate object. The process of
beholding an image acts a bit like that simile. As a per-
son beholds an artwork, that person's gaze is also held by it.
A deep, uncanny engagement with a piece of art, the feel-
ing of being recognized by a painting even as *you* are the
one recognizing *it* is a complex process of perception-as-
psyche. Mary's contemporary, Austrian art historian Alois
Riegl called it the "beholder's involvement."[18]

As this theory of art perception developed, concepts of psychological perception emerged as well. Looking helped thinkers look *into* processes of the mind. Ideas of sympathy (feeling for someone or something, often with concern for), empathy (feeling with someone or something, an emotional response elicited by another's emotional state),[19] and projection (ascribing one's own feelings to others or objects) were being teased out and named. Because of aestheticians like Alois Riegl, emotional responses to art such as Mary's *Chrysanthemums* led to a way of examining the unconscious.

In the epistolary exchange between Riegl's contemporaries Sigmund Freud and Wilhelm Fliess, the idea arose that a person could project feelings onto others—and, by extension, onto objects, too. Then the other person, or the object (including natural objects), could project back to us our own feelings, sometimes acknowledged (or "normal" in Freud's terms), sometimes unacknowledged. "Whenever an internal change occurs, we have the choice of assuming either an internal or an external cause," Freud wrote in his first piece about the concept of projection in 1896. Projections are "normal so long as, in the process, we remain conscious of our own internal change. If we forget it . . . then we divorce ourselves from our own emotions and feel them coming at us from another source, and there we have paranoia."[20] The transfer of emotions onto the talismanic items that shine from still life paintings—and the sense that the images are alive with feeling and meaning—coursed through painters who valued the "sympathetic" or emotional, as Mary did.

INTERLUDE

"Wheeler was a notorious namedropper," independent curator and Onteora resident Jane Curley said in her Lauren Bacall voice. "Why did she hardly mention George Reid?" My husband and I were visiting Onteora as guests of George Reid's lateral descendant, Caryl Clark.[21] This statuesque, white-haired musicologist, professor at the University of Toronto, had invited us to stay in the loft of the Onteora Library that George Reid had built, a woodland caprice of a bookish building with balcony and snug reading areas. Clark gave us breakfast, guided me to the archives, let my husband lounge in the library, then introduced me to Curley, a spritely brunette who applies red lipstick with panache. The two guided me on a tour of the so-called cottages of Onteora, now splendid, renovated (sometimes historically preserved, sometimes not) Arts and Crafts era edifices. I viewed Bonnie Brae from the road that separates it from the rest of the houses. Though the interior has been thoroughly renovated, the exterior is much the same as when Mary lived there. Curley speculated about the curious dividing line. Why, if they were members of the colony, build across the road? Perhaps it was simply that there had been a lot for sale there.

Mike and I walked the paths of Onteora, clambering up and down the stone slabs behind the library. One can almost inhale the remnant odors of contradictory influences at Onteora still: a piney sweetness and stony earthiness of Wheeler's back-to-the-land impulses, as well as the crisp smell of precisely stacked woodpiles, the whiff of the moneyed insularity of the new wave of Wall Street and social blue book candidates for membership who would have driven Wheeler crazy. That evening, we slept in a cozy alcove bedroom off the balcony of the library, where Caryl Clark had rigged up mosquito netting against the insects coming through the nineteenth-century screened windows. It was a hot, damp, sweaty, quiet night; just the slightest breeze lifted the leaves.

Long before the Depression of the 1930s, late Victorians called their own period of 1893 to 1896 the Great Depression. It began the same year as the exposition, when the collapse of railroad construction, the crisis in silver, and skyrocketing unemployment rocked the North American economy. During the Panic of 1893, in both Canada and the United States, the prices of farm products crumpled, and depositors besieged the banks.[22]

Candace Wheeler's authority at Onteora was waning. Her brother Frank Thurber's grocery business went bankrupt in the Panic; to stabilize his fortunes, he sold portions of his acreage at the art colony. He did not select his buyers by their artistic profiles but sold to those who had cash to buy into the mountain retreat. These were Wall Street

businessmen who had been able to shelter their own fortunes and who knew a land bargain when they saw one. As her brother's wealth, which had bolstered Candace's dominance, was depleted, so her rustic values of simple living began to vanish. New York financiers did not want to lug water from wagons brought up the mountain by oxen.[23] Nor did they want to hear a directorial tone from a woman of a certain age who liked to be in control and who was now without financial clout, despite the fact that she had a worldwide reputation in design.

Charles Hazen Russell, a New York attorney who served in the state legislature and a newcomer to Onteora, admired Bonnie Brae and its fresh, easygoing and industrious Canadian artist-architect. When Russell approached George to plan and build a cottage for him at Onteora, George was at first reluctant. He knew it would be a distraction from painting and said that he "did not want to spend his time on architecture."[24] But to support himself and Mary, he relented and, during the Depression, built two structures: a residence for the influential Russell and another building that realized an idea he had after the Panic overcame Toronto.[25] Fiscally anxious George had decided that he and Mary should make a version of Shinnecock, William Merritt Chase's summer painting school in Southampton, Long Island. Chase had begun the school four years earlier, and Canadian students had been traveling down to it. Couldn't they divert some of them to the Catskills?[26] To lure them, George designed a gabled student cottage with bedrooms for ten and a large central teaching studio, then constructed it on Bonnie Brae land.[27]

With the design for the Russell house, George slipped into a new unofficial role as Onteora architect, edging out Wheeler's son Dunham, just as his mother's back-to-the-land egalitarianism and feminism were being supplanted. The businessmen were inching Wheeler out of power, and she began her retreat, though she resolutely stayed at Pennyroyal for the rest of her long life.

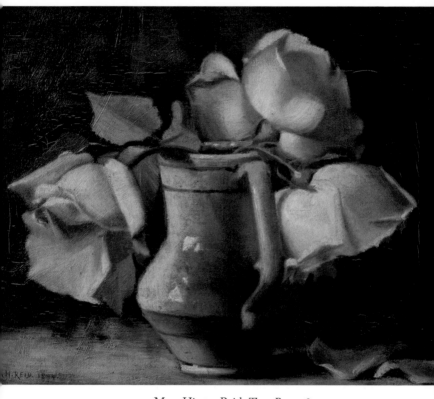

Mary Hiester Reid, *Three Roses*, 1894,
oil on canvas adhered to board, 30.5 x 23 cm,
collection of the author, Toronto.

CHAPTER SEVENTEEN

Three Roses

I.

By 1894, after the Chicago exposition, Mary was at the top of her game. In the midst of the Panic and Depression, she painted her luscious *Three Roses*. A country milk pitcher with a low belly and a stout handle gathers up a triad of pink roses, like characters in a stage play, two heads huddling together while the third turns away. It is one of her most sensuous, in some ways one of her most anguished still lifes. The heads of the roses can barely lift themselves up. This is part botanical fact (the necks of hybrid tea roses are often not sturdy enough to hold up the heads) and part floral drama she chose to display. "Nothing in a still life in this tradition is unintentional," art historian Katharine Lochnan reminds me as she examines the painting.[1] Mary allows currents of emotion to come into the blooms almost as if osmosed from the water in that pitcher right up through the stems. The earthenware holder of the roses is as solid as a house with its graspable handle positioned right

toward us. Lochnan notes the reflections in the earthenware. It is as if we could pick that jug right up.

Like the continent's Depression, or perhaps her own, Mary's roses languish, looming from the dark background. One of them even drops two tear-shaped petals onto the table below. Another rose—the youngest?—barely out of the bud, has tightly folded petals. Each one is flushed, the pink of the inside of a mouth. The top flower almost pats the back of the one that has let two weeping petals go. It is a highly emotional scene—roses acting out a romance? The still life has a narrative quality.

If you take the liberty of running your hand across *Three Roses*, it is as smooth as a dressing gown, yet the brushstrokes are visible. Mary used a series of small brushes; the navy-blue lines around the jug are tipped in with a thin, pointed brush; and the strokes for the roses have a quick strike feel to them. There's no sense that she's following predrawn shapes—and she doesn't outline the flowers or the jug. She is drawing with her brush, using tiny crossing strokes to get the edges of the roses in colors that range from tan to tongue-pink to tooth-white. The thoughts, or should I say the vision, seem to have a smooth path through her arm to the brush to the canvas. The greens are quickly jotted in by her empathic wand: three blossoms so fully realized it seems they exude a scent.

Our term still life derives from the Dutch word stilleven. In Dutch the separate words mean still *moment*. The sense that something—a whole identity for a flower—is being lost even as it is at its fullest is caught in the floppy droop and the petals on the table below. The painter makes

one remember that a moment existed, that it flowered fully, that it was fraught and complex, and that a woman in a lace collar holding a palette insisted on its essence.

2.

In 1893 to '94, her work popped up at the Pennsylvania Academy of Fine Arts. Then she showed two paintings at Toronto's Palette Club: *The Long Seam* and *At Close of Day*. A reviewer in *Toronto Saturday Night* assessed it. "Mrs. Reid gives us something new in *The Long Seam*, a little maid sewing in a room, in which the color and soft rendering of the whole are well done. The pathos and loneliness of *At Close of Day* will be felt by all: the solitary woman who sits with folded hands and weary attitude is given with great breadth and feeling."[2] After the Chicago exhibition, critics began writing about the moods of her work. I wish I could see the painting of the seamstress—I've found no record of where it is now. The description of it recalls a long tradition of pieces that show women at domestic work or sitting in solitude, from Chardin to Vuillard, except that Mary was watching this work from a different viewpoint. She certainly had to pin up her hair and do some of those house-hold chores on her own; as well, she was the person who found and hired the women who helped her.[3]

"Against brown walls, the servant bends / over the cov-erlet she mends— / brown hair, brown flocking, a dun hand / under the lamp, the servant bends," begins "Vuillard Interior," a triolet by Elise Partridge, a poet who wrote

about domestic activities and their trance-like repetitions. There's a loneliness in the "knotting, nodding, the servant blends / into the coverlet she mends"[4] of this poem that echoes the feeling that the journalist picks up when he describes the "great breadth and feeling" in MHR's now lost, but maybe just hiding, *At Close of Day.*

3.

She'd begun to paint Mermet roses. The Mermet is a sumptuous rose, introduced in France in 1869 and bred by Jean-Baptiste André Guillot.[5] A contemporary rose catalog describes Mermets in bygone terms: "Pale, peach pink blooms of the most exquisite form . . . forerunners of the classic conical shape that became the model of beauty for hybrid tea roses . . . exquisitely soft and genteel."[6]

By the time they returned to Toronto, Mary was prepared to show "two groups of roses and a brilliant but softly tinted autumn landscape."[7] She barreled ahead with her work: altogether, she exhibited the following winter and spring at Ottawa (Royal Canadian Academy and National Gallery of Canada), Montreal (Art Association of Montreal), the Ontario Society of Artists in Toronto, Hamilton Arts & Crafts, and Toronto Industrial Exhibition.

4.

In the spring of 1893, Mary Evelyn Wrinch, who was living the ethos of Cassatt's *Pursuing Fame* mural, graduated from Bishop Strachan School. She was sixteen years old, her hair curling behind soft small ears, her blue eyes wide and observant, her posture relaxed. By late summer, she was collecting her brushes, paints, and personal supplies.[8] That fall, around the time of Mary's show at the Palette Club, vibrant Mary Evelyn began her studies at the Central Ontario School of Art and Industrial Design with three highly successful artist-teachers—Laura Muntz, who would be a rare female role model; Robert Holmes, a botanical and nature artist; and George Reid.[9] Immediately she proved herself a talented and responsive student. Adventurous and determined, she darted with her brush and took her subjects from the natural world. (Years later, the studies she did at this time with Holmes would inspire woodcuts of wildflowers.) Her style example was her teacher Laura Muntz's "splash-and-dash," as Mary Evelyn recalled when she was nearly ninety years old.[10] But her most powerful influence was George, conveyor of his absolute conviction that one must draw with one's brush, abandoning elaborate preparation.

When, in a mere year, it was time to submit paintings to be considered for the Ontario Society of Artists' 1894 exhibition, seventeen-year-old Mary Evelyn, purposeful and gifted, wearer of simple dresses gathered at the neck, submitted her work. It was accepted. She exhibited for the first time among the grown-ups and received the validation of being a painter for real. Emily Nichols Hatch, one of

the students of American painter William Merritt Chase, observed, "There were many ages when women could do tatting and if they were adventurous might paint roses on fans and china tea plates. For an ordinary woman to aspire to landscape or still life more to portraiture, was thought as audacious as Daedalus trying to fly to the sun . . . Times have changed!"[11] As Cassatt suggested in her mural, young girls really could pursue fame.

Then, in the blue-gray-violets of snow shadows on Church Street, Toronto, in the winter of 1894, seventeen-year-old Mary Evelyn Wrinch planned her trip to the Catskills.[12]

5.

Two months after Mary's fortieth birthday, she and George guided eight students from Toronto to Onteora. There were two men, Frederick Challener and Rex Stovel, and six women, Alice Carter, Harriet Mary Ford, Carrie L. Hillyard, Ethel Miller, Ida Rupert, and Mary Evelyn Wrinch.[13]

It was one of the two men that summer, Frederick Challener, George's long-time student, who seemed to learn most from Mary. His tiny oil painting *Still Life with Roses* attests to this. Of the women, Harriet Mary Ford (1859–1938), nearly Mary's contemporary, was already a significant painter, having studied and shown abroad—though the anonymous art critic of *Toronto Saturday Night* declared that the work she presented at the Ontario Society of Arts

"lacks luster." Mary was singled out in that same review: "I would like specially to mention Mrs. Reid's picture on the south wall, a little interior piece: a lady playing the piano, a gentleman seated beside her, drinking in the music. It is poetic in feeling and won me to tarry by it."[14]

Yet here, in June, she had little time to tarry. She was marshaling an octet of apprentices who were jolting along in the railroad cars to a new mountainside art-land summer camp. Now she was managing a large family of students, responsible for a household of ten. Next door to her dreamhouse à deux stood a dormitory full of ambitious younger painters needing to be supervised, taught, and fed. Sequestered in a hollow across the road from the other cottages of Onteora, the Reids had created a colony within a colony, an eccentric summer family. The prime goal was art instruction, but summer school does not involve only classrooms. Education comes from role models, and Mary's industry presented one type for those six women.

Whether she was teaching the students or administering and organizing, the eight of them more than filled Mary's summer, especially since George was now in demand to design and construct houses for other Onteora residents. As the man engaged with his students, his clients, his construction projects, and his paintings, with Mary left to attend to the details, she painted, ironically, a piece called *An Idle Hour*. Then, despite these demands, she up and showed the works she managed to get done that summer at four exhibitions later in the year.

The couple moved among the students, in the heat, in the damp (for it can rain buckets in the Catskills), urging

them, modeling for them the artist's life. Fred and Rex, Alice, Harriet, Carrie, Ethyl, Ida, and Mary Evelyn had nothing to do but concentrate on art and focus on themselves. The colony was like a little terrarium, an aesthetic ecosystem unto itself, a glasshouse for art—and for inevitable upsets, for inevitable triumphs and hurts.

Now Mary Evelyn Wrinch, one of the younger members of this student group, was intimately lodged inside MHR's life all summer long. She watched the older woman paint—as well as organize and manage—and she listened to critiques from the older woman's husband.

Nestled at Onteora, a very complicated set of impulses crossed—a set of vines intertwining. Just as in the wild, or in a garden let go, tendrils attach with vigor to whatever is upright. They reach toward the light. Whatever is upright supports—or suffers—the tendril's attachment. In the same way that it is almost impossible to trace the progress of a vine once it is established, Mary Evelyn intertwined with Mary Hiester, and both with George Agnew Reid.

It is a Gilded Age, as Mark Twain termed it. The art and the relationships of these three people are rich and fraught and full, gilded with the filtered light of these mountains. At night, with windows screened and screen doors filtering the breeze, George and Mary lay on their summer bed.[15] Did they use mosquito netting? Her menstrual rags hung discreetly out of the way of the students (six of whom also had this worry), the fire laid for the cool air that comes in on summer nights. (A hired servant went to bed in the maid's room that George designed, having emptied the ladies' chamber pots.) They've been married eleven years. They

know each other intimately. He has portrayed her face, her hands, her arms, and her bosom. But this summer, a metamorphosis, both in their art and in their relationship, has begun. Soon the chrysalis of their marriage would crack open, and another version of their union would make its way out.

6.

This is the summer Mary wiped the sweaty tendrils from her face and painted *Three Roses*. She did not paint it on a stretched canvas. It is oil on board. Those three pink roses loll from a pitcher possibly obtained right there in Tannersville, with its neat navy-blue line around its top and its low-slung bottom. Its sprawled inhabitants are tea roses—called so because their scent resembles the odor of tea. Tea roses look their best when trained to climb over a trellis so that we can look up into their faces. They bruise easily with rain or wind. The blowsy tenderness of these blooms endeared them to nineteenth-century gardeners—and lovers. They are sensuous but wistful, pristine but sexual; they are perfect—for a minute or two—and then they all too humanly rust at their edges. They almost demand that you look at them because they are shortly going to go away—or at least change.[16]

INTERLUDE

I.

A few hours away from Onteora, in New York City, the American Fine Arts Society occupied double-story ground floor galleries about fifty magnificent feet deep and seventy-five bravura feet wide,[17] below the studios of the Art Students League of New York at 215 West 57th Street. This 1892 piece of Gilded Age architecture, limestone fronted, French Renaissance style, is still the league's home. Though the galleries are long gone, one gets the feel of those fin de siècle exhibitions as the doors open, and especially when climbing the staircase to the studios above.[18] The exhibition catalog of 1894 lists the members of the American Fine Arts Society and their addresses, among them Cecilia Beaux, Mary Cassatt, and James McNeill Whistler. Of the 317 works in that exhibition, forty-seven of them were by women, though no one would expect Mary's name to be among them. I couldn't resist looking, though.

And I found George there. After the Chicago exposition, he had won a gold medal at the San Francisco Midwinter Fair and then, having hobnobbed at Onteora, he was invited to show—and sold—a work called *The Other*

Side of the Question. It hung on the wall with New York painters Robert Van Vorst Sewell, A. Brewster Sewell, W. Hamilton Gibson, Hubert A. Olivier, and Elihu Vedder,[19] not names we instantly know now but individuals who were players in the New York art world then. The husband of MHR was thriving.

2.

Fly through the imagination to feel into an artwork?

Or anchor footnotes?

They are tandem acts, but the former feels like a balloon ride and the latter like doing my taxes. I'd misplaced the handwritten note about the American Fine Arts Society that I had scribbled in allowable pencil on the allowable notebook in the Thomas J. Watson Library at the Metropolitan Museum of Art in New York City, where I had, just as it was closing one day, discovered the catalog and sat counting the forty-seven works. Computers were allowed at the library, but I'd scampered in after a busy day of in-person appointments in my former city, sans computer, realizing I just had the time to look at the fragile catalog.

Back in Toronto, in my yoga pants and a stained shirt, I flopped on the floor of my little study awash in extraneous papers, looking for the lost scrap, and actually groaned. It was loud enough for my husband to leave his study and cross the living room to come and find out what happened. (Mike was the kind of scholar who managed huge projects in the world of James Joyce studies. He could keep track of the details for

hundreds of thousands of citations. How thorough he was, how measured . . .) I confessed my problem.

Peering around the door, he said, "Everyone loses notes, Molly."

When I think of quotidian moments in my marriage, I light on this thirty seconds, small as a sequin. His face, voice, and simple thought was like a NASA telescope photo sent back from outer space. One of those photographs of vastness that make a person know we all exist in the enormity of time and space. Of course, everyone loses things! Having grown up with outsized responsibilities, where losing something had whopping consequences, a casual, rescuing remark felt profound.

The note surfaced later, but it did not have all the details that it should, and a year in COVID-19 lockdown made sure I have to cite it, incomplete. I wouldn't get back to the Met to check it. Like so much of the fractured evidence of Mary's life, it was fragmentary—and therefore, in its smudgy, penciled way, on an earth transformed by a pandemic, precious as a shard.

It's also precious as a shard because Mike is gone. We could not make a proper funeral for him during COVID-19. Instead, I threw him an online Irish-Jewish ShivaWake. From New York and Dublin and Zurich, from Buffalo, Tulsa, Toronto, and Montreal, his many friends, colleagues, and students attended and spoke. I thought they would drop in for a few minutes and disappear, but they stayed— some for hours. So many who had been guided by his editing of the 63-volume James Joyce Archive spoke about his willingness to spend hours tracking down answers to their

questions, his piquant sense of humor, his kindness. What it all amounted to was: his attention. To me, that kind of attention is an example of love.

Through a long marriage, the recognition of each other diverts, re-focuses, and, if you are lucky, as we were, returns. We were lucky because the tumultuous parts of our lives— the romances, the early marriages, Mike's initial diagnosis and his skyrocketing early successes coupled with later devastating professional losses in what Irish literature scholars refer to as "the Joyce wars," my own early successes as a poet and spokesperson for poetry—had been negotiated, leaving us . . . able to see one another. To give each other our attention.

Marriage let me observe his scholar's habits, how he did his work in our apartment where bookshelves with two collections (Joyce and poetry) lined almost every wall, the small paintings fighting for space. In our decades-long gabfest of literary gossip and politics, during our badminton games and agility training, he saw me. I saw him. We got each other.

George's attention was diverted elsewhere.

Toronto
&
an
Arrangement

George Agnew Reid, study for *A Modern Madonna*, 1893,
charcoal on paper, George Reid Sketchbook,
E.P. Taylor Research Library and Archives,
Art Gallery of Ontario, Toronto.

Modern Madonna

I.

Not too far away from Mary's Arcade studio in Toronto in St. George's Ward, around Front Street West, a thirty-two-year-old woman with luxurious dark hair had the money worries of a single mother. Mary Jung was raising her two children: Mary, age eleven, and Henry, age ten. (She'd given her status to the census taker as married, not as widowed, but there was no adult male husband entered for in the household. Her daughter's father was listed as from Bavaria.[1]) When Mary Jung arrived at the Arcade, she walked past the glittering tiers of boutiques with their leather gloves and shoes, millinery, woolens, and linens she could not afford. Then she climbed the stairs to the artists' studios and lofts above. Mrs. Jung was capable of holding a pose, and she had a piercing, melancholy that George Reid recognized. Using some of the money from the sale of their works, he hired her to model.

He positioned, then draped her for a painting called *A Modern Madonna*.[2] In George's tender charcoal sketch

for the work, Jung's hair is bound up away from her child. The baby is swaddled into a bundle, the infant head buried against the mother's cheek. We can just see the baby's eye and ear. The mother's eyes, full of love and sadness, stare out in the unseeing way of the deeply absorbed. Yet those are worried eyes, the face full of awe and concern, the baby's presence suggests, for the future. Mrs. Jung resembles Mary, and she shares Mary's name, but George sketches her as a loving, anxious, slightly sad mother, not an angry, disappointed one.

The sketch is alive with affection. It's a testament to George's perceptions and his drawing skill. Stuart Reid, the Canadian artist who is one of George's lateral descendants, has defined a portrait as a figure that conveys "the mystery of being alive,"[3] and the charcoal draft for *A Modern Madonna* conveys that sense of awe. George recognizes the mother's bereft vulnerability and depicts it with empathy. Returning again and again to help him finish the painting, Mary Jung became "one of his favorite models."[4]

Had Mary and George settled all issues of childbearing? Couples today can wrestle with infertility treatments for ten or fifteen years, but their option was a solution prevalent in nineteenth-century lives: to adopt a child. In an era of orphanages and large families, parents gave or loaned their children to relatives or family friends. Children became wards.

The Reids could have contracted with Dr. Barnardo's Boys' Home.[5] Or the Toronto Girls' Home.[6] But they do not appear to have done so. Or did they adopt in a less conventional way? Students can perform adoptive roles. Mary Evelyn Wrinch was a kind of student-child, though her

mother was very much alive and presumably paying the Reids for instruction as well as for Mary Evelyn's studio at the Arcade.

The type of teaching that George and Mary chose—taking students into their own house, traveling with them, supplying them with board, living with them 24/7—created intimacy. They were parent figures, with all the intensity of the demands and responsibilities of family life. But students are not really children. And teachers are not really parents. They are instructors. Teachers are some of the most romantic figures in many of our lives, and the trespassing of sexual borders, the aura of incest that surrounds the teacher-student liaison because of their parent and child roles is famously and infamously enacted for many. It was in this aura of intimacy, after George had painted Mary Jung, that he began a portrait of Mary Evelyn Wrinch.

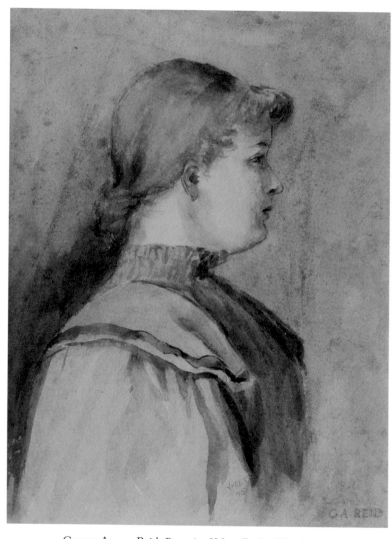

George Agnew Reid, *Portrait of Mary Evelyn Wrinch*, 1895,
watercolor, 19 x 15 cm,
private collection, Calgary.

Portraits

I.

Two studios on either side of George's in the tower were available, and seventeen-year-old Mary Evelyn was looking for Toronto space, as were two other talented students in the Reids' classes, Henrietta Moodie Vickers[1] and Rex Stovel. Stovel moved into one, while Wrinch and Vickers shared the space flanking George's other side. He ensconced himself among his devotees, creating another art colony at home. Mary's studio was off to the side, or possibly on the level below with their sleeping quarters.[2]

After George portrayed Mary Jung and Henrietta, he set about painting a tender portrait of Mary Evelyn. Her sandy hair is pulled back into a braided bun at the nape of her milky neck. She is fleshy and soft and full faced, with a long nose and a prim, rosebud mouth. (But a photograph taken five years later show that full face with a body slender and purposeful.[3] George portrayed both of his Marys as more mythically round and fecund than the energetic individuals in photographs.)

George "was a born teacher," Mary Wrinch later recalled. "He worked by telling, not doing, so that we didn't copy his palette."[4] He talked to his students. He didn't take his own brush and demonstrate. Some instinct allowed him to put his gaze in the same line as his students to see as they saw, then urge them on toward their own visions. And Mary Evelyn in particular internalized his gaze in line with hers.

2.

Mary found herself in an echo chamber of multiple Marys as George turned from her toward a model named Mary, then toward a gifted student named Mary. But in 1895, just as he was painting portraits of studio-mates Henrietta and Mary Evelyn, MHR reversed roles. She decided to paint his portrait, to require that *he* sit for *her*. Somehow, George, among the demands of drawing up plans for a church at Onteora (yet another commission), teaching, and painting his own work, did stop for her. In control of the brush, she rendered him sexy, bearded, sensuous, alive—and looking off to the side. In her depiction he's the dreamer, gazing away. Or is his attention diverted? His gaze is outside the painting, away from the painter, yet she calls him to her with an Impressionistic blur. It's soft, loving, vibrant—sunlit, as if she'd been taught by Renoir.

The portrait calls him back to her, and the fact that he took the time to sit for it signaled to the students the primacy of their love relationship. The Reids were husband and wife, and the wife stated this in no uncertain terms. But

even so, those terms were tentative. Boundaries wavered. George's enthusiasm for the talent and zest of Mary Evelyn Wrinch, just out of her girlhood, was plain.

INTERLUDE

Girlhood and boyhood were deeply compelling states of growth to a friend of Candace Wheeler, a Norwegian-American popular novelist and critic named Hjalmar Hjorth Boyesen (1848–1895). "Quite a figure in literary society, a young Norseman who had adopted our language and views," Wheeler describes him, "but in whose work there was always a pleasant smack of Scandinavianism. We saw very much of him at our house and studio and enjoyed his friendship."[5]

The prolific Boyesen, who published twenty-four books at a rate of almost one a year as well a huge number of critical articles, framed his twelve-page exploration of the work of George Agnew Reid in the *Monthly Illustrator*[6] with thoughts about growing up. The Columbia University professor's nostalgic backward glance[7]—Boyesen died suddenly later that year—was lavishly illustrated with reproductions of George's paintings as well as his line drawings. It was a huge coup for George to have *A Modern Madonna*, the painting that Mary Jung modeled for, land on the cover of the April 1895 issue of the New York art and artists magazine with Boyesen's lengthy article inside. In it, Boyesen labels George Agnew Reid a "sympathetic realist," and that label stuck.

Boyesen, from Candace Wheeler's Onteora circle, is the ultimate link between George Reid and the ideas of Empathists like the Vischers, Lipps, and Riegl. The forty-seven-year old novelist-critic had received his PhD from the Royal Fredrik University in Christiania, Norway, at twenty-one,[8] then immigrated to the United States. In a spasm of homesickness, he wrote his first and best-known novel, *Gunnar: A Tale of Norse Life* (1874), which was championed by William Dean Howells. Howells began serializing *Gunnar* in the *Atlantic Monthly*, and a correspondence between the two writers reinforced Boyesen's conviction that realism was the best path for the American novel, just as George was convinced that realism was the best route for Canadian painting.

As readers were devouring *Gunnar* in the *Atlantic Monthly*, Boyesen journeyed to Germany[9] for postgraduate study at the University of Leipzig.[10] There he entered into an atmosphere of ideas about Einfühlung and a multitude of German variants coined by Vischer. Boyesen embraced the concept that the artist injects feeling into the artwork, which is then reexperienced by observers or readers who feel themselves into the artwork. He was inspired by the notion that the most vibrant communication is created when subjects deeply connect to the memories an artist or a writer is trying to bring alive.

Boyesen packed up ideas about sympathy with his bags as he returned to the United States and academe (first at Cornell, then at Columbia), married an American, and had two sons, thoroughly embracing his new country while still haunted by his boyhood in Norway. Like George, who idealized his growing up, Boyesen had written passionately, if

sentimentally, about the starkly beautiful landscape of his youth—even as George painted his own youth avidly and nostalgically. When, in the *Monthly Illustrator*, Boyesen calls George's work an example of "sympathetic realism," the idea of "feeling into" lands in its visual equivalent in North America.

"Of the seven ages of man which Shakespeare distinguished, I have never ceased to regard boyhood as the most interesting," Boyesen declares, and then proceeds to try to describe his impressions of what makes boys boys and girls girls. "Boys have an undeniable affinity for the woods," he claims. "A certain happy-go-lucky bravado, which is inseparable from the gambling instinct, characterizes more or less both the savage and the boy; while the girl, as far as I am aware, has nothing in her composition even remotely corresponding to it."[11]

Images of boyhood from George's paintings *The Story*, where one boy is telling four little boys a tale, and *Drawing Lots*, where three young boys on a brick wall are gambling, present an iconic boy who "would pity himself as a milksop and a mollycoddle if he could extract entertainment from such effeminate pursuits as picking flowers or berries or practicing on the piano."[12] (Girlhood, for Boyesen, is downright floral, a time "when a girl's fancy roams in flowery meads, among daisies and marigolds."[13])

The novelist-critic applauds George for reinforcing the bravado he believes in: "It is evident that Mr. Reid has perceived these characteristics in boys and girls and embodied them in his paintings." Boyesen enthuses about George's worldly, well-traveled life: "He is a Canadian, but has

studied in Philadelphia and New York, and in Europe, and so has had an opportunity to study young human nature in a great variety of climes and aspects."

Along with the compassionate idea of sympathy (perhaps construed as something effeminate?) comes an avalanche of macho-boy stereotypes: "With that sympathetic realism which has characterized his pictures of more adult persons and more serious scenes, he has given us here the boy and the girl, which we know, and which we were, and it does us good to have those days so recalled." Boyesen then launches back into his own life—"I remember in my own boyhood..." —for the rest of the piece.

George Agnew Reid, reproduction of *The Evening Star*,
c. 1895, George Agnew Reid scrapbook, Edward P. Taylor
Library and Archives, Art Gallery of Ontario.

The Evening Star

I.

In 1895 George painted a now-lost work called *Evening Star*. Sitting on the grass, a girl dressed only in a flimsy shift looks out into the gloaming. The girl's gown has slipped to expose both breasts, and she looks toward the Evening Star, the planet Venus, long the symbol of love, beauty, and sexuality. The model bears something of a resemblance to full-cheeked Mary Evelyn Wrinch, though her face is turned too far toward the horizon to really know. But the half nude in the grass, with no hint of gravity pulling on her burgeoning breasts, certainly isn't George's forty-one-year-old wife. Instead, a very young woman, typically dressed from ankle to ear, has been disrobed down to a bare shift . . . Are we to think that she came to this dishabille by herself?

George shows her at the end of girlhood, all alone, as she looks openly, trustingly, toward the horizon.

2.

That summer, George ventured back to Onteora with the architectural plans he'd been asked to draw and began to build a church. He created an exquisite, intimate Arts and Crafts monument to the sacred. It does not give off the feel of denominational Christianity; it is a house of worship that imitates the hum of being deep in a forest temple. Inside the church, George painted soft-toned murals that released him from any stricture of size. He had to paint with huge gestures, arms extended. The fusion of architecture and painting was perfect for him; his art fell just at the nexus of the two, just as his year fell at the nexus of the sacred and the sexual.

Against the serenity of the chapel came the frenzy of that summer: supervising the construction, teaching the students—and then preparing paintings for a New York exhibit. He showed at the Seventeenth Annual Exhibition of the Society of American Artists in 1895, listing his Toronto address as "The Arcade."[1] His work *In a Daisy Field*[2] was chosen by a jury that included painters William Merritt Chase, Childe Hassam, and John Twachtman and sculptor Augustus Saint-Gaudens. *In a Daisy Field* hung in the grand galleries with these artists—as well as the work of Arthur Wesley Dow and Alice Beckington. Beckington went on to help found the American Society of Miniature Painters; she taught miniature painting at the Art Students League upstairs in that building from 1905 to 1916. Earlier one of her students was Mary Evelyn Wrinch.[3]

It's now a two-and-a-half-hour drive from Onteora to Manhattan—then it was either a boat ride down the Hudson River or a train ride. I can't pinpoint whether Mary and George made the easy journey to Manhattan from Onteora that summer or early fall to see George's painting hung. If they did, she may have come under the spell of the deeply atmospheric Tonalist paintings of John Twachtman. She was imbibing Tonalist tenets somewhere, if only from conversations at Onteora. Such efforts may have hibernated within her, sleeping for a decade before her imagination could use them.

But in 1895, as her husband was painting daisies and a bare-breasted girl in a meadow, Mary was not interested in diffused emotion. She was focused on a figure—a solid, fighting, theatrical man—in a ukiyo-e print that she had brought back from Paris during a time of freedom and romance when she was portrayed by her husband as a dreamer by a fireplace.

Mary Hiester Reid, *Chrysanthemums: A Japanese Arrangement*,
c. 1895, oil on canvas, 45.7 cm x 61.0 cm,
Art Gallery of Ontario, Toronto.

CHAPTER TWENTY-ONE

Chrysanthemums:
A Japanese Arrangement

I.

Time had snapped open like a paper fan. This year was not simply one of the numberless, overlapping waves in which one progresses through marriage and a life; 1895 contained the months when MHR painted one of the most splendid works of her career, *Chrysanthemums: A Japanese Arrangement*. Back from Onteora, in the quiet hours when George was teaching at the Central Ontario School of Art and Industrial Design, Mary came to the need for her own shift.

She set up her still life, positioning her ukiyo-e print by Kunisada of a Japanese kabuki actor on the wall. Below the fierce gray warrior, she placed a clutch of chrysanthemums. The mums, flowers of autumn and symbols of maturity in both East and West, tumble from the mouth of a blue-and-white ginger jar featuring three wise men. With a palette of deep colors and what looks like a flat brush, she issues her statement of strength. For the images of masculine power and wisdom, she evens the brushwork. But single, vivacious

strokes conjure up her bouquet of hardy blooms. They nod vigorously from their yellow centers, painted with a rapid feel and no fussiness.

Or is the painting one of sheer longing? Daniel Chen, adjunct curator of Chinese ceramics at Toronto's Gardiner Museum, notices that the vibrant blue of the ginger jar in this painting indicates that it may have been exported from China earlier than the ginger jar Mary featured in *Roses in a Vase*. Perhaps the jar arrived in the West in the late seventeenth or early eighteenth century and was passed down, as the ginger jars that George Washington owned were passed down through his wife Martha's children, symbols of white status in the new republic. This deep navy blue (as opposed to the lighter, greenish-blue of the travel scene on the other ginger jar she painted) depicts three Taoist immortals contemplating deer, emblems of the wish for auspiciousness and blessings—and, perhaps, the longing for freedom.

In a lively phone conversation with Chen from San Francisco on a May afternoon when Toronto was seized with huge gusts of wind and our cell phone connection went in and out, he described the lives of scholar officials, the sort of individuals who might meditate on the Taoist immortals. "They were well-read men," the urbane and animated curator explained, "but they were chained to their desks." In deadening routines, they worked on business and policy statements, office workers in silken robes. To relieve their boredom and to keep their dreams alive as they toiled at official documents, they positioned such imagery as the three Taoist immortals contemplating the deer before them. They would far rather have been strolling, "engaged

in philosophical conversation," Chen said. But imagery like this allowed them to "imagine themselves" in other lives.[1]

With the painting of *Chrysanthemums: A Japanese Arrangement*, Mary (or M.H. Reid as she signed this one, in a gender-obscuring flourish) imagined herself into another life, and she did it with considerable detail. In helping to source and date the Kunisada print, dealer Stuart Jackson guessed that it was one sheet of a triptych. He also noticed that Mary rendered the two cartouches in the print, one that would name the actor and the other the painter's signature.[2] She captures the print's two light sources: at the top right is a lantern and at the top left is the moon. It's a complex layout, a piece of a triptych included in a work of three major areas (the print, the flowers, and the vase). To use the musical terms she was fond of, she's in full vocal range.

Did she, in working out the composition, realize that she could take her husband away, lifting him out of the student adulation, away from Mary Evelyn Wrinch, and disengage them all from such complicated vectors of loyalty? For soon, she would turn up a job for herself—and travel to Spain. As she worked on the canvas, MHR was making more than a painterly arrangement: she was making a marital one. In 1896, the Reids up and left North America.

PART SEVEN

Spain

Mary Hiester Reid, *Castles in Spain* (central panel), c. 1896,
oil on canvas, 53.7 x 137.8 cm,
Art Gallery of Ontario, Toronto.

Castles in Spain

I.

For it seems that George dropped everything.

He went to his employer, the Central Ontario School of Art and Industrial Design, and secured a leave of absence.

He stopped badgering the city fathers to let him paint a mural at the new Toronto City Hall.[1]

He sent his third work off to the jury for the American Fine Arts Society. (But this was the last year he showed in those magnificent New York galleries on West 57th Street— and the exhibition catalog listed his address as Paris.[2])

He pried himself away from all he had started: paintings, projects, students, friendships.

Scissoring himself out of his own picture, he diverted all of the forward motion of his career to book a passage for two on the *Kaiser Wilhelm*. He would cross the Atlantic again with his wife, leaving the shadow Marys, his model Mary Jung and his student Mary Wrinch, behind.

For MHR had gotten herself a gig involving a fresh concept in Canada: a national cultural journal, *Massey's Magazine*. Her assignment was not as an illustrator but as a travel essayist, a sharp observer in print. It was George's job to be *her* illustrator.

2.

They packed their bags. In the dead of winter, on January 18, 1896, the Reids boarded a train for New York City with luggage for six months of travel.[3] Running away, slipping away, hurrying away—even perhaps storming away—this trip, their third transatlantic adventure à deux, returned them both to the framework of their marriage. The nascent seeds of a love triangle were ploughed under the waves. As Mary jolted in her berth on the *Kaiser Wilhelm*, crossing the wintery Atlantic, she was thrown free of the soft, juvenile breast in *Evening Star*, tossed free of Mrs. Jung's Madonna, sprung from the claustrophobia of the Toronto Arcade.

In the first year of the magazine, she was to create several of the planks of the cultural platform that *Massey's* built. As a self-possessed traveler—a girl who once had moved across North America, a young adult who then had journeyed back across her continent alone, and as a young woman who had sailed across an ocean twice and lived in Paris—she now intended to locate the general reader in the world of art, not only by writing about art but by writing about her own method of self-discovery: travel itself. Her

husband was coming along for her ride—and it would all take place in the home of her sister: Spain.

3.

Like a raconteur at a dinner party, in her first installment of "From Gibraltar to the Pyrenees," Mary reveals that she's an excellent scene-setter and wickedly willing to poke a little fun at people. Warm, gossipy, in her version of a Chaucerian pilgrimage, she introduces us to the characters she meets on the ship. First "was the distinguished painter . . . with his family and band of students." That's William Merritt Chase, the instigator of Shinnecock, after which they modeled their summer art school at Onteora. Chase boarded along with a cluster of his apprentices. "There was the bishop, in leggings, breeches, and black silk apron," chatty Mary adds, along with the "young German" and a "Briton with his theatrical-looking wife." Companionable, opinionated, grabbing a name that Frances Hodgson Burnett's popular novel coined, she zeroes in on "the fair-haired little girl" whom adults have dressed "in complete masculine attire" and "whom we had dubbed Little Lord Fauntleroy."

Within sight of Gibraltar, the pilgrims became transfixed by the "faint and blue" enormous rock on the horizon, "growing momentarily more definite." For Mary, Gibraltar was "realizing some, at least, dreams of our castles in Spain."[4]

4.

The coppers and umbers of MHR's triptych *Castles in Spain* are as subtly graded as the motivations for coming to Iberia. The three-part painting (a larger central section flanked by two smaller side panels) is stylized, something in the way Mary styled her prose. Her triptych contains the sunlit dream of turrets tucked far away on a dry hill, flanked by trees. She was returning to the spot where, nine years before, her sister had welcomed them, where George had drawn a portrait of the nun, and where she and her husband had been alone together and in love.

Yet Mary left no record that she and her sister were able to meet. Did the nun's order let Carrie go? When he was interviewed decades after, George didn't think to include it as important. For him, the stated reason for the trip was viewing the Velázquez paintings they had missed on their honeymoon.[5]

5.

Hotel agents boarded the ship before it landed, each one "in the hurry and scurry" hawking the advantages of their hostelries. Imperiously, Mary the travel queen demanded "to be escorted to 'Cook's'" (Cooks Travel Bureau) with "two men carrying our bags." She swept past "the unfortunates . . . who have not decided upon their hotel" and who "are badly pulled about in the efforts of the various agents to secure them."[6]

Efficient, observant, determined not to be taken advantage of, yet distracted by the odor of flowers—"how sweet are the violets and narcissi which an eager vender thrusts into our faces"—she arrived with her mate at "a very decent and moderate house in the quarter known as—Irish Town!" Mary mocks herself immediately: "Ye gods of sea and land! Have we come all these weary miles to find ourselves in Irish Town!"

She plunges us into her experiences of "old mossy walls, gateways and tiled roofs which are a joy to the eye . . . women with water jars . . . the donkeys with their . . . burdens of oranges, lemons, onions and tender green lettuce; the herds of silky haired goats which early in the morning are driven through the streets and milked at various doors." Each description layers another unpainted canvas before us, and hints of unwritten novels, too. After she notices "a fair-haired little English housewife bargaining for a pair of chickens with a handsome young Moor," she pauses to wonder at "what a strange coming together of East and West it was."[7]

As she passed the figures of the British soldiers, "the marks of military possession" of a "garrison town," she detailed statistics, the height of the Rock (1,340 feet), the population (25,000), the year the British obtained possession of the much-disputed peninsula (1704), disagreeing succinctly with the guidebooks and giving her own advice: "The guide books unite in declaring that Gibraltar is not picturesque. *Do not believe them.*"[8]

6.

To sketch in Gibraltar required a permit, which the Reids obtained, and it seems Mary went off to sketch alone, observed by "about fifteen men and boys who had gathered to watch my operations." "The Highlander [guard] on duty near me charged gallantly . . . but though he was answered by some of them in unmistakably impertinent English I found that they did not venture to return."

Advice-giver, she mentors her readers: "Let no one be deterred from visiting this beautiful southern peninsula on account of not knowing the language." She finds "that English and a little French, no matter how poor, suffice," and goes on to say she learned four words: "first *gracias*, that I might be able to thank them in their own tongue; second, *cuanto, how much*, the necessity for which is obvious." What? Has she forgotten that she spent time navigating Spain and studying Spanish earlier in her life?

Mary has developed a persona! She is an almost-Mary, a Mary as traveler. Anticipating what she thinks her reader would need to hear, she erases her worldliness in favor of a sensible turn-of-the-century women's-pages voice, the voice a bit like that of Florence Hartley's etiquette manual.[9] When she ponders which word she will take as the fourth, (the third was mañana, tomorrow), she tells a kind of fairy tale:

> but when I came to the fourth [useful word], I
> was in almost as great a difficulty as the favored
> mortal to whom the fairy godmother has granted
> a limited number of wishes. However, I at last

decided upon *agua caliente*, hot water, as repre-
senting an absolutely indispensable article.

After this, she congratulates herself on not learning
"stilted phrases found in all the phrase books,"[10] instead rely-
ing on only four choices (plus her French). Does the fact that
she poses as a first timer make her unreliable, or just a writer
who knows her audience—or simply a person with so deep
a longing for the freshness of that first experience that she is
willing to erase it just to have it again? These are the contra-
dictions that made Mary very much who she was, a woman
whose social mask was sewn inside a deep division between
public and private life, a woman with a willingness—even
an eagerness—to transform to meet the expectations of her
readers, the once-little girl, then the young woman who lived
politely as her relatives' guest.

Day by day, she tracked her steps with George toward
the dream castle, like St. Teresa's spiritual castle, a state to be
longed for. Day by day, she wrote their steps down, having
walked miles together, just the two of them—those dream
turrets a little closer in the imagination, refreshed. We can
learn a lot about someone's personality from syntax and
word choice. She has an easy flow. She is rarely pompous,
usually relaxed. She presumes a kind of equality with her
reader, yet she is a firm, even if gentle, advisor. Persona or
not, I believed her because she seemed true to her reactions:
excited, afraid, thrilled, cautious, exuberant. And above all,
for me as a word person, this is the place where, except for
a handful of letters, she drenched a novella-size three-part
long-form piece of journalism in words, words, words.

7.

We all need parents throughout our lives, even in age, and those of us with deceased parents can still be nurtured by the memories of those individuals. What hunger did this new location provoke in Mary as her steps dislodged old unconscious patterns? Somehow the ghost of her father, dead since her infancy, came to feed her. With "a treasured smelling bottle" to sniff against all the street odors, "a square of linen doing duty as a handkerchief" and "a few . . . coins" nestled in her skirt pocket, she approached the excavations in the Rock with George. On the way, she had "the good fortune to see a number of the monkeys" as they leapt about, and mused that they came from "Barbary Apes," even then going extinct. She stopped her whole travel article to describe her unconscious fears. When she entered "a particularly dark and damp passage" of the gun galleries inside the Rock, she vividly fantasized about a hungry father Barbary ape ("a really spirited parent") who needed to feed his family. There, in the leaky caves, that ape father appeared in her imagination, giving her "a secret thrill of apprehension" at his "agility,"[11] and at the same time frightening her with his "spirited" desire to satisfy the hunger of his little ones.

The dislocation of travel is like stirring a tidal pool with a stick. Out of the pool comes all of the life that has been quietly anchored there. Fantasies and memories bubble up in the mind, and, Mary writes, "my fears rose again." (Just as she wrote those words, Sigmund Freud employed the

word psychoanalysis for the first time.[12]) Like anyone in discomfort, Mary wants to escape.

"Altogether I felt very much relieved to get out of the place."[13]

8.

They set out for Ronda, then Malaga, then eight hours in the dark to Granada. After the confusion at the train station came "a jolting journey of half-an-hour through the streets and up the steep hills which lead to that part on which the Alhambra stands." At last they arrived at a "hospitable inn" with the unlikely name of Washington Irving and fell "asleep with the soft plash of a fountain in our ears, and the blissful consciousness that the Alhambra was at our very doors."[14]

The next day, she relishes being amazed. "I must confess that before seeing the Alhambra I had thought of it as a beautiful toy, commanding a sort of indulgent admiration, and was surprised and delighted to find it so impressive." She gives its history and sweeps her audience inside: "In the glazed tiles we have, of course, the original colors, almost invariably rich blues and greens, but from the stucco work nearly all color has gone, leaving it an ivory white."[15]

Meanwhile, her mate assists her with the sketches that will provide the illustrations for her article. He draws the Southport Gate, Gibraltar, the Moorish Bridge at Ronda, a caped man who frightened his wife, the Gate of Wine at

the Alhambra. Mary's candor, the ability to tell a story about herself, her humor and ease mark a flexible personality with a full palette of contradictory emotions. The anxiety she expresses is part of her fascination with the new. She can be absorbed by the monkeys—and at the same time have a fearful fantasy about a father ape. She's dazzled by the costumes, describing a caped man but then calls him a villain. She counters each instant of her curiosity with fear. Then she partly overcomes the fear in order to go on.

She is not a bold, fearless fictional heroine. She is human and complex, in the throes of contradictory responses. She ventures out, gets scared, reckons, ventures out again. Curiosity drives her. She wants to see, to observe, to absorb—and to describe—yet she wants the warm cloak of the familiar as well.

Requesting their coffee for seven thirty a.m., and surprised actually to get it, they congratulated themselves "upon not looking like 'tourist bodies'; we carried no bright red book, nor did we have field-glasses or satchels over our shoulders." But like all tourists, they were readily identifiable. A young woman with an infant selling violets besieged them, a "handsome" fellow "who aspired to act as guide," and a "Gipsy King . . . wearing fantastic dress, who both wanted to sell us his photograph and to pose for us (he had noticed that we carried sketching traps). We resolutely declined all offers." But they all were persistent, and Mary caved.

I feel bound to add that later on in our stay we weakly did all of the things which we had refused so emphatically at the outset. I delighted the woman with the baby by buying violets which I really did not know what to do with, we employed Juan, who indefatigably dragged us from one point to another, we sketched the old 'Gipsy King,' and yes, I must confess it—we even bought his photograph.[16]

What is so worth reading, in four long columns about the Alhambra, is Mary's smooth apprehension of what we now perceive as impossibly opposing cultures. She delves into the history of the Christian and Moorish influences, full of facts and cautious with conjecture: "In a small room at the entrance of this court is a vase, about four feet high … and ornamented with two animals like llamas or camels. As the Moors were forbidden by the Koran [sic] to represent animal life, these two departures from their customs were probably the work of Christians."[17] Yet she also feels free to comment condescendingly on hygiene levels: "By the way, whenever I see these fine old fountains in the vicinity of what was once a Mohammedan place of prayer, I regret that frequent ablutions have not been made obligatory by the Christian religion; a really *clean* Spain would be such a delight."[18]

INTERLUDE

As the Reids fled their entanglements, so my husband and I had fled Toronto. The third party in our marriage had not taken the shape of an adorable student or a sexy model; it wasn't the intrusion of possible new love, but the intrusion of possible death. Mike had been diagnosed with his ninth melanoma recurrence, and our escape to Spain was a prologue to his entering what became three years of a targeted gene therapy drug trial. Well past the end of the drug trial, we lived again, as we had for decades, with cancer merely as a chronic disease. But in Spain, not only did I think I might be losing him, I was also losing the shape of a marriage that I had depended on.

Tracking Mary to the Prado from our hotel in Madrid, I was shocked at the ease with which we could pick up the couple's trail, though part of my mind was seized by the upcoming drug trial. I have often at these times of illness experienced his condition as a third party in our marriage, drawing my husband's attention. I sensed him retreat into a frozen place of infirmity, like that cave Mary described in the Rock. Mary, in the last years of the nineteenth century, had been watching her husband remove himself into a place of attachment to other models, other adorations. A

twenty-first-century couple tracking a nineteenth-century couple—a woman whose husband's affections have strayed and a woman whose husband's attentions have riveted on his health—it's hardly the same. Yet, as we walked where they walked, we had more in common at that moment than I would have thought.

Mary Hiester Reid, Canadian, 1854–1921, *Castles in Spain*,
side panels, c. 1896, oil on canvas, overall: 53.7 x 138.8 cm.
Gift of the Gordon Conn–Mary E. Winch Trust, Toronto,
1970, 70/18, © Art Gallery of Ontario.

Madrid and the Prado

I.

I could not replicate the same time of year that Mary visited Madrid. She was there in spring. We went in the fall, having been warned by my Spanish teacher that my Spanish was so awful I must never stray from my hotel. In the long halls of the Prado, devoid of the tourist lines of summer, we could hear the slight smack of our rubber soles against the floors, and it was easy to conjure up the slap of the leather soles that the Reids would have worn as we headed for room 12, the Velázquez royal portrait room.

"A journey to Madrid to study these masterpieces is worth all the expenditure of time and trouble it requires," Mary wrote, "for to see them is an education one cannot afford to miss." Knowing that our eyes were locked on what their eyes saw 119 years before seemed to cut a rind of existence away. About Velázquez, Mary wrote, "The combination of freedom and handling with perfect tone and beauty of color had certainly never been equaled . . . His painting is robust, with no affectations; realistic, yet with

infinite delicacy of modeling." Freedom. No affectations. Viewing the same thing another person looked at a century before supplied us a snap of connection. "A picture must always be a satisfying thing to look at," she insisted.

Mary dropped her women's pages tone entirely when she showed herself as a critic; about painting she was never coy. "Some of Whistler's, some of Sargent's canvases approach these, but in the former, one so often finds a lack of color sometimes called a refinement of color, or a certain crudeness, and in the latter, a suggestion of *paint* which one never feels in Velasquez [sic]."[1]

We joined the crowd at the Prado around *Las Meninas*, the portrait of the royal family that includes Velázquez himself as the portraitist, his most complex and beloved painting, of enormous dimensions compared to Mary's still life work, and even compared to George's large paintings. "There is probably nowhere a finer portrait picture than the group known as Las Meninas," Mary wrote, "full of character, faithfully portraying the period, even to the dwarfs and dogs, yet giving us a picture, which, in itself, without connection with historical personages, must always be a satisfying thing to look at."[2]

Beyond us, a painter had set up an easel to copy the masterwork, just as artists were doing when Mary stood before this opus. William Merritt Chase and his students traipsed there daily to set up their easels and copy. "They were all working with the greatest enthusiasm at the Museum," Mary observed, ". . . painting with loving care those canvases of Velasquez [sic] and Greco which are so dear to the

artist." The apprentices absorbed art through their imitating hands. Copying was—and is—a form of learning. "The museum was like one vast atelier," Mary decided, "and to study in it was a genuine pleasure."[3] "Genuine" is a word she uses more than once. Painting (and, to a certain degree, the dislocation of travel) is so absorbing that it can relieve a person from wearing a socially constructed self. Free of "musts" and "shoulds," the student engrossed in rendering a copy can suspend time, as if the apprentice's hand were gripping the ghost hand of the historic artist.

Velázquez's *Las Meninas* triggered Mary to expostulate on form and content.

> Yet there is not, in this great picture, nor in any of his which I have seen, that 'separation of the method of expression from the idea to be expressed,' which George Moor [sic] says is the 'sure sign of decadence.'[4]

What does it really mean to separate the method of expression from the idea to be expressed? Well, to take the time to develop expertise means, at the first stage, to separate the *practice* of communicating from the *urge* to convey something. (Yet you cannot exercise your skill without something—a vision, a concept, an image—to explore.) Initially, emotion is fettered in the brush (or the pen, or any instrument), but as you grow more skilled, a subtle line is crossed, and emotion becomes *un*fettered *from* that brush. Perhaps that's the best of what it means to loosen up.

2.

Loosened up in Madrid, George sketched Mary looking out from their balcony. Did she allow him? Or did he sneak it? It was years since he cast her as the dour-faced woman in *Mortgaging the Homestead*. He draws her from the back and side, leaning over the wrought-iron railing, looking down at the rooftops and a church tower. It's an open, engaged angle—and a loving portrait. Her pose is youthful and intent. He labels it like a snapshot, *A High Balcony, Madrid*. To sketch someone is to observe not the role but the posture, the attitude, and, in the neutral way of describing, the bare personality of the subject. Even if you are sketching someone you dislike, you come to appreciate the angle of the head, the slide of the nose. Close observation ultimately equals appreciation. And George was brought again to his wife as he sketched her craning out to see the view.

They left Velázquez and Madrid for charming Segovia and landed at a terrible hotel which she wrote about.

> Our hotel was the 'Burgalessa,' chosen, I think, more because it had a pronounceable name than on account of any acquaintance with its merits; the other . . . repelled us for some reason, but I would say to possible travelers to Segovia, *take the other*; it cannot possibly be any worse than the 'Burgalessa,' and there is a wide range of possibility of its being better.

What traveler of this kind hasn't made an awful mistake in the choice of hotel? Making the best of it is part of her charm: "And yet, to be perfectly just, we had a most enjoyable view from the balcony."[5]

Mary both endured the rules of all the cultural prejudices of her day and participated in them. Dark haired and dark eyed, she was predisposed toward blondes: "It is true that light hair and eyes have still what economists would call a 'scarcity value,' but every here and there a blond head appears, a refreshing sight after all the duskiness of the south."[6] Thoroughly North American, a proper settler lady, she internalized the intolerances of her culture, even to the point of enacting them on herself. She played a fruitless game of typecasting people. Readers today would wince at her stereotypes: the Spaniards with their "dark skins" have "a national tendency to procrastinate."[7] She is caught in all the contradictions of her time.

Yet travel also made Mary a tolerant person, if only because life in distant places gave her psychological distance, uncoupling everyday automatic responses. Like twenty-first-century experiments in body cognition,[8] where the idea of moving intertwines with what moves us emotionally, as Mary and George observed and moved, they seem to be observing and moving one another. The *Massey's Magazine* article collaboration with George as the silent sketcher gave Mary the liberty of her cranky opinions. "To be quite candid, the repetition of the shells is tiring," she complains of Casa de las Conchas in Salamanca, its exterior walls patterned in shells, like a "piece of spotted print."[9]

After my husband and I trekked past the polka-dotted shell house, we meandered to the Roman bridge that Mary wandered to, then sat down with a snack. At night, we heard trucks roar past the lovely Hotel Rector. (Unlike the dreaded Burgalessa, I'd highly recommend it.) And we found the ochre square where she was mobbed by a throng of students.

> It was a distinct relief to me one sleepy afternoon, as I sat making a note in pencil of this doorway, to have fifteen or twenty young students rush out from one of the class-rooms with a shout such as I had supposed was the peculiar privilege of American youth during the years allotted to mental culture; it was refreshing to hear a really hearty sound, and to set eyes on something young in the midst of all the age and mustiness and general dilapidation.

She loved the rush of the young men—recalling the art students who hurried to Eakins's classes. But a woman alone in Salamanca, "unless unmistakably a working woman, was an unaccustomed sight." To them, she was a strange lady-object in a dark travel dress. "I must confess, though, that they were a bit rude. . . . How anxious they were to find out what language I understood: French, German and Spanish they tried," as they milled about her. But she wouldn't stop what she was doing: "I went on cheerfully with my sketch, occasionally waving them aside when they obstructed my view."[10]

Her singular trait of going on cheerfully probably defines her entire way of being. No matter what, she brushed aside obstructions if she could. The combination of perseverance and good spirits made the woman who wrote lists of her paintings and how much they sold for, and who now packed and unpacked from the south to the north of Spain while recording her reactions in writing. She is a testament to the idea that a person can *decide* what to feel. Like choosing colors on a palette, or choosing words, she cultivated her optimism. This wasn't unrealistic joyfulness but a go-toward-the-positive stance.

When George appeared, the threat of the students dissolved, "and a little later," Mary "enjoyed their evident discomfiture when they discovered I was not entirely alone; they fell back quite deferentially as we walked away." Her bearded husband, her sketcher, had been in the shadows behind her. "What a difference the presence of a man makes!"[11] she exclaimed, with all the levels of complicated support that implies.

3.

I had been following Mary for three years, while my well-wife support systems were fraying. The therapist who helped me cope with my husband's illness (devising ways to keep my own life going) had a stroke and closed her practice. A good friend's husband died, and she cut off from her former companions—me among them. Here I was, tracking a

mute subject born in early April like my long-dead sister, and who, I had to confess, looked a lot like my long-dead mother and bore a resemblance to my great-grandmother Molly McMann (born about ten years after Mary). As Mike's illness became more complex and demanding, I wondered, Should I just give Mary up?

But why give up on a woman who didn't give up? Because I couldn't get an internet connection on my laptop in a hospital waiting room? Or because I hadn't found a diary that said "I discovered my husband naked with our student"? Or a letter that whined "I feel like leaving George"?

Mary was not our contemporary. She did not think like a modern "us." Her world was not our world. No one then threw off their stays and corsets in the flash of hot sex— getting her clothes off took more time than an MRI.

Yet.

How many people in our world would like to cultivate her persistence?

My husband said cheerfully, "What's the agenda?" The agenda was to go to Burgos Cathedral. It was hardly a place to find "a shepherd with his belated flock," [12] as Mary saw. We barely found a parking place for our little car. But, as she instructed, the cathedral was worth it—"so fine with its airy spires, many statues and delicate pinnacles" that MHR "dreaded to go in lest I be disappointed; but the interior is scarcely less satisfactory . . . and the eye wanders with delight from the massive sculptured pillars and wonderfully wrought railings, to the glorious rose window and the lantern or dome." [13] It is a delicate, frothy, satisfying Gothic fantasy. "We knew we would miss the cathedral," Mary wrote,

making a Tonalist painting in words for her long farewell to Burgos, "beautiful from every point of view, but, perhaps, particularly so at sunset, seen from a distance against a tender sky of rose and violet, with tall poplars clustering about it, and mingling with its own slender spires; in the foreground a winding road, and sometimes a shepherd with his belated flock."[14] From here, she and George would head north, passing San Sebastian and heading through the Pyrenees, up through France to Paris.

The tone of her third and last *Massey's* article feels calmly confident. Something in her, like the stained-glass windows, seems to have annealed—or healed. At this point, her prose suggests that she is solid, going forward. She and George would travel on to Paris, the city that made them both as artists. "We had been living with the past," she wrote of leaving Burgos, "and the present was waiting to take us back."[15]

My husband and I went back to Toronto and changed our lives forever. The ninth recurrence and drug trial put us into a new relationship. Some of what we were used to doing and being for the last quarter century would permanently alter. In some essential way, the "we" of our marriage would not be the same. We entered a horrible year, and I lost touch with Mary after all. Then twelve months passed. Mike found a routine and a pattern. I slowly adjusted to a new him. Somewhere about the 140th day, he cracked a joke. And so, things were not the same but still the same. I looked once more to see how Mary was handling her life. Going on with her task.

I returned as she was saying her prolonged and soft goodbye to Spain and understood once more that this

ochre and umber country was the home of her sister, who
had joined a larger flock of sisters in her convent. Despite
Mary's supremely documented trip, I couldn't tell you
whether they connected, and I certainly tried to find out.
I can only read her words as a poet reads them: the good-
bye she composed is a statement of longing, a farewell to
something supple, beautiful, psychically embedded, like
a relationship so deep it is present in every move. Even
if she didn't lay eyes on her sister or speak to her in the
English Carrie rarely used, a seeking hunger for the sensu-
ous, instant, genetic connection between siblings is there in
the atmosphere of the words of this artist who painted the
ache of tones. She wrote her goodbye in prose, but it falls
into lines of poetry:

> Good-bye to the sleepy, old towns,
> the picturesque beggars, the jogging railway
> trains;
> good-bye to the mantilla and cloak,
> the guitar and castanets; good-bye
> to all the heroes of chivalry, Moorish and
> Christian,
> with whose deeds we had become so familiar,
> to the palaces they had lived in and
> the churches where they had worshipped;
> good-bye to all the glorious past, and
> to the decaying but still beautiful present.[16]

INTERLUDE

Mary Evelyn Wrinch's life changed during the Reids' months abroad. Fascinated by miniatures for several years, she studied the techniques of miniature painting in Toronto with elderly, British Miss Hemming. In the aura of the older lady's teaching, Wrinch took a sidestep from painting in oils to watercolor on ivory with the tiniest of brushes.[17] In London in 1896, Alyn Williams founded the Society of Miniature Painters, an attempt to rejuvenate the Renaissance art form.[18] Similar to the Arts and Crafts movement's renewal of handicraft and opposition to industrial manufacturing, the miniaturist movement aimed to replicate practices that required hours of execution with the thinnest of brushes. In that same year, the Gallery in New Bond Street hosted the first show of miniatures in London. The diminutive portraits, complex as tiny flowers, were a magnet for anyone interested in technique, and certainly for those fascinated by the past.[19]

But in the present, and in the absence of the Reids, more significant changes were to come. Her studio-mate, Henrietta Moodie Vickers, planned to depart for Tangiers.[20] This prompted Mary Evelyn to think about the atelier they shared next to George in the Arcade. Without his present

influence, she decided to leave the Arcade, to go out on her own, and she began looking for a new workspace. She discovered one on Imperial Lane, off Yonge and Shuter Streets, and also found an artist to share the space with— Clara Hagarty, the flower painter. By 1897, all was reconfigured. Mary Evelyn Wrinch, twenty years old, was painting in new quarters, a talented young woman on her own.[21]

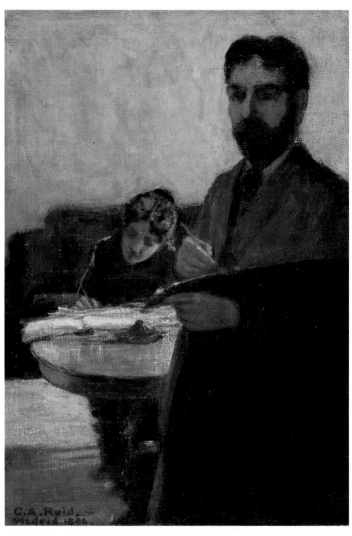

George Agnew Reid, *Sketch Portraits of
George Agnew Reid and Mary Hiester Reid*, 1896,
oil on canvas, 34.9 x 24.4 cm,
Art Gallery of Ontario, Toronto.

A Husband Sketches a Marriage

I.

In "the decaying but still beautiful present" of Paris, Mary and George passed the former studio of George's friend Paul Peel, found it vacant, and, in the ghostly shock of remembering the young painter's death, rented the place for two months.[1] They were bent on recapturing their original Paris stay, engineering a kind of Great Return to their earlier years in the city, even to the point of re-enrolling at the Académie Julian for George and the Académie Colarossi for Mary. This time, they ignored classical techniques and embraced those of Impressionism. Yet Impressionism was no longer new; by then, the methods of painters like Renoir and Monet were codified enough to be taught at both academies. Though, for Europeans, those Impressionist techniques were already more derriere than avant garde, the easy, obvious brushstrokes, where color is laid side by side, engrossed the couple. They were alone together—and side by side.

As they spent April and May of 1896 furiously producing new work, George entered a double portrait he had done in Madrid in the competition for the Paris Salon. *Sketch Portraits of George Agnew Reid and Mary Hiester Reid* was accepted. It was a picture of their marriage—from his point of view. Prominently bearded, l'artiste at his easel, George placed himself as the central figure in the foreground. Behind him, he positioned Mary *not* as a painter but as a writer. Though the work portrays a traditional and deeply sexist arrangement, the figures exist in the glow of working together, one at her writing (head partly down), the other at his oils. It is a nineteenth-century depiction of Work and Love. "Couldn't I for once have you and the work at the same time?" Sigmund Freud famously wrote a decade before when wooing his future wife, Martha Bernays.[2]

In *Sketch Portraits* neither figure looks at the other. She gazes down, he out and away. She has his back, as well as her own industry. He is a man whose eye is on his work—not on another woman.

2.

Paris was like a refrain: they met the same sentiments and the same rhythms as the first time, but in a different spot in their unfolding song. George became attached to the work of Rodin's favorite painter, the muralist Pierre Puvis de Chavannes, whose symbolist paintings with pale figures against decorative backgrounds earned him the sobriquet "the painter for France."[3] George spent hours studying Puvis

de Chavannes's work at the Pantheon and the Sorbonne.[4] Under this influence, he now saw himself as the painter for Canada and his interest swung toward public art and murals.

Mary, for her part, doubled down on her commitment to still lifes, bringing a new range of colors to her work—yellow would never be merely yellow again, nor gray merely gray. You can't step twice into the same river, Heraclitus reminds us, though for two months they tried—and seemed to succeed. Paris united them again with their art and their careers. By the time George and Mary sailed for New York on the Dutch ship *Spaarndam*,[5] they were focused and forward moving. They made it to New York and headed up the Hudson to Onteora by mid-June, in time to welcome a new group of painting students for the summer.

They were in sync.

On March 18, 1897, Elizabeth Cooper Wrinch passed away at age fifty-seven. Mary Evelyn stood at her mother's graveside in Toronto's St. James Cemetery beneath the gloomy pines. She was an orphan now. A woman on her own might supplement her future income by learning to paint miniatures and sell them, keeping a small household thriving. Miniatures would be less expensive to create than paintings on canvas or board—though, as she may or may not have put into her equations then, they consume quite as much time.

In the grief at the loss of mother-daughter bonds, for they had traveled together back and forth across the ocean and settled into Toronto together, and her mother had supported all her art education, Mary Evelyn made a decision, just as Mary Hiester had made a decision at about the same age when her own mother died. Later that year, Mary Evelyn paid for an ocean voyage, crossing the Atlantic to London, determined to study the art of miniature painting with Alyn Williams at the Society of Miniatures.[6] She would be in Britain—far, far away from the influence of George Reid who was continuing to enlarge his painting proportions.

Under the tutelage of Alyn Williams Mary Evelyn made art with the smallest of movements of the elbow and wrist. Instead of standing yards or feet from a wall or an easel to examine progress, she hovered over what she did. She focused on something small that was also a world, training her eye on translating the human face into the size of a pocket mirror. With a brushstroke, the miniaturist rescales the large and moves, monitors, manages, and rules it. Small things appear to make gods of their human makers.

But after only a year of study, she departed in 1898 for life in Canada again, a nascent miniaturist. Thoroughly on her own, she was still hungry for more practice, more knowledge—and more independence. By the winter of 1899, she made her way to New York City. Intrepid, determined, gifted, the twenty-one-year-old settled in to learn from Alice Beckington.[7] Beckington, who had studied at the Académie Julian in Paris, was a founding member of the American Society of Miniature Painters in 1899 and later taught these techniques at the Art Students League.[8] In New York, Mary Evelyn made even surer progress, learning the techniques of expressive portraiture—at small, but electric, dimensions.

PART EIGHT

Arts
&
Crafts

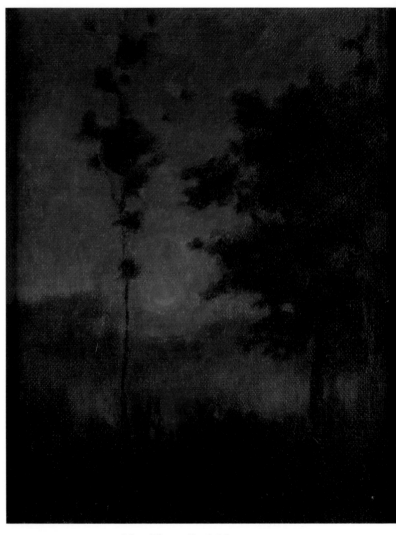

Mary Hiester Reid, *Moonrise*, 1898,
oil on canvas, 50.8 x 40.6 cm,
City of Toronto Art Collection, Toronto.

Moonrise

I.

A solo tree.

Mary plunged into nature. Abandoning the captivity of flowers in interiors, she took herself through a threshold to the outdoors, painting *Moonrise* at Onteora in 1898 on the land of the Lenape. One of her first mature landscapes, it snubs the obvious division into three in favor of a human-shaped figure, raising its arms to the sky.

Painting en plein air requires packing up the paints, the palette, the canvas, the easel, and the campstool. It is like traveling on a small scale. Even if the remove is only yards or meters away, going to each site becomes a mini-voyage. She might very well have finished the landscapes in her studio at colder times of the year, but their inspiration is outdoor light, from April through October—and specific times of day, too. These are before breakfast, and after supper, when she was not called upon to respond to others, when the tasks of the day have either not yet begun or are over—and she could take herself off alone. By venturing

outside, she removed the impediment of being available inside a house—at the mercy of tradesman who call, the woman who comes to wash up, not to mention friends (no phones to announce an arrival), students, and certainly a husband. The boundaries of her subject loosened, becoming much more mysterious, partly the result of having to paint when the light was low and she could see less. Her palette changed to vivid blue-greens. Her harvest moon, orange, full, and low, almost becomes a sun.

With *Moonrise* she softens borders, going for the opposite of crisp and clear, embracing the mysteriousness that low light presents. For the next fifteen years, she will paint landscapes and gardens en plein air, another *Moonrise* and *Moonrise October* (undated, after 1900), as well as *Afternoon Sunlight* (1903), *After Sunset* (1903), *Summer Landscape* (c. 1905), *After the Snowfall* (c. 1905), *Nightfall* (1910), and *At Twilight, Wychwood Park* (1911).[1]

2.

When Robert Browning, whom Mary refers to in her travelogue, wrote "Two in the Campagna," he and Elizabeth Barrett Browning had been married about eight years. "Two in the Campagna" is a candid love poem, written about two working poets who are married and, despite all the household demands (as well, in the Brownings' case, as child-rearing and illness), continue to share the art they practice. The poem offers a wonderfully mature view of

marriage, and it is highly visual—a word painting that uses blurred landscape imagery to convey a nuanced view of long-term love.

> I wonder do you feel today
> As I have felt since, hand in hand,
> We sat down on the grass, to stray
> In spirit better through the land . . .

One partner asks the other to "touch" "a thought" with him, an evanescent thought, like spider thread. "Help me to hold it!" he exclaims, even as a Tonalist painting aims to hold a moment of transitional light. The thought flees through the countryside, "First it left the yellowing fennel," then ends up in "one small orange cup" with "five beetles . . . blind and green." "Hold it fast!" Browning shouts among the "endless fleece" of the "feathery grasses everywhere"[2] that one can sense in the feathery strokes of *Moonrise*.

MHR is after the ineffable, the subject of lyric poetry: the feeling of that rising moon. Because she aims to get at something that can't quite clearly be seen—one cannot shine a bright light on the moon—she seeks what she only partly perceives. It's a mature stance: tolerant of ambiguity, as a woman in her mid-forties is fortunate to be. But a hard reality connects "Two in the Campagna" to *Moonrise*.

> I would that you were all to me,
> You that are just so much, no more

In a working partnership of artists, where art is primary, neither person is "all" to the other. From a solely romantic point of view, to be "just so much, no more" can feel desperately sad, but the knowledge that personalities have limits (just as lines of poems do) allows for compassion to enter the arena of passion. Working on canvas in a way that lets her skill so easily combine with her intuition, Mary gives a viewer to understand that life is both complex and mysterious, that boundaries slip and slide, that every part does not fit every other part, even as every nook of one person does not fit every cranny of the other.

3.

When Candace Wheeler described the landscape of Onteora in the Catskill Mountains, she detailed exactly the placement of *Moonrise*.

> It was a view of mountain-tops with blue wavering mists lying in the valleys, and sun-struck patches of forest above them. On the east was a great *triangle* where Round Top and High Peak—the "cloud maker and cloud breaker" of the Indians, sloped away from each other; the space between filled with a far-off opalescent plane of miles of the Hudson Valley, and beyond them the Berkshires built against the distance in shadowy tints of violet and indigo.[3]

The "shadowy tints of violet and indigo" form MHR's palette. Round Top and High Peak preside in the background with their "great triangle"—and a u-shape between providing a loop for the sun. In the Onteora archives, a photograph of this same view displays both the mountains and the single tree, with the Bear and Fox Inn positioned on the left and the lodge and main gate at center. It looks like MHR painted the work from the veranda of the Bear and Fox.[4]

In the dreamy landscape of *Moonrise*, we don't know where the tree stops and the earth starts. In that interim area, abstraction can begin. The painting's just as dynamic as Mary's still lifes, though it *isn't* still. It's active, glowing with its assertion: one tree insistent, individual, standing up—and standing up for itself—placed against that eternally feminine astronomical body, the moon, rising.

Mary's turn toward landscape coincided with the surge of women's suffrage. The urge to get out of the house economically and politically happened just when she was coaxing herself toward an art that dissolved clear boundaries. Women's strict roles were beginning to dissolve, too, prompting a misogynist backlash. Rabid anti-suffragist Stephen Leacock even lamented about what would happen to the celebration of Christmas if women had jobs.[5] But the prevailing atmosphere at Onteora was subtler, harder to defend against. The condescension and the easy humor struck off women's habits were part of the fabric of living at the colony. Mark Twain, while at the Bear and Fox, quipped that the inn's "walls were so thin you could hear a young

lady next door change her mind."[6] Jokes about the habits of "ladies" were the air that Mary breathed.

4.

Women's mock parliaments,[7] Canadian satirical plays written by suffragists, were staged as a day in an imaginary parliament populated only by women. Sometimes over fifty actresses were involved. Each play would open with a parliamentary question period, and such questions as "Would the government ban men working as teachers once they married?" would be posed. Then the actress members of parliament would agree that "matrimony must end a man's teaching career." New laws would be proposed, such as banning men from wearing knickerbockers when they rode bicycles, or a "ten o'clock curfew for men on the street who were unaccompanied by their wives."[8] While Mary was sending home her travel articles from Spain, feminist actresses held a mock parliament in the newly reconstructed pagoda-like building of Toronto's Allan Gardens conservatory. With turn-the-tables wit and sly humor, a number were staged across Canada between 1896 and 1915, "a highly popular and distinctly Canadian form of suffrage spectacle."[9]

At Onteora, Mary lived among women making their own ways in the world, both a legacy of the fourteen female vice-presidents of the first board of directors as well as Candace Wheeler and her sister-in-law Jeannette Thurber.[10] Because at this time there was no running water, no electricity, and no nascent telephone service (even though the

new leadership supplanting Wheeler made inroads toward citifying the place), the members of Onteora made their own music, their own theater, their own cuisine, their own paths through the woods, their own swimming holes, their own tennis, their own golf, and their own summer fairs. The summer fairs—with produce and games and animals as well as, in former Onteora Club librarian E. Davis Gaillard's account, "auctions, Punch and Judy shows, goat rides, temples of fortune, vaudeville, and a host of other imaginative activities"[11]—brought the larger community to Onteora, particularly in the glory years of 1898 to 1906.

Although Candace Wheeler and Jeannette Thurber established the atmosphere of creative play, it was George Reid who took that atmosphere and turned it into houses. Now in his late thirties, he went into a frenzy of building and money-making, completing nearly ten Arts and Crafts cottages at Onteora from 1897 to 1902, becoming the secret Canadian architect of an American institution.[12]

5.

His Canadian identity was paramount to George; he endured a reactionary storm that seized his career after he returned from Spain and Paris. Castigated for embracing European Impressionism instead of Canadian realism, he was still determined to be Canada's painter—especially since there was a mural competition for a theater in Ottawa. In the end, though, Frederick Challener, the former student inspired by Mary's roses, received the commission. Then George had

to reckon with a painter he had trained superseding him. Whether he felt pierced or just a prick of jealousy, he summoned up his personal connections to reapproach the city fathers with a new plan for murals in City Hall.

This time he insured that he would succeed: he proposed in 1897 that the murals be executed at his own (which also means his wife's) expense. George and Mary paid to jumpstart his career as a muralist. Combining his painter's eye with his architect's knack, he demonstrated the level of his grandiosity and his willingness to part with personal money required to achieve his goal.[13] (Today if you tour Toronto's Old City Hall and look at the murals, you'll know who foot the bill.)

The woodsy freedom of summers painting in Onteora presented a painful contrast to the small city studios of the Toronto Arcade, where the Reids worked among George's students and other painters. Each year, the return from the expanse of their studio-house and the trails at Onteora to the smaller, more communal living quarters chafed. After erecting so many houses for others, couldn't George design and build a year-round house of his own, perhaps based on their Onteora studio-house? Perhaps he could devise a structure to house a marriage and two artists and get away from busy, noisy, distracting Toronto, a city that was growing every which way before any concept of urban planning. George and Mary located a plot of land on the western edge of Toronto near High Park in a spot that wasn't rural (rural houses, for George, felt "separated too much") but also wasn't urban, where houses are "huddled."[14] Their friends the painters Gustav and Ellen Hahn as well as the architect Eden

Smith and jeweler William Reid (no relation) were design-
ing and erecting houses in nearby lots.

In drawing plans, George relied on the principles of
Bonnie Brae at Onteora, a stucco and half-timber monument
to the marriage of two working artists within a community
of artists. Building began. Just at the crest of the twentieth
century, George finished the quasi-Elizabethan Arts and
Crafts house with a studio for two, a fireplace, inglenook,
and window seats. [15] With its steep gable roof and a low pri-
vacy wall around a front garden, it was located on a street
called, with colonial callousness, Indian Road (once home to
the Mississaugas of the New Credit). In January 1900, they
moved in.

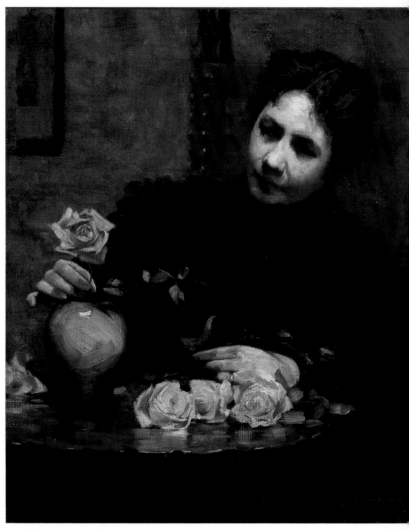

George Agnew Reid, *Portrait of Mary Hiester Reid*, 1898,
oil on canvas, 76.8 x 64.1 cm,
Art Gallery of Ontario.

Portrait of Mrs. Reid
Arranging Roses

I.

In the same year that Mary was painting a tall solo tree, George was painting Mary. He portrayed her placing a single pink rose in a turquoise vase, a cluster of yellow roses waiting to be arranged on the table below the gold band of her wedding ring. Behind her is the chair that she features in her painting of her Paris studio. From her dark, heavy jacket, it seems that her husband might have finished *Portrait of Mary Hiester Reid* in the wintertime in Toronto, perhaps with greenhouse blooms. The light casts deep shadows under her eyes, absorbed in her activity. He even triangulated: Mary's head forms the apex of a triangle of her face and her roses. The face is the color of the rose she holds. She is matronly, with rounded cheeks, yet we know from photographs that she wasn't this fleshy. Here she's a pillow to sink into, a comfort. She has her signature self-contained allure that surfaces in every picture of her.

2.

To be married to an artist or a musician or a poet or any creative means to exist with someone who is absorbed in concentration (on something other than you). A spouse has to have a huge tolerance for the partner's attention to be elsewhere, and a trust that it will return. "Where *were* you?" my first husband would say to me back in our twenties. "What do you mean?" I'd say. I was right there in the room with him—I'd simply, in my head, entered the lines of a possible poem. I did not realize that another person would experience this as my "going away."

At the time I exclaimed to my then new, now lifelong friend, visual artist Katie Kinsky, "I would never marry another poet!" And she agreed. We thought then that competition would destroy a marriage. But part of the difficulty in my own first marriage was that I could not explain the quirks of how I made art, the strange double-track consciousness of being there but not there—that my young husband only felt as *not there*.

3.

George and Mary understood something essential about artists: the need to go into an idea, a concentration that shuts the other out, but not entirely. They had to trust that being shut out released them into their own individual concentrations. As for competition, Mary was a nineteenth- and early-twentieth-century paragon of support. She may

not have chafed at that. She was not our contemporary; she didn't have a twenty-first-century mindset. She may have experienced rage but buried it so deep it could never surface in her world—or she may have been so clear on a woman's role that she didn't seethe or fume. In the nexus of what seems an unquestioning support for her husband, combined with a drive toward her own aesthetic life and career, she nudged, prodded, lightly elbowed open a door for maintaining a creative life and a marriage. She kept that door cracked, slightly ajar, inching into an artist's life, by tolerating ideas many find intolerable a hundred years later.

Part of Mary's being able to venture into landscape painting was the security that her marriage offered her; two other words for that security are friendship and esteem. To esteem a partner is to feel the wealth in every aspect that the partner brings to marriage. Despite the inhibition her marriage exacted, their bedrock friendship and obvious appreciation for one another encouraged the making of art. That their marriage included art did not always make things smooth—what richly lived life is not full of imbalances and contradictions?—but it did give them an ability to rebalance that which a more brittle relationship would not. A capacity to play generates that flexibility.

The parallel play at the foundation of Mary and George's companionate marriage, two artists painting together, thrived in the atmosphere of extravagant recreation at Onteora. The practices and off-hour fun of so many distinguished writers, artists, designers, and musicians recalls recreation's prefix and root: re-creation. Play is invention within boundaries, the prime constituent of art making, mid-twentieth century

Dutch philosopher Johan Huizinga reminds us.[1] Within its precinct, the loose associative sparks that urge art into being ignite. Without a sense of play, British psychologist D.W. Winnicott maintains, there is no creativity at all.

Onteora, with its mountain and fantasy cottages, defined adult artistic play in Winnicott's phrasing as an "intermediate area of experiencing, to which inner reality and external life both contribute." In this midway space—the realm of dreams and fantasies that contributes to writing a poem, composing a song, painting a painting—we become lost to time. The softened space between interior and exterior could be called a creative adult's third state, particularly apt for the painter of threes, MHR. In *Playing and Reality*, Winnicott calls play "the third part of the life of a human being, a part that we cannot ignore." Winnicott's "triple" state is "the substance of illusion, that which . . . in adult life is inherent in art and religion."[2] Playing is the other side of solitude. In a *Paris Review* interview, psychologist Adam Phillips, the biographer of Winnicott, responded to the idea this way: "In order to be absorbed one has to feel sufficiently safe, as though there is some shield, or somebody guarding you against dangers such that you can 'forget yourself' . . . I think for Winnicott it would be the definition of a good relationship if, in the relationship, you would be free to be absorbed in something else."[3]

4.

Though Mary was painting outside at this time, in *Portrait of Mary Hiester Reid*, George returned her to the house, an icon of a woman arranging flowers. Yet the house he put her back into contained a studio she shared with him. His painting didn't put her back into a kitchen but into preparation for a floral artwork. About that time, despite the grumblings about his Eurocentric influences, George was elected president of the Ontario Society of Artists. In an exercise of his power, he ensured that women were to be admitted. MHR, and all women applicants to come, had a place at last.[4]

5.

Mary and George spent their time between two houses built expressly with their own Arts and Crafts principles and tailored to their own work and living—right down to the chairs with open hearts for backs that George designed and the mirror he created for the foyer. Mary, in an Art Nouveau moment, paid tribute to her old Paris neighbor Eugène Grasset and painted peacock feathers along the frame of that mirror. Then she handwrote "Vanitas Vanitatum" (vanity of vanities) to twit anyone, including herself and her husband, adjusting a hat or a cravat in their foyer. For years, they had been living and painting and adapting to the space around them (as most of us do), but now they had the luxury of dimensions adjusted to *them*. The Toronto house was like bespoke clothing. They slipped it on.

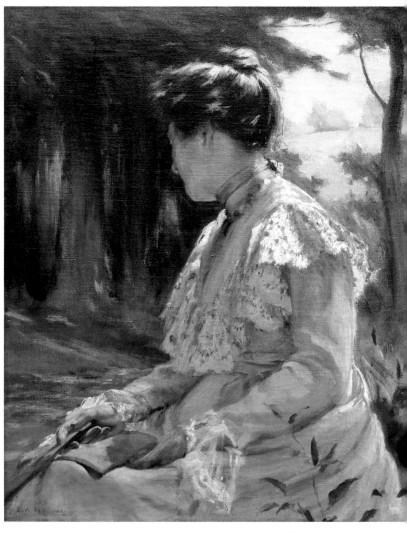

George Agnew Reid, *Portrait of Mrs. Reid*, 1902,
oil on canvas, 76.2 x 63.5 cm,
Reading Public Museum, Pennsylvania.

Mrs. Reid in a Frock, Outdoors

I.

Summer afternoons: gauzy gowns and lawns. Four years after the flower-arranging portrait, at Onteora George painted a new portrait of Mary, this one in a summer frock with a turquoise ribbon at her neck. It's the loveliest and most romantic of his portraits of her, finished in a period of privileged relaxation in the art colony where their companionship thrived. George paints her as a figure outdoors at last, her head turned toward such trees as she herself was painting. This likeness is loose of brushstroke, easy of clothing, mild of weather. Sunlight through transparent lace highlights her artist's bare hands. Those exposed fingers hold a brush and paper (or is it a fan and a slender book?). His Impressionistic style is matched by her pose—a slightly girlish demurral, though her posture is settled—and celebrated by the creams and yellows that make the dress glow. Her head turns to reveal a handsome, enticing neck—probably not the neck she really had at age forty-eight, but one with a scrim of youth.

Just at the height of their cozy marital comfort, on George's birthday, July 25, their cases were loaded on the stagecoach, a wooden horse-drawn coach with a roof and partially open sides that took passengers from Tannersville to Catskill.[1] There they boarded one of the glamorous night boats that navigated down the Hudson to New York City, carrying well-to-do tourists between Saratoga Springs and New York City. The chandeliered steamships with gilded wood in their swanky staterooms were favored by honeymoon couples; Mary and her husband started out in honeymoon style to catch the ship to Glasgow, Scotland, George's ancestral homeland where he had never been.[2]

In Glasgow, their mission to see the philosopher Thomas Carlyle's portrait was thwarted at first: they found a blank rectangle on the wall. *Arrangement in Grey and Black, Number 2* by James McNeill Whistler had been lent to another exhibition. They stayed at a small four-story hotel, the Old Waverley,[3] and visited Henry Mavor, the editor of the *Scottish Art Review*, whose brother James they knew in Toronto. Mavor took them to the studio of muralist and portrait painter George Henry. There, Mary listened to the jocular talk of the male artists, the rivalry and jokes about John Singer Sargent, and the badmouthing of Art Nouveau.[4] It was part of her life in the orbit of men, great men as they hoped to be, full of opinions about the art they made and would make. She was swept into their company as a mongrel: part wife, part painter. The conversations were heady, the aura romantic, bittersweet for a woman of forty-eight, the jokes and put-downs recalling the talk of the spirited

crowd of painters in their studio home in the nights when she first moved to Toronto, a young wife.

Giving up on the Whistler, they climbed on an omnibus for Edinburgh and stayed at the much grander eight-story, block-long Waverley Hotel[5] on Princes Street for the festivities of the coronation of King Edward VII. With the end of the Victorian era, they shed parts of their own lives. Now they were established in their own domains, with solid connections; they had created two worlds for themselves, and they were queen and king of both of them. Down they went to London, where they'd made advance arrangements through their old student Rex Stovel to take the studio of Irish portrait painter William Orpen.[6] When Orpen made a brief return to London, stopping at his 21 Fitzroy Street studio, he discovered George painting not some ambitious historical subject but yet another portrait of Mary "in a white gown," as Muriel Miller describes it.[7] She keeps posing for him, in thin gowns, and he can't seem to get enough of capturing her.

2.

They went on from London to Stratford and the Cotswolds, walking and sketching with John Young Hunter, a figure painter, at his home Bourton-on-the-Hill with its converted-stable studio. Mary, working outside, fascinated with sunlight and shadow, produced two of her twilit Tonalist works *Night in the Village (England)* and the dreamy, contemplative *Landscape with Sheep*. She and George painted

and walked, sauntered and sketched, finally making their way to Wolverhampton and the gallery to which the Whistler portrait had been lent, viewing Whistler's portrait of Carlyle at last.[8]

Mary stood with a man looking at a likeness of a man who made popular a doctrine of Great Men. Carlyle was vastly influential, and his theory of Great Men as heroes who singularly create turns of history exerted a cultural and political and educational force well beyond the Great War era. "The History of the world is but the Biography of great men," he famously wrote in *On Heroes, Hero-Worship, and the Heroic in History*,[9] published in 1841, before she was born, just as women of her mother's generation began to seek equal rights. The idea of the daring man who transformed history divided the tapestry of world humanity into a series of actions by single leaders, similar to the Romantic notion that art is made alone by a solo genius. As it came to be interpreted in encyclopedias and classroom history books, Carlyle's belief in exemplars so dominated thinking that we still revere doorstopper biographies of world leaders, looking into their lives for clues as to how we have all come to be where we are. If we look at heroes, Carlyle opined, we find the heroic in ourselves. George, who took Carlyle to heart, cast his subjects as knights of farm life and believed in himself as the paladin of Canadian painting.

Mary existed in an ocean of creative, influential men viewing themselves as champions. She bobbed among them like a cork, nearly indiscernible but for light glancing off the bit of gold foil embedded in its cap.

3.

MHR processed the schema of Whistler's portrait into a template that she would hold onto for a decade. It was not the figure of Carlyle she would absorb, but the arrangement of gray with black that Whistler used. Mary, who typically mulled over visual experiences, keeping shapes and forms in the back rooms of her mind for years before she released them and made them her own, looked so deeply that she recalled, either from memory or from sketches that she made, details of this painting ten years later when she made her culminating work, *A Study in Greys.*

Whistler had captivated her since her second visit to Europe, or perhaps before, in her student days. Three months before she left the Pennsylvania Academy of Fine Arts to marry George Reid, Whistler had delivered his famous "Ten O' Clock" lecture at the very late hour of ten p.m. in Prince's Hall, Piccadilly, London. In that speech, he firmly divided art from nature, staking the claim that art need not imitate nature, let alone reproduce it exactingly. Whistler emphasized, "*The artist is born to pick, and choose.*"[10]

Mary's compositions are arrangements. And the way she led her life was a matter of selecting. She accommodated, she inspired, and she marshaled order. She was said to be a composed individual, "of such quiet strength,"[11] and she almost musically composed her endeavors—not only her paintings but her choices, relationships, and, as her life went on, her very hours.[12] If a woman stands among men, listening to talk about art through the notions that Carlyle

espoused, where Great Men shape history and the history of ideas, then tones—voiced without words—might be the very avenue to what she has to say. She stood before the mellow palette of the portrait, shifting her weight from leg to leg as one must do when standing for so long, and absorbed something she would never see again but, in a decade, deftly use.

They sailed back to North America from Liverpool on the *Lake Simcoe* that October. The ship ploughed through huge waves—fourteen days of roiling side to side and meals flying off plates.

INTERLUDE

Georgiana Uhlyarik, Fredrik S. Eaton curator of Canadian art at the Art Gallery of Ontario, unlocked the huge storage area, and we both strode in as the great steel door clanged shut. There, in an archival storage box, was a trove of miniatures by Mary Evelyn Wrinch, glowing from their mountings. Every stroke of the watercolor on ivory is thinner than a pencil line. The details of an eyebrow, the lace at a neck, the complexion and the gaze of a few children, a large group of young women, a man or two, and several older women. As I looked at the collection, I saw a note, in Wrinch's own distinctive hand: "All these miniatures painted entirely from life—No photographs used—Mary E Wrinch."[13] No shortcuts.

To climb the stairs up to the studios at the Art Students League on West 57th Street in New York, with their heady smells of paint and linseed oil, meant to pass the huge first-floor exhibition space of the American Fine Arts Society. There her teacher George had shown his paintings in 1894 and 1895. And, from a distance, listing his address as Paris in 1896, as his marriage was righting its course. She had been his pupil then. But now she was an

accomplished woman on her own, preparing to earn her own living, having plunged into two metropolises, solo. She'd become a traveler, too.

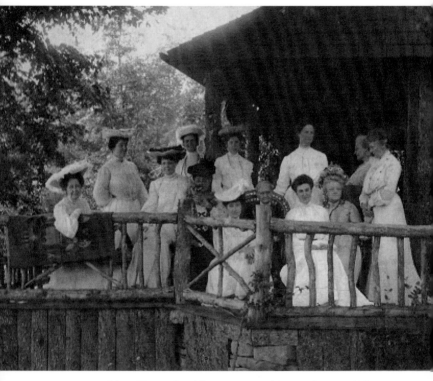

Mary Hiester Reid (top row, second from left, in profile),
Onteora Ladies on the Porch of Witchwood, August
12, 1904, photographer unidentified, reproduced with
permission of E. Davis Gaillard Archive, Onteora Library.

Lunch, Friendship, and Menopause

I.

But Mary was staying home. Since the ocean turbulence of her last return trip, she rooted into her life on Indian Road, with the reward of friendship with her neighbor, the painter and craftswoman Ellen Smith Hahn. It's because of Ellen, who seemed to handle bringing up three daughters[1] while integrating book crafts into her domestic life, that we have the few bits of surviving correspondence in Mary's hand. By this time, Mary's circles of women friends and colleagues were widening. Mary was a member of the Toronto Ladies Club, the Women's Canadian Club, the Social Service Club, and the Women's Art Association and she showed at the Heliconian Club.[2] She was a founding member of the Women's Canadian Historical Society and a member of the Imperial Order of Daughters of the Empire. These clubs and organizations created a stable network of middle-class women. Their voices, always separated from men's voices (the Arts and Letters Club, of

which George was an officer, wouldn't admit women until 1985[3]), joined and layered.

Her social network was as full and rich as the cookbooks in their households. They ate together, laughed together, intrigued with and against one another in all the machinations of groups and clubs (some of them still vitally operating today). These sororities stabilized women artists' identities as full, real, and independent—though sidelined. Marginalization served the tight exchanges among them; the bonds were sturdy—and perhaps more valuable to Mary as she entered a phase that women whispered about and wondered about and sometimes consulted their doctors about: menopause.[4]

By 1904 Mary was fifty, still trim, going at least half gray, and entering or perhaps emerging from hot flashes, memory glitches, and vaginal dryness—if she had any symptoms at all. Although there were experiments with hormone replacement as early as this, the vast majority of women turned to a handy remedy to soothe the tiny vaginal tears that result from intercourse past a certain age: liquor. A shot of whiskey, recommended by their doctors and their friends, might just blunt the symptoms.[5]

Ellen lived in a house nearby, built by her friend the architect Eden Smith, who had given the living room fireplace an inglenook, something George admired and later emulated.[6] In 1895, she had married her teacher, Art Nouveau muralist Gustav Hahn (1866–1962).[7] The sound of Gustav's soft Swabian accent (he was born in Reutlingen, Germany) connected Mary to the German framing of sentences in her childhood among her Pennsylvania Dutch

Muhlenberg family. Gustav had emigrated in 1888 along with his talented brothers Emanuel, a sculptor, and Paul, a cellist.[8] George, too, appreciated Gustav. Soon the trim, goateed George and the bespectacled, soft-mustached Gustav began to collaborate. On many levels, the four were at home with one another. For these adherents of Arts and Crafts principles, design contributed to an atmosphere of intimate community, and being chez nous involved Mary and George in all the matters of habitat—not only what houses should look like but what the people living in a group of dwellings should concern themselves with: the education of children and the governance of those abodes, too.

In that very first year of anchoring themselves in the Indian Road community, Mary and George helped found the Arts and Crafts Society (later the Canadian Society of Applied Art).[9] They gathered others into their circle, and since Gustav was intensely interested in Art Nouveau (or Jugendstil as it was known in Germany, "youth style"), the Hahns and the Reids shared aesthetic and social views. The two men exerted their energies on a huge mural project for the decoration of the Queen's Park legislative buildings as well as on a project to bring art into public schools. George became chair of an Ontario Society of Artists committee of five—the other four being his friend Gustav, C.W. Jefferys (the artist, art critic, and champion of Mary's work), Frederick Challener (their former student, now a mature artist), and Canadian landscape painter and teacher J.W. Beatty.[10] They developed a pamphlet about art education to be distributed in schools.

Teaching seemed intimately connected to the home, and the home attached to governance. Reid, Hahn, Challener, and others exhausted themselves preparing documents for legislative approval of their mural project. For those in the Arts and Crafts Movement, shape and style led thought. To teach a child to draw was to teach a child to think. To create legislation in a designed environment was to legislate for humanity on a human scale with human concerns.

2.

On August 12, 1904, the women of Onteora gathered for "The Mary Luncheon," in which a baker's dozen of women members, each named Mary, came together for lunch. When independent curator Jane Curley and Caryl Clark, George's lateral descendant, showed me the photograph of the Mary Luncheon, we all searched for MHR's face. At last we saw a figure way at the back of the photo, ghostly, tonal, separated from the cluster. In both of the archival photographs of that afternoon, Mary is the thirteenth woman, in profile while the main dozen faces the camera. She appears in a meditative state, a participating figure but not a full participant. Hers is a knowing profile—a face keeping its own counsel, absorbed in something, as if she were lost in time, or lost in play. Her figure is atmospheric, gray, in-between, present, yet almost ethereal. Like her Tonalist paintings, she is Tonalist herself.

She seems to be disappearing, in the way that menopausal women can experience feeling socially invisible. Later the long-legged Caryl stretched out on a chair at the Onteora Library that her ancestor George had designed, while vibrant Jane tucked herself into a couch. I pulled out my notebook as we mulled over what we'd looked at. The photograph reminded us that the Reids were separated from the rest of the colony because of George's job as a manager, as well as their differences with Candace Wheeler. There were subtle financial and social disparities that would never exclude MHR but might, because of George's usurpation of architectural commissions and the school of painting they ran at Bonnie Brae, rank her slightly to the side.

With Mary beginning her disappearance into age, George suffered another disappointment. After three years of extreme effort, preparing proposals and badgering lawmakers, the legislature turned down the mural proposal. To recoup, and to keep carrying out his Arts and Crafts mission, he turned to private house décor, making murals in Toronto homes and building more houses at Onteora.[11] Far more lucrative than hammering away at legislators, this permitted George to return to his own imagination—the engine that allowed him to get up in the morning, to be healthy, to go on, to make friends, to make art, and to live with a woman who was fostering that imagination at every point simply by exercising her own.

MHR was making her way past the gray curtain of menopause and aging. She would emerge from this transition (sometimes so long that one does not realize the

power one can come into as one approaches full age) to paint her supreme still life, *A Study in Greys*, and later to portray the garden, the dried flowers, the singular elm of her late period.

Meanwhile, George built a home at Onteora for the diminutive, pixie-like actor Maude Adams, who made a fortune on Broadway in 1905.[12] Her wild success in J.M. Barrie's *Peter Pan; or, the Boy Who Wouldn't Grow Up* became part of a tapestry of men's longings for boyhood, unfurling desires for an innocence before hard-fisted economics, for the preserve of the imagination, and for rural environments, all impulses of the Arts and Crafts movement.

As Mary coped with menopause and George managed with failure, as Mary managed with George's disappointment, and as George coped with Mary's menopause, Toronto grew into a gridded city, with paved streets and streetcars. That city encroached on Indian Road. By 1906, their house seemed besieged by a thoughtless onslaught of right angles obliterating natural curves. The direction of the society into grids and the direction of politics into collusion with industry underpinned their urge to withdraw. Wasn't there anywhere that could embody all their aesthetic principles, the very things that made them feel alive and made life together worth living?

The six-year age difference between the couple both stretched out and snapped back during these years. Had they reached a sexual rapprochement as her body changed? What made the bond between a graying woman of fifty and an ambitious, but thwarted, man of forty-four now?

For there was certainly a bond, and George was about to build a monument to it.

In 1906 their friends approached them with an intriguing idea: they could buy a park. Wychwood was forest-land on the rim of what had been Lake Ontario thousands of years before it receded to the shoreline as they knew it then. Located on an ancient trail made by First Nations peoples, the land stood high above the city, north of Davenport Road and west of Bathurst Street, a wooded hill that had the feel of the hills near Onteora. Left wild by the inheritors of the estates of painter Marmaduke Matthews and those of two others who were joined in a trust creating Wychwood Park, the tract was undeveloped except for two houses, one of them inherited by Matthews's son-in-law, Ambrose Goodman. Now Goodman approached Eden Smith, Gustav, George, and a few others with the idea of dividing up the park into an enclave of houses à la Onteora.[13]

INTERLUDE

During the summer of 1906, before Canadian painter Tom Thomson or any of the Group of Seven painters ventured into Muskoka, the fearless Mary Evelyn Wrinch traveled to the Lake of Bays to paint en plein air, having convinced her friend the writer Kathleen MacFarlane Lizars to come with her.[14] Lake of Bays, with its multiple bays or forks, is deep, cold, long, and wide. On its irregular shoreline of over a hundred miles[15] dotted with hunting cottages, Mary Evelyn Wrinch tackled that least of feminine subjects: logging.

She endured the black flies and the sometimes shockingly cold nights to get to a light that reflected off lake water, portraying a northern landscape that had rarely been painted in oils before, let alone by a young, relentless woman. She and her friend Kathleen roughed it,[16] and loved it, and Mary Evelyn was bent on building a house at Lake of Bays—where her work was the very opposite of the delicate miniatures she had learned to refine during her sojourns in London and New York City, now the mainstay of her living.

Mary Evelyn Wrinch, *Miniature of Mary Hiester Reid*, 1906,
watercolor on ivory, 6.5 x 4.9 cm,
Art Gallery of Ontario, Toronto.

Two Marys, a Miniature

I.

Mary Evelyn Wrinch had a question in mind after she set herself up in a Toronto studio. With her honed skills, the twenty-nine-year-old began a small business of painting miniature portraits in watercolor on ivory. To round out her income, she taught art two afternoons a week at her alma mater, Bishop Strachan School.[1] Her memberships in the Ontario Society of Artists, the Heliconian Club, and the Women's Art Association[2] all provided many occasions on which she could network for business. Plus, she could look, really look with her trained eye, at fifty-two-year-old Mary Hiester Reid.

She approached her mentor with the question. Would she sit for a portrait in miniature?

Their negotiation of roles, begun over a dozen years before and now as intricate as the in-and-out shoreline of Lake of Bays itself, curved yet again. Audacious student approaches teacher, young adorer of George to older wife of George. The jealousies, the affections, the mutuality, the

enmity, the echoes of mother and daughter love, the connection between the electric Mary Evelyn and the controlled Mary Hiester: all were present in this interaction, opposing yet combining forces at work when MHR said yes.

Mrs. George Reid, sitting for her portrait, could regard Mary Evelyn in all her freshness and see her former student grown up, a possible reflection, less a rival, less an object of jealousy. Yes, the younger woman was a draw on her husband's attention, but she was also a draw on her *own* attention. Each eyed the other, model and miniaturist.

Most of the other miniatures that we have from Mary Evelyn Wrinch's hand show their subjects full face forward, but here her former teacher looks intimately, kindly, with warmth and a kind of sad knowledge, back toward the painter. Even though the turned head was a stock portrait pose, MHR gives a convincing backward glance as she positions herself to go on. Though such miniatures always put subjects in the best light, there is a benign softness in the portrait without a hint of animosity, rivalry, or rebellion. The miniature homage, done stroke by fine stroke, marks what would become a tandem moving forward of both women, tied to George, yes, but also to one another. It is a tiny testament to the complexities of human liaisons.

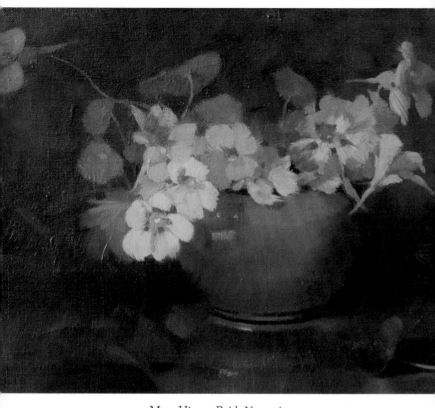

Mary Hiester Reid, *Nasturtiums*, 1910,
oil on canvas, 30 x 45 cm, collection of the author, Toronto.

Nasturtiums, a Restoration

I.

In the same year that one Mary painted the other in miniature, George dug a foundation for what would be called Upland Cottage at 81 Wychwood Park. By September 1906, he was supervising labor; the following year, at the end of a not particularly snowy February and March,[1] Mary moved into the incomplete house, still in a raw state, waiting for its surface details. The wood and stucco structure recreated the ambience of the Cité fleurie from their Paris days. It is an ample, comfortable Arts and Crafts storybook castle-in-the-trees.[2]

As he built their Upland Cottage, George noticed the plot of land next door, across a difficult ravine.

A board for the park was appointed, and he, as a member, oversaw a road built and lots sold and developed, with a tight commitment to the enclosed woodsy atmosphere that remains today. By 1907, when all the furnishings were in and Mary was painting at last, George made another leap to art world power, becoming president of the Royal

Canadian Academy of Arts.[3] He then started writing the letters and helping to make the proposals for what would become the National Gallery of Canada. Once more he began promoting the idea of murals in the parliament buildings and traveled to Quebec to plan exhibitions of paintings. He still saw his mission as a provider of public art for a nascent nation.

But that plot of land across the ravine next door: would he be up to the challenge of building a small house there in the future? Perhaps for his darling, his talented other Mary, that vibrant twenty-nine-year-old artist on her own, and also for her sister Agnes? He, paternal and strong, could give them his protection. He, the younger partner in his own marriage, still in sexual need, would feel needed, and perhaps more.

2.

Mary settled into the house where she would paint her culminating works. Here was a rural environment within the city, with a separate structure and laws that kept its winding roads and Arts and Crafts commitment, with neighbors who were university professors and artists. Like Onteora, it was exclusive, it was communal, and it fostered aesthetic intensity.

However disruptive 1907 had been for them, finishing construction and moving to Wychwood, still they packed up and traveled to Tannersville, New York. That summer, automobiles appeared on the Onteora roads. The horses

reared and fled and were chased, captured, then led back
to the barns. One of the car-driving artists carried a bushel
of carrots in his car to settle the ponies so that he could
drive past.[4] Mary stayed through September and licked
a penny stamp and smacked it upside down on a picture
postcard dated Tannersville, New York, five p.m., October
2, 1907. On the front of the card is a photograph of Onteora
Church, designed by her husband and labeled "Echoes
from Onteora." On the card she drops a note to her friend
Ellen, still living in the Indian Road area as the Hahns'
house in Wychwood was being built. It's a brief message
about domestic arrangements. There were at least two help-
ers with Upland Cottage that summer, Mrs. Davies and
Mrs. Newton.

> To Mrs. Gustav Hahn,
> 96 Boustead Avenue, Toronto, Canada
> Oct. 2nd We hope to [illegible] house on
> Monday morning next. I have asked Mrs. Davies
> to leave the keys with you. Mrs. Newton may call
> for them as she is taking some things in.[5]

In a still life, things stay put, but in a life that moves by
train and horse coach between Toronto and Tannersville,
arrangements are constant. Domestic life claimed the
painter MHR and made her simply Mary writing to Ellen,
friend and domestic anchor.

Two summers later, as the Hahns were at last mov-
ing to Wychwood Park, Mary wrote a much more lyri-
cal letter to her friend. It begins with a prime fact of her

domestic life at Onteora; without help, she didn't have time to paint: "I've no maid so I am busy." Then it continues with a word-painting: "Bird songs in the woods, devil's paint-brush in the fields." (Devil's paintbrush is a little red wildflower that would have dotted the yellow fields.) Her friend, too, receives a query about aesthetic discussions and preferences they shared. Was Ellen Hahn wholly against the color red? Her friend Mary, enchanted by the vermilion of the wildflower, probes: "Perhaps it is only in art & not in nature that you object to red."[6]

Then comes the core of what MHR's been doing all summer at Onteora: "Haven't done a stroke of painting, cooking & cleaning take all my time." The dilemma of housework (and this is hard housework—no vacuum cleaners, no dishwashers, and possibly at certain points in the summer no running water, for the wells may not have been deep enough for that) dominates Mary's entire married life. Even doing a load of dishes becomes a major chore—and there may have been students' needs to take care of as well.

The sweet, caring intimacy, an easy back and forth, displays the friendship of the women. "You are the only person I know who can do both house work and art work," she writes to Ellen, a mother who had learned to oversee a family—and bind books, too. "How goes the book binding?" Ellen Hahn, about whom the world knows very little now, comes a bit more alive to us through Mary's gentle inquiry. No narcissism, no angst: genuine noticing of another, acceptance of conditions, and persistence, too. For MHR, diligence includes hope: "Hope to get someone for part of the summer so able to paint." But the records show

that there wasn't much painting getting done from 1907 to 1909.

Mary, alone, made this time to write to Ellen while George barreled on "to Lake Champlain for the pageants" with their friend C.W. Jefferys. Two states, New York and Vermont, had joined to celebrate the tercentenary of the arrival of Samuel de Champlain into the Indigenous territories of the Wendat (Huron) and Algonquin Nations, what was then called the New World.[7] Even U.S. President Taft was to appear at the festivities.[8] Then when the actor who was supposed to portray Champlain was unable to go on, George donned a pair of jackboots and a plumed hat, participated in a single rehearsal, and romped across the stage in a belted waistcoat. Later he painted a huge historical colonialist work, *The Arrival of Champlain at Quebec*.

Mary ends her letter to Ellen with "Had a lot of neuritis."[9] Neuritis is a catch-all word referring to nerve pain. It is difficult to know what kinds of nerves Mary is experiencing pain with—and whether this is the reason she does not accompany George to Vermont. Brachial neuritis involves pain in the shoulder, arm, and hand. Cranial neuritis involves the head and neck. Bell's palsy, the facial paralysis that was thought to be caused by exposure to an open window, could be extremely painful. Mary's neuritis could also have been optic neuritis (swelling of the optic nerve). Or she may have had vestibular neuritis, also known as labyrinthitis, a temporary dizziness caused by inner ear inflammation. We know she eventually developed angina pectoris nine years later, so she could have been referring

to early symptoms of coronary artery disease. Any one of these could have caused her not to travel.[10]

Whatever she was ill with, she had no help, she seemed to be alone, and George had taken off to sketch and cavort in a costume drama. Yet she woke to birdsong and walked the fields, and if she painted little, this fallow period would bring a creative burst the following year. But first there were cooking issues to surmount, and Ellen's domestic concerns. "Hope you have solved the problem of gas," Mary commiserates: "How troublesome it is for you to manage with your little oil stoves." Then she offers a solution: "Mrs. Ward would be pleased for you to use the stove." Mary's housekeeper, Mrs. Ward, could admit Ellen to the house to use the much more convenient appliance. The Upland Cottage kitchen, designed partly after the studios at the Cité fleurie, had echoes to MHR's stove problems in Paris, though by this time a twentieth-century cooker had solved them. The convenience of this appliance was partly responsible for her creative burst of 1910, in which MHR celebrated her privacy by painting *The Inglenook in My Studio*, then explored the halftone life of the unconscious and dreams with her Tonalist *Nightfall* and produced *Nasturtiums*.[11]

3.

Nasturtiums is a lively painting of a baker's dozen of yellowy-pinky-orange annuals flopping happily out of a round green ceramic container. With these silky, edible

flowers, another set of colors comes in to MHR's work: ruddy gold to orange. These flowers, so classically sunny, bring the outdoors in. They glow against a dark background (a weirdly interior version of the stage that George swashbuckled across). By 1910, Mary had been at Wychwood for three years, and on Indian Road for five earlier years, thoroughly anchored in her domestic life. The painting exudes contentment; nothing seems to be dividing those flowers, which the *Montreal Herald* on April 9, 1910, determined had "a delicate tone and texture."[12]

Poor old *Nasturtiums* hadn't arrived at my building in Toronto in the best condition. I'd known that from the report from Eldred's, the online auction house where I'd bid on it—and was thrilled to get it—but the reality of the flaking frame and the dirty canvas hit me when my husband opened the elaborate casing and withdrew the work. Who knows in what dining rooms or living rooms *Nasturtiums* had hung? How many cigarettes had been blown in its direction? *Nasturtiums* had no provenance. There it was, too loose in its stretcher, crack lines in the center, one corner damaged. The corner was slightly bulging, and paint had flecked off.

It needed more than conservation; it needed resurrection. Mike and I dropped off the painting at the end of September[13] with Andrzej Ornoch, the Polish-Canadian restoration genius who brought the historic 1846 painting of *William Henry Boulton* by George Berthon back to life for the Art Gallery of Ontario.[14] By the time Ornoch had room in his schedule for *Nasturtiums*, winter had set in. That January, the raw cold at the suburban commuter GO

Train station near the conservator's home forced me to the taxi stand, but the driver insisted on dropping me blocks away for fear of getting stuck in the snow. I high-stepped through crusted ice to Ornoch's driveway, barging into his ranch-style house like a wet, down-coated terrier, shaking off the snow, standing in my boots' puddle.

Andrzej Ornoch is a precise, lanky individual who greeted me with a formal grace, a cordial courtier making a disheveled visitor feel at home. Once at his dining room table, he lifted the Mary (as we kept calling it) like a baby from a stroller. *Nasturtiums* was without her frame. It had been taken to restorer Mariola Czarnota, who lifted every single gold flake from the old wood frame with its bull's-eye pattern and glued it back in place.

Patience. Ornoch seemed like a man who could wait for a Great Lake to drip through a kitchen funnel. Trained in the European conservation style developed in Poland after the bombings of World War II destroyed the facades of many historic buildings, he works traditionally. Wrapping minute bits of cotton on a slender wooden handle, he had gently spit on the cotton and swabbed the painting clean. Hundreds upon hundreds of small swipes, with patience and efficiency over the 1,404.48 square centimeters of the painting. Point three of his report: "Surface cleaning with saliva and followed by distilled water rinse."

The Mary had been filled with crack lines and lost paint at the bottom as well as the top right edge. He was on it: "Consolidation of paint insecurity in upper right corner, drying crack lines in centre and crack lines and paint losses

along the bottom and right edges of painting with 3–5% Isinglass."

The top right corner had buckled. He "relaxed" it by applying moist and dry blotters to "allow flattening of the distorted area and gentle local re-stretching of canvas." He had to fill cracks and to inpaint certain areas. "Fills done with Calcium Carbonate and 5% Rabbit Skin Glue (RSG)." And he had to color the fills. "Fills toned down with Schmincke Watercolours."

And after Ornoch inpainted the upper right-hand corner "with 10–15% B-72 in Cyclosol and dry pigments" and applied an "acid-free Coro-Plast backing board"[15] to the reverse of the painting, and after he anchored it in its restored frame, the Mary, my antidote to snow, was ready to take home.

Wychwood, Portrait of the Artist as a Tree

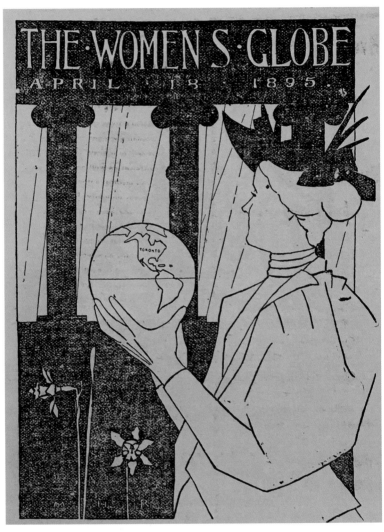

Mary Hiester Reid, *The Women's Globe*, cover and interior
illustration in the women's supplement to *The Globe*
(Toronto), April 18, 1895.

The Women's Globe

I.

Homes. George had engineered and built a little house on the ravine next door. And his talented former student, thirty-three-year-old Mary Evelyn Wrinch had, with her sister Agnes, moved in. Every time Mary left her front door, she could look across and see it. And George could see it from his studio. In his painting *The Homeseekers*, a settler family searches for a homestead. By fifty, George had built home after home, for himself and Mary and for client after client. His life had become a pattern of four decades of home construction. When he wasn't actually designing dwellings, he was painting works about them, losing or seeking them. Now that he had built the ultimate haven, Upland Cottage with his handsome huge studio, he filled the emptiness after its completion with the challenge of devising a little one on a steep-sided gully.

Though Mary Evelyn had been accomplishing some of the most energetic paintings of her life at her studio at 9 Rowanwood, near Yonge Street, a subway was planned

nearby and the city had been encroaching.[1] To be tucked in a cottage on a ravine in the exciting new artists' community was enchanting. She saw the house of her painter-parents, her painter-father-teacher-sort-of-lover, her painter-mother-teacher-sister-rival-sort-of-beloved, every time she walked uphill toward the little bridge to her house.

All Mary had to do when she walked to her door was to look to the right. Their orbits now overlapped as they had when the younger painter was a student at Onteora, intersected as they had when George installed Mary Evelyn in a studio next to his at the Arcade. Twice before Mary had found her travel occasions worth extreme arrangements at times when Mary Evelyn Wrinch had intruded on the balance of her relationship with George. Two previous trips lifted them out of a solid, comfortable grid of connections, of a sense of home. Now she planned a journey that would do the same, wrenching them out of Wychwood Park when they had hardly settled in.

2.

A woman holds a globe in her hand. When Mary was asked, around the time she wrote for *Massey's Magazine*, to design a cover for the *Globe*'s Women's Pages, she didn't draw a figure sewing, or gardening, or holding a child, or standing with a husband. She drew a traveler. A particular kind—a woman with her hat on, the world in her palm. She stands in the suggestion of a garden (two daffodils) and holds that pun on the *Globe* while looking off toward the Ionic

columns of Europe and something of a curtain, or a curtain of rain. Fifteen years after she created this illustration, she was well past the midpoint of her life (at a time when the life expectancy for a man was forty-eight and for a woman, fifty-two[2]). Never having eaten a Big Mac or dumped sorbitol into a cup of coffee, Mary was fit at fifty-six—and looks so in photographs. She reached, stretched, and moved as she painted and tramped to find plein air sites, as she shopped or worked in her garden at Onteora. And she was reaching out to women who had chosen to live full- or part-time in Europe, writing, publishing, and painting.

She got in touch with her cousin Elizabeth McLenegan, then another cousin, *New York Herald* correspondent Lena McLenegan Yorke. She reached out to her painter friend Harriet Mary Ford, who now lived as a Canadian expat in England, and to her former student Henrietta Vickers, whom she had painted with Frederick Challener in *At the Piano* around the time she drew her *Globe* illustration. Vickers lived in Tangiers and had a studio in Paris.

And she contacted Mother Caroline Hiester. Mary had not seen her sister in over a decade, presuming they had met in Spain. What was their bond now, at fifty-six and fifty-seven? Could Carrie journey from Spain to Belgium in time to coincide with the Brussels exposition of 1910? *The Baedeker's Guide, Belgium and Holland, including the Grand-Duchy of Luxembourg*, fifteenth edition, was appearing in 1910, just in time for a European adventure.[3] George was ready for one, since his painting *The Homeseekers*, where a settler family attempts to ford a river in a covered wagon, would be displayed at the Festival of Empire at the Crystal

Palace in 1911.[4] After eight years at home, Mary could look forward to absorbing works she had longed to see—Rubens, Hals, and Vermeer. With the freedom of hotel life, she could roam the streets of London, Amsterdam, and Brussels with a sketchpad.

3.

Mary didn't simply close the door on Upland Cottage; she had to get it ready to be sublet. It was let to Michael Chapman, the son-in-law of British painter G.F. Watts (an iconic Victorian figure who is now perhaps best known for his brief May-December marriage to actress Ellen Terry—and his moody portrait of her at age sixteen).[5] Arrangements, packing, details, and goodbyes: the train to Onteora, then on to New York, they were checked off on the roster of the SS *Columbia*, sailing to Glasgow on May 28, 1910.[6] But the death of Edward VII and the cancellation of that exhibition put an end to the festival; George's painting went on to be shown at Liverpool's Walker Gallery.[7]

Mary met up with Harriet Mary Ford at the Jolly Cricketers Hotel in Great Marlow, Buckinghamshire. Ford painted, created murals, designed jewelry, and wrote as a cultural reporter.[8] Financially independent, the daughter of a barrister, and living with her longtime female companion, she had once studied with George and Mary at Onteora, then teamed up with George to start an Arts and Crafts magazine called *Tarot*. *Tarot* lasted for only two issues, dying after a scathing anonymous review in *Saturday Night*.

Ford decamped to Europe after that—and after another demeaning, provincial review she received when she drew a New Woman riding a horse on her poster for the Toronto Horse Show.[9] Now Mary had a chance to reconnect with a painter who was about her age and who had made a life abroad with another woman, while also maintaining ties to Canada. Living as openly LGBTQ+ as one could in that era, Ford was a window to an alternate existence.

4.

Carrie chugged up through Spain and France in the August weather, the windows of the trains open, the cinders flying. She was on her way to Huy, Belgium, to a convent south of Liège. Mary and George also traveled to Huy, staying at L'Aigle Noir (Black Eagle) inn. At last, the sisters looked into each other's faces, Mary's possibly more lined than the more protected Carrie. They saw their resemblances, the flicker of their mother's features, or those of aunts or cousins. Even if what each said to the other was unsatisfactory or perfunctory, the meeting was profound. It brought with it two half-centuries of lives lived, bonded by heritage, separated by choices. Each of the Hiester girls had made her way.

Mary never saw Carrie without a time limit. Either George was waiting in a hallway—or in the same room—and certainly a gaggle of the other sisters of Mother Caroline Hiester were there as well. This visit, supervised, attenuated, created through extreme effort on both their

parts, allowed the two women their brief bonds of child-hood. They had a full look at one another, and they heard the mutual timbre in their voices, speech that had to leap over a decade, looks that had to absorb over a hundred months of days and nights, of meals and fasting, of sleeping and restlessness, of disappointments and satisfactions. Pure delight—with nostalgia and the melancholy of memory. One sister's hands had clasped rosaries; the other's two gripped the long handles of her favorite sable brushes. That meeting still has the whiff of a prison visit. "Nuns fret not at their convent's narrow room," Wordsworth wrote. Did Mary fret at her sister's walls? "In truth the prison, into which we doom / Ourselves, no prison is," Wordsworth insisted in this sonnet about sonnet-making, a poem that is also about how the very limits we choose release us.[10]

Then it was over. What they drank in had to endure after this, the last time they would see each other.

5.

Hot chocolate, smooth cow's milk cheese . . . Mary found herself in Haarlem, the Hague, Rotterdam, Delft, then Amsterdam. Beyond the bustle of the canals, she located the many-figured *Night Watch* by Rembrandt in the Rijksmuseum, a narrative painting beloved by her bearded husband. She found the Vermeers, taking in the lit interiors. She gawked at the dashing brushstrokes of Frans Hals and the deep, dark floral Netherlandish still lifes of the sixteenth century. The days went deep into September.

Back home, classes had started, but George, with privileged seniority, had secured a substitute to take over his first five weeks of lessons. Sublimely experienced travelers now, Mary used her rusty French in Belgium, while, in the city of Paris (which they thoroughly ignored on this trip), the Ballets Russes premiered Stravinsky's *Firebird* and Pablo Picasso entered the throes of Analytical Cubism, finishing *Girl with Mandolin*.[11] Mary's hunger was not for the future; it was to reconnect and make sense of history—art history, and her own.

She met Henrietta Vickers in Brussels to tour the Exposition universelle et internationale de Bruxelles, the world's fair. With Henrietta, Mary absorbed the worldly opinions of an artist living unconventionally in Paris and Tangiers—a long way from Toronto's Ontario Society of Artists. Meeting with Harriet Mary Ford and Henrietta Vickers allowed Mary to examine the paths of women who had made more radical choices than she had, to compare her life with theirs, to let others' difficult routes and triumphs enrich her own, if only by framing her alternatives.

6.

They went to England next. Through another Toronto visual artist, Ethel Miller, they'd found a place to stay on the Suffolk coast. When Mary and George unpacked at Beta Cottage in Harwich to relax and sketch in the October weather, political tremors had begun to disturb the satisfyingly stable world. That October, there was a revolution

in Portugal; then in November, across the Atlantic, one in Mexico. These were mini-quakes that presaged the eruption in four years that would change all Western political order with the assassination of Archduke Ferdinand and the onset of what Mary would come to know as the Great War. The modernist art that the Reids ignored would upend the aesthetic order, too.

But life at Beta Cottage presaged none of that. They sketched on, safe as houses. Then they booked the SS *Haverford*, an American liner, that left London not for the convenient New York to Onteora to Toronto route, but instead to reach port at Philadelphia. They packed yet again in one of packings so numerous and so repetitious that the folding and storing of their clothes and artworks was ordinary punctuation at the end of another journeying sentence. In Philadelphia, Mary met up with her newspaperwoman cousin, Lena McLenegan Yorke. She and George stayed two weeks there and in the Reading area, giving Mary a chance to bring, as after her honeymoon, news from Carrie to her family. This visit, too, would prove to be her last.

The punishing trouble of transatlantic chamber pots and lumpy beds and rushed meetings and problematic food and scurrying through museums and pacing through exhibition grounds in the heat—they were ample trade-offs for a chance to see her sister and friends, to receive infusions of Vermeer and Rembrandt and, most importantly, to change into that pod of two they became when she and George were on the road. Travel gave her unfettered chances to readjust to the prospect of the adoring neighbor next door at home.

INTERLUDE

Once when I was curled up in a chair reading one of my own books, Mike strolled past and quipped, "Reading your favorite author?" I had to laugh. And my laughter almost always would light him up. He wasn't a belly laugher— more of a bright-eyed chuckler.

At some point in every disagreement, one of us would snort, or snicker, or chortle—or at least raise an eyebrow and start to smile. One of us would arrive at some sense that whatever was so serious, so capable of fracturing what we had built for so long, just wasn't worth it. Whatever we were at odds with, eventually one of us would find it exasperating enough to turn funny—whether it was our epic standoff over the washer-dryer (I caved; he got his choice), or even our barely spoken, tenderly fierce impasse over whether to attempt another drug trial (at last he grinned; and we didn't).

Of course, I will never get at what kept Mary and George together—not just the fact that few people divorced in their era—but the internal workings of what kept them vital and alive and willing to form their dual union around a third person. If merriment has colors, my guess is that Mary's mirth was not a single hue from the standard eight-color

Crayola box—it was derived from the 152-color bonanza. That's just a deduction from the few times Muriel Miller fully describes her in a hundred or so pages of *George Reid, a Biography*, linking amusement to her name: "Brilliant ... darling ... sparkling ... vivaciousness. ... Ever the enthusiast, her vivacity and outgoing nature ... a favorite ... her rippling laugh ... [and again] her rippling laugh."

Currents undulating in union.

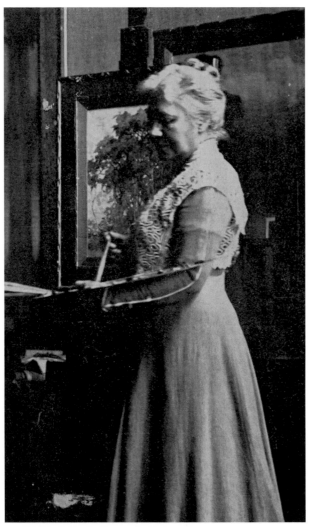

Photographer unknown, Mary Hiester Reid, 1910s,
reproduction from Memorial exhibition catalog, Edward P.
Taylor Library and Archives, Art Gallery of Ontario.

Art Metropole

I.

A ménage à trois doesn't have to be exclusively under one roof, and it certainly doesn't have to be explicitly sexual. This subtle ménage, created over time, with quiet, deep ties and an energy that fed the art of all three, was both absolutely open and absolutely private, as only an unusual relationship in conservative, Protestant Toronto could be. Attachment in all its myriad geometries had been and was being expressed. Nearness fueled the creativity of both women, their fatherless childhoods reenacted with a man who housed them not in conventional structures but in studio-houses, made for the inventive play of creative lives. Their properly dressed figures exhibited proper attitudes—a married couple, and next door two sisters—but the architecture they lived in and the paintings they painted indicated otherwise.

They lived outside convention, just as Wychwood was outside the city limits, run by its own board, yet they also lived within the conventions of civil behavior. They didn't photograph themselves naked or leave sexy letters, but

the fact that the letters are so scant in an age when letter writing was the main method of communicating has just a swirl of ashes about it: someone, sometime, may have done some wholesale burning of documents. What these three have left the rest of us is the ambiguity and complexity of an aesthetic family, with all the blurring of emotions and interactions that a family can have. Because Mary Evelyn was so much younger than George and Mary, their triad will always have a generational twist. Their ménage—to passersby a quartet, anchored by Mary Evelyn's sister Agnes—is more like a tiny community where roads curved, obscured by an atmospheric fog of romance and sexuality.

What is clear is their attachment, their imaginative natures, George's obsession with building and housing, Mary's determination to paint psychological reality, and Mary Evelyn's fresh resolve to paint the environment of the twentieth century. They refused to pin themselves down, and it's difficult for me to do it a hundred years later, but in 1910 they were spatializing an intimate relationship. Near this time Mary painted *Autumn, Wychwood Park* (reproduced at the end of this book). She infused her palette with purples and oranges to make an end-of-year woodland threesome. A triad of umber tree trunks dominates, one thick, divided trunk in the foreground, a substantial, but thinner one to the right, and, in the middle ground, a sapling between. Yet after this painting, of leaves descending to revealing the structures of forest beings, a new shift in the menage emerges. By 1912 and 1913 the two Marys would act on it in tandem.

2.

They decided to show their work together.

Architects Mitchell and White had built an elegant four-story structure at 241 Yonge Street the year before. They lavished on it glazed terra cotta tiles, a huge arched window, and a cornice of lion's heads—and it still stands in their 1911 conception. Called the Art Metropole, it performed the multiple functions of art gallery, blueprinting facility, and art supply emporium.[1] In a deepening rapprochement they collaborated in the winter of 1911 and 1912 for a show that opened in March 1912.

The hanging of a duo show requires one artist to match or highlight or oppose the other's works of art, and vice versa. The artwork of one person on her wall reflects that of the other on the opposite wall. The harmonies and the dissonances set up an atmosphere, a vibration, that makes a third entity. It's a fused experience wherein a viewer is always comparing and contrasting, noting color, shape, and size of the paintings as they correspond. When the two women exhibited together, it was their "letter to the world," as Emily Dickinson wrote. And the show was received with enthusiastic reviews and sales, just as Dickinson hoped in her last line, "Judge tenderly—of Me."[2]

1912 was also the happy year that the Ontario legislature acted to formally designate the art school a college, the Ontario College of Art (now OCAD U), and George became its principal.[3] Enviably, it was about the best job an artist of that moment could get.

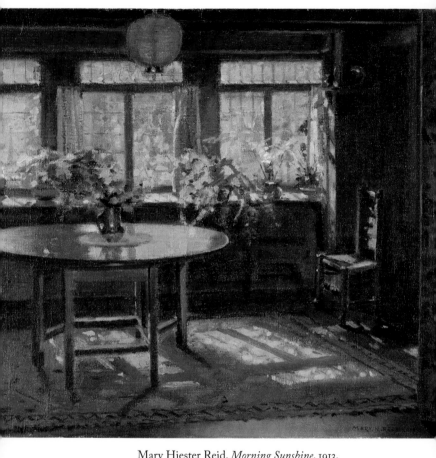

Mary Hiester Reid, *Morning Sunshine*, 1913,
oil on canvas, 63.5 x 76.4 cm,
National Gallery of Canada, Ottawa.

Self-Portrait as a Table and Chair

I.

To make a painting smile. In *Morning Sunshine*, Mary equates bliss with readiness: the dust cleared out, the table-top empty and clean, ready for the next project, for the future. In high contrast to thick, floor-length Edwardian velvet curtains, thin curtains hang just to the window ledge to let in the light. This is a very modern room for 1913—a forward vision of contentment, ease without encumbrance. *Morning Sunshine* revels in the relaxed brushwork used to make the glow flooding the dining room windows.

Mary painted it in the same year as her smooth, composed melancholy portrait of the roses in *A Study in Greys* in Chapter Two. Both works were finished within meters of Mary Evelyn, installed next door, in the year of the Armory Show in New York that Mary would never have been invited to, in the year when modernism broke through and a world war was as unthinkable to some citizens as women actually achieving the vote. If the energy of a paradox is holding two contradictory stances or ideas at once, then

these two paintings in a single year, perhaps at the same time, make her a singularly paradoxical—and human—individual.

She rarely fails to express the full range of emotions. If she were a pianist, she might have the touch of equal weight in every finger, able to tap each key with the same pressure. I wonder if expressing a full range of emotions only comes about when a person is deeply aware of what they feel in all of the combinations of sensations, and that includes uncomfortable complements like bitterly happy and sadly thrilled. Comfort with oppositions can move a feeling adult successfully through the world. Ignoring these oppositions can strand a person in a false childhood. Childhood is the place of pure feeling and primary colors. But as an experienced adult, you cannot replicate that purity. And if you deny the complexity of your impressions, attempting to sort them out and oversimplify, life falsifies. But MHR is true.

When Georgiana Uhlyarik led me to *A Study in Greys* at the Art Gallery of Ontario, and I saw the myriad grays between the black and white of the relationships of three objects, three flowers, three colors, a horizon line that divided the painting into two-thirds and one-third, I did not realize it was Mary's final statement about triangulation. She would not paint those threes anymore. She would not have to. It was resolved. There was *Morning Sunshine*.

She tackled it as George came and went to the newly renamed Ontario College of Art. Deep inside her domestic and aesthetic solitude, her husband, friends, and neighbors orbited around her but were not invited into this painted

moment. The dining room, not prepared for other peo-
ple to dine, is a sanctuary for growth. That single chair at
the right side has its own private view of the sunlight and
table. *Morning Sunshine* is an interior portrait of an inte-
rior, the secret garden inside. There's a greenhouse sense,
warm, moist, plant nurturing; no conflict, anxiety, or fear;
no unease or noise. If this painting had a sound effect, it
might be the squeak of a screen door, or an insect buzz.

"Alone," Gaston Bachelard, wrote about interior space,
". . . we are at the origin of all real action that we are not
'obliged' to perform."[1] He reminds us that we can examine
existence "while polishing a piece of old furniture." As every
serious housekeeper understands, "we sense new impressions
come into being beneath this familiar domestic duty."[2] Mary
has polished that table to the highest gloss, or as Bachelard
whimsically remarks, "every piece of furniture wants to
be friends."[3]

"Form," American poet and translator Richard Howard
once suggested in a conversation, is "the inside of an inside."
He was talking about form in poetry: that a sonnet, say, is
not a *container* for the poem but an interior structure the
poem is built around. *Morning Sunshine* is a portrait of a
refuge with a chapel-like feel (a very MHR sort of chapel,
with an Asian paper lantern). The tabletop is so engulfed by
light that it looks like glass. The chair (unlike the chair she
painted as a student in Paris, wedged among other furni-
ture[4]) waits in the shadow, almost like a dancer ready to be
called on stage.

1913 was a stopping point year for Mary, just shy of sixty:
there she balanced a painting in gray with a painting in

green. It took a lifetime of going on with her task to get here, as odysseys that bring us home to understanding do, and *Morning Sunshine* along with *A Study in Greys* poise together on a fulcrum of love and work.

2.

At the invitation of its current owners, Marc and Sarah Giacomelli, to visit Upland Cottage on November 11, 2019, Remembrance Day in Canada (Armistice Day in the United States), I joined Georgiana Uhlyarik, Art Gallery of Ontario curator, and two chic young Mary Wrinch enthusiasts, AGO assistant curator Renée van der Avoird and intern from the University of Toronto Erin Stodola, to knock on the door. The distinguished publisher and producer Mr. Giacomelli invited us stand in Mary's light. Her dining room was remarkably the same, Upland Cottage lucky enough to have been lived in only by two families after the Reids (and both thought of themselves as stewards of the house).[5] It was not late spring, of course, as the greens of the painting suggest; there'd been an early snowfall. Yet the weaker, differently angled rays provided just enough similarity of light to trigger four talkative visitors and an amiable host to fall silent. Weirdly, we were experiencing a kind of Einfühlung as we felt our way into the same room that the painting replicates. It's not quite that a century dropped away, but a "then" entered into our "now." We became sheltered beings within her shelter.

Soon we all left for various reasons on this holiday, including ceremonies commemorating the 101st anniversary of the end of World War I. After 1914, this sanctuary dining room would be very changed. The glossy table would be moved. A small army of chairs would be crowded in. The solitary refuge would pulse with women and sewing machines.

<div style="text-align: center;">

3.

</div>

In the summer of 1914, as Mary and George painted in the Catskills, the trains of Canada were commandeered, the country consumed by the war effort. In August when Britain and its allies declared war on the Central Powers (Germany, Austro-Hungary, and Turkey), Canada, too, as part of the Empire, entered the Great War. Within weeks, more than 32,000 men had flooded the recruiting offices, ballooning the sturdy regular army of just over 3,000, and pushing the limits of the tiny Canadian navy to create a convoy to carry them all across the Atlantic.[6] At Onteora, where Mary and George were painting, all was calm. (This wasn't an American war yet: the United States would not enter the conflict for another three-and-a-half years.)

But suddenly the lax border between the two countries tightened, and getting across it on any train made available to civilians, let alone with the couples' possessions and art supplies, and all in time for the start of the term at the Ontario College of Art, proved time-consuming and difficult.[7] Unknowingly, Mary was spending her last summer at

Bonnie Brae. The huge upheaval of the war prevented her from ever seeing her studio-house again. When she finally arrived home in Wychwood Park, she had a new role and a new way of being—exclusively at home, with no more travel. She would stay in the studio off her dining room and begin the later, reconciling chapters of her visual diary.

When the three curators and I left Upland Cottage that day, we looked next door and saw the ravine that had to be crossed to get to what used to be Mary Evelyn Wrinch's house, now a huge house on landscaped ground. The young Wrinch enthusiasts in their knitted caps and gloves had seen Upland Cottage not as I saw it, but as the place where Mary Evelyn, "the British Mary," as she was sometimes called, frequently visited and eventually lived.

INTERLUDE

By the start of the war, Einfühlung had settled comfortably into the English lexicon as the word "sympathy," not much associated to its German sources. "Feeling into," had been translated by Victorian novelist Vernon Lee as "sympathy" about fifteen years before.[8] Lee, who wrote under the nom de plume Violet Paget, was a figure of protean interests. She was fascinated by perception and by the work of Lipps (who, disliking the way this Violet Paget took him up, later trashed her work in print).[9] But John Singer Sargent, a painter Mary revered, knew Vernon Lee in her youth, and painted an exquisitely sympathetic portrait of his friend. Lee/Paget understood very well how physical our pleasure of apprehension is, though she was mocked for explaining the word sympathy in bodily and personal terms. When we take in a vision, she claimed, we take it inside our bodies. Sympathy: Lee made it a one-word bridge from the Viennese School concept to twentieth-century ideas of feeling emotionally connected.

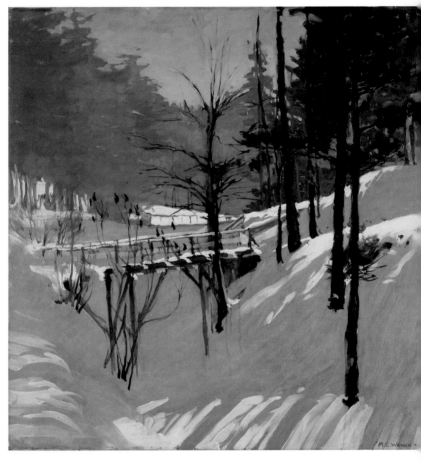

Mary Evelyn Wrinch, *The Little Bridge*, 1915,
oil on canvas, 88.2 x 86.9 cm,
National Gallery of Canada, Ottawa.

The Little Bridge

I.

Mary Evelyn Wrinch, thirty-eight years old and in the midst of a fully mature painting career, made a magical work she called *The Little Bridge* in 1915. It portrays her path to her neighbors George and Mary Reid, depicting the wooden conduit that links her house on one side of a ravine to Upland Cottage on the other. The footbridge crosses an otherwise dangerously angled crevice in the land that, without it, would force a walker to traipse the long way around. In this portrait of the physical passage between them, she loads the idea that a bridge has been built between herself and the older couple in an almost fairy-tale snowscape of that rough terrain.

Amy Rose, librarian and archivist at the National Gallery of Canada, and Sharon Odell, storage technician, led me down to one of the vaults to view *The Little Bridge*, a sparkling painting that takes the grays MHR had so smoothly laid down in *A Study in Greys* two years before and uses them with MEW's snowy panache. Wrinch's

brushstrokes make white and violet dashes; bare canvas shows through. The atmospheric painting reaches levels of snow abstraction, with a suggestion of the small Wrinch house at the center.

The Little Bridge was accomplished in the winter of 1915—after the sharp realization that the conflict had not ended by Christmas as the Allies had anticipated. Now trenches were being dug between Allied troops and German lines. Trenches like that ravine over which her intimate companion George, her teacher no more, her possibly past and definitely future lover, had built a bridge. Instead, bridges in Europe were being destroyed. And farmers from Kirby-le-Soken, where she had been a little girl, now hurried onto ships, and Canadian men departed farms to enlist. They climbed onto trains, then sailed to cross European ravines.

2.

Was Mary, with her German name Hiester, subject to the anti-German sentiment that began to permeate Canadian life? Her good friend Ellen Smith Hahn suffered to see her husband Gustav hounded for his German accent and suspected as a spy.

Torontonians woke on May 8, 1915, to the *Globe and Mail* headline "*Lusitania* Is Lost: Many Drown Torpedoed without Warning," learning that the British cruise ship had exploded the previous day, sinking in eighteen minutes and drowning 1,191 civilian passengers, including children.[1] The thought of so many children dying in the conflict inflamed the city—and

was one of the impetuses for the United States to join the war. The sinking of the ship breached—in fact, erased—nineteenth-century codes of war.

In the toxic atmosphere of anti-German sentiment, Gustav and Ellen Hahn and their family retreated to a farm in Myrtle, near Whitby, Ontario. About nine months after the *Lusitania*, Gustav's brother the sculptor Emanuel Hahn wrote indignantly to George about the allegations against him and the third brother, the musician Paul Hahn.

> Students allege I & my brother Paul condoned & glorified sinking of Lusitania. False. Paul had previously been accused of making similar statements. I am true to my naturalization of 1903. My father came to Canada due to opposition to military obligations in Germany & I believe that the military ambition of Germany is the cause of the war & hope to see it broken by a victory of the allied powers.[2]

It was nearly impossible to thwart such chauvinism and social shaming, as the Hahns bitterly learned. But Mary, despite keeping her German maiden name, was woven into Canada's social world. Listed in the *1910 Canadian Blue Book* (the Reids, it says, received guests on Saturday),[3] she was a member of most of the city's women's clubs, and her family had contributed to the founding of the United States. Perhaps most importantly, she was shielded by her married name. George's social reputation increased as his artistic cachet waned, and Mary's social standing rose with it.

3.

From her house at Wychwood Park, she ran a full domestic establishment as well as a painting studio, and both despite and because of the war, she entertained there. The fruit and vegetable market wasn't exactly around the corner. A horse had to be hitched to a carriage and driven downtown, or a large basket lugged down the hill to Dupont Street, where the Bathurst electrified streetcar could be boarded.[4] Though she had a housekeeper during wartime, that didn't mean MHR had no household responsibilities. Some, like buying peaches, came with a double mission. She could paint them, then eat them.

Hector Charlesworth, former city editor and music critic for the *Mail and Empire*,[5] observed her at a downtown fruit and vegetable market contemplating peaches—and annoying the vendor because she was choosing hard, unripe ones. It would take ages for them to soften enough to bite, the vendor insisted, but MHR was searching the tumble of fruit for the perfect sizes, shapes, and colors for a still life. Muriel Miller describes her as laughing lightly, saying, "Somehow a craving to paint the texture of the peach overcame me."[6]

Such local peaches as Mary chose were grown in the mild belt between Lake Ontario and Lake Erie, and of course with wartime conservation, they would certainly be eaten after they were painted. From *The New Galt Cookbook*, "a comprehensive treatment of the subject of cookery," published in Toronto, there were peach recipes galore, each attributed to a household cook, from canned peach jelly to

peach and apricot pie. If Mary, in a burst of energy, felt like "beating [a batter] unmercifully," she could have made peach fritters.

Peach Fritters

Peel a dozen peaches and cut them in half, removing the stones.

Sprinkle them with sugar and have ready at once a batter made by mixing a cupful of flour, a half teaspoonful of salt, a teaspoonful of sugar and a yellow rind of a lemon grated, and adding a half cupful of milk and the beaten yolks and whites of two eggs beaten well, finally add a teaspoonful of sweet olive oil or melted butter.

Beat the batter unmercifully and dig each half of peach in the batter so as to completely cover it.

Fry the peach fritters five or six minutes, or till a fine brown, and are tender through.

Sprinkle them lightly with powdered sugar after steaming, and serve hot.[7]

4.

Mary threw open the doors of Upland Cottage to the Red Cross and a hive of sewing began. Industrious women crammed the dining room.[8] "New" women with cropped hair sat at treadle sewing machines. Traditional hand sewers arrived, tying back their long hair. Shears in their

fingers, they leaned over tables draped with fabric to cut out the shapes for sleeves and plackets of uniforms, or for the simple squares and rectangles of bandages. They wrapped thread around their fingers, sewed hems, straightened seams. As in Mary's childhood, when her mother's cousin marshaled women's efforts in Reading, Pennsylvania, for the American Civil War, Upland Cottage morphed into a DIY manufacturing spot.

The war years also brought Mary new friends: their younger Wychwood neighbors, Ada Mary Newton Currelly (1879–1965) and her husband, C.T. Currelly (1876–1957), George's particular pal, the archeologist-collector who was shaping the Royal Ontario Museum. The Currellys were not artists, though C.T. had a profound interest in antiquities and had collected for Sir Edmund Osler, a patron of George's early work. In the wartime world of arts influencers, while Onteora was off limits, George and Mary spent portions of their summers as guests of the Currellys in Canton, near Port Hope, Ontario.[9]

George, at fifty-seven, principal of the art college, a past president of the Royal Canadian Academy of the Arts, knew what he would do to help the war effort: he could sell art. He helped band Toronto artists together to create a show and sale of their work at the Royal Ontario Museum, where his neighbor C.T. was director.[10] The vast exhibit, with Canadians rushing to open their pocketbooks, earned a substantial sum for the troops.[11]

5.

Then, Mary and Mary Evelyn joined together to make a private sale of their paintings, repeating their Art Metropole collaboration. When MHR and MEW put their work on display, the show, promoted by George, drew attention to each woman's sales, and the necessity of sending the proceeds to the Canadian government. This time the relationship of the three was not a debut; it was a fact in the war's upheaval. Standing on the social ceremony of what formerly, in the prewar city, might have been construed as an inappropriate liaison paled in comparison to huge new necessities.

The war affected Mary's friendship with Ellen Smith Hahn profoundly, and Mary wrote from Wychwood to Ellen in her farmhouse in Myrtle the day after the armistice on November 12, 1918: "We have all our flags out. I didn't see the celebrations yesterday—too serious an occasion for horseplay." Sensitive to her friend, Mary downplayed the nonstop celebrations that had spontaneously broken out all over the city. Ellen, so far away, was nearly lost to her. "Let's hope for a regenerated world," Mary wrote.[12]

But their world together would not regenerate; Ellen did not move back to Wychwood, though she cherished their friendship and saved that letter.

INTERLUDE

"Some neighbors had the flu," Mary wrote to Ellen in that same note. ("Flu" means the Spanish influenza pandemic.) Then she followed, "We escaped." Mike and I, masked and socially distanced, were managing to escape our pandemic, a century later. All alone together, we developed two routines. One was our evening dance-walking through the rooms of our tenth-floor downtown Toronto condo: two thousand steps every night. (We measured out a path that took one hundred steps and repeated it twenty times, fast, slow, and in-between, depending on the beat of the music we played. We never missed a night.)

Our other routine, not every day, but on lots of days, was the five p.m. Murmur Massage. We met in bed for that unguarded talking between couples that usually only happens late at night. Our bed became like the front seat of a vintage car: host to a low-voiced exchange on a fantasy drive.

At first, we would lie there together. Then we'd slip into our mode: it was soft and sweet and familiar as a blanket in a world that was hard and mutating and unfamiliar for us, and for everyone else in a transformative time. But we had another crisis that made the pandemic recede—Mike was on his twelfth melanoma recurrence. He still played

badminton! (That's a fast game.) Well, health is compli-
cated, and contradictory. Like marriage. And personalities.
So, we had to talk. And touch each other. Not for sex. Just
for . . .

So, we were lying there together in our big bed that
takes up most of the room. Snuggling up. I sniffed him.
It was so great that he smelled human and not like metal
from some medication he used to take. Smell. It goes right
to the brain's hippocampus—jogging memories. Each
time I've visited any of Mary's environments, I've taken a
deep whiff. You can rarely smell the past, but inhaling lets
you connect with the odors the historical person might
have smelled: apples, cheddar cheese, horse dung, wet
cobblestone . . . Mike smelled like fall. Like school. Stuff
about the day bubbled up as our murmur began. Trifles
about our online work lives fizzed up, then evaporated. Or
dinner details. I'm the intuitive cook; he got out a ruler to
measure sweet potato cubes. We were like two bits of a
jigsaw puzzle sky cut so irregularly that it looked like we
would never fit. Then you turn the pieces the other way.

"Turn over," I would say. "Would you like a massage?"
I'd start rubbing his back—so much bonier than when we
were forty-five and finally decided to get married after a
twenty-year gap of separate odysseys with other people.
His face would be mushed into the pillow. After a few
minutes, I'd ask the murmur question: "How are you doing
in there?" Then he'd surprise me. Even if I thought I knew
how he was, I realized I *didn't* know. Was I misinterpret-
ing his frown? I was projecting what I was feeling, just
like Vischer, Riegl, Lipps—the Empathists—like the

process Freud defined. Then he'd start confirming on his part what I'd known or felt for weeks—sometimes years!—with mumbles.

Things about his colleagues. His doctor. His many doctors. His memory. Our wills. Anxiety. And the thing we could only say when we felt so, so safe: fear.

He was not facing me. I was looking at his back. Or maybe my eyes would be closed. Usually these backrubs were more like absently stroking the furry spine of an imaginary collie. Only sometimes did I get energetic enough to be anything approaching a fake masseuse. Really, I was petting him.

Sometimes the kitchen timer went off. We ignored it. Or if dinner really was burning, I clambered out to rescue it. Then I'd be back, looking at him. My husband was still cute. Quite lean, bearded and twinkly.

We'd decided to invent a family of two—something I'd imagined since I was a child. At the age of twelve, I thought, as my father tore the legs off the kitchen table and the liquor bottles clattered in the garbage can, that all I wanted was a nice calm house where the lady cooked and the gentleman read the newspaper and then they sat down together at a table with four sturdy legs. A classic cis-gendered 1950s Anglo vision born of . . . fear.

I don't know the times Mary was afraid. Of all her spaces I've visited, I've never been in a Reid bedroom. It took everything I had not to ask Marc Giacomelli if I could intrude on Mary's former bedroom in Upland Cottage.

"Are you ready for your turn?" Mike would ask me. Of course. He was more purposive and massaged my legs. (I

have a leg glitch that gets exacerbated in a rousing badminton game.) He'd be completely silent. I always spilled the beans. "Sometimes"—I had to work my way up to this, but it came out—"because of your brain tumor, I feel like we're living through a tragedy."

There, I murmured it.

Nothing from Monsieur Masseur. Steady strokes on the calves.

"Well," he muttered, "just don't say that too often."

I obeyed. Brain tumor? Yes, melanoma, as was the case for former U.S. President Jimmy Carter, can metastasize to the brain. Mike had stage 4 melanoma for forty years, living with it as if it were like diabetes. And I lived with chronic caregiving this way, too. My phrase "living through a tragedy"—that's something that every single person on the face of our environmentally challenged, virus-seized planet could actually lay claim to. Yet it's Mike's phrase, "just don't say that too often" that we—I mean every human on Earth—can use to preserve ourselves. Mike's hope. Mary's philosophy of cheer. On with the task! Simply the resolve to go on opened doors for her. Stuck doors. And for Mike as well. Us.

After this particular murmur massage, talented oncologists at Toronto's Princess Margaret Cancer Centre shrank his tumor to a manageable blip. Then our whisperings became about how scared we *were* rather than *are*. As he continued on with an international academic project, I realized I had no idea how many people were walking around, masked, in physically distanced lines, with managed brain tumors. You never know.

Fresh thoughts come to a prone person. Lying down—as Freud famously suggested with his image of the couch—lets ideas come. To create a space for thought as play, as Dutch philosopher Johan Huizinga reminds us in *Homo Ludens*, is to reassemble ideas—with whimsy. The Empathists and their ideas played about the room. So did Gaston Bachelard, their inheritor, who said about the spaces of intimacy, "Their being is well being."[13] Our talk would shift from dailiness to world events, just as Mary's postcards did . . . Then it was time to get up. We'd get out of bed. And a tectonic plate of everyday would shift inside a century of thoughts, from pandemic to pandemic.

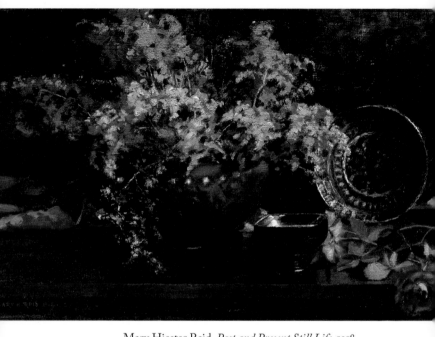

Mary Hiester Reid, *Past and Present Still Life*, 1918,
oil on canvas, 55.9 x 91.4 cm,
Art Gallery of Ontario, Toronto.

Past and Present Still Life

I.

Two red hearts in the shapes of roses beat in the lower right-hand corner of *Past and Present Still Life*, Mary's last oil painting (though not her last work). Heart trouble plagued her. Throughout the nineteenth century, British, Canadian, and American medicine viewed heart disease, especially angina pectoris and heart attacks (with extreme chest pain radiating down the arm and gasping, choking sensations), holistically and related the physical heart to matters of feeling, in particular seeing anger as the instigator of bouts of pain.[1]

Mary hasn't painted dried plant material until now. Dead grasses burst in a flurry—or fury?—above those red roses in this, her richest, blackest painting. From its darkness, the embossed metals of the platter, cup, and vase catch the light. A dried bouquet (the past) effuses over the lip of its container. The color of blood surfaces in the roses.

"Suffering from neuritis," she wrote to Ellen in her letter on the day after the armistice during the pandemic of her

day. "Some neighbors had the flu. We escaped." Preliminary to her first heart attack in 1919, her so-called neuritis, going on for at least nine years, had intensified to the point where she wrote of it to her friend for at least a second time. In sheer number of sentences, the subject of illness equals the subject of the armistice in her letter.

When Mary decided to paint that dried bouquet after a horrific war, she did it with a sense of monumental casualties and within a personal and a global context of illness. The arrangement of the still life and the brushstrokes themselves (especially if we follow Vischer's lead that empathy suggests sensing through our own subtle body movements) contain an aura of aftermath and illness in the past. As for the present, those deep red hybrid tea roses could have come from Mary's own garden, cultivated and tended to throughout the war and the subsequent pandemic. Not only did she live in a modern house, but she painted modern roses, hybrid teas that grow on straight, long stalks with upright blooms.[2]

Yet in the painting, those two tall red roses lie down like dying soldiers or flu victims—not anchored in water—gasping on a tabletop below an arrangement of dead, preserved grasses. A last painting is like someone's last words, and this reminds me of some of the last written words that the British poet Edward Thomas composed in the trenches. In "Rain," he writes: "this bleak hut, and solitude, and me / Remembering again that I shall die." Contemplating death doesn't fend it off, but it does provide a certain consolation of scrutiny.

But here I pray that none whom once I loved
Is dying tonight or lying still awake
Solitary[3]

Refreshing in the beauty of its candor, the painting, like
Thomas's poem, is both bleak and brave. Mary's previ-
ous love of grays chars to a variety of browns and blacks.
Without denial, she inscribes death directly: dark and dried.

2.

As she painted a portrait of dying, her husband found the
Ontario College of Art at a deficit, and George's friend and
neighbor C. T. Currelly as well as the Minister of Education,
Henry John Cody, came to its rescue. After its budget
stabilized, the school grew so fast that George secured the
lands east of the Grange to build a new school—and going
a week without sleep or much food, he drew up the plans
himself. He was in a work frenzy as Mary was increasingly
debilitated.

When the science of cardiology emerged, emotions,
"conduits between mind and body, spirit and matter," were
integral to the study of heart disease. The psychological and
the physical were in continual dialogue and perceived as
mutual, especially in cases of angina pectoris.[4] The spas-
modic, suffocating pain (angina) in the chest (pectoris) was
inseparable from the anxiety of the feeling of being stran-
gled. Early cardiologists described "something peculiar in

the pain" of angina "as if it were combined with something of a mental quality. There is a feeling and fear of impending death."[5] The word pain leaps out of the raw umbers and blacks of Mary's painting. The year after *Past and Present Still Life*, 1919, she suffered a heart attack and was in so much agony that she was "bedridden for days."[6] A lifetime of feelings expressed in paintings of flowers and jars and trees had accumulated. On October 21, 1919, she wrote to Ellen, "Feeling better but still very shaky."

3.

In a sentence so simple it belies the hundred years of struggle, she declared in that same letter, "Went to Alcina Avenue to vote."[7] No heart condition was going to prevent her from doing *that*. The woman who had, in every sense, painted her heart out fulfilled a promise to cast a vote that all the circumstances of her life had led her toward.

4.

The brother of George Reid's early patron Sir Edmund Osler (who was also one of C.T. Currelly's former clients and a patron at the Royal Ontario Museum) was Sir William Osler. A Canadian physician, sometimes called the father of modern medicine, Osler was a faculty member at the University of Pennsylvania and became one of the founders of the Johns Hopkins University School of Medicine.[8]

Among his focuses was heart disease. In the 1890s, he posited four types of angina: "true," "false," "hysterical," and "vaso-motor."[9] Thus Osler was instrumental in the medical disconnection of the emotions from the heart, attaching instead "false" and "hysterical" angina to hypochondria and neurosis. As Freud's and his contemporaries' theories came into general parlance, emotion was rhetorically, paradoxically severed from the science of the body. The early investigations into dreaming and Vischer's concept of empathy had, by the time of Mary's angina attacks, transformed to now divorce the emotional from the physical aspects of angina. "False" and "hysterical" angina were becoming feminized and neurotic as Mary was actually dying of her heart trouble.

European modernist painters had sheared off emotion and realism from shape, form, and color in painting. The young Canadian men in the Group of Seven eschewed domestic scenes for the magnificence of the vast northern landscape, not merely the pines of the Catskills or the maples of Wychwood Park. Even at the moment when she cast her vote, Mary, in career and in health at once, was falling into the margins.

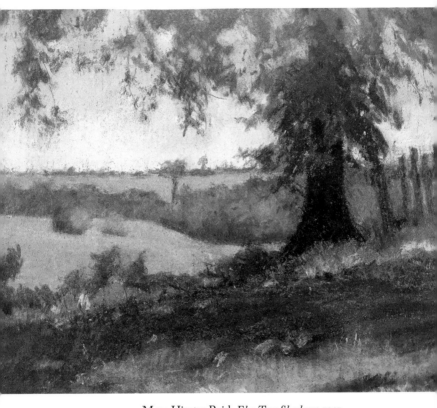

Mary Hiester Reid, *Elm Tree Shadows*, 1921,
colored chalks on gray wove paper, 30.5 x 35.6 cm,
Art Gallery of Windsor.

CHAPTER THIRTY-SIX

Elm Tree Shadows

I.

Her attacks increased over the next two years.

She could no longer stand for long periods at an easel.

Maintaining the flexibility that characterized her whole life, she abandoned oils completely for the pastels that she had taken up some years before.[1] Pastels are messy, but you can use them on your lap, even lying down, if propped up by pillows, and you can accomplish something with lower energy—especially if you only have a few good hours. Then you can look out your window and draw your garden, which Mary did. Her pastel works are buoyant and full of color—there's none of the bleakness of *Past and Present Still Life*. She didn't need a brush to do them—and probably blended with her fingers.[2] It's almost as if that last oil painting released her into an alternate medium.

The pastel *Elm Tree Shadows* is her last known work. Her choice of colors? Green and green-blue, the hues of growth. Her last image is of that august elm throwing its shadows. The trunk of her elm fills in with thick, dark,

sturdy shades of umber. Her tree's green-blue branches and leaves reach out horizontally across the entire top of the pastel, hinting at the huge oval reach of its crown.

2.

But Mary fretted. George was preparing for the Beaux Arts Costume Ball at the Ontario College of Art. Would she be able to stand for hours to receive guests as the wife of the principal? Her heart attacks, the crushing pain, the breathlessness and panic had continued. She'd spent days, sometimes weeks, in bed. George left for the costume ball alone.

But after he shut the door, Mary summoned a mischievous surprise energy. She had secretly planned a costume after all, and when George was down the road, she changed into "an old time gown and beflowered poke bonnet."[3] It was just the type of dress she wore as his model, decades before, in *Gossip*, when she posed for him by a spinning wheel. After she outfitted herself, she made her way across the street to Ada and C.T. Currelly's house. She'd asked for their help to execute her plan, and they'd agreed to escort her as a disguised guest to the costume ball.

When the three arrived at the event, Ada and C.T. brought her into the receiving line with them, her face hidden by the flaps of the bonnet. Engineering every minute of this surprise, Mary inched forward in the line of attendees with the Currellys, finally reaching the end, where George shook the hands of all. Mary extended her hand to him, and he extended his, as the bonnet flaps revealed at last

the ailing woman whom he had once painted in sensuous yellow gloves. When did he recognize her? At that very moment? Had the Currellys told him? Or had he known all along? At whatever stage he realized that Mary had come to him, he received the gift of recognition that she gave him: their union transformed into the sweep of calico and the gesture of their youth.

The preparation, the summoning up of strength, the visiting of the dressmaker to create the perfect costume, and the visit to the milliner to create the perfect hat to disguise her thinning gray hair, all swept up the energy of the past into the present. It must have been exhausting. And fun, too. I don't know whether she was able to manage even half a dance that night, or whether she was able to stand much, or for how long she stayed. But she made elaborate arrangements, and she showed up. It was a bittersweet exercise in arrangement and control—and one of love.

3.

Mary Evelyn Wrinch and her sister Agnes had moved from the awkwardly placed house on the ravine next door into a new house built on Alcina Avenue, the street behind Wychwood Park, where Mary had gone to vote. No longer next door but on her own street, Mary Evelyn's complex relationship with her mentor rebalanced again. In reverse tenderness, the younger Mary reached out to take care of the older one. It was Mary Evelyn who brought the cups of tea now.

Still life became closer to stilled life. The setup of the still life (positioning subjects before, behind, to the left and right of one another) that had guided so much of Mary's existence became a way of guiding her exit from the world. She drew both Mary Evelyn and their friend Marion Long to her. Mary abandoned innuendos and spoke directly, instigating a conversation with Mary Evelyn while Marion Long was within earshot. "George will be needing a wife," Mary stated unequivocally, according to Marion, who told biographer Muriel Miller.

Into the silence of the jars and jugs and plates and vases, she expressed her wishes out loud, in front of a witness. It was going to happen whether she approved or not, so she approved it, she directed it, she was heard. In her gesture of delivering to her husband his desire and recognizing Mary Evelyn's yearning, she freed them both into what she suspected they would do after her death. Regally, modestly, with insight, she gave them her permission, and most importantly included a witness. Through sheer gossip—who could resist this story?—Marion Long, the third party, would tell how the older painter made a gift of her husband to his second wife. Soon their world would know that he went on with his first wife's imprimatur. They all became part of Mary's arrangement.

4.

Elm Tree Shadows may have been done on a day when she felt well enough to venture outdoors. Or the landscape might

just be invented, the pastel worked as the artist lay among the pillows in her inglenook, with a fire going in late summer. For Mary had seen many wych elms, another name for Scotch elms,[4] the tall and wide and mythic shade tree she drew with chalk. Wychwood (from the Old English *wice*, meaning pliant, or in this case pliant-branched or bending[5]) is associated with Celtic elves and fairies and with the underground. In classical Greek mythology, Orpheus sang to his wife Eurydice in Hades while standing in an elm grove—the tree that signals a way to the afterlife.[6] If a person could choose one quality to maintain to the very end, flexibility might be the ideal.

Mary died on October 4, 1921.

INTERLUDE

It amazes me how little Mike and I talked about death. I was the one who would have to bring it up. When I would say, "I'm going to need to know this"—about taxes, about passwords—he would give me the information, wincing. I had poked a sore spot, yet again. But there had been silent, inner preparation. For two verbal people, our most essential communications were unspoken.

I would look at his brown-flecked eyes with an expectation of tacit communication. We listened, looked, smelled, and touched in a non-verbal world, silent as two swans. In this way, we were Empathists. We felt our way into one another. Our wordless dialog was like the speech of paintings.

In our bedroom where Mike had collapsed, as the 911 paramedics barreled out of the elevator and down the long hall toward our apartment, I asked him aloud: "Are you going to start the MAID process?"

"Yes."

As the paramedics knocked on the door, we spoke quickly. "You might not see our apartment again," I said. And he said, "I know."

As Mike entered Princess Margaret Cancer Center,

he requested Medical Assistance in Dying. It is a complex process.

"Honey, you have to summon up all your strength to say what you want," I said to him in the blue hospice room before the first MAID interview, before the energetic volunteer doctor, who was hard of hearing, walked into the room. Mike had lost most of his hearing. Legal questions were yelled and answers murmured back into a small amplifier the doctor held. She certified that he passed the first interview.

He was so weak he could not raise his head.

The second day on the Hospice floor the three independent witnesses arrived. Miraculously, Mike coiled his hand around a ballpoint pen for the 30 long seconds that he once might have used to scratch a cat's head, then scribbled.

On the third day, came the final, serene volunteer physician. The man in the bed summoned up the old lucidity that had allowed him once to verify a cache of *Ulysses* manuscripts so that the National Library of Ireland might raise the 12.6 million Euros to buy them. I thought of Mary's *Past and Present Still Life*: two roses, a dried arrangement, the darkest of her dark backgrounds. When the physician shouted the questions, Mike's voice, dry as the wisps of desiccated grass Mary painted, whispered that yes, he wanted to be in control of his own death.

Now he was approved. Sixteen floors below, the city of Toronto spread its grid around the hospital in a neighborhood Mary and George would have known so well. Just a block or two away both their works nestled in huge curatorial storage areas beyond enormous, locked museum basement doors.

One last question, the physician hollered, "When do you want the intervention?"

"Tomorrow," Mike whispered.

On his last day, I brought a suitcase with his clothes. It would also double as something to take home the few possessions left in the hospice room. The intervention would take place at two p.m. By eleven a.m., I had trimmed his beard and brushed his teeth. At one thirty p.m., the kindest of nurses would arrive to prepare him. But now we had two and a half hours. It struck me then that we could have been in an airport, waiting for an international flight. Dressed in his favorite shirt and matching socks, my husband lay awaiting, lucid to the end.

In the bare room, the few objects were our witnesses. The big clock above the bed ticked on with its task as I sat holding Mike's hand. Our suitcase stood at attention. His bed did its job and supported. My sweater did her job and warmed.

J.E.H. MacDonald, *In Memoriam MHR* (headpiece), c. 1922,
Gordon Conn Papers, Edward P. Taylor Library & Archives,
Art Gallery of Ontario, Toronto.

POSTLUDE

I.

"... my great loss," George wrote a month later, in a moving response to a letter of condolence, "I miss ... her great qualities of mind and heart and her wonderful personel [sic] charm [that] made her a magnet of human attraction." In his slanted, even hand, the loops of the Gs going well below the line, the Ts crossed with extravagantly long top bars, he breaks down as he writes. "She was so much to me that I have scarcely the fortitude to face the ... separation."

Then he details her illness and thoughts before death: "I am glad she did not suffer much, and practically none at the last, we both know it must come some time, but I thought she was otherwise so well that the heart malady would not get 'the upper hand.' She was very calm and strong about it and said she would not mind when the end came, and had made such preparations as she thought necessary."[1]

In her will, she left George the Onteora property.[2] (Candace Wheeler, still at Pennyroyal, passed away two years later.)

2.

Eight months after Mary died, George loped down the path to Alcina Avenue and took the hand of Mary Evelyn Wrinch and brought her across the threshold of Upland Cottage. Why wait the prescribed whole year to get married? He was sick of his grief and empty bed. Mary Evelyn moved into Mary's studio at last. She reigned over her inglenook, cooked on her stove, slept on her mattress. The stricken George, sheared from decades of close support, neither changed his abode nor changed his habit of calling his wife "Mary."

In time, Wrinch stopped painting in oils on canvas—perhaps that was George's domain—and began vivacious works on paper, using the layered techniques of British artist Walter Donne. In further years, she persuaded George to buy a car, and off they would motor into the countryside and the wild she loved. They sailed to Europe, too, on a mission to learn new teaching techniques. They would go on together for nearly three decades, almost but not quite as long as George's marriage to Mary Hiester.

Yet for the year after her death, they felt Mary's presence powerfully and devoted themselves to a huge retrospective show of her work. Friends, collectors, and artists stepped forward to make this landmark exhibition, the first by a woman ever at the AGO. The old Mr. Reid and the new Mrs. Reid drove themselves to the deadline of coordinating it. Along with members of the clubs and organizations to which they belonged, they energetically helped her devoted friends contact hundreds of people who

owned Mary's paintings to contribute to her show. Group of Seven artist J.E.H. MacDonald designed the headpiece, "In Memoriam," that was published in the catalog *Memorial Exhibition of Paintings by Mary Hiester Reid* by the art gallery in 1922.[3] You could say George and Mary Evelyn were haunted by her. They worked with an emotional palette of reverence, remembrance, relief, freedom, and love—and with the essential drop of guilt that, like a brush tip of red, makes all the other colors vibrate.

It was her circle of friends who secured her reputation, raising the cash to buy *A Study in Greys* and *Chrysanthemums, a Japanese Arrangement* for the Toronto Art Gallery, now the AGO. "It was an open secret that the Toronto Art Gallery was keen to possess one or two of Mrs. Reid's flower pieces," *Saturday Night* magazine revealed, but the gallery had no funds to buy them. The reporter went on to emphasize Mary's women friends' "ardent desire" to make this happen. The friends organized a committee, visited George and Mary Evelyn, and bought the two works from George so that they could donate them to the gallery.[4] Only two? Why not a third? George added *The Phlox Garden* to round out the contribution. If it weren't for the "Friends of Mary Hiester Reid" designated on the museum gift, we might now be only seeing Mary in a portrait by her husband, arranging flowers, instead of viewing major pieces of MHR's flower diary themselves.

"The career of flowers differs from ours only in inaudibleness," Emily Dickinson wrote to her cousins Louise and Frances Norcross in April 1873,[5] just at the time when Mary was gathering herself up for her vocation of painting. With

this exhibition Mary's career of flowers and trees left a legacy of her life commands. Paint. (And write.) Travel. (Take mental journeys, too.) Marry. (Call that intimacy, one-to-one.) Notice. (Persistently.)

<p style="text-align:center">3.</p>

Writing retrospectively about her painting, her admiring critic and friend C.W. Jefferys singled out *A Study in Greys* as "the picture presented to the Toronto Art Gallery by several of the artist's women friends." In "The Art of Mary Hiester Reid," his memorial essay that remained unpublished until 2001, Jefferys pits Mary's impulse to infuse everyday objects and nature with "sympathetic" values, or emotions, against "the tempest and the earthquake" of modernist subjects. He calls modernist painting after World War I "Ego writ large." Then he gives Mary's art a voice. To Jefferys, her paintings speak. They are the language that bursts out of silence, "but our ears are not infrequently deaf to the still small voice, whose message may be more pregnant with meanings." The "still small voice" that comes after an earthquake's devastation, or after a fire's rampage, refers to how the Old Testament God spoke to the prophet Elijah.[6] Jefferys likens the voice of Mary's work to something that after drama and disaster we can actually hear. It speaks the way a deity speaks when we are finally quiet enough. It is a woman's voice, "pregnant" with significance.

He heard her. But he also chose to emphasize the color that would forever connect her to melancholy and a certain

sort of (dreary?) domesticity. He emphasizes her "gentle fortitude." She *did* act gently—she had to—but she exercised a steel-gray brand of fortitude that any of us today could use. "The name of Mrs. Reid will always have a prominent place," he fallibly predicted of the woman he called his country's "foremost woman painter."

Jefferys, in an act of his own empathy, tried valiantly to get at what made her paintings whisper, chatter, growl in undertones, murmur, and sigh. They spoke the language of feeling. She herself is inside those voices, he insists: "The ultimate value of a work of art is determined by the quality of the self expressed in it." Then he goes beyond, to the self in the world: "The larger conception of art includes self-expression plus the expression of the selves of others, and of that vast domain beyond ourselves."

The self and other selves. As Jefferys comes down to the interrelationships of those blooms and jars, the trunks of those trees in Mary's work, he arrives at the psychological, the quality of seeing and being seen that Vischer, Lipps, Riegl, and Freud (as well as phenomenologist Bachelard and psychologist Winnicott) worked to understand. His memorial for Mary overlaid colors of thinking that were present in aesthetic and psychological discussions throughout her life. "In a word," he concludes his memorial, ". . . Sympathetic Self Expression."[7]

But gray is not just smog or blur. It can be the liveliest of colors. In poetry, the music of a line emerges from its unstressed syllables. You can't stress every word—you'll wreck your music. And gray is like knowing that unstressed syllables are the undercurrent where a poem rides. If you

are making gray on a palette, you can have fun first making a dull charcoal out of blue, yellow, and red, and then brightening it up with blue for a blue-gray, or adding more red for a lavender-gray or more yellow for a tan-gray. Soon you are painting with all the subtle colors that make up a world.[8]

4.

As stewards of her paintings, the second Mrs. Reid and George Reid lived with Mary's presence, the product of her hand, for all the years of their marriage. They maintained scrapbooks of George's and Mary's reviews, they kept photographs and catalogs of sales. When Muriel Miller knocked on the front door of Upland Cottage, thinking that she was simply going to write a biography of the eminent George Reid, the couple found themselves remembering Mary in detail. She was everywhere. From the travel itineraries to the floorplans of houses to the objects on the fireplace mantels. There was the cassone she brought back from Europe. There was the Japanese print. There was the pewter plate. Her objects surrounded all who entered Upland Cottage, containing their history of interactions with the one who painted them, carrying her touch. The mirror with the peacock feathers she painted and the "Vanitas Vanitatum" that she lettered reminded anyone who looked in it that she was present, holding their reflections.

"First Love"

It looked at me, I looked
Back, delight
Filled me as if
I, not the flower,
Were a flower and were brimful of rain.
And there was endlessness.
Perhaps through a lifetime what I've
Desired
Has always been to return
To that endless giving and receiving,
The wholeness
Of that attention,
That once-in-a-lifetime
Secret communion.

—DENISE LEVERTOV[9]

TIMELINE

1854	Mary Augusta Catherine Hiester (MHR) born April 10 in Reading, Pennsylvania
	Father, Dr. John Philip Hiester (b. June 9, 1803), dies September 15
1860	George Agnew Reid (GAR) born July 25 in East Wawanosh (now Wingham), Ontario
1861	American Civil War begins April 12
1863	MHR, mother, and sister, Carrie (b. May 29, 1851), take refuge with cousin Henry McLenegan in Beloit, Wisconsin
1865	American Civil War ends May 9
1867	Confederation unites Ontario, Quebec, New Brunswick and Nova Scotia to form the Dominion of Canada on July 1
	International Exhibition of Arts, Manufactures, and Products of the Soil and Mine, held at Fairmount Park in Philadelphia, Pennsylvania May 10-November 10
1875	Mother, Caroline Amelia Musser (b. December 28, 1808), dies November 8
1877	Mary Evelyn Wrinch (MEW) born May 12 in Birch Hall, Kirby-le-Soken, Essex, England
1881	MHR enrolls in the Philadelphia School of Design for Women
1883	MHR and GAR enroll at the Pennsylvania Academy of the Fine Arts
1885	GAR paints *Portrait of Mary Hiester Reid*
	MHR and GAR marry May 13 in Philadelphia
	MHR and GAR embark on first European tour to England, France, Spain and Italy; return to Toronto in fall, open a studio and living quarters on Adelaide Street East
	MEW leaves England and arrives in Bronte (now Oakville-Toronto region), Ontario, Canada
1887	MHR and GAR set up quarters at 31 King Street East; accept more students for art instruction
	Construction begins on the tour Eiffel in Paris
1888	MHR poses for GAR's *Gossip*
	MHR and GAR joint exhibition at Oliver, Coate and Company

	MHR and GAR take studio and living quarters at 65 Boulevard Arago, Cité fleurie, Paris
	MHR enrolls at Académie Colarossi; GR enrolls at the Académie Julian
	Construction begins on Candace Wheeler's Onteora artist colony
1889	MEW moves to 619 Church Street, Toronto; attends Bishop Strachan School
	MHR and GAR return to Toronto in October; set up studio and living quarters in the Arcade (Yonge Street near Temperance Street)
	GAR's *The Story* sold to Sir Edmund Osler for $1000
1890	GAR elected to the Royal Canadian Academy of Arts
	GAR appointed instructor for the Central Ontario School of Art and Industrial Design
	MHR poses for GR's *Mortgaging the Homestead*
1891	MHR and GAR spend summer in the New York Catskills at Tannersville; meet Candace Wheeler and artists of Onteora
	MHR paints *Roses in a Vase*
1892	GAR and MHR build Bonnie Brae in Onteora
1893	MHR exhibits *Chrysanthemums* (1891) at the World's Columbian Exhibition in Chicago
	Mary Jung poses for GAR's *A Modern Madonna*
	MEW enrolls at the Central Ontario School of Art and Industrial Design; studies under GAR
	Panic of 1893 leads new residents to Onteora; attorney Charles Hazen Russell hires GAR to plan and build his cottage
1894	MHR and GAR hold summer art instruction at Onteora; MEW attends
	MHR paints *Three Roses*
1895	GAR paints *Portrait of Mary Evelyn Wrinch* and *The Evening Star*
	MHR paints *Chrysanthemums: A Japanese Arrangement*; illustrates women's supplement cover of *The Globe*
1896	MHR and GAR embark on second European tour to Spain, Gibraltar, and Paris; MHR travel essay published in three parts in *Massey's Magazine*, illustrated by GAR
	MEW leaves the Arcade and moves to a new studio on Imperial Lane
	GAR paints *Sketch Portraits of George Agnew Reid and Mary Hiester Reid*
	MHR paints *Castles in Spain* and *Studio in Paris*
1897	MEW studies under Alyn Williams at the Society of Miniatures in London, England
1898	MHR paints *Moonrise*
1899	MEW studies miniature painting under Alice Beckington and Art Students League in New York
1900	MHR and GAR finish construction and move into new house near High Park on Indian Road
1902	MHR and GAR travel to Scotland and England
	MHR and GAR help found the Arts and Crafts Society
1904	"The Mary Luncheon" celebrates the Marys in Onteora
1906	MEW paints *en plein air* in the Lake of Bays in Muskoka
	MEW paints *Miniature of Mary Hiester Reid*

	MHR and GAR begin construction on Upland Cottage in Wychwood Park
1907	GAR named President of the Royal Canadian Academy of Arts
	MHR and GAR move into Upland Cottage
1910	MHR and GAR take third and last European tour through Netherlands, Belgium and England; meet Carrie; visit Philadelphia and Reading before return to Toronto
	MHR paints *Nightfall* and *Nasturtiums*
1912	MHR and MEW hold joint exhibition at Art Metropole in March
	GAR appointed principal of the Ontario College of Art
	MHR paints *A Fireside*
1913	The International Exhibition of Modern Art, also known as the Armory Show, opens February 17 in New York City
	MHR paints *A Study in Greys* and *Morning Sunshine*
1914	MHR spends last summer at Bonnie Brae
	Great Britain declares war on Germany August 4, bringing Canada into World War I
1915	*Lusitania* torpedoed March 7
	MEW paints *The Little Bridge*
1917	United States declares war on Germany April 6, entering World War I
1918	Worldwide influenza pandemic begins (ends 1920)
	MHR paints *Past and Present Still Life*
	Armistice between Allies and Germany signed November 11 ending World War I
1919	Treaty of Versailles signed June 28
	MHR votes in Ontario general election on October 20; the first Ontario election in which women could vote and run for office
1921	MHR draws last known work, *Elm Tree Shadows*
	MHR dies October 4 in Upland Cottage
1922	GAR and MEW organize MHR retrospective memorial exhibition at Toronto Art Gallery (now Art Gallery of Ontario), October 6–30
	GAR and MEW marry in December; MEW moves into Upland Cottage
1940	Murial Miller interviews GAR in January
1947	GAR dies August 23
1969	MEW dies September 19

BRIEF BIBLIOGRAPHY

Anderson, Janice, and Foss, Brian. *Quiet Harmony: The Art of Mary Hiester Reid.* Toronto: Art Gallery of Ontario, 2000.

Boutilier, Alicia, and Bruce, Tobi. *The Artist Herself: Self-Portraits by Canadian Historical Women Artists.* Kingston: Agnes Etherington Art Centre / Hamilton: Art Gallery of Hamilton, 2015.

Boyanoski, Christine. *Sympathetic Realism: George A. Reid and the Academic Tradition.* Toronto: Art Gallery of Ontario, 1986.

Hill, Charles C. *Artists, Architects and Artisans: Canadian Art 1890-1918.* Ottawa: National Gallery of Art, 2013.

Mastin, Catherine. Female Self-Representation and the Public Trust: Mary E. Wrinch and the AGW Collection. Art Gallery of Windsor E-publications, 2012. https://www.agw.ca/mk_page.php?a=exhibitions&b=archive&c=list&d=female.

Miller, Muriel. *George Reid: A Biography.* Toronto: Summerhill Press / University of Toronto Press, 1987.

Oneill, Therese. *Unmentionable: The Victorian Lady's Guide to Sex, Marriage, and Manners.* New York: Little, Brown and Company, 2016.

Sangster, Joan. *One Hundred Years of Struggle: The History of Women and the Vote in Canada.* Vancouver: UBC Press, 2018.

Schweigert, Scott. *American Impressionism: The Lure of the Artist's Colony.* Reading, PA: Reading Public Museum, 2011.

Simpson, Marc. *Like Breath on Glass: Whistler, Inness and the Art of Painting Softly.* Williamstown, MA: Sterling and Francine Clark Art Institute, 2008.

Terry, Andrea. *Mary Hiester Reid Life and Work.* Toronto: Art Canada Institute, 2019. https://www.aci-iac.ca/art-books/mary-hiester-reid/.

Werbel, Amy. *Thomas Eakins: Art, Medicine, and Sexuality in Nineteenth-Century Philadelphia.* New Haven: Yale University Press, 2007.

IMAGE AND LITERARY CREDITS

Image Permissions

Cover:

Mary Hiester Reid, *Chrysanthemums*, 1891, oil on canvas, 52.9 x 76.2 cm, National Gallery of Canada, Ottawa. Gift of the Royal Canadian Academy of Arts, 1893. Photo: NGC / Mary Hiester Reid, *Chrysanthèmes*, 1891, huile sur toile, 52.9 x 76.2 cm, Musée des beaux-arts du Canada, Ottawa, Don de l'Académie royale des arts du Canada, 1893. Photo: MBAC.

George A. Reid, *Portrait of Mary Hiester Reid*, 1885, oil on canvas, 76.7 x 64.3 cm, National Gallery of Canada, Ottawa. Gift of Mary Wrinch Reid, Toronto, 1965. Photo: NGC / George A. Reid, *Portrait de Mary Hiester Reid*, 1885, huile sur toile, 76.7 x 64.3 cm, Musée des beaux-arts du Canada, Ottawa, Don de Mary Wrinch Reid, Toronto, 1965. Photo: MBAC.

Chapter One, page 2:

George Agnew Reid, Canadian, 1860–1947, Mary Hiester Reid in her Paris studio at 65 Boulevard Arago, 1888–1889. Page 134 of Scrapbook 1, E. P. Taylor Library and Archives. Gift of Mary Wrinch Reid, 1957, LA.GRF.VI.134. © Art Gallery of Ontario.

Chapter Two, page 14:

Mary Hiester Reid, Canadian, 1854–1921, *A Study in Greys*, c. 1913, oil on canvas, overall: 61 x 76.2 cm (24 x 30 in). Gift of Friends of Mary Hiester Reid, 1923, 665. © Art Gallery of Ontario.

Chapter Three, page 26:

Mary Hiester Reid, Canadian, 1854–1921, *A Fireside*, 1912, oil on canvas, overall: 61.2 x 46 cm (24 1/8 x 18 1/8 in). Purchase, 1987, 87/174. © Art Gallery of Ontario.

Chapter Four, page 32:

Anonymous. Silhouette labeled "Grandmother," one of Mary Hiester Reid's grandmothers, likely Mary Catharine Muhlenberg (1776–1843), undated, paper, 12.5 x 10 cm (5 x 4 in). Private collection, Texas. Courtesy Dr. and Mrs. Edgar Nace.

Image and Literary Credits

Chapter Five, page 42:
Mary Hiester Reid, *Spring*, undated, pastel on card. Agnes Etherington Art Centre, Queen's University, Kingston. Gift of the Gordon Conn Trust, 1964 (07-029).

Chapter Six, page 60:
Mary Hiester Reid, *Nightfall*, 1910, oil on canvas, 76.5 x 102.0 cm, The Robert McLaughlin Gallery, Oshawa, Ontario.

Chapter Seven, page 76:
George Agnew Reid, Canadian, 1860–1947, *Study of a Woman with Arms on Head* done at Academy of Fine Arts, Philadelphia, 1884, oil on paper, overall: 18.6 x 9.5 cm (7 5/16 x 3 3/4 in). Gift of Mary Wrinch Reid to the E.P. Taylor Reference Library, 1957. Transferred to the permanent collection, 1988, 82/159.3. © Art Gallery of Ontario.

Chapter Eight, page 98:
George A. Reid, *Portrait of Mary Hiester Reid*, 1885, oil on canvas, 76.7 x 64.3 cm, National Gallery of Canada, Ottawa. Gift of Mary Wrinch Reid, Toronto, 1965. Photo: NGC / George A. Reid, *Portrait de Mary Hiester Reid*, 1885, huile sur toile, 76.7 x 64.3 cm, Musée des beaux-arts du Canada, Ottawa. Don de Mary Wrinch Reid, Toronto, 1965. Photo: MBAC.

Chapter Nine, page 108:
Frederick Sproston Challener, *Portrait of Mary Hiester Reid*, unknown. Charcoal on paper, overall (paper): 17.5 x 12.7 cm. Purchase with assistance from Wintario, 1976, 76/149. © Art Gallery of Ontario.

Chapter Ten, page 116:
Mary Hiester Reid, *Still Life with Daisies*, no date noted, oil on canvas, 20 x 16 ½ in, from the University of Lethbridge art collection; purchased with funds provided by the Alberta Advanced Education Endowment and Incentive Fund, 1988.

Chapter Eleven, page 126:
George Agnew Reid, Canadian, 1860–1947, *Gossip*, 1888, oil on canvas, overall: 152.4 x 101.6 cm (60 x 40 in). Art Gallery of Ontario. Gift of the Academy of Medicine, Toronto, 1964, 63/39.

Chapter Twelve, page 136:
"Juin," 1896. From "Calendrier *la Belle Jardinière*," by Eugène Grasset. Paris, 1896. Artist Eugene Samuel Grasset. Photo by The Print Collector via Getty Images.

Chapter Thirteen, page 152:
Mary Hiester Reid, *Studio in Paris*, 1896, oil on canvas, 25.6 x 35.9 cm, Art Gallery of Hamilton. Gift of Mr. Gordon Conn, 1975, 75.18. Photo: Michael Lalich.

Chapter Fourteen, page 162:
George A. Reid, *Mortgaging the Homestead*, 1890, oil on canvas, 130.1 x 213.3 cm, National Gallery of Canada, Ottawa, Royal Canadian Academy of Arts diploma work.

Deposited by the artist, Toronto, 1890. Photo: NGC. / George A. Reid, *Une hypothèque sur la ferme*, 1890, huile sur toile, 130.1 x 213.3 cm, Musée des beaux-arts du Canada, Ottawa, Morceau de réception à l'Académie royale des arts du Canada. Déposé par l'artiste, Toronto, 1890. Photo: MBAC.

Chapter Fifteen, page 176:
Mary Hiester Reid, *Roses in a Vase*, 1891, oil on canvas, 35.6 x 45.7 cm. Private collection, courtesy of The Cooley Gallery, Old Lyme, Connecticut. Photo: Nancy Pinney.

Chapter Sixteen, page 188:
Mary Hiester Reid, *Chrysanthemums*, 1891, oil on canvas, 52.9 x 76.2 cm, National Gallery of Canada, Ottawa. Gift of the Royal Canadian Academy of Arts, 1893. Photo: NGC / Mary Hiester Reid, *Chrysanthèmes*, 1891, huile sur toile, 52.9 x 76.2 cm, Musée des beaux-arts du Canada, Ottawa. Don de l'Académie royale des arts du Canada, 1893. Photo: MBAC.

Chapter Seventeen, page 202:
Mary Hiester Reid, *Three Roses*, 1894, oil on canvas adhered to board, 30.5 x 23 cm, author's collection, Toronto. Photo: Candice Ferriera.

Chapter Eighteen, page 218:
George Agnew Reid, Canadian, 1860–1947, *Study for A Modern Madonna*, 1893. Page 13 of Scrapbook 1. E.P. Taylor Library and Archives, Art Gallery of Ontario. Gift of Mary Wrinch Reid, 1957, LA.GRF.V1.13.

Chapter Nineteen, page 222:
George Agnew Reid, *Portrait of Mary Evelyn Wrinch*, 1895, private collection, Calgary. Photo from Masters Gallery Ltd., Calgary, Alberta.

Chapter Twenty, page 230:
George Agnew Reid, reproduction of *The Evening Star*, c. 1895. Page 231 of George Agnew Reid scrapbook, Edward P. Taylor Library and Archives, Art Gallery of Ontario. Gift of Mary Wrinch Reid, 1957.

Chapter Twenty-One, page 234:
Mary Hiester Reid, Canadian, 1854–1921, *Chrysanthemums, A Japanese Arrangement*, c. 1895 oil on canvas, overall: 45.7 x 61 cm (18 x 24 in). Gift of Friends of Mary Hiester Reid, 1923, 666. © Art Gallery of Ontario.

Chapter Twenty-Two, page 240:
Mary Hiester Reid, Canadian, 1854–1921, *Castles in Spain*, central panel, c. 1896, oil on canvas, overall: 53.7 x 137.8 cm (21 1/8 x 54 1/4 in). Gift of the Gordon Conn–Mary E. Wrinch Trust, Toronto, 1970, 70/18. © Art Gallery of Ontario.

Chapter Twenty-Three, page 254:
Mary Hiester Reid, Canadian, 1854–1921, *Castles in Spain*, side panels, c. 1896 oil on

canvas, overall: 53.7 x 137.8 cm (21 1/8 x 54 1/4 in). Gift of the Gordon Conn–Mary E. Wrinch Trust, Toronto, 1970, 70/18. © Art Gallery of Ontario.

Chapter Twenty-Four, page 268:
George Agnew Reid, Canadian, 1860–1947, *Sketch Portraits of GAR and MHR*, 1896, oil on canvas, overall: 34.9 x 24.4 cm (13 3/4 x 9 5/8 in). Gift of Mary Wrinch Reid to the E.P. Taylor Reference Library, 1957; transferred to the permanent collection, 1982, 82/159.14. © Art Gallery of Ontario.

Chapter Twenty-Five, page 276:
Mary Hiester Reid, *Moonrise*, 1898, oil on canvas, 50.8 x 40.6 cm, accession number: A75-162, City of Toronto Art Collection, Toronto.

Chapter Twenty-Six, page 286:
George Agnew Reid, Canadian, 1860–1947, *Mary Hiester Reid*, 1898, oil on canvas, overall: 76.8 x 64.1 cm (30 1/4 x 25 1/4 in). Gift of Mary Wrinch Reid, Toronto, 1954, 53/36. © Art Gallery of Ontario.

Chapter Twenty-Seven, page 292:
George Agnew Reid, Canadian, 1860–1947, *Portrait of Mrs. Reid*, 1902, oil on canvas, overall: 30 x 25 in). Gift of George A. Reid. Courtesy of the Reading Public Museum, Reading, Pennsylvania.

Chapter Twenty-Eight, page 302:
Onteora Ladies on the Porch of Witchwood, August 12, 1904, Document 2017.08.17.00032, reproduced with permission of E. Davis Gaillard Archive, Onteora Library, Tannersville, NY.

Chapter Twenty-Nine, page 312:
Mary E. Wrinch, Canadian, 1877–1969, *Portrait of Mary H. Reid*, 1906 watercolor, overall: 6.5 x 4.9 cm (2 9/16 x 1 15/16 in). Gift of George A. Reid, 1922, 637. © Art Gallery of Ontario.

Chapter Thirty, page 316:
Mary Hiester Reid, *Nasturtiums*, 1910, oil on canvas, 30 x 45 cm, author's collection, Toronto.

Chapter Thirty-One, page 328:
Mary Hiester Reid, *The Women's Globe*, 1895. Larry Becker Newspapers, City of Toronto Archives, Toronto (Fonds 70, Series 655, File 20). https://gencat.eloquent-systems .com/city-of-toronto-archives-m-permalink.html?key=121795 / Originally published as the cover and interior illustration in the Women's Edition, the *Globe* (Toronto), April 18, 1895, and reproduced in limited numbers as a colored poster.

Chapter Thirty-Two, page 340:
Photographer unknown, *Mary Hiester Reid*, 1910s, reproduction from Memorial exhibition catalog, Edward P. Taylor Library and Archives, Art Gallery of Ontario.

Chapter Thirty-Three, page 344:
Mary Hiester Reid, *Morning Sunshine*, 1913, oil on canvas, 63.5 x 76.4 cm, National Gallery of Canada, Ottawa. Photo: NGC / Mary Hiester Reid, *Matin ensoleillé*, 1913, huile sur toile, 63.5 x 76.4 cm, Musée des beaux-arts du Canada, Ottawa. Photo: MBAC.

Chapter Thirty-Four, page 352:
Mary E. Wrinch, *The Little Bridge*, 1915, oil on canvas, 88.2 x 86.9 cm, National Gallery of Canada, Ottawa. Photo: NGC / Mary E. Wrinch, *Le petit pont*, 1915, huile sur toile, 88.2 x 86.9 cm, Musée des beaux-arts du Canada, Ottawa. Photo: MBAC.

Chapter Thirty-Five, page 366:
Mary Hiester Reid, Canadian, 1854–1921, *Past and Present, Still Life*, 1918, oil on canvas. Overall: 55.9 x 91.4 cm (22 x 36 in). Gift of George A. Reid, 1922, 636. © Art Gallery of Ontario.

Chapter Thirty-Six, page 372:
Mary Hiester Reid, *Elm Tree Shadows*, 1921, colored chalks on gray wove paper 1959.019. Permission of Art Gallery of Windsor.

Postlude, page 382:
J.E.H. MacDonald, *Memoriam MHR* (headpiece), c. 1922, reproduction from Memorial exhibition catalog, Edward P. Taylor Library and Archives, Art Gallery of Ontario.

Page 437:
Mary Hiester Reid, *Autumn*, Wychwood Park, c. 1910 (50.A.40), Museum London.

Literary Permissions

Page: xv
Excerpt from "Poem" from *POEMS* by Elizabeth Bishop, © 2011 by The Alice H. Methfessel Trust. Publisher's Note and compilation, © 2011 by Farrar, Straus, and Giroux. Reprinted by permission of Farrar, Straus, and Giroux.

Page 390:
'First love' (14-line excerpt) by Denise Levertov, from *THIS GREAT UNKNOWING*, © 1998 by The Denise Levertov Literary Trust, Paul A. Lacey and Valerie Trueblood Rapport, Co-Trustees. Reprinted by permission of New Directions Publishing Corp.

Page 206:
"Viullard Interior" from *Chameleon Hours* copyright 2008, by Elise Partridge. Reprinted by permission of House of Anansi Press Inc., Toronto, www.houseofanansi.com and by permission of The University of Chicago Press, Chicago, www.press.uchicago .edu.

NOTES

Chapter One

1 Registration Records, Archives of the Pennsylvania Academy of the Fine Arts, Philadelphia, PA. Author visit, October 2, 2014.

2 Florence Hartley, *The Ladies' Book of Etiquette, and Manual of Politeness: A Complete Hand Book for the Use of the Lady in Polite Society* (Boston: Lee and Shepard, 1872), 31.

3 Mary H. Reid, "In Northern Spain," *Massey's Magazine* 3, no. 6 (June 1897): 375.

4 Reid, "Northern Spain," 377.

5 Hartley, *Ladies' Book of Etiquette*, 31.

6 "Historical Note," World's Columbian Exposition. Records, Special Collections Research Center, University of Chicago Library, https://www.lib.uchicago.edu/e/scrc/findingaids/view.php?eadid=ICU.SPCL.EXPO1893&q=attendance.

7 Paul A.W. Wallace, "Henry Ernest Muhlenberg," *Proceedings of the American Philosophical Society* 92, no. 2 (May 5, 1948): 107–110, http://www.jstor.org/stable/3143408.

8 Hartley, *Ladies' Book of Etiquette*, 31.

9 Reid, "Northern Spain," 377.

10 See, for example, Christina Simmons, "Companionate Marriage," *Making Marriage Modern: Women's Sexuality from the Progressive Era to World War II* (Oxford Scholarship Online, 2009), https://oxford.universitypressscholarship.com/view/10.1093/acprof:oso/9780195064117.001.0001/acprof-9780195064117-chapter-4.

11 Brian Foss, "Hiester, Mary Augusta Catharine (Reid)," in *Dictionary of Canadian Biography*, vol. 15, University of Toronto / Université Laval, 2003–, accessed July 12, 2014, http://www.biographi.ca/en/bio/hiester_mary_augusta_catharine_15E.html.

11 Holmes was president of the Ontario Society of Artists and a teacher at the Ontario College of Art. "Robert Holmes, 1861–1930," Ontario's Historic Plaques (photo by Alan L. Brown), accessed February 20, 2021, https://readtheplaque.com/plaque/robert-holmes-1861-1930.

13 Foss, "Hiester."

Chapter Two

1 John Donne, "Holy Sonnets," Representative Poetry Online, University of Toronto Libraries, https://rpo.library.utoronto.ca/poems/holy-sonnets-batter-my-heart-three-persond-god.

2 James MacNeill Whistler, *Mr. Whistler's "Ten O' Clock"* (London: Chatto and Windus, 1888).

3 Mary H. Reid, "From Gibraltar to the Pyrenees," *Massey's Magazine* 1, no. 5 (May 1896): 297–308 and no. 6 (June 1896): 373–84; Mary H. Reid, "In Northern Spain," *Massey's Magazine* 3, no. 6 (June 1897): 375–83.

4 Eve M. Kahn, *Forever Seeing New Beauties: The Forgotten Impressionist Mary Rogers Williams* (Middletown, Connecticut: Wesleyan University Press, 2019), e-book, ch. 1.

5 Andrea Terry, *Mary Hiester Reid: Life and Work* (Toronto: Art Canada Institute, 2019), 67. https://aci-iac.ca/art-books/mary-hiester-reid.

6 Linda Nochlin's classic essay, "Why Have There Been No Great Women Artists?" (*ARTnews*, January 1971), pulsed in the back of my mind as I looked at the objects in *Greys*.

7 "Much Good Work at R.C.A Exhibition," *Montreal Gazette*, November 21, 1913, 5.

8 D.W. Winnicott, *Playing and Reality* (New York: Tavistock, 1982), 5.

9 Rachel Gotlieb, "Pot(tery) Tales in Victorian Painting and Literature," The Robert and Marian Cumming Lecture, Gardiner Museum, November 26, 2018.

Chapter Three

1 "News Letter from the (Wychwood Park) Archives" (July 2000), courtesy Pamela Bonnycastle.

2 Muriel Miller, *George Reid: A Biography* (Toronto: Summerhill Press, 1987), 18.

3 Mount Pleasant Cemetery and Crematorium map, accessed January 22, 2020, https://www.mountpleasantgroup.com/en-CA/Resources/cemetery-maps.aspx.

4 Author conversation with retired professor Janice Anderson, Canadian Women Artists History Initiative Conference, Kingston, ON, May 9, 2015.

5 Andrea Terry, *Mary Hiester Reid: Life & Work* (Toronto: Art Canada Institute, 2019), https://aci-iac.ca/art-books/mary-hiester-reid.

6 Janice Anderson, "Negotiating Gendered Spaces: The Artistic Practice of Mary Hiester Reid," in Brian Foss and Janice Anderson, *Quiet Harmony: The Art of Mary Hiester Reid* (Toronto: Art Gallery of Ontario, 2000), 47. (MHR first admitted to the Ontario Society of Artists in 1887, was elected to the executive council in 1907, serving four more times subsequently.)

7 Brian Foss and Janice Anderson, *Quiet Harmony: The Art of Mary Hiester Reid* (Toronto: Art Gallery of Ontario, 2000), 23.

Chapter Four

1 Henry Melchoir Muhlenberg Richards, *Pennsylvania-German Genealogies, Descendants of Herman Melchior Muhlenberg* (The Pennsylvania-German Society, 1900), 54.

2 The Muhlenberg House is on the United States National Register of Historic

Places. "Henry Melchior Muhlenberg House," Wikipedia, accessed August 2, 2019, http://en.wikipedia.org/wiki/Henry_Melchior_Muhlenberg_House.

3 "Muhlenberg, Gotthilf Heinrich Ernest (1753–1815)," Global Plants database, https://plants.jstor.org/stable/10.5555/al.ap.person.bm000332926 (accessed February 17, 2021).

4 Henry Ernst Muhlenberg papers, Historical Society of Pennsylvania, Collection 0443, accessed February 20, 2021, http://www2.hsp.org/collections/manuscripts/m/ Muhlenberg0443.html.

5 "William Augustus Muhlenberg 1796–1877," University and Archives Record Center, University of Pennsylvania, accessed November 17, 2019, https://archives .upenn.edu/exhibits/penn-people/biography/william-augustus-muhlenberg.

6 V.E.C. (Valeria Elizabeth Clymer) Hill, *A Genealogy of the Hiester Family* (Lebanon, PA: Report Publishing Company, 1903), 31.

7 "Declaration of Sentiments" (also known as the Declaration of Rights and Sentiments), Seneca Falls, 1848, National Park Service, https://www.nps.gov/ wori/learn/historyculture/declaration-of-sentiments.htm, last modified February 26, 2015.

8 *The Annual Report of the Secretary of Internal Affairs of the Commonwealth of Pennsylvania for 1874–5, Part Three, Industrial Statistics*, vol. 3 (Harrisburg, PA: B.F. Meyers, Printer, 1876), 71.

9 *The Transactions of the Medical Society of the State of Pennsylvania Annual Session, Philadelphia, May, 1854* (Philadelphia: T.K. & P.G. Collins, Printers), 126, quoted in S.W. Butler, ed., *The New Jersey Medical Reporter and Transactions of the New Jersey Medical Society* 7, no. 12 (December 1884): 215.

10 Ben Gelber, *The Pennsylvania Weather Book* (New Brunswick, NJ: Rutgers University Press, 2002), 70.

11 Obituary reprinted from *New Jersey Medical Reporter* in "Medical Intelligence," *New England Journal of Medicine* 51, no. 21 (December 20, 1854): 426.

12 Metropolitan Museum of Art, Department of Asian Art, "The Art of the Pleasure Quarters and the Ukiyo-e Style" in Heilbrunn Timeline of Art History (New York: The Metropolitan Museum of Art, 2000–), October 2004, http:// www.metmuseum.org/toah/hd/plea/hd_plea.htm.

13 "The United States and the Opening to Japan, 1853," Office of the Historian, Foreign Service Institute, United States Department of State, accessed December 20, 2019, https://history.state.gov/milestones/1830-1860/opening-to-japan.

14 Metropolitan Museum of Art, "The Art of the Pleasure Quarters and the Ukiyo-e Style."

Chapter Five

1 Miller, *George Reid*, 11–13.

2 Christine Boyanosky, *Sympathetic Realism: George A. Reid and the Academic Tradition* (Toronto: Art Gallery of Ontario, 1986). Exhibition catalog.

3 Alois Riegl, trans. Evelyn M. Kain, *The Group Portraiture of Holland* (Los Angeles: Getty, 1999), 258.

4 Riegl, *Group Portraiture*, 151.

5 Riegl, *Group Portraiture*, 292.

6 "Theodor Lipps," Encyclopaedia Britannica, accessed May 30, 2019, https://www
 .britannica.com/biography/Theodor-Lipps.

7 George W. Pigman, "Freud and the History of Empathy," *The International
 Journal of Psycho-Analysis* 76, no. 2 (April 1995): 237–256.

8 The Confederate Army fired on Fort Sumpter on April 12, 1861.

9 "William Muhlenberg Hiester," Wikipedia, accessed March 23, 2019,
 https://en.wikipedia.org/wiki/William_Muhlenberg_Hiester.

10 Irene Reed, *Berks County Women in History* (Leesport, PA: Tudor Gate Press,
 2005), 222.

11 Kristin Leahy, "Women during the Civil War," Historical Society of
 Pennsylvania, last updated December 2012, https://hsp.org/collections/catalogs-
 research-tools/subject-guides/women-during-the-civil-war.

12 Rowan Davidson, Robert Short, and Jennifer L. Lehrke, City of Beloit,
 Wisconsin, Architectural and Historical Intensive Survey Report (Madison, WI:
 Wisconsin Historical Society, 2015–16), 207.

13 *The Pennsylvania German Society, Proceedings and Addresses, Reading, October
 27, 1905, Vol. XVI* (Lancaster, PA: Press of the New Era Printing Company,
 1907), 21.

14 Map 3: Major Railroads, 1860, National Park Service Map, accessed December 20,
 2019, https://web.archive.org/web/20190712061058/http://www.nps.gov/nr/twhp/
 wwwlps/lessons/9stlouis/9locate3.htm.

15 The Last Will and Testament of Mary Hiester Reid, May 21, 1917, City
 of Toronto, in the Mary Hiester Reid research records, Janice Anderson
 Documentation Files, Concordia University.

16 "Do trains have gears?" USCB ScienceLine, University of Santa Barbara California,
 http://scienceline.ucsb.edu/getkey.php?key=3007.

17 *The History of Rock County, Wisconsin . . . Containing Portraits of Prominent Men
 and Early Settlers* (Chicago: Western Historical Company, 1879), 806.

18 *History of Rock County*, 806.

19 Beloit College Indian Mounds, accessed July 13, 2020, https://www.beloit.edu/
 logan/about-the-museum/indian-mounds.

20 Rock County Court, Wisconsin, Probate of the Estate of Caroline A. Hiester,
 January 24, 1876, in the Mary Hiester Reid exhibition records, Janice Anderson
 Documentation Files, Concordia University.

21 Probate of the Estate of Caroline A. Hiester.

22 Jennifer Nicoll, Collections Manager / Exhibition Coordinator, Agnes
 Etherington Art Centre, Queen's University, email correspondence with author,
 February 5, 2021.

23 "Pictures at Exhibition of Royal Canadian Academy," *Globe Toronto* (November
 20, 1914): 7.

24 Nagengast, "An Early History of Comfort Heating," HVACR News, November
 6, 2001, http://www.achrnews.com/articles/87035-an-early-history-of-comfort-
 heating.

25 Andrea Terry, *Mary Hiester Reid: Life & Work* (Toronto: Art Canada Institute,
 2019), 4.

26 Marjory MacMurchy, "Representative Women: Mrs. G.A. Reid," *Globe*
 (Toronto), July 16, 1910, A5, quoted in Terry, *Mary Hiester Reid*, 4

27 Marjory MacMurchy, "Representative Women: Mrs. G.A. Reid, Painter," *Globe* (Toronto), July 16, 1910, quoted in Terry, *Mary Hiester Reid*, 4.

28 "History," Aamjiwnaang First Nation website, https://www.aamjiwnaang.ca/ history/. See also "Aboriginal Peoples in Ontario," Kingston, Frontenac, Lennox & Addington Children and Youth Services Planning Committee, https:// kflachildrenandyouthservices.ca/indigenouslearningcircle/aboriginal-peoples-in-ontario/. Both sites accessed July 23, 2020.

29 As an adult in 1899, George Agnew Reid painted *Forbidden Fruit*, a retrospective portrait of himself as a boy lounging on the hay in a darkened barn, reading.

30 Muriel Miller, *George Reid: A Biography* (Toronto: Summerhill Press, 1987), 18.

31 Miller, *George Reid*, 16–18.

32 Miller, *George Reid*, 19–20.

33 Miller, *George Reid*, 19.

34 Probate of the Estate of Caroline A. Hiester.

35 Miller, *George Reid*, 24.

36 "Inflation Calculator," U.S. Official Inflation Data, Alioth Finance, accessed July 10, 2019, https://www.officialdata.org/.

37 Rock County, State of Wisconsin, court probate documents dated December 15, 1875, January 24, 1876, and June 11, 1876.

38 Probate of the Estate of Caroline A. Hiester. On June 10, 1876, Mary Hiester signed for "Carrie" E. Hiester "in the presence of H. McLenegan" on the probate document. Rock County, State of Wisconsin, court probate document, June 10, 1876.

39 Colta Feller Ives, *The Great Wave: The Influence of Japanese Woodcuts on French Prints* (New York: The Metropolitan Museum of Art / New York Graphic Society, 1974), 7.

Chapter Six

1 George Inness quoted in Clara Ruge, "The Tonal School of America," *International Studio* 27, no. 105–108 (November 1905–February 1906), 60.

2 Wanda M. Corn, "The Color of Mood: American Tonalism, 1880–1910," in Marc Simpson, ed., *Like Breath on Glass: Whistler, Inness and the Art of Painting Softly* (Williamstown, MA, Sterling and Francine Clark Art Institute, 2008), 111.

3 Henry Melchoir Muhlenberg Richards, *Pennsylvania-German Genealogies, Descendants of Herman Melchior Muhlenberg* (The Pennsylvania-German Society, 1900).

4 *Capitalism by Gaslight: The Shadow Economies of 19th-Century America*, online exhibition, The Library Company of Philadelphia, 2012, http://www.librarycompany .org/shadoweconomy/section2.htm.

5 C.W. Jefferys, "The Art of Mary Hiester Reid," in Brian Foss and Janice Anderson, *Quiet Harmony: The Art of Mary Hiester Reid* (Toronto: Art Gallery of Ontario, 2000), 19–23.

6 Matt Knowles, "Dressing the Late 19th Century Woman," Vintage Fashion, 1840–1940, http://www.knowlesville.com/vintage/getting-dressed.html.

7 Death Becomes Her: A Century of Mourning Attire exhibition, Metropolitan Museum of Art, New York, October 21, 2014–February 1, 2015.

8 Marc Simpson, ed., *Like Breath on Glass: Whistler, Inness and the Art of Painting*

Softly (Williamstown, MA, Sterling and Francine Clark Art Institute, 2008), 3–4.

9 Ruge, "The Tonal School," 57.

10 Samuel J. Burr et al. Memorial of the International Exhibition: Being a Description Written Up by Buildings, by Nationalities, by Classes, and as Far as Practicable by Individual Exhibits, Information Obtained by Personal Inspection of Every Exhibit, and Consultation with Exhibitors Or Their Representatives (L. Stebbins, 1877).

11 Burr et al., Memorial, 554.

12 Mary Frances Cordato, "Toward a New Century: Women and the Philadelphia Centennial Exhibition 1876," in *Representing the Expansion of Women's Sphere: Women's Work and Culture at the World's Fairs of 1876, 1893, and 1904* (PhD diss., New York University, 1989), 135.

13 Cordato, "Toward a New Century," 125, 123.

14 Cordato, "Toward a New Century," 121.

15 F. Graeme Chalmers, "The Early History of the Philadelphia School of Design for Women," *Journal of Design History* 9, no. 4 (1996): 247, www.jstor.org/stable/1316042.

16 "The Prospectus of the Philadelphia School of Design for Women 1875/776, Philadelphia School of Design for Women" (1875), 4, quoted in F. Graeme Chalmers, "The Early History of the Philadelphia School of Design for Women," *Journal of Design History* 9, no. 4 (1996): 250, www.jstor.org/stable/1316042.

17 Muriel Miller, *George Reid: A Biography* (Toronto: Summerhill Press, 1987), 64.

18 Chalmers, "Early History," 237.

19 "The Prospectus of the Philadelphia School," 251.

20 Amelia Peck and Carol Irish, *Candace Wheeler: The Art and Enterprise of American Design 1875–1900* (New York: Metropolitan Museum of Art / Yale University Press, 2001), 20.

21 Peck and Irish, Candace Wheeler, 22–23.

22 "From comfort station to exhibit space in Fairmount Park," WHYY Radio, March 23, 2012, https://whyy.org/articles/from-comfort-station-to-exhibit-space-in-fairmount-park/.

23 Peck and Irish, *Candace Wheeler*, 20.

24 Peck and Irish, *Candace Wheeler*, 46.

25 Peck and Irish, *Candace Wheeler*, 42.

26 Peck and Irish, *Candace Wheeler*, 47.

27 "The Prospectus of the Philadelphia School," 251.

Chapter Seven

1 Christine Boyanoski, *Sympathetic Realism: George A. Reid and the Academic Tradition* (Toronto: Art Gallery of Ontario, 1986), 19–20, 55.

2 Alice Barber Stephens, *The Women's Life Class*, c. 1879, oil on cardboard, 12 x 14 in., illustration for William C. Brownell, "The Art Schools of Philadelphia," *Scribner's Monthly* 18 (September 1879).

3 Author's visit to the Pennsylvania Academy of the Fine Arts, October 2, 2014.

4 See photographs in Paris and portraits by George Agnew Reid in Muriel Miller,
 George Reid: A Biography (Toronto: Summerhill Press, 1987), 34.

5 Amy Werbel, *Thomas Eakins: Art, Medicine and Sexuality in Nineteenth-Century
 Philadelphia* (New Haven and London: Yale University Press, 2007), 55.

6 "Eakins the Teacher," Pennsylvania Academy of the Fine Arts, last updated
 November 18, 2014, accessed via the Internet Archive, https://web.archive.org/
 web/20141118045826/http://www.pafa.org/museum/Research-Archives/Thomas-
 Eakins/Eakins-the-Teacher/82/.

7 Jamey Gigliotti, "Revolutionary Artists, Revolutionary Institution," Pennsylvania
 Center for the Book (Fall 2009), https://pabook.libraries.psu.edu/literary-cultural-
 heritage-map-pa/feature-articles/revolutionary-artists-revolutionary-institution.

8 CPI Inflation Calculator, https://www.in2013dollars.com/us/inflation/
 1876?amount=10.

9 Jill Berk Jimenez, ed., *Dictionary of Artists' Models* (New York: Routledge, 2013).

10 Alice Barber Stephens, *The Women's Life Class*, illustration, Pennsylvania
 Academy of the Fine Arts, last updated August 14, 2014, accessed via the Internet
 Archive, https://web.archive.org/web/20140814080134/http://www.pafa.org/
 museum/Exhibitions/Past-Exhibitions/Anatomy-Academy/Image-Gallery/
 Image-Gallery/874/vobid--5843/.

11 Werbel, *Thomas Eakins*, 106, 115.

12 "Eakins the Teacher."

13 "George Clymer," Wikipedia, accessed November 17, 2019, http://en.wikipedia
 .org/wiki/George_Clymer.

14 Werbel, *Thomas Eakins*, 61–62.

15 Werbel, *Thomas Eakins*, 62.

16 Werbel, *Thomas Eakins*, 46.

17 Thomas Eakins, "The Agnew Clinic," Philadelphia Museum of Art, http://www
 .philamuseum.org/collections/permanent/69110.html?mulR=1756|1.

18 Werbel, *Thomas Eakins*, 66.

19 Werbel, *Thomas Eakins*, 16, 75.

20 "Portrait of Dr. Samuel D. Gross (The Gross Clinic)," Philadelphia Museum of
 Art, accessed January 23, 2020, https://www.philamuseum.org/doc_downloads/
 education/object_resources/299524.pdf.

21 Miller, *George Reid*, 24–25.

22 Miller, *George Reid*, 30.

23 Miller, *George Reid*, 34.

24 Miller, *George Reid*, 33.

25 Miller, *George Reid*, 34.

26 Miller, *George Reid*, 38.

27 David M. Ludlum, *Early American Winters: Vol 1: 1604–1820 and Vol 2: 1821–1870*
 (American Meteorological Society, 1966, 1968) and Hans Neuberger, "Climate in
 Art," Department of Meteorology, The Pennsylvania State University (February
 1970), http://doi.org/10.1002/j.1477-8696.1970.tb03232.x.

28 Miller, *George Reid*, 38.

29 "A Brief History," City of Reading, PA, http://www.readingpa.gov/content/
 history-reading and "Reading, Pennsylvania," Wikipedia, accessed December 4,
 2019, http://en.wikipedia.org/wiki/Reading,_Pennsylvania.

30 "Yard No. 132 SS City of Chicago," ClydeSite, last updated August 28, 2016, accessed via the Internet Archive, https://web.archive.org/web/20160828111114/. http://clydesite.co.uk/clydebuilt/viewship.asp?id=4764.

31 Miller, *George Reid*, 39.

32 Therese Oneill, *Unmentionable: The Victorian Lady's Guide to Sex, Marriage, and Manners* (New York: Little, Brown and Co., 2016), 182, 185.

33 Marriage Notice. Janice Anderson Documentation Files, Box 18, Concordia University.

34 Geoff Mynett, *Service on the Skeena: Horace Wrinch, Frontier Physician* (Vancouver, BC: Ronsdale Press, 2020), 384.

35 "Elizabeth Wrinch (born Cooper), 1839–1897," MyHeritage, https://www .myheritage.com/names/elizabeth_wrinch, and "Family of Leonard Wrinch and Elizabeth Cooper," Attfield Family Tree, http://www.john-attfield.com/paf_tree/ attfield_current/fam1603.html. Accessed December 13, 2020.

36 "Family of Leonard Wrinch and Elizabeth Cooper," Attfield Family Tree.

37 Mynett, *Service on the Skeena*, 9–10.

38 Mynett, *Service on the Skeena*, 8–10.

39 "Family of Leonard Wrinch and Elizabeth Cooper," Attfield Family Tree.

40 Mynett, *Service on the Skeena*, 12, photograph.

Chapter Eight

1 "S/S City of Chicago, Inman Line," Norway Heritage, http://www.norwayheritage .com/p_ship.asp?sh=cichi.

2 Muriel Miller, *George Reid: A Biography* (Toronto: Summerhill Press, 1987), 40.

3 "Border Crossings and Passports," Ancestry.com, accessed August 10, 2020, https://www.ancestry.com/search/categories/img_bordercross.

4 "History of Passports," Government of Canada, April 10, 2014, http://www.cic .gc.ca/english/games/teachers-corner/history-passports.asp.

5 George W. Hudson, *The Marriage Guide for Young Men: A Manual of Courtship and Marriage* (Ellsworth, ME: Published by the author, 1883), quoted in Therese Oneill, *Unmentionable: The Victorian Lady's Guide to Sex, Marriage, and Manners* (New York: Little, Brown and Co., 2016), 143.

6 Miller, *George Reid*, 40.

7 "Lime Street Chambers (Former North Western Hotel) (1084209)," accessed September 18, 2012, https://historicengland.org.uk/listing/the-list/list-entry/ 1084209.

8 Dane Gabriel Rossetti, *Dante's Dream*, Walker Art Gallery, National Museums Liverpool, https://www.liverpoolmuseums.org.uk/artifact/dantes-dream.

9 Wehman, Henry J. *The Mystery of Love, Courtship and Marriage Explained*, (New York: Wehman Brothers, 1890; e-book Norderstedt Hansebooks, 2018).

10 Miller, *George Reid*, 40.

11 Louis Énault, *Paris-Salon 1885, par les Procédés Phototypiques de E. Barnard & Cie.* (Paris: E. Bernard & Cie, Imprimeurs-Éditeurs, 1885), ix, https://ia902907 .us.archive.org/29/items/parissalon 1885pt2enau/parissalon1885pt2enau_bw.pdf.

12 Laurence Madeline and Pauline Willis, *Women Artists in Paris 1850–1900* (New Haven, Yale University Press, 1971), 254.

13 Kathleen L. Nichols, "French Women Painters, 1893 Chicago World's Fair and Exposition," accessed March 23, 2019, http://arcadiasystems.org/academia/cassatt11c.html.

14 Miller, *George Reid*, 41.

Chapter Nine

1 Therese Oneill, *Unmentionable: The Victorian Lady's Guide to Sex, Marriage, and Manners* (New York: Little, Brown and Co., 2016), 9.

2 Muriel Miller, *George Reid: A Biography* (Toronto: Summerhill Press, 1987), 41.

3 "Discalced Carmelite Convent Museum," Turismo y Planificatión Costa del Sol S.L.U., 2020, http://www.visitcostadelsol.com/explore/museum-and-galleries/discalced-carmelite-convent-museum-p34181.

4 Miller, *George Reid*, 41.

5 St. Teresa of Avila, *The Interior Castle,* or *The Mansions*, 3rd ed. (London: Thomas Baker, 1921). Translated from *El Castillo Interior*, or *Las Moradas* (1577), http://www.sacred-texts.com/chr/tic/index.htm.

6 John Kramer, "The Virgen del Carmen Festivities in Málaga," Spain-Holiday .com, July 12, 2018, https://www.spain-holiday.com/Malaga-city/articles/the-virgen-del-carmen-festivities-in-malaga.

7 Mary Hiester Reid exhibition records, Charles C. Hill Documentation Files, National Gallery of Canada Library and Archives.

8 Geoff Mynett, *Service on the Skeena: Horace Wrinch, Frontier Physician* (Vancouver, BC: Ronsdale Press, 2020), 16.

9 Mynett, *Service on the Skeena*, 17.

10 Mynett, *Service on the Skeena*, 16.

Chapter Ten

1 Before 1908, people freely crossed the Canadian-American border without stopping, with no inspection, and no papers provided. See Bruce Murduck, "Canadian Immigration Information for Genealogists," Family Historian, May 2006, http://www.family-historian.com/sources/immigration/.

2 Adelaide Street is now a major east-west artery in downtown Toronto, and Toronto Street is now a narrow, obscure stretch along a few downtown blocks.

3 Mary Hiester Reid research records, Janice Anderson Documentation Files, Concordia University, correspondence between Kathy Hooke and Loren Lerner, forwarded by Brian Foss, October 31, 2003.

4 Mary Hiester Reid exhibition records, Charles C. Hill Documentation Files, National Gallery of Canada Library and Archives.

5 CPI Inflation Calculator, https://www.in2013dollars.com/us/inflation/1886.

6 Muriel Miller, *George Reid: A Biography* (Toronto: Summerhill Press, 1987), 47.

7 Amy Marshall and Gary Fitzgibbon, *Description & Finding Aid: Frederick S. Challener Collection* (Toronto: Art Gallery of Ontario, 2002), accessed January 10, 2020, http://ago.ca/sites/default/files/SC013.pdf.

8 Miller, *George Reid*, 46.

9 Julia Roberts, *In Mixed Company: Taverns and Public Life in Upper Canada* (Vancouver: University of British Columbia Press, 2009), 166.

10 Rachel Gotlieb, "Pot(tery) Tales in Victorian Painting and Literature," The Robert and Marian Cumming Lecture, Gardiner Museum, November 26, 2018.

11 Tidy, a British plantsman, had established a greenhouse in 1877 and sold flowers from his shop. See Deirdre Kelly, "The long-lasting bloom of Tidy's," *Globe and Mail*, December 1, 2007, https://www.theglobeandmail.com/news/national/the-long-lasting-bloom-of-tidys/article698896.

12 Because inflation and conversion records of Canadian funds were not kept during these years, I have relied on inflation records of U.S. funds.

13 Mary Hiester Reid exhibition records.

14 The Reids' studio was razed about 1902 for the construction of the King Edward Hotel. See "The Omni King Edward Hotel," Wikipedia, accessed September 21, 2019, https://en.wikipedia.org/wiki/The_Omni_King_Edward_Hotel.

15 Correspondence Mary H. Reid, Onteora, to Ellen Hahn, July 9, 1909. Mary Hiester Reid exhibition records, Charles C. Hill Documentation Files, National Gallery of Canada Library and Archives.

16 CPI Inflation Calculator, https://www.in2013dollars.com/us/inflation/1886?amount=25.

17 James Ashton, *The Book of Nature: Containing Information for Young People Who Think of Getting Married, on the Philosophy of Procreation and Sexual Intercourse; Showing How to Prevent Conception and to Avoid Child-Bearing. Also, Rules for Management During Labor and Child-Birth* (New York: Wallis and Ashton, 1861), 38. Ashton continues: "This plan injures neither party, nor does it really diminish the pleasurable sensations of the connection. If you once form the *habit* of withdrawal, you will find it to be a far more desirable and satisfactory mode than it at first appears."

18 Ashton, *Book of Nature*, 38.

19 Ashton, *Book of Nature*, 38–39.

20 "How effective is pulling out?" Planned Parenthood, accessed November 11, 2018, https://www.plannedparenthood.org/learn/birth-control/withdrawal-pull-out-method/how-effective-is-withdrawal-method-pulling-out.

21 Ashton, *Book of Nature*, 40.

22 Ashton, *Book of Nature*, 39. Ashton's italics.

23 Geoff Mynett, *Service on the Skeena: Horace Wrinch, Frontier Physician* (Vancouver, BC: Ronsdale Press, 2020), 21.

Chapter Eleven

1 "Relatives of Adam Reid," Ancestry, accessed January 10, 2020, https://www.ancestry.ca/genealogy/records/adam-reid_20832076.

2 "Canadian mail order catalogues–history," Library and Archives Canada, December 30, 2019, https://www.bac-lac.gc.ca/eng/discover/postal-heritage-philately/canadian-mail-order-catalogues/Pages/catalogues-history.aspx.

3 James Ashton, *The Book of Nature* (New York: Wallis and Ashton, 1861), 40–41.

4 Therese Oneill, *Unmentionable: The Victorian Lady's Guide to Sex, Marriage, and Manners* (New York: Little, Brown and Co., 2016), 178.

5 Although St. James Cathedral was a few blocks east, Church of the Holy Trinity had no pew fee and a tradition of making everyone at home.

6 Muriel Miller, *George Reid: A Biography* (Toronto: Summerhill Press, 1987), 50–51.

7 Mary Hiester Reid exhibition records, Charles C. Hill Documentation Files, National Gallery of Canada Library and Archives.

8 Mary Hiester Reid exhibition records.

9 Now the Ontario College of Art and Design University (OCAD U), the school was founded as Ontario School of Art in 1876 and renamed the Toronto Art School in 1886. In 1890, its name changed again to Central Ontario School of Art and Industrial Design. (See ocadu.ca/about.)

Chapter Twelve

1 "Cité Fleurie," *Paris Parcours: Themes and Playful Itineraries in Paris, France*, January 21, 2013, http://www.parisparcours.com/lieu/100168/30/cite-fleurie.

2 "Guillaume Apollinaire, 'A la Santé,'" *Poetica: Poésie, poèmes et poètes*, https://www.poetica.fr/poeme-1152/guillaume-apollinaire-a-la-sante/; "In the Santé," *Art of Europe*, http://www.artofeurope.com/apollinaire/apo6.htm; both accessed January 10, 2020. Apollinaire wrote the poem in 1913, the year that Mary finished her *Study in Greys* in Canada and the landmark Armory Show opened in New York.

3 George A. Reid, *Dreaming*, 1889, oil on canvas, 166.5 x 124.4 cm, National Gallery of Canada, Ottawa. Gift of the Royal Canadian Academy of Arts, 1890.

4 "Coke (fuel)," Wikipedia, accessed December 18, 2019, https://en.wikipedia.org/wiki/Coke_(fuel).

5 "Académie Colarossi," Artist Biographies: British and Irish Artists of the 20th Century, accessed January 10, 2020, http://www.artbiogs.co.uk/2/schools/academie-colarossi.

6 "Camille Claudel and Nogent-sur-Seine," Musée Camille Claudel, accessed January 10, 2020, http://www.museecamilleclaudel.fr/en/node/256.

7 "Carr, Emily," Canadian Women Artists History Initiative, last updated June 9, 2020, https://cwahi.concordia.ca/sources/artists/displayArtist.php?ID_artist=62.

8 Gabriel P. Weisberg and Jane R. Becker, eds., *Overcoming All Obstacles: The Women of the Académie Julian* (New Brunswick, NJ: Rutgers University Press, 1999).

9 "Académie Colarossi," Artist Biographies.

10 Melanie Paquette-Widmann, *Eugène Grasset: A Passion for Design* (Pittsburgh, PA: CTG Publishing, 2012), ebook.

11 Arsène Alexandre, "Eugène Grasset," *Les Arts Français: arts, métiers, industrie* (1919), quoted in Paquette-Widmann, *Eugène Grasset*.

12 Nancy Hass, "The Borrowers," *T, the New York Times Style Magazine*, February 21, 2021, 130.

13 "Les Mois," Victoria and Albert Museum, http://collections.vam.ac.uk/item/O549346/les-mois-print-grasset-eugene.

14 "Jacques Blanchard, *The Belle Jardinière, historic old store*," Musée d'Orsay, accessed January 11, 2020, https://www.musee-orsay.fr/en/collections/works-in-focus/architecture/commentaire_id/the-belle-jardiniere-historic-old-store-20144

.html?cHash=363c277227&tx_commentaire_pi1%5Bfrom%5D=849&tx
_commentaire_pi1%5BpidLi%5D=850.

15 "Octave Uzanne's View of Grasset," in Paquette-Widmann, *Eugène Grasset*.
Originally in *L'Art et L'Idée* (1892), translated from the text in *Les Arts Français: arts, métiers, industrie* (1919).

16 Muriel Miller, *George Reid: A Biography* (Toronto: Summerhill Press, 1987), 52.

17 Mary Ann Caws, "In the Studio: Marie Bashkirtseff at the Académie Julian," *Laphams Quarterly*, August 19, 2019, https://www.laphamsquarterly.org/roundtable/studio.

18 Miller, *George Reid*, 55.

19 "Waiting by the Fireplace, 1889," reproduced in Brian Foss and Janice Anderson, *Quiet Harmony: The Art of Mary Hiester Reid* (Toronto: Art Gallery of Ontario, 2000), 37.

20 Marilyn Ibach, "Paris Exposition of 1889," Prints and Photographs Reading Room, Library of Congress, September 2001, https://www.loc.gov/rr/print/coll/250_paris.html.

21 "Origins and Construction of the Eiffel Tower," Tour Eiffel website, https://www.toureiffel.paris/en/the-monument/history.

22 MacDowell, https://www.macdowell.org/about.

Chapter Thirteen

1 Albert Kostenevitch, *Bonnard and the Nabis* (New York: Parkstone Press International, 2005), 25, https://archive.org/details/BonnardAndTheNabisByAlbertKostenevitch.

2 Kostenevitch, *Bonnard*, 25.

3 Kostenevitch, *Bonnard*, 12.

4 Brian Foss and Janice Anderson, *Quiet Harmony: The Art of Mary Hiester Reid* (Toronto: Art Gallery of Ontario, 2000), 38.

5 Gaston Bachelard, trans. Maria Jolas, *The Poetics of Space* (New York: Orion Press, 1964), 138.

6 Henri Matisse, *The Red Studio*, Issy-les-Moulineaux, Fall 1911. Museum of Modern Art. On the museum's website, Matisse is quoted as saying, "Where I got the color red—to be sure, I just don't know. I find that all these things . . . only become what they are to me when I see them together with the color red" (https://www.moma.org/collection/works/78389).

7 Kostenevitch, *Bonnard*, 25.

8 Kostenevitch, *Bonnard*, 25.

9 Stuart Jackson, Stuart Jackson Gallery, interview with author, Toronto, May 7, 2019. Jackman is "inclined to think" that the print of the actor is by Utagawa Kunisada (1786–1864) and dates it to about 1840.

10 Gregory Currie, "Empathy for Objects," in *Empathy: Philosophical and Psychological Perspectives*, eds. Amy Copan and Peter Goldie (Oxford: Oxford University Press, 2011), https://doi.org/10.1093/acprof:oso/9780199539956.003.0007.

11 Candace Wheeler, *The Annals of Onteora, 1887–1914* (New York: E.W. Whitfield, 1914), 71, quoted in Amelia Peck and Carol Irish, *Candace Wheeler: The Art and Enterprise of American Design 1875–1900* (New York: Metropolitan Museum of

Art / Yale University Press, 2001), 57. Peck and Irish note that an edited and somewhat changed version of *The Annals* appears in Wheeler's *Yesterdays in a Busy Life* as the chapter "Onteora."

12 Nathan Chronister and Tobias Anderson, *The Catskills: A Sense of Place* (Arkville, NY: The Catskill Center for Conservation and Development, Inc., 2001), 1, https://static1.squarespace.com/static/54984d33e4b0fd2ebe2b6881/t/56ccc88a2b8dde5ff1f05218/1456261303230/Module+V+%28Culture+%26+Arts%29.pdf.

13 Amelia Peck and Carol Irish, *Candace Wheeler: The Art and Enterprise of American Design 1875–1900* (New York: Metropolitan Museum of Art / Yale University Press, 2001), 57.

14 Peck and Irish, *Candace Wheeler*, 57.

15 Emanuel Rubin, "Jeannette Myers Thurber and the National Conservatory of Music," *American Music* 8, no. 3 (Autumn 1990): 294–325.

16 Wheeler, *Annals of Onteora*, 2, quoted in Peck and Irish, *Candace Wheeler*, 57.

17 Peck and Irish, *Candace Wheeler*, 56–57.

18 Peck and Irish, *Candace Wheeler*, 59–60.

Chapter Fourteen

1 Doug Taylor, "Toronto's Yonge Street Arcade (demolished)," Historic Toronto, July 29, 2016, https://tayloronhistory.com/2016/07/29/torontos-yonge-street-arcade-demolished/.

2 Muriel Miller, *George Reid: A Biography* (Toronto: Summerhill Press, 1987), 56.

3 Miller, *George Reid*, 55–56.

4 CPI Inflation Calculator, https://www.in2013dollars.com/us/inflation/1890?amount=1000.

5 Mary Hiester Reid exhibition records, Charles C. Hill Documentation Files, National Gallery of Canada Library and Archives.

6 Brian Foss and Charles Hill, conversation with author, Ottawa, September 20, 2019.

7 George Reid, "The Evolution of Two of My Pictures," *Massey's Magazine* (January 1896): 11.

8 Charles C. Hill, "Mortgaging Canada: George Reid's 'Mortgaging the Homestead' and the 1891 Federal Election," *Journal of Canadian Art History / Annales d'histoire de l'art Canadien* 32, no. 1 (2011): 49–59.

9 Hill, "Mortgaging Canada," 54.

10 Andrea Terry, *Mary Hiester Reid: Life and Work* (Toronto: Art Canada Institute, 2019), 13.

11 Geoff Mynett, *Service on the Skeena: Horace Wrinch, Frontier Physician* (Vancouver, BC: Ronsdale Press, 2020), 27.

12 Catharine Mastin, *Female Self Representation and the Public Trust: Mary E. Wrinch and the AGW Collection* (Windsor, ON: Art Gallery of Windsor, 2012).

13 Prospectus (1869), quoted in Bishop Strachan School, *The History of the Bishop Strachan School 1865–2016* (Toronto: Bishop Strachan School, 2016), 1, https://www.bss.on.ca/wp-content/uploads/History-of-BSS.pdf.

14 Joan Murray, "Mary Wrinch, Canadian Artist," *Canadian Collector* (September 1969): 16–19.

Chapter Fifteen

1 Conversation with Jeffrey and Betsey Cooley, Lyme, CT, March 7, 2013.

2 Nicole Juday Rhoads, Barnes Arboretum, St. Joseph's University, Philadelphia, correspondence with author, January 27, 2017. Even Rhoads at the Barnes Arboretum hesitated to identify these roses, especially since MHR elided the leaves, which would have been the best hint as to their name.

3 Muriel Miller, *George Reid: A Biography* (Toronto: Summerhill Press, 1987), 61.

4 Mary Hiester Reid exhibition records, Charles C. Hill Documentation Files, National Gallery of Canada Library and Archives.

5 "Review of the New York City Watershed Program," National Academies of Sciences, Engineering and Medicine, Washington: National Academies Press, August 10, 2020. https://www.ncbi.nlm.nih.gov/books/NBK566284.

6 Miller, *George Reid*, 62.

7 Eugène Grasset, exposition catalog cover for "Les Arts de la Femme," 1892, reproduced from Bibliothèque des Arts Décoratifs, les archives de l'Union Centrale des Arts Décoratifs (UCAD), Paris, reproduced on Margery Masinter, "The Sisters Form a Plan," Cooper-Hewitt, April 1, 2014, https://www.cooperhewitt.org/2014/04/01/meet-the-hewitts-part-six/.

8 Amelia Peck and Carol Irish, *Candace Wheeler: The Art and Enterprise of American Design 1875–1900* (New York: Metropolitan Museum of Art / Yale University Press, 2001), 60.

9 Peck and Irish, *Candace Wheeler*, 60.

10 Elizabeth Bisland, "A Nineteenth-Century Arcady," *Cosmopolitan* 7 (September 1889), 517, quoted in Peck and Irish, *Candace Wheeler*, 61–62.

11 Charles C. Hill, "Mortgaging Canada: George Reid's 'Mortgaging the Homestead' and the 1891 Federal Election," *Journal of Canadian Art History / Annales d'histoire de l'art Canadien* 32, no. 1 (2011): 58.

12 G.A. Reid, "The Evolution of Two of My Pictures," *Massey's Magazine* 1, no. 1 (January 1896): 14.

13 Christine Boyanoski, "Artists, Architects, and Artisans at Home," in ed. Charles C. Hill, *Artists, Architects, and Artisans: Canadian Art 1890–1918*, (Ottawa: National Gallery of Canada, 2013), 88–89.

14 Bingbin Cheng, development intern, Gardiner Museum, Toronto, email correspondence with author, September 15, 2018.

15 The Last Will and Testament of Mary Hiester Reid, May 21, 1917, City of Toronto, in the Mary Hiester Reid research records, Janice Anderson Documentation Files, Concordia University.

16 Bishop Strachan School, *The History of the Bishop Strachan School 1865–2016* (Toronto: Bishop Strachan School, 2016), 1, https://www.bss.on.ca/wp-content/uploads/History-of-BSS.pdf.

Chapter Sixteen

1 Luis Egidio Meléndez's *Still Life with Limes, Box of Jelly, Butterfly and Vessels*, c. 1750–1775, oil on canvas, or *Still Life with Oranges, Melon and Boxes of Sweets*, c. 1750–1775, oil on canvas, both in the collection of the Museo Nacional del Prado,

Madrid, https://www.museodelprado.es/en/the-collection/artist/melendez-luis-egidio/9bcadfb7-1f31-41e1-acac-479afdfa496b.

2 "Oliver Impey," in David Battie, ed., *Sotheby's Concise Encyclopedia of Porcelain* (London: Conran Octopus, 1990).

3 Steven Ujifusa, "Japan-a-mania at the Centennial," PhillyHistory Blog, May 12, 2010, http://www.phillyhistory.org/blog/index.php/2010/05/japan-a-mania-at-the-centennial.

4 Oshima Ryota, "No one spoke," in Kenneth Rexroth, trans., *One Hundred Poems from the Japanese* (New York: New Directions, 1955, 1964), 116.

5 Muriel Miller, *George Reid: A Biography* (Toronto: Summerhill Press, 1987), 66. "The Summer Cottage and Its Furnishings" in *The Canadian Architect Builder*.

6 Miller, *George Reid*, 63.

7 Miller, *George Reid*, 64.

8 The Last Will and Testament of Mary Hiester Reid, May 21, 1917. Mary Hiester Reid exhibition records, Janice Anderson Documentation Files, Concordia University.

9 Sally Webster, *Eve's Daughter/Modern Woman: A Mural by Mary Cassatt* (Urbana and Champaign, IL: University of Illinois Press, 2004), 64.

10 Amelia Peck and Carol Irish, *Candace Wheeler: The Art and Enterprise of American Design 1875–1900* (New York: Metropolitan Museum of Art / Yale University Press, 2001), 66.

11 Peck and Irish, *Candace Wheeler*, 63. The board was created by an act of Congress in 1890.

12 Diane Boumenot, "Sophia goes to MIT," One Rhode Island Family, October 11, 2011, https://onerhodeislandfamily.com/2011/10/11/remembering-sophia-hayden-bennett-part-2/. In a dark dress with front ruffles and melancholic downcast eyes, Hayden holds a T-square in an MIT archives photo. Also "Sophia Hayden, American Architect," Encyclopedia Britannica, last updated January 30, 2021, https://www.britannica.com/biography/Sophia-Hayden.

13 Anna Burrows, "The Women's Pavilion," University Libraries Digital Collections, University of Maryland, December 22, 2005, http://hdl.handle .net/1903.1/309.

14 Webster, *Eve's Daughter/Modern Woman*, 64.

15 Webster, *Eve's Daughter/Modern Woman*, 10.

16 Candace Wheeler to Mrs. Potter Palmer, October 2, 1891, quoted in Peck and Irish, *Candace Wheeler*, 63, and Dr. Roann Barris, "Inside the Woman's Building: Allegories of Modern Women," accessed January 2012, https://www.radford.edu/ rbarris/Women%20and%20art/amerwom05/womensbuildingmurals.html.

17 *Canadian Department of Fine Art: World's Columbian Exposition, 1893, Catalogue of Paintings* (Toronto: E. Blackett Robinson, Printer, 1893), University of Alberta Archives, Edmonton.

18 Alois Riegl, trans. Evelyn M. Kain, *The Group Portraiture of Holland* (Los Angeles: Getty, 1999), 11.

19 Nancy Eisenberg and Janet Strayer, *Empathy and Its Development* (Cambridge: Cambridge University Press, 1987), 5.

20 Extracts from the Fliess papers, "Draft H—Paranoia," 209.

21 Author visit to Onteora, Tannersville, NY, July 18, 2013.

22 John Douglas Belshaw, "Economic Cyles," in *Canadian History: Post-Confederation*, BC Open Textbooks, https://opentextbc.ca/postconfederation/chapter/7-4-economic-cycles.

23 Peck and Irish, *Candace Wheeler*, 62.

24 Miller, *George Reid*, 65.

25 "History of the *Toronto Star*," *Toronto Star*, accessed January 20, 2020, https://www.thestar.com/about/history-of-the-toronto-star.html.

26 Susan Butlin, *A New Matrix of the Arts: A History of the Professionalization of Canadian Women Artists, 1880–1914* (PhD diss., Carleton University, 2008), 59.

27 Miller, *George Reid*, 65.

Chapter Seventeen

1 Katharine Lochnan, R. Fraser Elliott curator of prints and drawings, retired, Art Gallery of Ontario, conversation with author, November 25, 2018.

2 "The Palette Club Exhibition," *Toronto Saturday Night* 7, no. 10 (January 27, 1894): 6.

3 M.H. Reid to Hahn, July 9, 1909.

4 Elise Partridge, "Vuillard Interiors," in *Chameleon Hours* (Chicago: University of Chicago Press, 2008), 96.

5 "Guillot (1827–1893), Jean-Baptiste André (fils)," Help Me Find, accessed January 19, 2020, http://www.helpmefind.com/gardening/l.php?l=7.10307.

6 "Catherine Mermet Roses," Roque Valley Roses, https://www.roguevalleyroses.com/rose/catherine-mermet.

7 "Art Notes," *The Week* 11, no. 9 (January 26, 1894): 208–209.

8 Muriel Miller, "Famous Canadian Artists: Mary E. Wrinch, ARCA, Landscapist in Oil, Block Print Artist and Miniaturist," *Onward* (January 28, 1940): 58.

9 Catharine Mastin, *Female Self Representation and the Public Trust: Mary E. Wrinch and the AGW Collection* (Windsor, ON: Art Gallery of Windsor, 2012), 12.

10 Joan Murray, "Mary Wrinch, Canadian Artist," *Canadian Collector* (September 1969): 16–19.

11 Judith Bernstein, Madeline Burnside, Jeanette Ingberman, Ann-Sargent Wooster, *19th-Century Women Artists* (New York, Whitney Museum of Art, 1976), quoted in Ronald Pisano, *An Exhibition of Women Students of William Merritt Chase* (New York: Marbella Gallery, 1973), 3.

12 Susan Butlin, *A New Matrix of the Arts: A History of the Professionalization of Canadian Women Artists, 1880–1914* (PhD diss., Carleton University, 2008), 38.

13 Muriel Miller, *George Reid: A Biography* (Toronto: Summerhill Press, 1987), 65.

14 "Ontario Society of Artists," *Toronto Saturday Night* (April 28, 1894): 7.

15 "Is it safe to open a window?" National Museum of American History, accessed January 20, 2020, http://americanhistory.si.edu/object-project/household-hits/window-screen.

16 Georgia Torrey Drennan, *Everblooming Roses for the Out-door Garden of the Amateur: Their Culture, Habits, Description, Care, Nativity, Parentage, with Authentic Guides to the Selection of Everblooming Varieties of Roses* (New York: Duffield and Company, 1912), 239.

17 Christopher Gray, "Streetscapes/Art Students League at 215 West 57th Street; An 1892 Limestone-Fronted Building That Endures," *New York Times*, October 5, 2003.

18 Gray, "Streetscapes/Art Students League."

19 Sixteenth, Seventeenth, and Eighteenth Annual Exhibitions of the Society of American Artists, catalogs 1894, 1895, 1896.

Chapter Eighteen

1 1891 Census of Canada, St. George's Ward, Toronto West, Ontario, Nominal Return of the Living, 44, Library and Archives Canada, accessed January 20, 2020, http://central.bac-lac.gc.ca/.item/?app=Census1891&op=pdf&id=30953_148172-00585, and "All 1891 Census of Canada results for Mary Jung," Ancestry.ca, accessed January 20, 2020, https://www.ancestry.ca/search/collections/1891canada/?name=Mary_Jung&child=Henry&gender=f&residence=_toronto-ontario-canada_1654339. (Toronto's districts were divided into wards, each one with a saint's name.)

2 The whereabouts of the final painting, *A Modern Madonna*, are unknown.

3 Stuart Reid, "Zones of Immersion," PechaKucha, January 29, 2015, https://www.pechakucha.com/presentations/zones-of-immersion.

4 Muriel Miller, *George Reid: A Biography* (Toronto: Summerhill Press, 1987), 64.

5 David Wencer, "Historicist: Dr. Barnardo's Children," Torontoist, August 2, 2014, https://torontoist.com/2014/08/historicist-dr-barnardos-children/.

6 Kathryn, "Toronto Orphanages and Day Nurseries," Toronto Library Reference Blog, January 17, 2011, https://torontopubliclibrary.typepad.com/trl/2011/01/toronto-orphanages-and-day-nurseries.html.

Chapter Nineteen

1 Granddaughter of Susanna Moodie, author of an iconic Canadian memoir, *Roughing It in the Bush*.

2 Muriel Miller, *George Reid: A Biography* (Toronto: Summerhill Press, 1987), 67.

3 "Alice Breckon with Wrinch Family Members, 1900," Trafalgar Township Historical Society. https://images.ourontario.ca/TrafalgarTownship/3384318/data?n=1.

4 Mary E. Wrinch Reid records. Joan Murray Documentation Files, 1968, The Robert McLaughlin Gallery, Oshawa, Ontario.

5 Candace Wheeler, *Yesterdays in a Busy Life* (New York: Harper & Brothers Publishers, c. 1918), 151–152, https://archive.org/details/yesterdaysinbusyoowheeiala.

6 Hjalmar Hjorth Boyesen, "Boyhood and Girlhood," *The Monthly Illustrator* 4, no. 12 (April 1895): 3–8.

7 Loren Lerner, "George Agnew Reid's Paintings," in eds. Claudia Mitchell and April Mandrona, *Our Rural Selves: Memory and the Visual in Canadian Childhoods* (Montreal: McGill-Queen's University Press, 2019), 20–40.

8 Clarence A. Glasrud, "Boyesen and the Norwegian Immigration," Norwegian American Historical Association Online, accessed January 20, 2020, http://www.naha.stolaf.edu/pubs/nas/volume19/vol19_2.htm.

9 Benjamin W. Wells, "Hjalmar Hjorth Boyesen," *The Sewanee Review* 4, no. 3 (May 1896): 299–311.

10 Max J. Herzer et al., eds., *The Reader's Encyclopedia of American Literature* (New York: Thomas Crowell, 1962), https://archive.org/stream/in.ernet.dli.2015.129224/2015.129224.The-Readers-Encyclopedia-Of-American-Literature_djvu.txt.

11 Boyesen, "Boyhood," 9.

12 Boyesen, "Boyhood," 6–7.

13 Boyesen, "Boyhood," 6.

Chapter Twenty

1 "Seventeenth Annual Exhibition," Society of American Artists Catalog, 1895.

2 A drawing titled *Among the Daisies*, with a young woman in a bonnet looking demurely down at a meadow filled with daisies, is reproduced as an illustration for Hjalmar Hjorth Boyesen's "Boyhood and Girlhood" article in *The Monthly Illustrator*.

3 Stephanie Cassidy, editor and archivist, Art Students League of New York, email correspondence with author, July 17, 2018.

Chapter Twenty-One

1 Daniel Chen, adjunct curator of Chinese Ceramics, Gardiner Museum, telephone interview, May 4, 2018.

2 Conversation with Stuart Jackson, Stuart Jackson Gallery, May 7, 2019.

Chapter Twenty-Two

1 Muriel Miller, *George Reid: A Biography* (Toronto: Summerhill Press, 1987), 72.

2 "Eighteenth Annual Exhibition," Society of American Artists Catalog, 1896.

3 Miller, *George Reid*, 76.

4 Mary H. Reid, "From Gibraltar to the Pyrenees," *Massey's Magazine* 1, no. 5 (May 1896): 297.

5 Miller, *George Reid*, 76.

6 Reid, "From Gibraltar," 298–299.

7 Reid, "From Gibraltar," 300.

8 Reid, "From Gibraltar," 299. Reid's italics.

9 Florence Hartley, *The Ladies' Book of Etiquette, and Manual of Politeness: A Complete Hand Book for the Use of the Lady in Polite Society* (Boston: Lee and Shepard, 1872).

10 Reid, "From Gibraltar," 301. Reid's italics.

11 Reid, "From Gibraltar," 302.

12 "Sigmund Freud Chronology," Sigmund Freud Museum, accessed January 20, 2020, https://www.freud-museum.at/online/freud/chronolg/1896-e.htm.

13 Reid, "From Gibraltar," 303.

14 Reid, "From Gibraltar," 305.

15 Reid, "From Gibraltar," 306.

16 Reid, "From Gibraltar," 305–306.

17 Reid, "From Gibraltar," 306.

18 Mary H. Reid, "From Gibraltar to the Pyrenees," *Massey's Magazine* 1, no. 6 (June 1896): 377. Reid's italics.

Chapter Twenty-Three

1 Mary H. Reid, "From Gibraltar to the Pyrenees," *Massey's Magazine* 1, no. 6 (June 1896): 384. Reid's italics, and Reid, or *Massey's Magazine*, spells Velázquez with an S and no accent on the A.

2 Reid, "From Gibraltar," part 2, 384.

3 Mary H. Reid, "In Northern Spain," *Massey's Magazine* 3, no. 6 (June 1897): 375.

4 Reid, "From Gibraltar," part 2, 384; George Moore, *Modern Painting* (London: Walter Scott Limited, 1893), 96. Reid misspells "Moore" as "Moor." Moore, the Irish novelist and art critic, had studied at the Académie Julian in Paris in the 1870s, where his social circle included the Impressionists.

5 Reid, "In Northern Spain," 375, 377. Reid's italics.

6 Reid, "From Gibraltar," part 2, 382.

7 Mary H. Reid, "From Gibraltar to the Pyrenees," *Massey's Magazine* 1, no. 5 (May 1896): 298, 301.

8 University of Illinois at Urbana-Champaign, "Body Movements Can Influence Problem Solving, Researchers Report," ScienceDaily, May 13, 2009, www.sciencedaily.com/releases/2009/05/090512121259.htm.

9 Reid, "In Northern Spain," 379.

10 Reid, "In Northern Spain," 380.

11 Reid, "In Northern Spain," 380.

12 Reid, "In Northern Spain," 382.

13 Reid, "In Northern Spain," 381.

14 Reid, "In Northern Spain," 382.

15 Reid, "In Northern Spain," 382.

16 Reid, "In Northern Spain," 383. My lineation.

17 Joan Murray, "Mary Wrinch, Canadian Artist," *Canadian Collector* (September 1969): 16–19.

18 "Alyn Williams," Smithsonian American Art Museum, https://americanart.si.edu/artist/alyn-williams-5405, and Anthony J. Lester, "The Renaissance of Miniature Painting," The Royal Society of Miniature Painters, Sculptors and Gravers, http://www.royal-miniature-society.org.uk/history-of-miniature-painting.html, both accessed July 13, 2018.

19 Like William Howard Taft, the president of the United States, who later commissioned his portrait in miniature by Williams.

20 Susan Butlin, *The Practice of Her Profession: Florence Carlyle, Canadian Painter in the Age of Impressionism* (Montreal: McGill-Queen's University Press, 2009), 233.

21 Muriel Miller, *George Reid: A Biography* (Toronto: Summerhill Press, 1987), 67.

Chapter Twenty-Four

1 Muriel Miller, *George Reid: A Biography* (Toronto: Summerhill Press, 1987), 79.

2 Sigmund Freud to Martha Bernays, October 21, 1885, ed. Ernst L. Freud, trans.

Tania and James Stern, *Letters of Sigmund Freud*, (New York: Dover Publications, 1992), 177.

3 Jennifer L. Shaw, *Dream States: Puvis de Chavannes, Modernism, and the Fantasy of France* (New Haven: Yale University Press, 2002), 2.

4 Muriel Miller, *George Reid: A Biography* (Toronto: Summerhill Press, 1987), 80.

5 Miller, *George Reid*, 76.

6 Catharine Mastin, *Female Self Representation and the Public Trust: Mary E. Wrinch and the AGW Collection* (Windsor, ON: Art Gallery of Windsor, 2012), 12–13.

7 "Alice Beckington," Smithsonian American Art Museum, accessed July 13, 2018, https://americanart.si.edu/artist/alice-beckington-309.

8 The American Society of Miniature Painters 29th Annual Exhibition (New York: Galleries of William MacBeth, Inc., 1928), http://libmma.org/digital_files/macbeth/b16434031.pdf.

Chapter Twenty-Five

1 Mary Hiester Reid exhibition records, Charles C. Hill Documentation Files, National Gallery of Canada Library and Archives.

2 Robert Browning, "Two in the Campagna," quoted in Carol Rumens, "Poem of the Week: 'Two in the Campagna' by Robert Browning," *The Guardian*, July 26, 2010, https://www.theguardian.com/books/booksblog/2010/jul/26/robert-browning-two-in-the-campagna. The poem was published in *Men and Women* (1855). Robert and Elizabeth Barrett Browning were married in 1846 ("Robert Browning," Poetry Foundation, https://www.poetryfoundation.org/poets/robert-browning).

3 Wheeler, *Annals of Onteora*, 5, quoted in Amelia Peck and Carol Irish, *Candace Wheeler: The Art and Enterprise of American Design 1875–1900* (New York: Metropolitan Museum of Art / Yale University Press, 2001), 242, and in E. Davis Gaillard, *Onteora: Hills of the Sky* (Tannersville, NY: Onteora Committee for the Centennial Celebration, 1987), 1. My italics.

4 Uncredited and undated photograph in Gaillard, *Onteora*, 15.

5 Stephen Leacock, "The Woman Question," *Maclean's Magazine* (October 1915): 7–9.

6 Mark Twain, quoted in Gaillard, *Onteora*, 7.

7 Kym Bird, *Redressing the Past: The Politics of Early English-Canadian Women's Drama, 1880–1920* (Montreal: McGill-Queens University Press, 2004), 59, and Joan Sangster, *One Hundred Years of Struggle: The History of Women and the Vote in Canada* (Vancouver: UBC Press, 2018), 138.

8 Sangster, *One Hundred Years*, 138.

9 Sangster, *One Hundred Years*, 139.

10 Gaillard, *Onteora*, 2, 4.

11 Gaillard, *Onteora*, 10.

12 Muriel Miller, *George Reid: A Biography* (Toronto: Summerhill Press, 1987), 84.

13 Muriel Miller, *George Reid: A Biography*, 82.

14 George Reid, "The Summer Cottage and Its Furnishings," *The Canadian Architect and Builder* 14, no. 3 (1901), supplement, 57–58, quoted in Christine Boyanoski,

"Artists, Architects, and Artisans at Home," in ed. Charles C. Hill, *Artists, Architects, and Artisans: Canadian Art 1890–1918*, (Ottawa: National Gallery of Canada, 2013), 96.

15 Boyanoski, "Artists, Architects, and Artisans," 96–97.

Chapter Twenty-Six

1 Johan Huizinga, *Homo Ludens: A Study of the Play Element in Culture* (London, Boston and Henley: Routledge and Kegan Paul, 1949), 1–15.

2 D.W. Winnicott, *Playing and Reality* (New York: Tavistock, 1971), 1.

3 Paul Holdengraber, "Adam Phillips, The Art of Nonfiction No. 7," *The Paris Review* 208 (Spring 2014), https://www.theparisreview.org/interviews/6286/the-art-of-nonfiction-no-7-adam-phillips.

4 Muriel Miller, *George Reid: A Biography* (Toronto: Summerhill Press, 1987), 83.

Chapter Twenty-Seven

1 Gerald Smith, "Area stagecoaches weren't like what you see in westerns," pressconnects, February 11, 2016, https://www.pressconnects.com/story/news/connections/history/2016/02/11/area-stagecoaches-werent-like-what-you-see-westerns/80233038/. Photograph from Broome County Historical Society.

2 "Hudson River Night Boat Collection," New York Heritage Digital Collections, accessed September 4, 2019, https://nyheritage.org/collections/hudson-river-night-boat-collection.

3 The Old Waverley at 85 Buchanan Street became the Buchanan Hotel and closed in the 1990s, see "Buchanan Hotel," Yelp, https://www.yelp.ca/biz/buchanan-hotel-glasgow-2.

4 Miller, *George Reid*, 86.

5 "Historic Hotels in Edinburgh & Fife," Historic UK, accessed September 4, 2019, https://www.historic-uk.com/Scotland/EdinburghFife/CountryHouseHotels, and Miller, *George Reid*, 85–86.

6 "Sir William Orpen," National Portrait Gallery, accessed September 4, 2019, https://www.npg.org.uk/collections/search/person/mp03384/sir-william-orpen. Orpen was a colleague of Augustus John at the Slade, who was later knighted for his paintings of the Great War.

7 Miller, *George Reid*, 86–87.

8 Miller, *George Reid*, 87.

9 Thomas Carlyle, "Lecture I. The Hero as Divinity. Odin. Paganism: Scandinavian Mythology," *Heroes and Hero-Worship, and the Heroic in History*, https://www.gutenberg.org/files/1091/1091-h/1091-h.htm.

10 H. Barbara Weinberg, "James McNeill Whistler (1834–1903)," Heilbrunn Timeline of Art History (New York: The Metropolitan Museum of Art, 2000–), April 2010, http://www.metmuseum.org/toah/hd/whis/hd_whis.htm.

11 C.W. Jefferys, "The Art of Mary Hiester Reid" (1922), in Brian Foss and Janice Anderson, *Quiet Harmony: The Art of Mary Hiester Reid* (Toronto: Art Gallery of Ontario, 2000), 19.

12 "Invitation to Mr. Whistler's 'Ten O'Clock,'" Art Institute of Chicago, accessed

January 24, 2020, https://www.artic.edu/artworks/181408/invitation-to-mr-whistler-s-ten-o-clock.

13 Mary Evelyn Wrinch, untitled miniature portraits, watercolor on ivory, undated. Gift of Rheta and Gordon Conn, 1973, Art Gallery of Ontario, Toronto.

Chapter Twenty-Eight

1 "Sylvia Karen Hahn," *Globe and Mail* (January 4, 2001), https://www.legacy.com/obituaries/theglobeandmail/obituary.aspx?n=sylvia-karen-hahn&pid=189717569. Her daughters were the muralist Sylvia Hahn, Freya Constance Hahn, and Hilda Clair Hahn Hooke.

2 "Reid, Mary Hiester," Canadian Women Artists History Initiative, last updated November 27, 2019, https://cwahi.concordia.ca/sources/artists/displayArtist.php?ID_artist=59.

3 Susan Butlin, *The Practice of Her Profession: Florence Carlyle, Canadian Painter in the Age of Impressionism* (Montreal: McGill-Queen's University Press, 2009), 264, note 88.

4 Amarjeet Singh, Sukhwinder Kaur, and Indarjit Walia, "A Historical Perspective on Menopause and Menopausal Age," *Bulletin of the Indian Institute of History of Medicine* 32, no. 2 (July–December, 2002): 121–135, https://www.ncbi.nlm.nih.gov/pubmed/15981376, and J.M. Strange, "In Full Possession of Her Powers: Researching and Rethinking Menopause in Early Twentieth-Century England and Scotland," *Social History of Medicine* 25, no. 3 (August 2012): 685–700.

5 Judith A. Houck, "How to Treat a Menopausal Woman: A History, 1900 to 2000," *Current Women's Health Reports* 2 (2002): 350, http://homepage.ntu.edu.tw/~psc/how%20to%20treat%20a%20menopause%20woman.pdf.

6 Christine Boyanoski, "Artists, Architects, and Artisans at Home," in ed. Charles C. Hill, *Artists, Architects, and Artisans: Canadian Art 1890–1918*, (Ottawa: National Gallery of Canada, 2013), 100.

7 David Pepper, "Sylvia Hahn. Mural in Currelly Gallery," *Ontario College of Art Alumnus Newsletter* (1980). Ellen and Gustav married in 1895, see "Marriage Records for Gustav Hahn and Ellen Smith," Ancestry, accessed January 24, 2020, https://www.ancestry.ca/genealogy/marriage-records/gustav-hahn-and-ellen-smith.html.

8 "Paul Hahn," The Canadian Encyclopedia, December 16, 2013, https://www.thecanadianencyclopedia.ca/en/article/paul-hahn-emc.

9 Andrea Terry, *Mary Hiester Reid: Life and Work* (Toronto: Art Canada Institute, 2019), 93.

10 Muriel Miller, *George Reid: A Biography* (Toronto: Summerhill Press, 1987), 89–92.

11 Miller, *George Reid*, 91–92.

12 Ada Patterson, *Maude Adams, A Biography* (1907), http://www.ldsfilm.com/actors/MaudeAdamsBio.html.

13 Miller, *George Reid*, 93.

14 Photograph in "Painted from Life" exhibition, Art Gallery of Ontario, 2020

of Mary Evelyn Wrinch painting at Bass Lake, Ontario c. 1905–1910. Private collection.

15 "About Lake of Bays," Lake of Bays, accessed October 24, 2019, https://www .lakeofbays.on.ca/en/our-community/about-lake-of-bays.aspx.

16 Miller, Muriel, "Mary E. Wrinch, A.R.C.A.," January 28, 1940, in Famous Canadian Artists (Peterborough, ON: Woodland Publishing, 1943), 58.

Chapter Twenty-Nine

1 Wrinch taught at Bishop Strachan School from 1901 to 1936. See "Our Heritage," The Bishop Strachan School, accessed January 16, 2020, https://www.bss.on.ca/ our-heritage.

2 "Wrinch, Mary E.," Canadian Women Artists History Initiative, last updated August 13, 2013, https://cwahi.concordia.ca/sources/artists/displayArtist.php?ID_ artist=110.

Chapter Thirty

1 "Historical Data," Past Weather and Climate, Government of Canada, accessed October 24, 2019, https://climate.weather.gc.ca/historical_data/search_historic_ data_e.html.

2 Muriel Miller, *George Reid: A Biography* (Toronto: Summerhill Press, 1987), 93–95. Upland Cottage was admired by others, too. Henry Sproatt, the architect for the Gothic revival Hart House, as well as Victoria College on the University of Toronto campus, thought that he had grasped an exciting architectural concept and individualized it.

3 "Presidents," Royal Canadian Academy of Arts, http://rca-arc.ca/who-we-are/ presidents/.

4 E. Davis Gaillard, *Onteora: Hills of the Sky* (Tannersville, NY: Onteora Committee for the Centennial Celebration, 1987), 9.

5 Mary Hiester Reid, postcard to Ellen Hahn, October 2, 1907. Notes from Kathy Hooke, Charles C. Hill Documentation Files, National Gallery of Canada Library and Archives.

6 Mary Hiester Reid, Onteora, letter to Ellen Hahn, July 9, 1909. Notes from Kathy Hooke, Charles C. Hill Documentation Files, National Gallery of Canada Library and Archives.

7 Isabel Slone, "Settlers to Prince Edward County," Naval Marine Archive, The Canadian Collection, November 11, 2007, http://navalmarinearchive.com/ research/settlers/set_page1.html.

8 "Champlain, Ethan Allen, and Taft to Shake Hands," *Los Angeles Herald* 36, no. 269, June 27, 1909.

9 Reid to Hahn letter.

10 Dorland's Medical Dictionary Online, accessed October 26, 2019, https://www .dorlandsonline.com/.

11 *Nasturtiums* was exhibited in the 1910 Art Association of Montreal Annual Spring Exhibition. See St. G.B., "Art and Artists," *Montreal Herald*, April 9, 1910,

republished in Canadian Women Artists History Initiative, November 27, 2019, http://cwahi.concordia.ca/inputReviews/reviewsPDFs/A1910Apr9MH_9.pdf.

12 St. G.B., "Art and Artists."

13 A.G. Ornoch, Preliminary Condition Report of *Nasturtiums*, September 27, 2016.

14 For a step-by-step analysis of the restoration of the portrait, see "Restoration of the William Henry Boulton Portrait," https://ago.ca/restoration-william-henry-boulton-portrait.

15 A.G.Ornoch, Treatment Report, *Nasturtiums* by Mary Hiester Reid, October–December, 2016.

Chapter Thirty-One

1 "News Letter from the (Wychwood Park) Archives" (July 2000), courtesy Pamela Bonnycastle.

2 Andrew Noymer, "Life Expectancy in the USA, 1900–1908," UC–Irvine professor's website, accessed October 31, 2019, https://u.demog.berkeley.edu/~andrew/1918/figure2.html.

3 Karl Baedeker, *Belgium and Holland, including the Grand-Duchy of Luxembourg, 15th ed.* (Leipzig: Karl Baedeker, 1910).

4 Muriel Miller, *George Reid: A Biography* (Toronto: Summerhill Press, 1987), 100–101.

5 Kathryn Hughes, "GF Watts: the Victorian painter who inspired Obama," *The Guardian*, March 10, 2017, https://www.theguardian.com/artanddesign/2017/mar/10/gf-watts-the-victorian-painter-who-inspired-barack-obama.

6 Miller, *George Reid*, 101.

7 Miller, *George Reid*, 100–101.

8 Susan Butlin, *A New Matrix of the Arts: A History of the Professionalization of Canadian Women Artists, 1880–1914* (PhD diss., Carleton University, 2008), 31.

9 Butlin, "A New Matrix," 94.

10 William Wordsworth, "Nuns Fret Not at Their Convent's Narrow Room," *The Longman Anthology of Poetry* (Pearson, 2006), reproduced on Poetry Foundation, https://www.poetryfoundation.org/poems/52299/nuns-fret-not-at-their-convents-narrow-room.

11 "*Girl with Mandolin*, 1910 by Pablo Picasso," Pablo Picasso, accessed November 3, 2019, https://www.pablopicasso.org/girl-with-mandolin.jsp.

Chapter Thirty-Two

1 Patricia McHugh and Alex Bozikovic, *Toronto Architecture: A City Guide* (Toronto: McClelland and Stewart, 2017), 66, and Doug Taylor, "Toronto's architectural gems—241 Yonge St.—south of Dundas," Historic Toronto, July 10, 2013, https://tayloronhistory.com/2013/07/10/torontos-architectural-gems242-yonge-st-south-of-dundas/.

2 Emily Dickinson, "This is my letter to the World," *The Complete Poems of Emily Dickinson* (Boston: Little, Brown and Co., 1960), 211.

3 Muriel Miller, *George Reid: A Biography* (Toronto: Summerhill Press, 1987), 105–106.

Chapter Thirty-Three

1 Gaston Bachelard, trans. Maria Jolas, *The Poetics of Space* (New York: Orion Press, 1964), 71.
2 Bachelard, *Poetics of Space*, 67.
3 Bachelard, *Poetics of Space*, 71.
4 Janice Anderson, "Negotiating Gendered Spaces: The Artistic Practice of Mary Hiester Reid," in Brian Foss and Janice Anderson, *Quiet Harmony: The Art of Mary Hiester Reid* (Toronto: Art Gallery of Ontario, 2000), 39.
5 The Bonneycastle family purchased Upland Cottage after Mary Wrinch Reid's death and later sold Upland to the Giacomelli family. Interview with Pamela Bonneycastle, April 8, 2016.
6 "Canada Enters the War," Veterans Affairs Canada, February 14, 2019, https://www.veterans.gc.ca/eng/remembrance/history/first-world-war/canada/Canada3.
7 "Canada Enters the War."
8 Lauren Wispé, "History of the Concept of Empathy," in *Empathy and Its Development*, eds. Nancy Eisenberg and Janet Strayer (Cambridge: Cambridge University Press, 1987), 18.
9 Pigman, "Freud and the History of Empathy," 237–256.

Chapter Thirty-Four

1 Katheryn, "*Lusitania* Is Lost: 7 May 1915," Toronto Reference Library Blog, May 7, 2015, https://torontopubliclibrary.typepad.com/trl/2015/05/lusitania-is-lost-may-7-1915.html.
2 Emanuel Hahn, letter to George Reid, February 26, 1916, Hooke Correspondence, E.P. Taylor Research Library and Archives, Art Gallery of Ontario, Toronto.
3 Dau's Blue Book 1910 (Toronto, Hamilton, and London, 1909), 120.
4 "511 Bathurst," Wikipedia, accessed January 18, 2020, https://en.wikipedia.org/wiki/511_Bathurst.
5 Douglas Fetherling and Maud Mclean, "Hector Charlesworth," The Canadian Encyclopedia, March 6, 2015, https://www.thecanadianencyclopedia.ca/en/article/hector-charlesworth.
6 Miller, *George Reid: A Biography* (Toronto: Summerhill Press, 1987) 103.
7 *The New Galt Cookbook* (Toronto: McLeod & Allen, 1898), 219–221. Recipe from Mrs. Paddon, Chicago.
8 Information based on George Agnew Reid, 1917, oil on canvas collection of the Toronto District School Board acquired by Central Commerce Collegiate Institute, Toronto.
9 Miller, *George Reid*, 108.
10 Muriel Miller, *George Reid: A Biography* (Toronto: Summerhill Press, 1987), 105.
11 "Wrinch, Mary E.," Canadian Women Artists History Initiative, last updated August 13, 2013, https://cwahi.concordia.ca/sources/artists/displayArtist.php?ID_artist=110.
12 Mary Hiester Reid, letter to Ellen Smith Hahn, November 12, 1918. Mary Hiester Reid exhibition records, Charles C. Hill Documentation Files, National Gallery of Canada Library and Archives.
13 Gaston Bachelard, *The Poetics of Space* (New York: Penguin, 2014), 34.

Chapter Thirty-Five

1 Fay Bound Alberti, "Angina Pectoris and the Arnolds: Emotions and Heart Disease in the Nineteenth Century," *Medical History* 52, no. 2 (April 2008): 221–223.

2 "La France Rose Description," accessed July 16, 2018, http://www.helpmefind.com/rose/pl.php?n=3669.

3 Edward Thomas, "Rain" (1916), *The Longman Anthology of Poetry* (Pearson, 2006), https://www.poetryfoundation.org/poems/52315/rain-56d230ad7f92d.

4 Alberti, "Angina," 223.

5 Alberti, "Angina," 227. Quoting John Forbes, Alexander Tweedie, and John Connolly, eds., *The Encyclopaedia of Practical Medicine* (London, Sherwood, Gilbert and Piper, 1855), vol. 1, 81.

6 Muriel Miller, *George Reid: A Biography* (Toronto: Summerhill Press, 1987), 113.

7 Mary Hiester Reid, letter to Ellen Hahn, October 21, 1919. Mary Hiester Reid exhibition records, Charles C. Hill Documentation Files, National Gallery of Canada Library and Archives.

8 "Osler, Sir William," Dictionary of Canadian Biography, vol. XIV, accessed January 4, 2020, http://www.biographi.ca/en/bio/osler_william_14E.html.

9 Alberti, "Angina," 235.

Chapter Thirty-Six

1 Andrea Terry, *Mary Hiester Reid: Life and Work* (Toronto: Art Canada Institute, 2019), 71.

2 Terry, *Mary Hiester Reid*, 71.

3 Muriel Miller, *George Reid: A Biography* (Toronto: Summerhill Press, 1987), 114.

4 "Scotch Elm," The Tree Pages, accessed January 25, 2020, http://canadiantreetours.org/species-pages/Scotch_elm.html.

5 "Wych elm," Lexico, accessed January 25, 2020, https://www.lexico.com/en/definition/wych_elm.

6 Celia Campbell, "The Shade of Orpheus: Ambiguity and the Poetics of *Vmbra* in *Metamorphoses* 10," *Dictynna* 16 (2019), https://journals.openedition.org/dictynna/1814.

Postlude

1 Letter from George Reid, November 2, 1921. Photocopy in Mary Hiester Reid research records, Janice Anderson Documentation Files, Concordia University.

2 The Last Will and Testament of Mary Hiester Reid, May 21, 1917. Mary Hiester Reid exhibition records, Janice Anderson Documentation Files, Concordia University.

3 Brian Foss and Janice Anderson, *Quiet Harmony: The Art of Mary Hiester Reid* (Toronto: Art Gallery of Ontario, 2000), 16.

4 Andrea Terry, *Mary Hiester Reid: Life and Work* (Toronto: Art Canada Institute, 2019), 49.

5 Dickinson Norcross correspondence database, April, 1873, http://archive.emilydickinson.org/correspondence/norcross/l388.html

6 1 Kings 19:12, King James Version, accessed January 28, 2020, https://www.kingjamesbibleonline.org/1-Kings-19-12/.

7 C.W. Jefferys, "The Art of Mary Hiester Reid," in Foss and Anderson, *Quiet Harmony*, 19, 21, 23.

8 With thanks to my painting teacher Louise Reimer (https://www.louisereimer.ca/about), and Carol A. Macintyre, "Why Is Mixing Gray So Important," https://www.celebratingcolor.com/mixing-gray/.

9 Denise Levertov, "First Love," *This Great Unknowing: Last Poems* (New York: New Directions, 1999), 8.

INDEX

Note: MHR stands for Mary Hiester Reid and GAR for George Agnew Reid. Their artworks are listed under "works by."

Académie Colarossi, 6, 139–40, 143–44, 269
Académie Julian, 139, 154, 269
Adams, Maude, 308
Agnew, Thomas (grandfather of GAR), 52
Agnew, Thomas (uncle of GAR), 83
The Agnew Clinic (Eakins), 81
Allison, Emma, 67
American Civil War, 8, 46–47
American Fine Arts Society, 212, 213, 241
Anderson, Janice, 30, 155
angina and heart disease of MHR, 321–22, 369–71
Anshutz, Thomas Pollock, 82
anti-German sentiment, 354–55
the Arcade (Toronto), 163–65, 166, 179, 221, 284
Arrangement in Grey and Black, Number 2 (Whistler), 294, 296, 297
Art Canada Institute, 30
Art Gallery of Ontario
 miniatures of E.M. Wrinch, 299
 paintings by MHR, 15, 385
 shows by MHR, 12, 30, 384–85
artists, and presence for partners, 288–89, 290
artist's memories for later, 102–3, 154, 163, 233, 297, 298
Art Metropole, 343
Art Nouveau (New Art), 141, 305
"The Art of Mary Hiester Reid" (Jefferys), 386–87
Arts and Crafts movement, 265, 306

Arts and Crafts Society (later the Canadian Society of Applied Art), 305
Art Students League, 212, 299
artworks by MHR and GAR. *See* works by GAR; works by MHR
Ashton, James, 121–23, 129
Associated Artists company, 72
Atkinson, W.E., 84
Autumn, Wychwood Park (MHR), 342, *437*
Avoird, Renée van der, 348

Bachelard, Gaston, 155, 158–59, 347, 364
Beatty, J.W., 305
Beckington, Alice, 232, 273
"beholder's involvement," 196–97
Beloit (Wisconsin), 46, 47–48, 50–51, 53–54, 55–56
Benton, Jeremy, 74
birth control in late 19th century, 121–23, 129
Bishop, Elizabeth, xv
Bishop Strachan School, 172–73, 186
Board of Lady Managers, 194, 195
bodegon paintings, 189–90
Bonnard, Pierre, 154, 155–56
Bonnie Brae, 192
The Book of Nature (Ashton), 121–23, 129
Boyanoski, Christine, 43
Boyesen, Hjalmar Hjorth, 226–29
boyhood, 228, 229, 308
Bronte (ON), 114–15, 186
Browning, Robert and Elizabeth, 278–79
bullring in Spain, 112

Carlyle, Thomas, 296

Carrie (sister of MHR, Caroline
 Elizabeth)
 family and youth, 8, 31, 37
 house and life in Beloit, 54, 55–56
 move to Europe and religion, 8–9, 53,
 62–63, 65
 visits by MHR in Europe, 110–12,
 264, 331, 333–34
cars, 318–19
Carter, Alice, 208
Cassatt, Mary, and World's Columbian
 Exhibition, 192–95
Castles in Spain (central panel) (MHR),
 240
Castles in Spain (side panels) (MHR), *254*
Catskill Mountain Camp and Cottage
 Company, 160–61
Catskill Mountains, 159, 180–81, 280
Central Ontario School of Art and
 Industrial Design, 180, 207, 241
Challener, Frederick Sproston
 in mural competition, 283–84
 on OSA committee, 305, 306
 Portrait of Mary Hiester Reid, 108
 as student and follower, 118, 127, 208
Champlain, Samuel de, 321
Chapman, Michael, 332
Charlesworth, Hector, 356
Chase, William Merritt, 200, 243, 256
Chauncey Woolsey, Sarah, 183
Chen, Daniel, 236
cholera pandemic, 110
Chrysanthemums (MHR), *188*, 189–90,
 192, 196–97
*Chrysanthemums: A Japanese
 Arrangement* (MHR), *234*, 235–37, 385
Cité fleurie (Paris), 137–38
City of Chicago (ship), 89, 99
Clark, Caryl, 198, 306, 307
Clymer, George, 34, 79
Cody, Henry John, 369
Colarossi, Filippo, 139–40
Cole, Thomas, 94, 95
Columbia (ship), 332
"companionate marriage" of MHR and
 GAR, 10, 289–90
 See also marriage as partnership
conception prevention in late 19th
 century, 121–23, 129
Cooley, Jeff, 178
Corn, Wanda, 62
Coykendall, Sam, 160

Crane, Walter, 70
Croasdale, Elizabeth, 68
Curley, Jane, 198, 306, 307
Currelly, Ada Mary Newton, and C.T.,
 358, 369, 374–75
Czarnota, Mariola, 324

*Dante's Dream at the Time of the Death of
 Beatrice* (Rosetti), 101
Del Debbio, Christophe-Emmanuel, 140
Denis, Maurice, 154
Dickinson, Emily, xv, 343, 385
domesticity in art of MHR, 142, 156, 159,
 205–6, 347, 386–87
domestic life or role of MHR, 127–29,
 130, 138–39, 142, 165, 319–20, 356–57
domestic objects, in paintings, 20–21,
 156–58
Donne, John, 16
Donne, Walter, 384
Dunbar, Thomas, 181
duo shows, 343

Eakins, Thomas, 3, 78, 79, 80–82, 85
Early Spring (MHR), *42*, 49–50
Eiffel, Gustave, and tower, 146
Einfühlung ("feeling into" or sympathy),
 45, 158, 227, 351
Elm Tree Shadows (MHR), *372*, 373–74,
 376–77
Emily (sister of E.C. Wrinch), 94, 95
emotions and emotional responses to art
 in art, 257
 as concept, 158, 197, 227, 371
 in MHR's art, 66–67, 346, 386–87
 and Tonalism, 17, 61–62, 66
Empathists, 44
empathy, 45, 158. *See* 197
Europe travels. *See* travels of MHR and
 GAR to Europe
The Evening Star (GAR), *230*, 231
"The Evolution of Two of My Pictures"
 (essay by GAR), 168
Exposition Universelle (1889), 146

feelings. *See* emotions and emotional
 responses to art
A Fireside (MHR), *26*, 28–29
Fitzgibbon, Agnes, 179
Fliess, Wilhelm, 197
Ford, Harriet Mary, 208–9, 331, 332–33
Foss, Brian, 30, 167

Freud, Sigmund, 45, 197, 270
"From Gibraltar to the Pyrenees"
 (article by MHR), 243

Gaillard, E. Davis, 283
GAR. *See* Reid, George Agnew
George Reid: A Biography, 43
Giacomelli, Marc and Sarah, 348
Gibraltar, 245–46, 248
girlhood, 228
Globe, 330–31
gloves, 103–4
"going on cheerfully" of MHR, 29, 171,
 260–61
Golding, Clarissa, 94
Goodman, Ambrose, 309
Gossip (GAR), *126,* 128
Gotlieb, Rachel, 20–21, 119
Grasset, Eugène, 140–41, 142–43
 "Juin" in *La Belle Jardinière, 136,* 142
Great Depression (1893–1896), 199–200
Great War. *See* World War I
Grier, Rose, 173
Groden, Michael, 107
Group of Seven, 50
Guillot, Jean-Baptiste André, 206

Hagarty, Clara, 266
Hahn, Ellen Smith, 284, 303, 319–21, 322,
 354–55, 359–60
Hahn, Emanuel, 305, 355
Hahn, Gustav, 284, 304–5, 306, 355
Hahn, Paul, 305, 355
haiku poems, 149
Hallowell, Sara Tyson, 195
Hatch, Emily Nichols, 207–8
Haverford (ship), 336
Hayden, Sophia, 194
heart disease and angina of MHR,
 321–22, 369–71
Hemming, Miss, 265
Henry, George, 294
Hiester, Caroline Amelia (mother of
 MHR). *See* Musser, Caroline Amelia
Hiester, Carrie (sister of MHR). *See*
 Carrie
Hiester, John (father of MHR)
 death, 8, 38, 39
 description and marriages, 34–36
 as father, 36–38, 248
Hiester, John Louis (brother of MHR),
 36, 37

Hill, Charles, 167
Hillyard, Carrie L., 208
Holmes, Robert, 207
home design, 155–57
Howard, Richard, 347
Howells, William Dean, 227
Huizinga, Johan, 290, 364
Hunter, John Young, 295
Huy (Belgium), 333

ideas and play, 364
Imari ceramics, 190
Impressionism, 269
Indian Road house and life, 285, 291, 303,
 304–6, 308
In Memoriam MHR (MacDonald), *382,*
 385
Inness, George, 61, 66
International Exhibition of Arts,
 Manufactures, and Products of the
 Soil and Mine (1876), 64, 67–68

Jackson, Stuart, 237
japonisme and japonaiseries, 141, 149,
 153–54
Jefferson Medical College, 79–80, 81
Jefferys, C.W., 30, 127, 305, 321, 386–87
Jung, Mary, 219–20

Kaiser Wilhelm (ship), 241
Kinsky, Katie, 288
Kunisada, Utagawa, print by, 156, 235,
 237

Lake of Bays, 310
Lake Simcoe (ship), 298
Lambton Mills (ON), 179
landscape paintings, 85, 277–78, 281, 310
Lee, Vernon (Violet Paget), 351
Leonard (brother of M.E. Wrinch), 95,
 172
Leticia (sister of GAR), 128
Levertov, Denise, 389
Levin, Phillis, 102
Lipps, Theodor, 45, 158, 351
Lizars, Kathleen MacFarlane, 310
Lochnan, Katharine, 203, 204
Long, Marion, 27, 28, 376
Lusitania (ship) sinking, 354–55

MacDonald, J.E.H., and *In Memoriam
 MHR, 382,* 385

MacDowell, Marian and Edward, 148, 150
Macdowell, Susan, 82
MacDowell Colony, 148–49, 150
MacMurchy, Marjory, 51
Maggie (aunt of GAR), 83
Manning, Jenny, 93
marriage as partnership (MHR and GAR), 10, 90–91, 92, 280, 289–90, 308–9, 337–38
The Marriage Guide for Young Men (Hudson), 100–101
"The Mary Luncheon" at Onteora, 306
Massey's Magazine, 17, 242, 243, 259, 263
Matthews, Marmaduke, 309
Mavor, Henry, 294
McLenegan, Henry, 46, 47–48, 54
McLenegan, John, 62
McNab, Donald, 84
Memorial Exhibition of Paintings by Mary Hiester Reid (catalog), 30, 385
memories of artists for later, 102–3, 154, 163, 233, 297, 298
Las Meninas (Velázquez), 256–57
Mermet roses, 206
MHR. *See* Reid, Mary Hiester
MHR and GAR. *See* Reid, Mary and George (as couple)
Miller, Ethel, 208, 335
Miller, Muriel
 biography of GAR, 43, 53
 on bullring visit, 112
 on MHR, 338, 356, 388
 on Onteora, 181
 on proposal for Europe, 90
 on E.M. Wrinch for GAR, 28, 376
miniaturist movement, 265
mock parliaments by women, 282
A Modern Madonna (study for) (GAR), *218,* 219–20, 226
money and art, 183–84, 199–200
Monthly Illustrator, 226, 228
Moonrise (MHR), *276,* 277–78, 279–81
Morning Sunshine (MHR), *344,* 345–48
Morris, William, 184
mortgaging of farms, 168–69
Mortgaging the Homestead (GAR), *162,* 166–68, 169, 170
Muhlenberg, Henry Ernst, 33
Muhlenberg, Mary Catharine, *32*
Muhlenberg family, 33–34, 46
Muntz, Laura, 196, 207
Murray, Joan, 173

Musser, Caroline Amelia (mother of MHR)
 death and mourning, 8, 54, 66
 leaving Reading to Beloit, 8, 46–48
 marriage, 34, 35–36
 pregnancies, 36–38
Muybridge, Eadweard, 79

Nabis, 154, 155–56
Nasturtiums (MHR), *316,* 322–25
National Gallery of Canada, 144, 318
neuritis, 321, 367–68
Nightfall (MHR), *60,* 61–62, 65–66, 322
1910 Canadian Blue Book, 355
Novalis (poet), 158
nude models, 77–79

objects (domestic), in paintings, 20–21, 156–58
Odell, Sharon, 353
O'Keeffe, Georgia, 18, 19
Oliver, Coate and Company art dealers, 131, 192
Ontario College of Art (now OCAD U), 343, 369, 374–75
Ontario School of Art, 180
Ontario Society of Artists (OSA)
 exhibits of MHR, 118, 120, 130, 166
 GAR as president and chair, 291, 305
 MHR on executive, 30
 work of M.E. Wrinch, 207
Onteora artist colony, *302*
 art and play, 289–90
 church, 232
 creation, 160–61
 description, 7, 280–81
 "The Mary Luncheon", 306
 money and art, 199–200
 visit by author, 199
 and C. Wheeler, 7, 160, 161, 183–84, 199–200, 201, 280
 women at, 183, 282–83
Onteora and MHR and GAR
 GAR at, 200–201, 232, 283, 321
 home and studio, 191–92, 198, 383
 and M.E. Wrinch, 208, 210
 MHR at, 7, 182–83, 185, *302,* 306, 319–21
 painting school, 200–201, 208–10
 visits as couple, 181–83, 184–85, 191, 307, 318–19, 349–50
Ornoch, Andrzej, 323–25

Orpen, William, 295
Orrick, William P., 92
Osler, Edmund, 165, 358
Osler, William, 370–71

Palmer, Bertha, 193
pandemics, 110, 360–61, 368
Paris
 art students, 139–40
 studies of MHR and GAR, 6, 139,
 143–44, 146–47, 154
 studios of MHR, 2, 8, 141–42, 143, 155
 studios of MHR and GAR, 137–39,
 140, 269–71
Paris Salon, 165
Partridge, Elise, 205–6
Past and Present Still Life (MHR), 366,
 367, 368, 369
Peacock, Molly
 and biography of MHR, 43–44,
 261–62, 263
 deaths of mother and sister, 132
 divorce and first marriage, 102–3, 288
 family life, 149
 and Nasturtiums, 323–25
 at Onteora artist colony, 199
 as poet, 74–75, 134, 148–49
 as poetry teacher, 132–33
 prescience in poems, 102–3
 research notes loss, 213–14
 second marriage and husband (Mike
 Groden), 22–24, 107, 132–33, 214–15,
 252–53, 263–64, 337, 360–64, 378–80
 in Spain, 252–53, 255, 260
 Upland Cottage visit, 348, 350
Peel, Paul, 88–89, 269
Pennsylvania Academy of the Fine Arts,
 77–78, 166
perception, and paintings/art, 44–45,
 196–97
Petiet, Marie, 106
Philadelphia
 GAR in, 83, 84–85
 MHR and art, 68–69, 72–73, 77–79,
 82, 85–86
 MHR in, 56, 62, 64, 65, 87, 113, 336
Philadelphia School of Design for
 Women, 68–69, 72–73
Phillips, Adam, 290
play, 289–90, 364
plein air painting (landscape paintings),
 85, 277–78, 281, 310

Portrait of Mary Evelyn Wrinch (GAR),
 221, 222, 223
Portrait of Mary Hiester Reid (1885)
 (GAR), 98, 103–4
Portrait of Mary Hiester Reid (1898)
 (GAR), 286, 287, 291
Portrait of Mary Hiester Reid
 (Challener), 108
Portrait of Mrs. Reid (GAR), 292, 293
projection, 44, 45, 197
Puvis de Chavannes, Pierre, 270–71

Quiet Harmony exhibition and catalog, 30

Reading (Pennsylvania)
 with GAR, 87, 88, 336
 with mother and family, 8, 46–47
 return to, 62, 64, 336
recreation and art, 289–90
Red Cross and WWI, 357–58
Reid, Adam (father of GAR), 52, 55, 83
Reid, Eliza Agnew (mother of GAR),
 55, 83
Reid, George Agnew (GAR)—art and
 as artist
 as architect and builder, 55, 83, 190–91,
 200–201, 232, 283, 285, 307, 317–18, 329
 art education, 77, 80, 84–85, 88–89
 as art teacher, 180, 224, 335
 artworks (See works by GAR)
 in art world, 305, 317–18, 343, 358,
 369, 374
 exhibitions, 144, 195, 212–13, 232–33,
 270, 331–32
 exploration of in Boyesen's article,
 226–27, 228–29
 as illustrator for travel essays, 249–50
 MHR as model, 128, 138, 144–45, 167,
 170, 171
 MHR in art of, 104
 murals, 271, 283–84, 306, 307
 and Onteora, 200–201, 232, 283, 321
 painting ambition, 52–53
 in Philadelphia, 83, 84–85
 portrait, 268
 portrait of Carrie, 111–12
 portraits by MHR, 91, 224
 studies in Europe, 88–89
 as "sympathetic realist," 226–27, 228
 talent for art, 80, 83
 timeline, 390–92
 and C. Wheeler, 198

Reid, George Agnew (GAR)—personal
aspects
biography, 43
and boyhood, 228
death of MHR, 383
description, 9
family and youth, 52–53, 55, 83–84,
168–69
and G. Hahn, 305
liberal notions and equality, 183, 184
and MHR (*See* Reid, Mary and
George (as couple))
as protector for MHR, 9–10
relationship with M.E. Wrinch
and MHR (*See* Reid, Mary and
George, with M.E. Wrinch)
timeline, 390–92
E.M. Wrinch as partner, 384–85, 388
youth, 51–53
Reid, John (brother of GAR), 168
Reid, Mary and George (MHR and
GAR as couple)
adoption of child, 220–21
at art school together, 85–87
art studies in Paris, 139, 143–44, 154
art studios in Paris, 137–39, 140,
269–71
art viewing, 101, 105–6
and "bequeathing" of E.M. Wrinch,
19, 27–28, 376
costume ball at OCA, 374–75
at family home of GAR, 127–28
love and getting closer, 87–88
marriage, 92
marriage as partnership, 10, 90–91, 92,
280, 289–90, 308–9, 337–38
at Onteora colony, 181–83, 184–85, 191,
307, 318–19, 349–50
Onteora home and studio, 191–92,
198, 383
painting school in Onteora, 200–201,
208–10
painting school/teaching in Toronto,
118–19, 121, 127, 131, 221
proposal for Europe, 89–90
sale of artworks, 131
social standing, 355
Toronto as home, 117–19, 127–31,
284–85
travels (*See* travels of MHR and
GAR to Europe)
World's Columbian Exhibition, 196

Reid, Mary and George (MHR and
GAR), with M.E. Wrinch
intersection in Toronto, 313–14, 329
legacy and works of MHR, 384–85,
388
ménage à trois, 29, 31, 341–42
and miniature of MHR, 313–14
relationship as fact, 359, 375
start of relationship, 210–11, 221
Reid, Mary Hiester (MHR)—art and
as artist
ambition, 142
art education, 3–5, 6, 68–69, 72–73,
77–79, 82, 85–86, 139, 143–44, 146–47
artworks (*See* works by MHR)
career start, 5, 9
domesticity and domestic objects,
142, 156, 159, 205–6, 347, 386–87
emotions, 66–67, 346, 386–87
exhibitions, 11, 12, 118, 130, 131, 166,
180, 192, 195–96, 205, 206, 209, 343,
384–86
finances and sales, 11
and GAR (*See* Reid, Mary and
George (as couple))
ginger jars and Asia, 185, 236
images for later, 102–3, 154, 163, 233,
297, 298
inclination for painting and art, 51,
53, 68
legacy of works, 18–19, 385–88
in miniature of E.M. Wrinch, 313–14
as model for GAR, 128, 138, 144–45,
167, 170, 171
move to arts, 54, 63, 65
and objects, 20–21
at Onteora, 7, 182–83, 185, *302*, 306,
319–21
as poetry reader, 17
portraits, *98, 108, 268, 286, 292, 312*
portraits by GAR, 103–4, 138, 258, 287,
293, 295
recognition, 11, 12, 384–85
retrospective show, 384–86
reviews of works, 18, 50, 205, 209, 323
sales and prices, 90, 118, 120, 121, 130,
131, 166, 192
shows with E.M. Wrinch, 343, 359
signature, 130, 237
studio and house in Toronto, 27,
28–29
studio in Paris, *2, 8*, 141–42, 143, 155

styles and techniques, 6, 17, 18–19, 20, 142–43, 156, 189–90, 204, 235–36, 277, 281, 373
 as teacher of art, 69
 timeline, 390–92
 titles of works, 28
 and Woman's Building at World's Columbian Exhibition, 195–96
 and women's art, 106
Reid, Mary Hiester (MHR) (Mary Augusta Catherine)—personal aspects
 "bequeathing" of E.M. Wrinch to GAR, 19, 27–28, 376
 birth and infancy, 38–39
 botanical heritage, 7–8, 33–34
 in cemetery, 29
 character, 28, 30, 297–98, 338
 domestic life or role, 127–29, 130, 138–39, 142, 165, 319–20, 356–57
 family and youth, 3, 4, 7, 8–9, 33–39, 46–48, 50–51, 53–54, 55–56
 family house and contents, 54, 55–56
 and GAR (See Reid, Mary and George (as couple))
 "going on cheerfully" trait, 29, 171, 260–61
 grandmother, 32
 health and death, 27, 321–22, 367–68, 369–70, 373, 377, 383
 laughter, 165, 338
 letters and diaries, 30, 303, 319–21, 322
 love and marriage, 9–10
 menopause, 304, 307–8
 motto and mantra, 29, 171, 260–61
 move to Canada, 7
 in photo, 2, 8, 302, 306–7, 340
 relationship with M.E. Wrinch and GAR (See Reid, Mary and George, with M.E. Wrinch)
 threes, triads, and triangles in life, 19, 31, 39, 178–79, 342, 346
 timeline, 390–92
 as travel essayist, 242, 243, 244–51, 255–61, 262–63
 travels, 5, 7, 10, 11–12, 19
 women friends, 302, 303–4, 319–21, 335
Reid, Stuart, 220
Reid, William, 285
Reid family homestead, 168
Riegl, Alois, 44, 196
Rongier, Jeanne, 106

Rose, Amy, 353
roses, types of, 206, 211
Roses in a Vase (MHR), *176, 177*–78, 236
Rossetti, Dante Gabriel, 101
Royal Canadian Academy of Arts (RCA)
 election of GAR and MHR, 170
 exhibits of MHR, 118, 130, 166
 GAR as president, 317–18
 purchase of GAR's painting, 144
Royal Ontario Museum, 358
Ruge, Clara, 66
Rupert, Ida, 208
Russell, Charles Hazen, 200
Ryota, Oshima, 190

Sargent, John Singer, 351
schools (art/painting) of MHR and GAR
 at Onteora, 200–201, 208–10
 in Toronto, 118–19, 121, 127, 131, 221
Sketch Portraits of George Agnew Reid and Mary Hiester Reid (GAR), *268,* 270
Smith, Eden, 284–85, 304
Society of American Artists, 232
Society of Miniatures, 272
Spaarndam (ship), 271
Spain, trip of MHR and GAR, 109–12, 243–52, 255–61, 262–64
Staples, Owen, 191
still life, as concept, 204–5
Still Life with Daisies (MHR), *116,* 119
Stodola, Erin, 348
Stovel, Rex, 208, 223, 295
Studio in Paris (MHR), *152, 155*
A Study in Greys (MHR), *14,* 15–20, 21, 297, 308, 345, 346, 348, 385, 386
Study of a Woman with Arms on Head (GAR), *76*
suffrage for women, 281, 282, 370
Susan (sister of GAR), 128
sympathetic realism, 228
Sympathetic Self Expression, 387
sympathy, 44, 197, 351, 387
 See also Einfühlung

Talma, Louise, 150
Tarot magazine, 332
tea roses, 211
"Ten O' Clock" lecture (Whistler), 297
Terry, Andrea, 30

Thomas, Edward, 368–69
Thomson, Tom, 50
Three Roses (MHR), *202, 203–4, 211*
threes, triads, and triangles in MHR's
 life, 19, 31, 39, 178–79, 342, 346
Thurber, Frank, 159, 160, 161, 199–200
Thurber, Jeannette, 160
Tonalism, 17, 18, 19–20, 61–62, 66, 295
Toronto Art School, 131
Toronto Industrial Exhibition, 166
Trask, Katrina, 148
travels of MHR
 generally, 5, 7, 10, 11–12, 19
 travel essays, 242, 243, 244–51, 255–61,
 262–63
travels of MHR and GAR to Europe
 first, as newlyweds (1885), 99–101,
 105–6, 109–13
 second (1888), 131, 137–39, 143–44
 third, with Spain (1896), 237, 241–42,
 243, 244–52, 255–61, 262–64, 269–71
 fourth, in Scotland and England
 (1902), 294–96, 298
 fifth (1910-1911), 331–36
Twachtman, John, 233
Twain, Mark, 281–82
"Two in the Campagna" (Browning),
 278–80

Uhlyarik, Georgiana, 15, 16, 19, 299, 348
ukiyo-e prints, 40–41, 57, 141, 153, 156,
 233, 237
Upland Cottage
 building, 317
 changes with time, 349
 description, 27
 domestic aspects, 319, 322, 332
 visit by author, 348, 350
 in WWI, 356–58
 See also Wychwood Park

Velázquez, Diego Rodríguez de Silva y,
 89, 104, 255–56
Vickers, Henrietta Moodie, 223, 265,
 331, 335
Vischer, Friedrich Theodor, 158
Vischer, Robert, 45, 158
Vuillard, Édouard, 154
"Vuillard Interior" (Partridge), 205–6

Watts, G.F., 332
Weisberg, Gabriel and Simone, 139–40

Wheeler, Candace
 on Boyesen, 226
 description, 70
 and GAR, 198
 help for women artists, 70, 71–72
 and MHR, 73, 182, 195–96
 and Onteora, 7, 160, 161, 183–84,
 199–200, 201, 280
 Pennyroyal cottage, 159–60, 201
 and Woman's Building at World's
 Columbian Exhibition, 192,
 193–94, 195
Wheeler, Dunham, 161, 201
Wheeler, Tom, 159, 160
Whistler, James McNeill, 17, 57, 66,
 294, 297
Williams, Alyn, 265, 272–73
Winnicott, D.W., 20, 290
Woman's Building at Chicago
 Exhibition, 192–95
women
 and art exhibitions, 67–68
 at Chicago Exhibition, 194–96
 help from C. Wheeler, 70, 71–72
 and Onteora artist colony, 183, 282–83
 suffrage and social changes, 281–82
 The Women's Globe (MHR), *328,*
 330–31
Women's Building (Fairmont Park
 exhibition, 1876), 67–68, 70–71
Wordsworth, 334
works by GAR
 The Arrival of Champlain at Quebec,
 321
 In a Daisy Field, 232
 Drawing Lots, 228
 Dreaming (Revant), 138, 144–45
 The Evening Star, 230, 231
 Gossip, 126, 128
 A High Balcony, Madrid, 258
 The Homeseekers, 329, 331–32
 A Modern Madonna (study for), *218,*
 219–20, 226
 Mortgaging the Homestead, 162,
 166–68, 169, 170
 The Other Side of the Question, 212–13
 Portrait of Mary Evelyn Wrinch, 221,
 222, 223
 Portrait of Mary Hiester Reid (1885),
 98, 103–4
 Portrait of Mary Hiester Reid (1898),
 286, 287, 291

Portrait of Mrs. Reid, 292, 293
*Sketch Portraits of George Agnew Reid
 and Mary Hiester Reid, 268,* 270
The Story, 165–66, 228
*Study of a Woman with Arms on
 Head,* 76
works by MHR
 Autumn, Wychwood Park, 342, *437*
 Autumn in the Catskills, 180
 Castles in Spain (central panel), *240*
 Castles in Spain (side panels), *254*
 Castles in Spain (triptych), 244
 Chrysanthemums, 188, 189–90, 192,
 196–97
 *Chrysanthemums: A Japanese
 Arrangement, 234,* 235–37, 385
 At Close of Day, 205, 206
 Daisies, 130
 Early Spring, 42, 49–50
 Elm Tree Shadows, 372, 373–74, 376–77
 A Fireside, 26, 28–29
 The Guitar Painter, 130
 An Idle Hour, 209
 The Inglenook in My Studio, 322
 Landscape with Sheep, 295
 The Long Seam, 205
 Moonrise, 276, 277–78, 279–81
 Morning Sunshine, 344, 345–48
 From My Window, Paris, 166
 Nasturtiums, 316, 322–25
 Nightfall, 60, 61–62, 65–66, 322
 Night in the Village (England), 295
 Past and Present Still Life, 366, 367,
 368, 369
 Playmates, 179–80
 Roses in a Vase, 176, 177–78, 236
 Saw Mills, Muskoka, 28
 Still Life with Daisies, 116, 119
 Still Life with Roses, 184–85
 Studio in Paris, 152, 155
 A Study in Greys, 14, 15–20, 21, 297,
 308, 345, 346, 348, 385, 386
 Study of Peacock Feathers, 130
 Three Roses, 202, 203–4, 211
 Waiting by the Fireplace, 145–46
 The Women's Globe, 328, 330–31
World's Columbian Exhibition
 (Chicago), 11, 192–96
World War I, 349–51, 354–59
Wrinch, Agnes (sister), 329, 342, 375
Wrinch, Elizabeth Cooper (mother), 93,
 94–95, 114–15, 172, 272

Wrinch, Leonard (father), 93, 94
Wrinch, Mary Evelyn—art and as artist
 as artist, 299–300, 310, 313
 art studies, 207, 272–73
 exhibitions, 207–8
 GAR as teacher, 207
 at Lake of Bays, 310
 miniature paintings, 265, 272–73, 299,
 312, 313–14
 to Onteora, 208, 210
 portrait by GAR, 221, *222,* 223
 shows with MHR, 343, 359
 studio in tower, 223, 265–66
 studios in Toronto, 266, 329
Wrinch, Mary Evelyn—artworks
 The Little Bridge, 352, 353–54
 Miniature of Mary Hiester Reid, 312,
 313–14
Wrinch, Mary Evelyn—personal aspects
 education, 172–73, 186
 family and youth in England, 93–95
 with GAR as partner, 384–85, 388
 GAR's interest for, 224, 231, 318
 move out of Wychwood Park, 375
 move to Canada, 114–15, 186
 move to Toronto, 172–73
 relationship with GAR and MHR
 (*See* Reid, Mary and George, with
 M.E. Wrinch)
 "willed" to GAR by MHR, 19, 27–28,
 376
 at Wychwood Park, 27, 329–30, 350, 353
 youth in Canada, 124, 207
Wychwood Park, 309, 317, 318
 small house across ravine, 318, 329,
 350, 353, 375
 See also Upland Cottage

Yorke, Lena McLenegan, 336
*Young Women Plucking the Fruits of
 Knowledge or Science* (Cassatt), 194–95

ACKNOWLEDGMENTS

I am grateful to Access Copyright and to the Canada Council for the Arts for timely grants that rescued this project with support for research and writing.

Very special thanks go to my agent, Alexa Stark at Trident Media as well as to Susan Renouf, Executive Editor for this and for my previous book, *The Paper Garden*, for her perspective, support—and a lot of fun, too. Everyone at ECW Press has given energy and talent to *Flower Diary*, particularly David Caron, Co-Publisher and President; Shannon Parr, Editorial Coordinator; Jessica Albert, Digital and Art Director; Susannah Ames, Marketing and Publicity Director; Crissy Calhoun, copy-editor; Jen Knoch, proofreader; Jennifer Gallinger, Production Manager; David Gee, cover design; Emily Ferko, Rights Director; Cassie Smyth, Audiobook Manager; Christine Lum, Audiobooks and Accessibility Coordinator; and Aymen Saidane, Operations Manager. I'm hugely grateful, too, for Jeremy Wang-Iverson at Vesto PR, and Sheila Kay at Sheila Kay Ink.

Mary Hiester Reid has inspired many scholars, curators, librarians, archivists, artists, and fans of artists. I have learned from many and have as many to thank as her numerous paintings themselves. In particular, the generosity of six extraordinary art historians, cited formally in the list below, have been essential: Janice Anderson, Brian Foss, Charles Hill, Andrea Terry, Renée van der Avoird, and the buoyantly knowledgeable Georgiana Uhlyarik.

I am especially thankful for Melissa Alexander's elegant research and captioning as well as her timeline editing: and to the community of independent scholars, collectors, and curators who are devoted to Mary Hiester Reid: Joan Murray; Edgar and Carol Nace; and Jeffrey and Betsy Cooley and Tim Godfrey. For interpretation of Mary Hiester Reid's health conditions, I'm grateful to Dr. Jack Shanewise. For ongoing support and advice, I thank friends Cristina Austin, Theresa Casey, Barbara Feldon, Phillis Levin, and Alisa Siegal, as well as Jasen Miller and Michelle Foster Miller of Libra Fitness.

The following institutions and individuals provided invaluable advice and reproduction permissions:

Art Canada Institute | Institut de l'art canadien: Stephanie Burdzy, Senior Operations Executive

Art Gallery of Ontario: Georgiana Uhlyarik, Fredrik S. Eaton Curator, Canadian Art; Renée van der Avoird, Assistant Curator, Canadian Art; Katharine Lochnan, Senior Curator and R. Fraser Elliott Curator of Prints and Drawings, Emerita; Marilyn Nazar, Archivist; Tracey Mallon-Jensen, Copyright and Reproduction Rights Coordinator; Brenda Rix, Manager, Print & Drawing Study Centre; Erin Stodola, University of Toronto intern

Art Gallery of Windsor: Catharine Mastin, Executive Director Emerita

Art Students' League: Stephanie Cassidy, Archivist

The Bishop Strachan School: Susan Dutton, Archivist

Campbell House Museum: Liz Driver, Director/Curator

Canadian Broadcasting Corporation Radio: Alisa Siegel, documentarian; Karen Levine, producer

Carleton University: Brian Foss, Director of the School for Studies in Art and Culture

Casey Design: Theresa Casey and Robert Gray

City of Toronto Market Gallery: Neil Brochu, Curator/Supervisor, Collections & Outreach, City of Toronto Museums & Heritage Services

Concordia University: Janice Anderson, Affiliate Professor, Department of Art History

Gardiner Museum of Ceramic Art: Daniel Chen, Adjunct Curator of Chinese Ceramics; Bingbin Cheng, intern.

Hetti Design: Nethmie Hetti

Stuart Jackson Gallery: Stuart Jackson

Leon Levy Center for Biography, CUNY Graduate Center: Shelby White, Founding Trustee

Metropolitan Museum of Art, Thomas J. Watson Library: Kenneth Sohner, Arthur K. Watson Chief Librarian

National Gallery of Canada: Charles C. Hill, Former Curator of Canadian Art, Adam Welch, Co-curator of Canadian and Indigenous Art; Raven Amiro, Copyright Officer; Amy Rose, Library and Archives; and Sharon Odell, Storage Technician

Onteora Club: Jane Curley, independent curator; Caryl Clark, Professor of Music History and Culture and Louis Pauly, J. Stefan Dupré Distinguished Professor of Political Economy, both at the University of Toronto

Paul Hahn & Company: Alex Hahn

Pennsylvania Horticultural Society: Nicole Juday Rhoades, Director of Audience Engagement

Reading Public Museum: Scott A. Schweigert, Curator of Art and Civilization

St. Francis Xavier University Art Gallery: Andrea Terry, Director

Wychwood Park and community: Marc and Sarah Giacomelli and Pamela Bonneycastle.

Women's Art Association of Canada: Maggie Broda, President; Cal Lorimer, Executive Office Manager; Dale Butterill, President Emerita, and the artists who took up the challenge to paint in the tradition of MHR: Alison Galley, Heather Gentleman, Mary Lennox Hourd, Carolyn Jongeward, Elizabeth Prociw, Margaret Rodgers, Jocelyn Shaw, Catherine Somerville, and Anita Stein.

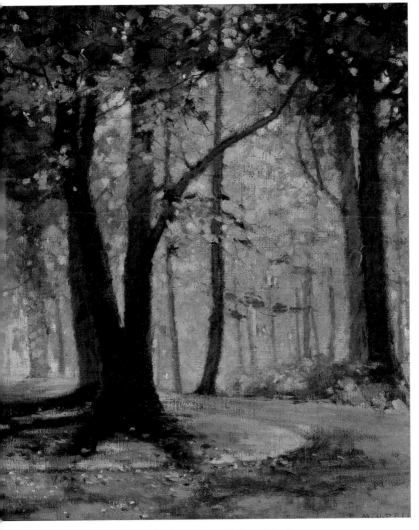

Mary Hiester Reid, *Autumn, Wychwood Park*, c. 1910
(50.A.40), Museum London.

This book is also available as a Global Certified Accessible™ (GCA) ebook. ECW Press's ebooks are screen reader friendly and are built to meet the needs of those who are unable to read standard print due to blindness, low vision, dyslexia, or a physical disability.

Purchase the print edition and receive the eBook free! Just send an email to ebook@ecwpress.com and include:

- the book title
- the name of the store where you purchased it
- your receipt number
- your preference of file type: PDF or ePub

A real person will respond to your email with your eBook attached. And thanks for supporting an independently owned Canadian publisher with your purchase!